JOURNEY TO THE TRENCHES

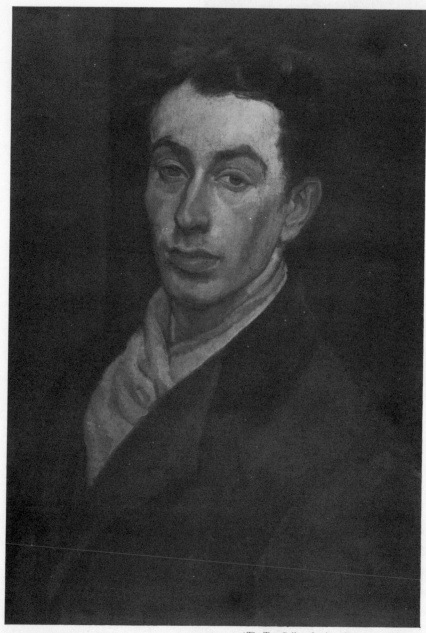

Isaac Rosenberg, self-portrait

JOURNEY TO THE TRENCHES

The Life of Isaac Rosenberg
1890-1918

JOSEPH COHEN

 Robson Books

812 - 912
COH

Set in 11/12 Baskerville Roman by
Cold Composition Limited, Tunbridge Wells, Kent
Printed and bound in Great Britain by
R. J. Acford Ltd., Industrial Estate, Chichester, Sussex

For *Gloria*
 Susan
 Cynthia
 and
 Jeffrey

Contents

Illustrations

Preface

My interest in the war poets of the twentieth century developed
during the Second World War when I was in the American army.
After demobilization in 1946, I immersed myself in the poetry of the
Great War. It was not long before I had developed a deep and abiding
feeling for Isaac Rosenberg, moved both by the tragic circumstances
of his life and the power and originality of his poetry, which
recorded the profound human suffering brought about by the devast-
ation of modern war.

In 1959-60, I had an opportunity to spend a year in London. By
then Rosenberg had become so much a part of my consciousness that
I devoted all the time I could spare to gathering information about
his life and work. I had been corresponding for several years with
Annie Wynick, his sister and literary executrix; and when my family
and I arrived in September 1959, we were able, through her good
offices, to go direct to an ideally suitable house near Hampstead
Heath. We became fast friends, though her real affection was reserved
for my two young daughters who, I like to think, gave her much joy.
She lived by herself, was growing old, and was ill much of the year,
and lonely. Yet she enthusiastically undertook to give me all possible
aid in my research. She was absolutely indefatigable in her efforts to
advance Rosenberg's reputation. The exhibition of his work at Leeds
University, organized by Jon Silkin and Maurice de Sausmarez, had
taken place in May and June of that year. Much of its success was
due to the countless letters she wrote and the dozens of telephone
calls she made in the attempt to locate and gather together drawings,
paintings, manuscripts, letters, books, and memorabilia. For the
smaller exhibition sponsored by the Slade School of Art in October,
she invited me to assist in transporting and assembling the collected
artifacts. After the show ended, because she was exhausted and ill,

she gave me the responsibility of seeing that everything was safely returned to its owners.

Annie Wynick and I spent an enormous amount of time together discussing Rosenberg, probing for particulars of his early years, searching out people who knew and remembered him. Respecting her, and eager for a biography to appear, they were generous in the extreme. Questing for new leads, she sent me on many a journey through the streets of Whitechapel, until I came to feel more at home there than I ever had in the quiet little Tennessee town where I was brought up. She took delight in my insistent questionings. Both of us worked hard and were rewarded by a resurgence of memories of the family's life in her youth. Details surfaced which she had not thought about in decades. She laughed over the tribulations of those times, never forgetting how hard their life had been, how filled with tragedy, as the mosaic of the past fell into perspective in our conversations. The heartaches were long since gone; what remained were the truths distilled from her memory, not all of them pleasant; but good and bad, she was keen to share them.

By the end of my sojourn in London, we were happy conspirators. Before I returned to America she made me promise I would write the book, and to ensure my doing so she handed me a letter one day which began, 'As literary executrix of the late Isaac Rosenberg's estate, I am happy to authorize you to undertake the preparation of a book-length definitive critical biography of Isaac Rosenberg.' She entrusted the family papers to my care and granted me unlimited permission to use from her memorabilia everything I wanted. The two other members of Rosenberg's immediate family, Mrs. Rachel Lyons and Mr. David Burton, both of London, were respectively four and seven years younger than Rosenberg, and though they were gracious and helpful, their recollections were sparse compared to Annie Wynick's. For their help, I am deeply appreciative, but my indebtedness to Annie Wynick is as boundless as my gratitude to her. Had I not wanted to write the book, it would still have been written, out of respect for her kindness.

When I returned to my home in New Orleans, circumstances precluded immediate preparation of the book. Its subsequent delay was never intended, and I have come to be haunted by the knowledge that Annie Wynick did not live long enough to see her cherished dream materialize. She died in 1961 at the age of sixty-nine.

Because of the affinity I have long felt with Rosenberg and the affection I had for Annie Wynick, this book has become something

of a personal odyssey. I have tried not to allow that dimension to affect its objectivity. Much information about Rosenberg has been lost and is irretrievable, but where surmises or conjectures occur they are based on a careful scrutiny of the available facts. If there is warmth in the book it has grown out of the satisfaction I have had in responding to the vicissitudes of the poet's life as these were revealed to me largely by his sister, and the discovery of the circumstances which make his poetry comprehensible and significant.

Acknowledgments

My obligations to those who have helped to bring this work into being are extensive. I have been aided by many people whose passion for Isaac Rosenberg's work prompted both warm responses to my original enquiries and sustained interest thereafter in my progress. I am chiefly indebted to Rosenberg's sister, Annie Wynick, whose help and counsel were of the first magnitude. I greatly appreciate, too, the interest taken and the help extended in 1959-60 by the other immediate members of Rosenberg's family, Mrs. Rachel Lyons and Mr. David Burton. To Ian Parsons, Chairman of Chatto & Windus, I am especially grateful; in the late 1950s he urged me to proceed with this study both in his letters and at our several meetings, and provided me with much valuable material from the Chatto archives. I am also indebted to the following people for their help and for allowing me access to extremely useful documents in their possession: Professor Denys Harding, Maurice de Sausmarez, Jon Silkin, Lazarus Aaronson, Professor Claude Colleer Abbott, Mrs. Cicely Binyon, Mrs. Lillian Bomberg, Horace Brodzky, George Charlton, David Dainow, Morley Dainow, Patric Dickinson, Rabbi Avner Fellner, Andrew Forge, John Garson, Morris Goldstein, Mrs. Millie Gross, Major L. Heap, Professor Jack Isaacs, I. E. T. Jenkin, Mrs. Sonia Cohen Joslen, Professor Alun R. Jones, Mrs. Marjorie Kostenz, Jacob Kramer, Mrs. Beth Zion Lask, Joseph Leftwich, Bar-Kochba Narod, Carmel Narod, Jennifer Symthe Nash, Sir Herbert Read, Miss Joan Rodker, Mrs. Marianne Rodker, Joe Rose, Anthony Rota, Sidney Scott, I. N. Shtenzl, Mrs. Robert Solomon, Jacob Sonntag, Miss Elsie Taylor, Miss Barbara Tillman, Julian Trevelyan, and Bernard Wynick. Among those who gave so much time and information to me in interviews and correspondence in 1959-60, there are some who are no longer alive. I have included their names with the living, for so they continue in my thoughts.

I am grateful to Dean James Davidson, Newcomb College, Dr. David Deener, Dr. Clarence Scheps and Dr. Herbert Longenecker,

Tulane University, and the Administrators of the Tulane Educational
Fund for sabbatical leave in order to write this book; to Mrs.
Dorothy Whittemore and Mrs. Margery Wylie of the Howard-Tilton
Library, Tulane University; and to Mrs. Janelle Simon, Mrs.
Rosemary Spillman, and Mrs. Jennie Schneider of my staff. To the
latter-named lady, I am particularly indebted for her preparation of
the manuscript.

For permission to quote poems and letters by Isaac Rosenberg
which are still in copyright acknowledgment is made to The Literary
Executors of Mrs. Annie Wynick and Chatto & Windus Ltd., the
publishers of *The Collected Poems of Isaac Rosenberg*, and also of
The Collected Works of Isaac Rosenberg, a new and expanded edi-
tion of which is currently being prepared by Ian Parsons for publica-
tion later this year — also to Schocken Books Inc., publishers in the
United States of the *Collected Poems*. I am grateful to the New York
Public Library, Astor, Lenox and Tilden Foundations, for permission
to consult and quote from the letters to Sir Edward Marsh now in
the Henry W. and Albert A. Berg Collection of English and American
Literature; to its curator, Mrs. Lola Szladits, I am especially in-
debted. Acknowledgments are due to The Trustees of the Ezra
Pound Property Trust, Faber & Faber Ltd., and New Directions Pub-
lishing Corp., Mrs. Marianne Rodker and Robert Rosenthal, Curator
of the University of Chicago Library, for permission to use copyright
extracts from the letters of Ezra Pound and John Rodker to Harriet
Monroe. For permission to reproduce photographs of Rosenberg's
paintings and drawings, I am grateful to the Carlisle Museum and Art
Gallery, Miss Joan Rodker, The Tate Gallery and The National Por-
trait Gallery, London.

Others who have either encouraged me along the way or provided
assistance are: my wife Gloria, J. B. and Shirley Cohen, Dannie and
Joan Abse, Gerald and Rae Plitman, Dorothy Jacobs, Jane
Buchsbaum, Judy Newman, Maury Midlo, Tiki Axelrod, Sylvia
Sterne, and my father, Louis Cohen. Finally, I am reminded of an
obligation I have of many years' standing to my friend and mentor,
Dr. Harry Ransom, Chancellor Emeritus of the University of Texas,
who shared my enthusiasm for war poets and guided my early
researches.

1
Death Of A Poet
1918

On Thursday, March 21, 1918, the German ringmaster of the Western Front, General Erich von Ludendorff, having carefully probed for weak points in the French and British sectors of the line, committed to battle the full might of nineteen German divisions at the juncture he considered most vulnerable. The 1914-18 circus now entered a new phase in that famous but futile spring offensive to reach Paris, with a general attack against the centre of the Front held by the British Fifth and Third Armies. Decimated by heavy losses, these armies were flanked on their left by the French, who were also short of men, and on their right by the Americans, whose strength had not yet reached its full potency. Among the soldiers of the Sixth Platoon, B Company, First King's Own Royal Lancaster Regiment, Fortieth Division, Third Army, in the front lines directly in the route of the German advance, was Private Isaac Rosenberg, 22311.

Despite the ferocity of the German onslaught, the First King's Own Regiment repulsed the initial attack and resisted the massive artillery barrage which followed. Scheduled for a respite from the front trenches on Sunday, March 24, Rosenberg's battalion retired several hundred yards behind the lines to brigade reserve. Though the threat of death was temporarily reduced, the move meant neither rest nor safety since the Germans had broken through elsewhere along the line. The situation was sufficiently critical for Rosenberg's company to be ordered to stand to at 4:30 every morning, maintaining battle readiness throughout the day. When he was not occupied with such duties, Rosenberg allowed himself to become annoyed at the inefficiency and silence of headquarters over his request for a transfer to the 'Judains', the Jewish Battalion which Vladimir Jabotinsky had organized, then serving in Egypt and Palestine. It was composed entirely of Russian Jews who had immigrated earlier to

England and the United States. For over a year Rosenberg had sought to join them, but his applications were stopped somewhere in the army's bureaucratic channels.

Nursing his annoyance, Rosenberg worked on the final wording of 'Through These Pale Cold Days', 'a slight thing'[1] as he described it, apparently motivated by his admiration of the 'Judains' and his desire both to join them and to write their battle hymns. But he was not ready to write the 'strong and wonderful' song (CW, p. 322), which would convey adequately his respect for the Jewish Legion. Instead, he only hinted at it in this new poem, expressing with detachment and restraint in classically bare verse the frustrated yearning of the Jews to return to Palestine, underlying which is Rosenberg's only half-articulated, thwarted yearning to escape from his harsh and hostile environment in France and live among his own kind:

> Through these pale cold days
> What dark faces burn
> Out of three thousand years,
> And their wild eyes yearn,
>
> While underneath their brows
> Like waifs their spirits grope
> For the pools of Hebron again –
> For Lebanon's summer slope.
>
> They leave these blond still days
> In dust behind their tread
> They see with living eyes
> How long they have been dead.
> (CW, p. 91)

The parallels Rosenberg draws in the poem are carefully balanced. The 'cold' is equated with discomfort, intolerance, the threat of physical destruction and the death of the spirit; opposed to it is the desert heat of Lebanon's summer, implicit within it comfort, friendliness, understanding, safety, and the triumph of the spirit. Rosenberg's yearning to join the 'Judains' is akin to their fierce desire to recover Palestine, the Promised Land, flowing with milk and honey; his attitude of resignation to the unlikelihood of a transfer or even of surviving the war in France parallels the Jews' frustrated expectations of recovering their homeland. The poem is completely pessimistic, for Rosenberg as an enlisted army private had no alterna-

tive to his personal fate. His theme is resignation. His final stanza —
the last verse he would ever write — serves curiously as his own
epitaph, recording for posterity his mirrored view of himself as the
sensitive stranger always in actively hostile or, at best, merely in-
different surroundings: it was *his* dark semitic face that burned
through the blond still days and his urges as a poet toward life and
peace that came into conflict with military callousness and the
ravages of war. He saw with his 'living eyes' how long he had himself
been dead, consigned to the hell of the Western Front, and he knew
beyond longing and despair the true meaning of loss.

He had endured endless hardships, continuous minor punishments
such as pack-drill for his absent-mindedness — he could never keep
his gas-mask with him — bitter cold, false hopes, lice, intolerance,
corporal harassment, seas of mud, and shell-fire. He had been in and
out of the front lines for two years, and had remained resolute.
However, a long siege he had spent in the forward trenches in the
winter of 1917-18 was beginning to tell on him. On January 26,
1918, he wrote to his patron and friend, Edward Marsh (at the time
private secretary to Winston Churchill), complaining about his poor
health, the indifference of his officers, the severity of the weather,
and the war's assaults upon his sanity. In a passage cancelled by the
censor Rosenberg told Marsh, 'what is happening to me now is more
tragic than the "passion play". Christ never endured what I endure.
It is breaking me completely.'

Hurriedly, as was his habit, he sent 'Through These Pale Cold
Days' to Marsh, to ensure, as far as was possible, that the poem
would reach England and safety. The war had added a new dimen-
sion to his natural carelessness, and that plus the uncertainties of the
postal service in the combat zone forced the poet to get his work off
to England at once. His letter was dated March 28. In the same hour
that he was writing to Marsh, the Germans renewed their attack.

The First King's Own Regiment, still in the reserve trenches,
moved quickly to the forward area, at one point suffering heavy
casualties in terrain exposed to the enemy's cross-fire. Twenty-four
hours later the Germans had overrun the front line, and the First
King's Own Regiment along with other adjacent units found them-
selves back in the reserve trenches, which became the new front lines.
Throughout that Saturday and Sunday, March 30-31, they stub-
bornly resisted the German advance. When the attack eased on
Sunday, the few survivors in Rosenberg's company were ordered to
the rear. In the early morning hours of Monday, April 1, All Fools'
Day, the Company made its way back under cover of darkness. The

men had not gone more than two hundred yards when a runner caught up with them. The attack had been renewed and every man was needed. Since they had earned their brief respite from the fighting they were not ordered to return, but asked to volunteer. No one had to go back. Among the few who did was Rosenberg.[2]

He had no use for combat heroics. He loathed the Army, despised and rejected its codes. Yet he prided himself on being a good soldier despite his absent-mindedness. He had never been physically strong and at the Front his body from time to time dangerously rebelled against his will. Just as he was determined that the war 'with all its powers for devastation [would] not master [his] poeting',[3] so he was equally determined that his spirit in the end would conquer the physical demands the Army made upon him. Certainly he knew what the odds were against his surviving that fateful hour. He did not have to volunteer, but he made the decision to go back as in 1915 he had made the decision to enlist. He returned, and within an hour of reaching the battle area, somewhere close to the French village of Fampoux, Isaac Rosenberg was killed in close combat. He was twenty-seven.

When Rupert Brooke died of blood poisoning in the Dardanelles in April 1915, all England joined to mourn his loss, stirred by the oratory of Winston Churchill, then First Lord of the Admiralty, who in his famous eulogy proclaimed: 'Rupert Brooke is dead. A telegram from the Admiralty at Lemnos tells us that this life closed at the moment when it seemed to have reached its springtime. A voice had become audible, a note had been struck, more true, more thrilling, more able to do justice to the nobility of our youth-in-arms engaged in this present war, than any other — more able to express their thoughts of self-surrender, and with a power to carry comfort to those who watched them so intently from afar. The voice has been swiftly stilled. Only the echoes and the memory remain; but they will linger.'

Between the deaths of Brooke in 1915 and Rosenberg in 1918, thousands of English families were bereaved. One death was as devastating as another. Yet now, more than six decades later, there is still an inescapable irony in the contrast between the deaths of these two poets. One was tall, blond and classically handsome, with roots deep in English society, possessing a name and a heritage. The other was short, oriental in his features, and dark. He was rootless, suspended between two heritages, unable to identify satisfactorily with either. One glorified the challenges of war; the other abominated them. When they died, one, already mythologized as a 'golden-

haired Apollo', was buried on the Greek island of Skyros in an olive grove close to the Aegean Sea; the other, whose forbears came out of the eastern Mediterranean and who wished desperately to join the 'Judains' in Palestine, was interred in such great haste that for eight years after the war ended the British government could not tell Rosenberg's family where his body was.

If Brooke's death in 1915 became the symbol of the brave sacrifices of the young, then Rosenberg's death on All Fools' Day in 1918 became the symbol of the futility of such sacrifices. If he had to die in combat there could not have been a more appropriate occasion: his whole life was permeated by the ridiculous, he was thought a fool by many, and he often employed the role and used the image to achieve desired ends. After his death his remains were subjected to the same absurdities he had experienced while he was alive.

With constant fighting raging back and forth between the British front line and reserve trenches, Rosenberg's body remained unburied for several days. He became 'the older dead' about whom he had written in his most powerful war poem, 'Dead Man's Dump'. Sometime during that first week of April, however, the British pushed the Germans back for a few hours, just long enough to collect and bury their dead. Rosenberg's remains were interred with those of several other British soldiers in a temporary grave. Subsequently, the Germans overran the British positions in that sector and many months elapsed before any thorough search for the grave could be launched. In time, the Germans were forced back, the Allies regained the initiative, the Armistice was signed on November 11, the war ended. Rosenberg's family still held a forlorn hope that he would turn up among the missing, but in their hearts they knew the Army could not even find his corpse. By the end of 1919 the Enquiry Department of the British Red Cross could tell Rosenberg's parents only that he had been killed by a large German raiding party and that the whereabouts of his grave were unknown. Taking over the search, the Imperial War Graves Commission through the early 1920s was able only to send through an unverified report that the remains had been buried at a point north of Fampoux and east of Arras.

On December 17, 1926 this report was discounted. The War Graves Commission told Rosenberg's family that the unmarked grave had been located at another point not far from Fampoux. It had been possible to identify several of the soldiers, though not Rosenberg. Nonetheless, his name appeared on the original burial list with those identified, and the Commission was satisfied that his

remains were thus found. They were reinterred nearby in the Balleul Road East Cemetery. By October 1928 the twelfth headstone in Row D, Plot 5 was in place bearing Rosenberg's name, a Star of David, and the inscription, 'Artist and Poet', for which extra engraving the Commission charged three shillings and thruppence. All that could be done had now been done. But the absurdity persists: it is likely that Rosenberg's remains, if they are in that cemetery at all, rest under one of the adjacent crosses.

Though Rosenberg relished the role of the fool, he was, in fact, not one; but his luck was forever bad and he compounded misfortune by shifting sideways, as it were, through life, asking his mirrored image — his twin brother, dead at birth — to make his judgments for him, with the result that apart from the sculptural magnificence of his best poems the most authentic image he presents is that of the sensitive unfortunate, a man for whom everything in life might have gone right but instead went wrong; a poverty-ridden wandering Jew, an impressively original though consistently awkward poet, an erratic but sometimes accomplished artist — in short, a gifted clown whose continuing troubles were sufficiently marked by their absurdities to turn the tragedy of his existence into black comedy. General Erich von Ludendorff was but one ringmaster who fixed his fate. The curtain that was rung down on April 1, 1918 had been raised many years before by another ringmaster, the poet's father, Dovber (later Barnett) Rosenberg, when he fled Russia to escape conscription into the Russian Army.

2

Russia to England
1859-86

Sometime in the year 1886, Dovber Rosenberg, the Levite, a native of Lithuania and a student of the Torah, was ordered to conscript duty in the Russian Army. Instead he slipped across the border and made his way to Hamburg, where he took passage for England.[4] There he disembarked, penniless in a strange land. Behind him in Russia he left his aging parents, who had planned for him a never-to-be-realized life of study in the synagogue; and a young wife who cared nothing for him. Ahead of him lay loneliness, failure, frustration and tragedy. Except for his childhood, Dovber Rosenberg lived a life permeated by bitterness.

He was born into a moderately well-situated family of rabbis and scholars sometime in the winter of 1859-60. He was the third of four sons of Hezek Rosenberg and his second wife, the first marriage having produced two daughters. They resided in Shtat, a small village in the province of Kovno, Lithuania, not far from Vilna. Dovber Rosenberg uttered his first cries in the bedroom of a Jewish-owned country inn on the road between Shtat and Panuverze. Eight days later, he was ushered through the rite of circumcision into the faith of his forefathers. Of his brothers, one was to die early in life, another was to live, like himself, in relative obscurity, while the third, Peretz Rosenberg, who preceded Dovber in age, became a well-known rabbi in Cape Town and Johannesburg.

Dovber's boyhood was spent in study and play. At the age of five his first instruction began, in the Hebrew alphabet. From that time forward he faced a succession of Hebrew teachers, some humane, some tyrannical. When he was not occupied with his lessons he roamed his father's lands and the neighbouring hills and forests with his brothers, developing a fondness for the countryside. In later years, as the vicissitudes of poverty and the rancour of his marriage

crowded in upon him, he frequently recalled the idyllic pastoral setting of his childhood, on one occasion, in 1915, composing a poem in Yiddish on the subject. In 'This Was My Youth', he commemorates a far-off world where snow-capped mountain peaks, blue skies, green grass, stately firs, and placid streams reflected beauty, serenity and stability. He recalls a fishing expedition in early spring, a family servant carrying him to the stream on his shoulders, while the servant's children follow behind with the fishing tackle. Obviously his happy childhood in the countryside and his recollections of that period of his life influenced Dovber Rosenberg's later attraction to peddling — not in the street markets of London but in the wayside hamlets of south-western England.

By 1870, when Dovber was a child of ten, his parents decided that he should prepare for the rabbinate. They sent him to a Jewish school in a nearby town. The arrangements were agreeable to him, the study was congenial, and he passed his adolescent years uneventfully. Yet while he went quietly and securely about his religious indoctrination, the already shaky conditions under which Jews lived and worked in Russia were rapidly deteriorating. The government decree of 1875 making conscription of Jews mandatory shattered his tranquillity and disrupted his parents' plans. Dovber abhorred the thought of army service; indeed, he had been assured from birth that simple labour was beneath his dignity. Apart from his ingrained priggishness and a natural antipathy toward the brutality and regimentation of army life, his fears were realistically grounded in the knowledge that Jewish conscripts endured constant humiliation and faced continual danger — not from Russia's enemies but from the non-Jewish conscripts among whom they served. Moreover, military service conferred no civil rights after one's term was completed. Dovber's father, as fearful as his son and equally naive, made enquiries and learned that he could purchase the boy's exemption. Given assurances, he caused, as Dovber was to write later, 'silver and gold to flow'. After considerable sums had been squandered on the local officials, Dovber's father realized that he was being duped and began to search for an alternative plan whereby his son might avoid military service and continue his preparation for the rabbinate.

A relative living at Kreitzburg, a small town in the province of Vitebsk, was contacted, and Dovber was told to come there to continue his studies. It was understood that since he could afford to pay for his upkeep he would live in the synagogue, thereby escaping the scrutiny of the town overseers. Bewildered and incredibly innocent,

he bade his parents goodbye and set forth on what was to be the first leg of a fugitive's journey.

Once settled in Kreitzburg, Dovber applied himself to his studies and pondered his escape from conscription. His situation remained precarious for he was now of draft age and without papers. Turning to one of the patriarchs in Kreitzburg whom he had come to trust, he learned that for two hundred roubles he could obtain the documents he needed. His father sent the money. After some months had passed, he received from the patriarch a forged certificate giving him 'a different characterization'. With it came a warning not to return to Shtat. Instead, he was advised to go to a town where no one knew him at all. He left Kreitzburg and travelled to Drinsk. Worried about his suspect status he came to be troubled even more by his continued dependence upon his father. Once in Drinsk he decided to support himself. He became a teacher. While he was an apt student, he had no inclination for teaching though this was the only work for which he felt prepared. But however much he despised teaching, he liked less being dependent on his parents.

As the Hebrew teacher in Drinsk, Dovber was entitled to live with the chief householder, a pious Jew whom he revered. His host's piety, however, was all on the surface, for Dovber was to realize later that he had 'fallen among hypocrites'. Though his autobiographical fragment is not specific, the inference is that the host abetted the arrangements which led to the young naif's marriage. Already past twenty, Dovber wanted to marry and was searching for a suitable mate. His naïvety, combined with his yearning for a bride, made him an easy prey. He was soon persuaded to make an alliance with Hacha, or Hannah (sometimes Chasa), Davidov, a local girl from an aristocratic family, no longer monied. They nonetheless had a comfortable income running a public inn across the road from the army barracks. Moreover, they possessed their own cow. Hacha was not unattractive though she was no beauty. She was artistically inclined, occasionally composing verse; and she was especially adept at using herbs for medicinal cures. These good qualities were further enhanced by the promise of a sizable dowry. That she was strong-willed, sharp-tongued, in love with another man (a cousin whom she had been forbidden to marry), and was, in a sense, being coerced into this unwelcome union, Dovber had neither the wisdom nor the experience to perceive. He was, in any case, blinded by the promise of the marriage portion.

The dowry was non-existent. Dovber was to say many years later, 'Hacha's family confided to me that if I took their daughter, the

Garden of Eden would surely be open before me. But I am very sorry to inform my dear readers that I didn't get anything from them. For they didn't give me anything but a virgin.' The marriage was in trouble from the beginning. They lived unhappily ever after.

Of course, Dovber himself brought little to his bride. His family still retained its property, but expenses were heavy, income was declining, and the prospect of government appropriation was increasing. Dovber did not expect to receive nor would he ask help from them. He had nothing of his own, save the respect in which people held him as a scholar in the several communities where he took up temporary residence. Small of stature, wiry, round-shouldered, self-centred, inexperienced, gullible, always serious, always preoccupied with his suspect status, he possessed neither the physical attributes nor the personal charms that would delight a young woman newly married.

Saddled now with a wife, Dovber began to look for something more profitable than teaching Hebrew to young boys. His in-laws suggested he should go to Moscow where Hacha's brother had a department store. Though Dovber, already using forged papers, could not obtain a permit to live and work there — which Jews were required to have — he took his wife to Moscow anyway. He worked for his brother-in-law until Minnie, his first child, was born. With his family started, Dovber decided it was time he began his own business.

Helped by his brother-in-law, he opened a butcher's shop. He knew nothing of meat-cutting, but it called for no special talent or training, and meat products sold quickly, bringing an immediate and satisfactory return. As the months passed, he became increasingly confident of success and began to look to the future with guarded optimism. Again his judgment was naïve. One night while the family slept, the district chief of police suddenly appeared with his men at the foot of Dovber's bed. He was ordered to get up and show his permit for living in Moscow and operating a business there. Unable to do so, he was immediately arrested and for a time he languished in prison under the threat of a forced march to Siberia and incarceration there. However, his brother-in-law managed to secure his release. Dovber's relief at this unexpected turn of events was soon tempered by the confiscation of his butcher's shop, together with orders to leave Moscow. Because she had an infant to care for, Hacha was permitted to remain. This she chose to do.

His ordeal in Moscow concluded, Dovber travelled deep into the Russian heartland where few Jews lived, convinced that the laws

against them would not be enforced in the interior regions. Harassment followed, however, driving him eastward to Azzia in Siberia. There he found work and saved his money against the time when he could send for Hacha and Minnie. Whether they were in communication with each other during this period Dovber's autobiographical fragment does not reveal, but certainly he was unaware that Hacha had no intention of joining him in Siberia. Soon after he left Moscow she filed papers for separation, a fact the fragment omits altogether. She did not, however, obtain a final decree, presumably for two reasons: guilt over arbitrarily depriving her infant of its natural father, and her own lack of confidence that she could maintain herself and the child without Dovber's help, however meagre.

The small sums Dovber was able to put aside went not toward supporting his wife and child but toward the annual renewal of his papers. As the 1885 expiration date drew near, he sent off the required sum. Yet no documents arrived; and to his consternation, his money was not refunded. The Russian authorities, working with the records in Shtat, had finally discovered his true identity. The only papers being prepared provided for his immediate induction into the army. Dovber quickly left Azzia, making his way back to Lithuania where he crossed the border and headed for Hamburg. He was twenty-six years old, and it was his intention to emigrate to the United States. Insufficient funds, however, carried him only across the North Sea to Hull. The Russian army no longer threatened him, but little else was changed; his old companions — poverty, loneliness, and gullibility — remained steadfastly with him. New misery presented itself in the formidable language barrier. Dovber Rosenberg's first assault on this obstacle was to change his first name to Barnett.

In Hull, Barnett spent his few remaining coins on a hotel room. Other immigrants he met advised him to go to Leeds which already had a large established Jewish community with charities for new arrivals. A Jewish agency in Hull gave him the necessary train fare. On his arrival in Leeds he went to the synagogue and was fortunate enough to find people who came from his own district. They gave him temporary lodgings and helped him obtain employment as a presser in a tailor's shop. The iron was heavy, and he was clumsy. He could not master the simple forward and backward strokes of pressing, and when be burned a garment the proprietor dismissed him, to their mutual relief. He turned to peddling but soon gave that up, partly because of the difficulty in making sales and partly because of the severity of the winter weather.

Barnett next obtained a job as an overseer in a small slaughter-

house, which he kept through the winter and into spring. The pay was small, but he put away pittances from week to week, mainly by living on bread, vegetables and tea. When the weather grew warmer he decided to try his luck again with peddling. Taking the money he had saved and borrowing a bit more, he bought a small stock of shoes, which he sold on the outskirts of Bristol. After a time he moved there and staked out the routes he was to take for the next forty years through Cornwall and Devon, on to the Isle of Wight. On the road he lived simply and frugally, finding pleasure in traversing the countryside, in daydreaming, and at night in studying the Bible. He did not trouble himself about finding kosher food, though it was important to him to maintain a kosher home. What his thoughts were of his wife and child he does not tell us. It appears that he made some effort to stay in contact with Hacha while he was living in Leeds, but there was no communication between them after he went to Bristol.

Nevertheless, Hacha came to England in 1888 with Minnie. No longer able to rely upon her brother for support, she decided that rejoining her husband in a loveless marriage was an alternative preferable to an uncertain, insecure existence in Russia. Though she had little positive feeling for her husband, she possessed a strong sense of family obligation. Minnie's needs apart, Hacha knew that her own reduced and unstable status as a married woman living apart from her husband would be unendurable within the context of Jewish communal life. She came to Leeds, took a room and immediately began to support herself and Minnie by selling embroidery and taking in sewing. Turning to the Jewish charities, she found them obliging in her efforts to find her husband. Soon Barnett was located, and he and Hacha were reunited.

From 1888 to 1897 the Rosenbergs made their home in Bristol. These were the best years they were ever to experience together. Taking up residence at 5 Victoria Square in the Temple district, they achieved a small measure of economic security. Barnett made little from his peddling, but Hacha took in lodgers as her parents had done before her, and in addition to rents, however small, she sold her embroidery and sewing. Barnett was away for an average of six months out of the year: in the spring and autumn he would be gone for a month or five weeks at a time. In the summer he stayed on the road continuously while the weather remained warm. He came home for holidays and the long winters. Hacha was strong-willed and managed well without him; though she grew increasingly bitter over his long absences and his easy life in the countryside, where he escaped

the daily responsibilities and frustrations of family life, relaxing in the evenings by reading the Bible or conversing with other pedlars and wayside acquaintances, preferring the company of farmers and the solitude of long lonely nights to the sharp tongue of his wife. Despising him for escaping so completely, Hacha thrived on her personal independence despite her dislike of living in Bristol. Of this particular displeasure, Barnett later wrote that 'she didn't find men after her fancy, and there were few Jews'. In the absence of any other evidence, it is unlikely that Barnett thought his wife unfaithful, but she was high-spirited and welcomed the attentions of others. Continually at odds with her husband, she nevertheless accepted her conjugal duties in the winters, for the majority of their five children born in Bristol were conceived either in February or March.

Isaac was born on November 25, 1890. He was the second of male twins. The first-born of the sons died at birth, and Isaac was so small that for a time it was doubtful whether he would live. In later years Hacha repeatedly told the story of his birth, remarking that 'he was so tiny you could have put him in a jug'. In a sense, Isaac never recovered from the loss of his twin. He seems to have been forever in search of this other side of himself, forever in need of making himself whole, forever aware that he had to cram two lives into his single existence.

After Isaac came Annie, the third child and second daughter, born on October 25, 1892. Rachel followed on October 29, 1894. Then came two sons, David, born on February 10, 1897, and Elkon, who was born in London in 1899. Along with Minnie, all reached adult-hood.

David's birth in February 1897, added a seventh mouth to be fed. The family's circumstances now became critical. Hacha refused to stay any longer in Bristol. She had watched some of her friends leave for London, and her next-door neighbours, the Levines, had recently gone there. They sent back glowing reports of the opportunities for good living; the streets, they said, were lined with gold. Between Hacha's desperation and Barnett's gullibility an immediate decision was made to move. Another factor which influenced the decision was the need to provide seven-year-old Isaac with an adequate Jewish education.

When everything was packed and ready, Barnett went ahead to London to find a place to live. He had now been in England for eleven years. His parents were still in Russia; his no longer young wife still cared nothing for him, and he had five children and a sixth on the way. His worldly wealth was almost as negligible on leaving

Bristol as it had been when he arrived in Hull. Loneliness and failure were even more familiar companions than they had been in Russia, though to be sure he had come to terms with himself, knowing that his small comforts were not in the midst of his wife and children but on the roads of Devon and Cornwall. London awaited him with new terrors. But these would be harder for his family to endure than for him.

3
Cable Street
1897-1900

In 1897 the poets who were later to distinguish themselves in the Great War were young children: Siegfried Sassoon was one year old, Robert Graves was two, Herbert Read and Wilfred Owen were four, Rupert Brooke was ten. Sassoon had been born into wealth, heir to a famous though curiously disparate family line on both sides. Graves's family was comfortable, his father an inspector of schools and the president of various literary societies in London. Read had five years of ease and security remaining before the death of his father, a prominent Yorkshire farmer, cast him into limited straits and an orphanage. Owen, at four, was taken by his parents from the bright and spacious Shropshire home of his maternal grandfather, when that country gentleman died, to a tiny house in Birkenhead where his father held a post as a poor but respected minor railway official. Brooke was beginning his formal studies at Hillbrow School near Rugby where his well-known and well-placed father was Housemaster of School Field. Though Owen's situation was to remain precarious and economically limiting for some years, and Read was soon to have an unanticipated Spartan existence thrust on his free young spirit, none of these contemporaries of Rosenberg experienced the squalor that he faced when he came to the Jewish Quarter of London. Young in years, he already knew the fierce dissension between his mother and father. Their cacophonous outbursts produced in him an internal disconsolation which now found its external equivalent in the destitution of the dwelling which became his home.

The Jewish Quarter in East London at that time extended into Bethnal Green to the north, Tenter Ground and Goodman's Fields to the south, with the heaviest concentration of Jewish immigrants living in Whitechapel, Mile End Old Town, and St. George's in the east. Even the greenest immigrant from the Eastern European *shtetl*

learned quickly to stay away from the East London docks and the dock workers, moving no closer to the Thames than Cable Street. It was a scant three streets away from the docks, and no Jews lived there if they could avoid it. Characteristically, Barnett Rosenberg, despite having lived for a decade in England, brought his family to Cable Street. Instead of gold, the streets were lined with drunks, prostitutes, thieves, swarthy sailors from Africa and the Orient, beggars, cripples, stevedores, and derelicts. All these struck terror into the hearts of the Rosenberg children. Even more menacing were the huge rats from the docks and the river. Years afterward, when Rosenberg composed his most famous war poem, 'Break of Day in the Trenches', apostrophizing the 'queer sardonic rat' with the 'cosmopolitan sympathies' (CW, p. 73), he was addressing an intimate of long standing.

Taking one room for his family at 47 Cable Street, Barnett hired a horse and cart and went to Paddington Station to meet their train from Bristol. He arrived late, which did not surprise Hacha. She had spent the previous hour searching frantically for Isaac who was lost, playing among the coaches. Piling luggage and family onto the cart, Barnett drove them across London, through Whitechapel to Cable Street, where they moved into their one room, dismayed at its inadequacies. Their new home was at the back of a rag and bone shop, behind which ran a railway. Were their circumstances not so desperate, the Rosenbergs' one room might have been comical, for in addition to its other gross limitations, it provided the only access to the loft, where the owner of the shop, Eli Bernstein, lived with his family. The single toilet was shared not only by the two families but by the sorters in the shop and the rubbish collectors who came to sell their rags, bones, and bits of metal picked out from the area's numerous refuse heaps. Perhaps the only redeeming facet to this otherwise grim, shabby setting was Hacha's furious determination not merely to survive and endure but to create a decent home-life for her children; her remarkable strength of will was counterpoised against Barnett's weakness.

The first task on settling in London was to arrange for Isaac's schooling. Bristol offered no organized Jewish education at all, whereas the fame of the Jews' Free School in Spitalfields was recognized in every Jewish community throughout the United Kingdom. This school, along with the available Jewish instruction in the voluntary Jewish schools and the sixteen State schools located in the East End, strongly influenced the Rosenbergs' decision to go to London. Forthwith, Barnett took Isaac to the Jews' Free School. This institu-

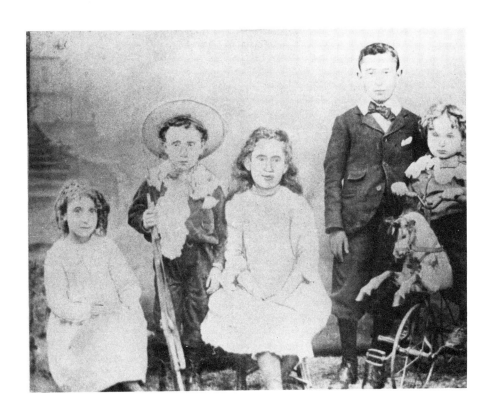

The younger Rosenberg children in 1902: Rachel, David, Annie, Isaac and Elkon

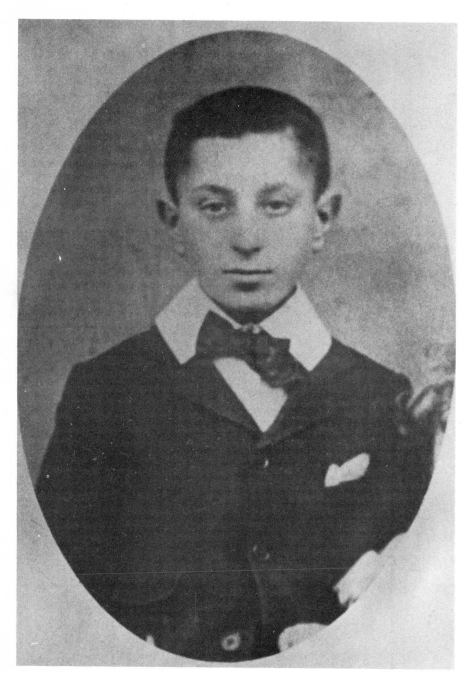

Isaac as a boy

tion, founded in the eighteenth century, was filled by 1897 beyond capacity with more than 3,500 children. As more and more Jewish voluntary schools developed, and as the State schools in the Jewish Quarter assumed a predominantly Jewish cast, with both the blessing and the support of the London School Board, the Jews' Free School tightened its admissions policies. That Barnett understood nothing of these pressures is evident from his description of his attempt to enrol Isaac:

> As soon as I arrived in London, I applied at a big brick building with two large gates. A doorman, who was also large, met me and asked me what my business was there. He opened the door and told me to enter with my child. But imagine my surprise when the man in charge told me politely to leave and take my boy with me as they had no room for him. Confused and scared, I argued that this was my only reason for moving to London, the need of my child now denied. After I got outside I thought there must be some mistake, so I returned. But when I opened the door, the big doorman blocked my way, showed me out, and slammed the door in my face.

Applications to the Jewish charities for help in gaining entrance to the Jews' Free School were unavailing. When all appeals failed, Isaac's embittered parents enrolled him in the Baker Street School, an ordinary State or board school, over ninety per cent Jewish, all male, located several streets away from his home. Isaac liked his secular subjects and he settled comfortably into the school routine. Religious instruction, which was extensive, was quite another matter.

Though it seems curious that Jewish education was provided in State schools, the government, through liberal interpretation of the Elementary Education Act of 1870, operated on the threefold premise that provision for religious instruction in the immigrant areas would help achieve Anglicization by encouraging the enrolment of immigrant offspring; virtually eliminate the need for more voluntary Jewish schools which, in addition to fostering separatism, were costly and often inadequately staffed; and guarantee the teaching of properly supervised secular subjects. The London School Board entrusted religious instruction in the East End to the Jewish Association for the Diffusion of Religious Knowledge. This organization was charged with recruiting and paying Jewish school-teachers, already employed by the School Board, for additional instruction in Jewish studies after regular school hours ended. Though the Association was not always successful, it had a good deal of leverage and it arranged for board schools under its aegis with over fifty per cent Jewish

enrolment to have a substantial number of Jewish teachers and, wherever possible, a Jewish headmaster. A minimum of five hours of Jewish instruction was provided on week-days and Sundays, though this was often extended by over-zealous teachers despite the long hours, low pay, and the waning enthusiasm of the young boys. Jewish holidays were regularly observed and the early closing of schools on Friday was officially permitted in order to give pupils time to get home to prepare for the Sabbath.

The Baker Street School, which Isaac attended from his seventh to his fourteenth year, was manifestly Jewish in all but one respect: the headmaster, a Mr. Usherwood, was not a Jew. However, a number of the teachers were, including Henry Hart and Joseph Jacobs, whose dedication to their calling made them local legends in their own time. Jewish instruction was not compulsory, but the staff practically made it so. Isaac, lacking interest in learning Hebrew, abhorred the additional regimentation, and by the time he was ten or eleven years old he absented himself at every opportunity. According to Sidney Scott,[5] a schoolmate, Isaac's truancy was frequent and successful enough to make up for the times he was kept in forcibly after school to study Hebrew. When he had to attend he was assigned to Henry Hart's classes. However, his nemesis was Jacobs, who served as master in charge of religious instruction. Jacobs would often station himself in the school's main doorway in the mornings, point to truants from the previous day's Hebrew class as they entered, and chide them for their negligence. Then, half an hour before regular instruction ended, he would send for these boys and keep them in his room until the Hebrew lessons started. Though beatings were no longer permitted, Scott says that when their absences were prolonged, Jacobs caned both him and Isaac. Apparently caning was as ineffective as urging, for there is no evidence that Isaac ever learned sufficient Hebrew or cared to use it in his letters, poems or conversation. There is nothing in Yiddish either — as a boy he could, of course, respond in Yiddish to his parents — and it is questionable whether he was ever *bar mitzvah*.

Hebrew, reverence for tradition, and participation in worship bored Isaac. On the other hand, legend and myth fascinated him and his absorption of the Bible as literature was absolute. He read and re-read the copy of the Old Testament at home. At what point he read the New Testament we do not know, though his father gave him an English Bible containing both testaments. E. O. G. Davies in his unpublished thesis says that Professor Henry Tonks told Isaac while he was studying art at the Slade School that the images and symbols

of physical love were more voluptuous in the King James Version of the Bible than in the Hebrew text. Thereafter, Isaac used the Authorized Version.

Usherwood's influence on Isaac was probably far greater than has been hitherto recognized. A kindly man, he is said to have presided over his charges with a firmness tempered by humour, good judgment and wisdom. Isaac began drawing very early and both his talent and his wayward preoccupation with sketching during class hours came early to Usherwood's attention. His interest in Isaac generated a positive, continuing response in the boy, just as the equally genuine but less welcome authoritarianism of Jacobs repelled him. Before he was ten years old Isaac was given the privilege of leaving class to sit in Usherwood's study, free to draw and to write as he chose. Usherwood occasionally supplied him with paper, crayons, and water colours. Once Joe Rose, another schoolmate and a neighbour, was called into Usherwood's study, where he saw Isaac standing next to the window holding up a picture about ten by twelve inches which he had just finished. The picture was of a woman in a long flowing robe, looking into a mirror, with her reflection reproduced therein. So intent was Isaac on his sketch that he was unaware of the other boy's presence. Rose's recollection is significant, for it establishes the fact that Isaac's attraction to the reflected image had already begun to express itself.

The encouragement Isaac received from Usherwood at this stage of his development accelerated his movement toward the main corpus of English writing and art and away from strictly provincial, ethnic concerns. Unlike Jacobs and Hart, Usherwood was able to take Isaac's sketching seriously. He did not have to reconcile the drawing of figures with the second commandment, which prohibited the creation of graven images. It was not that Jacobs and Hart were rigid in this respect; rather it had to do with a different set of values stemming from their traditional response to the commandment. To Usherwood art was necessary, it needed no justification; to Jacobs and Hart it was a frivolous pastime compared to the study of the Torah. From his earliest schooldays Isaac was to encounter, and both suffer and benefit from, tensions of this kind emanating out of his dual heritage. There was no question, however, as to which became dominant under Usherwood's gentle tutelage. Isaac's realities were transposed: art and literature were from that time forward far more meaningful to him than religion, the vicissitudes of everyday living, the political currents always in ferment in the East End, social conditions, and the competition for jobs.

Deprivation, strife and his intense need for self-expression made Isaac a serious and moody boy. He was not attracted to games. During school playtime he preferred to be by himself, reading or just sitting and thinking. But he had his lighter moments. In the mornings, like the other boys in the neighbourhood, he would climb onto the slow-moving brewery wagons and ride them to school. In fine weather, he and Sidney Scott, having conspired earlier in the day to 'cut Hebrew', would, when the final bell rang, head for the Blackwall Tunnel and Greenwich Park, where they would stroll or play on the extensive greens. Other afternoons he went to nearby Leman Street to visit Barnet and Mary Levine, whose parents had written to the Rosenbergs telling them that London's streets were lined with gold. The Levines had fine phonograph records and Isaac loved to listen to them. He enjoyed music but in his youth it remained primarily an entertainment for him. Writing in about 1910 to Miss Winifreda Seaton, a woman to whom he was introduced by the artist, John H. Amshewitz, Isaac, in reply to a query from her, said:

> Do I like music, and what music I like best? I know nothing whatever about music. Once I heard Schubert's 'Unfinished Symphony' at the band; and — well, I was in heaven. It was a blur of sounds — sweet, fading and blending. It seemed to draw the sky down, the whole spirit out of me; it was articulate feeling. The inexpressible in poetry, in painting, was there expressed. But I have not heard much, and the sensation that gave me I never had again. I should like very much to be one of the initiated.
>
> (*PIR*, p. 17)

Reading was Rosenberg's true delight, and sketching was his pastime, whether with pencil on scraps of paper or with chalk on the pavements outside his house, where he drew portraits of passers-by who, upon stopping, would be astonished to see their likenesses rapidly created by a tiny mite of a boy.

From the moment the Rosenbergs moved into Cable Street their shaky economic condition worsened. Burdened with five children, Hacha had little time for sewing or embroidery. With only one room, taking in a lodger would have been the final absurdity. Barnett continued to hawk his draperies and notions in south-west England. The most he could send Hacha weekly was five shillings; rarely did she receive as much as seven shillings and sixpence. There was nothing else Barnett could or would do. Lacking in ambition, he was well-meaning but inept; devoted to his study of the Torah, he had no business sense and was never moved to take stock of his situation and

consider the limitations of peddling, which was no longer the lucrative occupation it had been. As the population of villages and towns increased, small shops abounded and these retail outlets, along with improved transportation, spelled the doom of the pedlar. Country-women, long dependent upon door-to-door salesmen, no longer waited at home — they were gone to market. 'Peddling,' says Lloyd P. Gartner, 'was reduced to a fruitless exhausting occupation which led nowhere.' By 1899 the Rosenbergs were in a state of crisis.

That winter Hacha became pregnant again. Ordinarily, Barnett would have remained at home, dreaming by the fire, studying the Bible, tugging at his small pointed beard, trying hard to keep his gentlemanly composure in the face of Hacha's vociferous grievances. No money was coming in and their reserves were running out. There is some indication that Barnett took to the roads partly to insure that there would be food in the house and a roof over his children's heads, but also because he was sending money during this period to his aged, ailing father in Shtat. On January 19, his father wrote, 'The money you sent to me twice reached me, and many thanks to you, since I had little for necessities, and also for the obligations which remained from the marriage of my daughter, Braine Toyve'. Hezek Rosenberg's other remarks in the letter concern his son's problems: 'I received a letter this week from Mordecai Yeob. According to him, it appears that you didn't get my letter sent from Shtat since it is clear your wife didn't send it on because she disapproved of the things I wrote. Also, a second letter which I sent apparently never reached you . . . and Mordecai Yeob [says] that you are not doing well in business.'

Business, indeed, was so bad that Hacha's parents intervened to plead with Barnett to go to New York and try to establish himself there. Her sister, already in the United States, sent money for the passage. He went, and stayed for months trying to decide what to do. His brothers-in-law offered their help, and Hacha's sister sent more money to London to bring the rest of the family over. Now well into her pregnancy, Hacha was apprehensive about the voyage but she was desperate to rejoin her family, knowing she would obtain from them the security and comfort Barnett could never give her. But her expectations were cruelly thwarted. She discovered that Minnie was going blind.

Now in her teens, Minnie had been taught by her mother at an early age to do fine needlework. She was exceptionally good at it, contributing as a young child to the family income both by doing piecework and by occasionally obtaining a job as a draper's assistant.

The lighting at home and in the shops was poor. Over the years she developed eye strain which was ultimately diagnosed as glaucoma. Daily treatment was required. Heavily pregnant, Hacha took her every morning to Moorfields Hospital. Since she had no one to leave David and Rachel with and they were too young to stay alone, she brought them with her. An eye specialist in Finsbury Pavement was consulted. He offered to cure Minnie for fifty pounds. Hacha didn't have three shillings to spare — there was the travel money for America, but she was too proud to use it. Pride also forbade her accepting an offer from the Lunzers, a well-to-do Jewish family to whom she had sold needlework, to cover Minnie's expenses for an operation in Vienna. Heartsick, Hacha returned the travel money to her sister, giving up all hope of ever reaching the United States. At Moorfields Hospital the doctors decided to operate in a final effort to save Minnie's sight. For a long time it seemed as though the operation had failed; it was, however, successful and Minnie's recovery was eventually complete. The guilt and anguish over the nightmare was ended for Hacha by the slow-fused miracle of Minnie's recovery, but she knew in her heart it had cost her America.

Crisis followed crisis. Toward the end of Minnie's ordeal, Elkon, the third son and sixth and last child was born, delivered by a mid-wife in Cable Street. Barnett was still in New York and Hacha was penniless. For Elkon's circumcision ceremony the only food in the house consisted of a crust of bread and a piece of herring. Somehow they survived, but for Hacha 1899 was a pivotal year. When Barnett came back to London, they continued living together, but their marriage was practically over. Though they kept up appearances, no more children followed. For the remainder of their lives there were lengthy periods when Hacha would not speak to Barnett or come to the table when he sat down to eat. All this weighed heavily on Minnie and Isaac, the oldest of the children, and much of it probably explains the young Isaac's sombre disposition. During the last decade of Barnett's life, up to his death in 1936, Hacha refused to do anything at all for her husband, who now led a bachelor existence, relieved only by the solicitude of his two grown daughters living in London.

4
Jubilee Street and Oxford Street
1900-10

The beginning of the new century brought with it at least one improvement for the Rosenberg family. After three misery-begotten years they left Cable Street and moved into the first of three flats they were to occupy in the Commercial Road end of Jubilee Street up to 1907. Though they still crowded one another they now had several bedrooms, a tiny parlour, an equally tiny kitchen, their own toilet, and a room in the basement. They recovered their privacy. This Hacha cherished but not to the extent that she was willing to forgo having a lodger to help pay the rent. Behind the house there was, instead of a railway, a small garden with a grape-vine. Hacha planted the garden and tended the vine. Beyond resignation, she kept herself busy, selling her needlework, sewing, cooking and washing for the children — one would never have known by looking at them how poor they were — scrubbing the floors, and making friends with her neighbours.

Jubilee Street was almost entirely Jewish. On one side of the Rosenbergs was Miller's Milk Store, on the other a large, lively family named Kaufman. Constant noise issued from their doors and windows throughout the day and into the night. In the flat upstairs Nathan Rosenberg, a waste rubber merchant, lived with his wife, two daughters and two sons. The youngest, Joe Rosenberg (later Rose), tagged along behind Isaac on the way to school. The two families were not related, but became fast friends. Inside the house at No. 58 Jubilee Street, in a communal atmosphere, they shared joys and woes alike. Across from No. 58 was a grocer's. There both Rosenberg families, along with the rest of the neighbourhood, bought food on tick, settling their bills at the end of the week. Further down the block was a kosher butcher's shop run by a man named Coblenz. When she could afford it, Hacha bought her meat from him.

Once the family was settled in, Barnett stayed on the road as much as possible. During the winter or at other times when he was home for holidays, he took long walks every day, while Hacha did the housework. Except that he had become mildly hard of hearing and in a few years would be totally deaf, Barnett never changed. For the Rosenbergs, stability ebbed and flowed. In 1902 it seemed, but only seemed, to be flowing.

Isaac was now twelve years old. School was going well. He did a charcoal portrait of his sister Rachel, then aged eight, which so impressed Mr. Usherwood that he exhibited it. The next day two boys recognized Rachel from the drawing, stopped her in the street and said, 'You're Isaac Rosenberg's sister, we saw your picture.'

At the close of the school year Isaac was given an award for good conduct by the school authorities. For them it was a routine matter, but it whetted Isaac's appetite for special attention. He began to enter writing competitions. Two years later he won an essay contest sponsored by the Royal Society for the Prevention of Cruelty to Animals. The subject must have had little appeal to Isaac: his encounters with animals in his youth were limited to stray cats and dogs, rats, and dray horses: in the Rosenberg household there was no room or food to spare for pets. The essay has not survived; its contents are a matter for conjecture. Probably Isaac drew more on his imagination than on any real experiences with animals. There are no surviving early sketches or drawings of animals or birds; and his later use of them in his writing is strictly literary, never personal.

Hacha derived enormous pleasure from the achievements of her children. Her lodgers, like her children, brought her both pleasure and trouble, but at least they made it easier to pay the bills. In Jubilee Street the first one she acquired was a Pakistani named Haronof, whom she put in Isaac's room. He was well-to-do, but had a mean disposition. When he came home at night laden with fruit and nuts, Isaac would be in bed reading or composing verse by the light of a candle. Haronof would undress, get into bed, and order the light to be put out. In the dark, a disgruntled and sometimes hungry Isaac had to listen to Haronof sucking oranges and munching apples and nuts. Isaac complained to Hacha, but he knew nothing would be said to Haronof since the rent money was desperately needed. Hacha idolized Isaac but some things were not subject to negotiation; indeed, she allowed herself to be victimized by her generosity toward strangers.

One day while Haronof was living with the Rosenbergs, the authorities who ran the Jewish Shelter in Leman Street knocked on

their door. They had with them a woman carrying two babies. The woman claimed that her husband, the father of the two children, lived there. Barnett recalled that the man had in fact been a temporary resident. He had not stayed any length of time, and had gone off to America with a woman. The children were suffering from malnutrition; the mother was too weak to walk back to the Shelter. Hacha felt so sorry for them she took them in and gave them the basement room. She kept them for a year. Occasionally the woman earned a little pocket money as a charlady, but her earnings were ridiculous compared to Hacha's expenses. When she could stand it no more, Hacha told the woman to go. The woman notified her relatives in Whitechapel, who did not want to support her, and they gathered at Hacha's front door, shaking their fists and threatening her. Hearing the commotion, Mr. Miller, the owner of the milk store next door, came over to protect Hacha, threatening to call the police unless the people left and took the woman and her children with them. For all her toughness Hacha was an easy prey for lodgers throughout her life. When strangers came to the house with nowhere to go she allowed them to sleep overnight even if it meant huddling against the cold underneath the kitchen table.

If she could not afford the luxury of choosing her lodgers, Hacha had some choice in selecting her friends. She could choose among many, since her ability to effect cures with herbs was well known and many people called on her. A few of her neighbours would come to her every day to hear her read — or later recite verbatim — the serial in the Yiddish newspaper. She was addicted to serials; and sent one of her children daily to buy a paper, whereupon she would regale her listeners with its contents. She acquired other friends through her embroidery work. Her well conceived and well executed designs were very salable. Displaying greater business acumen than Barnett, she chose for her customers rich English Jews long domiciled in North London. It was in this way that she had met the Lunzer family who had offered to help Minnie. In the same street where the Lunzers resided, the Reverend Asher Amshewitz lived with his family and soon Hacha counted them among her customer friends. Shrewdly, she took either Minnie or Isaac with her on her trips to North London. For Isaac, meeting the Amshewitz children was particularly fortunate. It was not merely that as a teenager he was often welcomed into their midst; but he received advice and encouragement from one son, John H. Amshewitz, eight years his senior, who later became a well-known London painter.

Among the memorabilia carefully preserved by Annie is a photo-

graph of the Rosenberg children, excepting Minnie, taken about 1902 (see plate 2), probably by the photograph Peckoff in Whitechapel Road. Five children stare intently out. On the far left is Rachel, seated on a box; her face, ringed with curls, wants to smile but does not quite succeed. Next to her stands five-year-old David, looking military in a miniature Boer War suit. Seated on a stool next to him in the centre of the picture is Annie, hands resting in her lap, wearing a virginal white dress identical to Rachel's, looking serious and a tiny bit pleased at the same time. On the far right is three-year-old Elkon, sitting astride a beribboned pony tricycle, one foot touching the high pedal, the other dangling, unable to reach the low pedal. Between Elkon and Annie stands Isaac in a knickered, three-button suit, round full collar, with bow-tie askew. His stance is almost relaxed. Like Annie, he is serious and cooperative, intent on pleasing. Unlike the rest of the children, Isaac's hair is short-cropped, accentuating his large ears, poking out a little too far for his narrow face. He is small for his twelve years, but has the bearing of an adult — except for his bulging schoolboy pocket.

The scene is intended to suggest the outdoors, but like David's gun and Elkon's horse, the rug — simulating grass — and the backdrop are standard indoor props. The three-storey columned townhouse in the background is more likely to be found in Rome than in East London. The overall impression is one of lower middle-class stolidity, a two dimensional illusion directed, staged, and produced daily by Peckoff the magician.

Through his thirteenth and fourteenth years, Isaac methodically detached himself from the family unit. It was as though he walked out of Peckoff's picture. Long since resigned to the fundamental cleavage between his parents and unable to reconcile them, he concentrated his attention on his own pursuits. He took little notice either of the family's third move in Jubilee Street in 1904 to a flat with a sweet shop at the front or of a subsequent move around the corner in 1907 to Oxford Street (renamed Stepney Way in 1938). Hacha managed the sweet shop, recruiting the younger children as needed to help with making ice cream and sweets. After a few months the venture failed, though Hacha's successor made it pay handsomely. Isaac concentrated more and more on his drawing. He knew what his hands could do, but he had no grasp of his craft, no understanding of its wider implications. When he took a drawing to John Amshewitz to have it criticized, Amshewitz immediately offered him a half crown for it. Isaac rushed from the room, crying. He did not want charity, he wanted instruction. He discovered the

Arts and Crafts School in Stepney Green, and began to go there after regular school hours ended. Among his acquaintances was a boy named Morris Goldstein, who also aspired to be a painter. They became sufficiently good friends for Isaac to read his poems to him and ask for his reaction.

The afternoons at the Arts and Crafts School were soon terminated for Isaac as he reached school-leaving age in the spring of 1904. It was now his turn to go to work and help support the family. With Barnett's assent, Hacha looked for a post where his talents might be utilized and developed, and secured for him an apprenticeship at Carl Hentschel's, an engraving firm in Fleet Street, Isaac dutifully went to work. Having now escaped permanently from Hebrew lessons, he found himself in worse bondage: he had no opportunity to draw, he learned nothing about art, and much of his time was spent standing over hot vats of acids being prepared for the etching process. As he inhaled the fumes, he grew to hate his servitude. His only consolation lay in composing poems during his scant lunch break.

After work there were other consolations. When he finished in the late afternoons he would race to Farringdon Street Market to browse among the book stalls. One ha'penny or tuppence would buy a secondhand book. At this price he could afford to indulge himself with the English authors. One day he brought home a book by Thackeray. On opening it he was overjoyed to find inside several letters to Thackeray and several by him. After cherishing his prize for a few days he sought out a dealer who offered him twenty pounds. Having paid three ha'pence for the volume, Isaac accepted the offer and returned home bursting with excitement. Twenty pounds was more money than he could ever remember the family having in its possession. He gave most of it to his mother, keeping five pounds to buy paints and canvas. He felt more like a man of worth that week than he ever had before or would again for a long time. Though he went back repeatedly to Farringdon Street Market he never found another treasure, and, needless to say, his joy over the Thackeray turned sour when he read in a newspaper a week later that the book had fetched one hundred pounds at an auction sale.

Frustrated in his burning desire to study painting formally, and confined to pedestrian tasks at Hentschel's, Isaac became despondent. Already dour in his outlook, a permanent despair threatened to take hold of him. In a letter to Winifreda Seaton about his work, he wrote:

> It is horrible to think that all these hours, when my days are full of vigour and my hands and soul craving for self-expression, I

am bound, chained to this fiendish mangling-machine, without hope and almost desire of deliverance, and the days of youth go by.... I have tried to make some sort of self-adjustment to circumstances by saying, 'It is all *experience*'; but, good God! it is *all* experience, and nothing else.... I really would like to take up painting seriously; I think I might do something at that....

(*PIR*, p. 12)

Yet however depressing his work in Fleet Street, it nonetheless provided Isaac with a steady albeit small income, which meant that he could use part of his wages to study painting at night. Between 1906 and 1910 he began to hope that he might somehow be admitted to the Slade School. In 1906 it was out of the question, for he needed training in order to qualify for admission. On enquiry he learned that he could enrol for evening painting courses at Birkbeck College, located in Chancery Lane. The principal, A. W. Mason, allowed him to enter drawing classes in 1907-8. His main instructor was Miss Alice Wright, who also became his friend. Encouraged by this breakthrough, Isaac applied himself to his assignments. He worked hard in class, and on Sundays and holidays, weather permitting, he drew and painted favourite land and water scenes in the eastern outskirts of London. Unassertive about many things, Isaac had no hesitation in competing for prizes. At the close of the first year he was awarded first prize for drawing from the antique and second prize for drawing in light and shade.

The *Birkbeck College Student's Magazine* mentions Isaac's work twice in December 1908, reporting that 'In the National Competition an excellent head study in charcoal, by Isaac Rosenberg, was awarded a National Book prize.' He also won the Mason Prize that year for his nude studies from the life class. Again in 1910 in a description of the Art School's Annual Exhibition, the magazine listed his name as the winner of one of the principal awards for his 'three hours' study from the nude in oils'. This was the Pocock Prize, to which was added a Certificate of Honour for his other time-studies of the nude.

Winning these awards was immensely gratifying to Isaac, not only for the boost it gave his tortured ego but for the support it gave him in convincing his parents that he should leave Hentschel's. He lived for the day when he could terminate his apprenticeship and devote all his time and energy to drawing, painting, and writing. Birkbeck College became his catalyst: not only did he learn to paint there, he learned for the first time to think seriously about space, form, line, and colour.

Though his days and nights were full, he also found time to attend in 1909-10 the London County Council School of Photo-Engraving and Lithography in Fleet Street, otherwise known as the Bolt Court Art School. His earlier friendship with Morris Goldstein, who was there too, deepened; it is likely that he also met Paul Nash who would later be his classmate at the Slade. Along with Goldstein, Rosenberg took courses in painting from the school's founder, Cecil Rea. Whatever Isaac learned from Rea, he apparently never took Bolt Court seriously, though he sometimes went back to visit friends there even after he was enrolled at the Slade.

Though Isaac was beginning to entertain some serious expectations of making a living as an artist, he continued to compose poetry. Here he had deeper anxieties over his prospects. Blaming his apprenticeship at Hentschel's, he wrote to Miss Seaton:

> ... I despair of ever writing excellent poetry. I can't look at things in the simple, large way that great poets do. My mind is so cramped and dulled and fevered, there is no consistency of purpose, no oneness of aim; the very fibres are torn apart, and application deadened by the fiendish persistence of the coil of circumstance.

(PIR, p. 12)

Isaac's poems at this time were the typical outpourings of a young mind, undisciplined, untrained, highly imitative of the Romantic poets, principally Byron and Keats. His subject matter ranged from biblical themes to ponderous considerations of time, art, memory and loss. Because the earliest-known poem, the 'Ode to David's Harp' (though not printed in *Poems By Isaac Rosenberg,* published by Heinemann in 1922) has an Old Testament subject, Laurence Binyon in his introduction to that volume declared that Rosenberg 'cherished the traditions of his race and aspired to become a representative poet of his own nation'. On the strength of Binyon's assertion, critics and readers alike have always assumed that Isaac was intent on moulding himself into a 'Jewish' poet. Certainly he drew upon his religious heritage, but his aim was to make his mark as an English poet. He knew his Bible well, but in 1905 when he wrote the 'Ode to David's Harp' he was filtering the Old Testament through Byron's 'Hebrew Melodies'. Indeed, his 'Ode' is a simple imitation of Byron's 'The Harp the Monarch Minstrel Swept'.

As poetry the 'Ode to David's Harp' is inconsequential. Nevertheless, it is Rosenberg's first sustained verse. On reading it his family began to take his poetic inclinations a little more seriously. Minnie was commissioned to seek help for him. She turned to Morley

Dainow, the librarian at the Whitechapel Public Library, who invited Rosenberg to come and talk. In September 1905 Rosenberg sent him the ode and possibly some other verses. Dainow was impressed but advised Rosenberg not to write so much. 'Only write,' he said, 'when you feel inspired and then arise such poems as the "Harp of David" and "The Charge of the Light Brigade".' In the same letter he apologized for having been unavailable the previous Saturday but asked Rosenberg to come to the library the following Wednesday. He went; Dainow was even more impressed, and they arranged to spend Dainow's next free Saturday together.

On October 6, Dainow wrote to Barnett. It was, he said, 'a real pleasure for me to spend a day with your son Isaac. I have rarely met a lad of his age displaying such love for Art and Literature.' Dainow then gave Barnett a curious piece of advice, '. . . I trust that you will use your influence over him (which I think is profound) to emancipate him from the bonds of tyrannical orthodoxy.' Rosenberg was already fifteen and well on the way toward emancipation. Presumably he had complained to Dainow that his parents did not understand his artistic aspirations, and possibly Dainow inferred that a rigid orthodoxy was the reason for their inadequate responses to the boy's needs.[6]

Eager for some notice as a promising poet, Rosenberg submitted a poem to a London monthly journal, *The Jewish World*. Its children's page, edited by Bella Sidney Woolf, conducted a literary competition with book prizes for first and second place winners. The subject for the September 7, 1906 number was 'The Sea'. Rosenberg wrote a sea poem, now lost, and submitted it. He did not win, though he received a certificate equivalent to third place — one notch above an honourable mention. In reporting the results of the competition Bella Woolf, anticipating Edward Marsh's remonstrances over Rosenberg's style some years later, wrote: 'Now for a few remarks on some of the poems. Pauline Hirschbein's was melodious and pretty, but not original enough to gain a prize. I. Rosenberg's was original, but rather vague in parts.' Pauline Hirschbein probably sighed and turned her thoughts elsewhere, but the charge of vagueness would haunt Rosenberg for the rest of his life.

After Byron, Rosenberg devoured Keats and, to a lesser extent, Shelley. He was closer to Keats in essaying the role of the sensitive poet, attracted to the sensuousness of nature, frail, prepossessed with loss and change, drawn toward the infinite, always conscious of death as the ultimate escape from pain and suffering. Shelley's attrac-

tion, by comparison, was minimal; it was to a side of Rosenberg's thought that never found full expression: he was not a political person though he occasionally flirted with the rampant socialism in Whitechapel. Constantly oppressed, he acknowledged the oppression only in personal metaphors. Hentschel's printing works, the degradation in London's East End, later the war, were not from Rosenberg's point of view the manifestations of any malignant class or social force working in opposition to him as a representative or symbol of downtrodden society. Hence, Shelley's politics remained literary for him.[7]

Another important influence was Francis Thompson. Rosenberg's two poems 'A Ballad of Whitechapel' and 'A Ballad of Time, Life and Memory', both composed in 1910, draw heavily from Keats and Thompson. For a time Rosenberg was enthralled by Thompson to the point of hero-worship. Rosenberg once told Marsh that he had 'enjoyed some things of Francis Thompson more than the best of Shakespeare' (CW, p. 294). One can understand why Rosenberg felt a kinship with Thompson. Presumably he knew something of the other's hardships and struggles, poverty, poor health, thwarted hopes and premature death. He was probably familiar with the story of Thompson's arrival in London carrying only a copy of Blake in one pocket and a copy of Aeschylus in the other. His whole life would have evoked a sympathetic response from Rosenberg, particularly since — like him — Thompson was forced for a time into uncongenial work.

Despite his ravenous enthusiasm for Thompson, Rosenberg's depression deepened. He became obsessed with his lack of progress in poetry. He had celebrated his twentieth birthday — old (as he thought) for a poet — and could not understand why his shortcomings persisted. He tried to explain to Miss Seaton that they were attributable to an inadequate education:

> You mustn't forget the circumstances I have been brought up in, the little education I have had. Nobody ever told me what to read, or ever put poetry in my way. I don't think I knew what real poetry was till I read Keats a couple of years ago. True, I galloped through Byron when I was about fourteen, but I fancy I read him more for the story than for the poetry. I used to try to imitate him. Anyway, if I didn't quite take to Donne at first, you understand why. Poetical appreciation is only newly bursting on me. I always enjoyed Shelley and Keats. The 'Hyperion' ravished me. . . .

(PIR, pp. 14-15)

Before Rosenberg could find his own voice he would need to disengage himself from Francis Thompson, Byron and Keats, and learn what he might from other poets such as John Donne. This he was to do slowly and painfully in his early twenties when he chose William Blake, the Rossettis, Edgar Allan Poe, Emerson, Whitman, Ben Jonson, Shakespeare, Baudelaire and Verlaine to instruct him in the art and craft of poetry.

5

The Whitechapel Boys
Jan-Feb 1911

On December 31, 1910, a cold and windy Saturday night, London ushered in the New Year in its traditional manner. Though there were intermittent sleet and snow showers, the crowd that gathered outside St. Paul's Cathedral was larger than it had ever been before. Traffic had been halted a little after 11:00 p.m. On the stroke of midnight a rocket was fired, bursting over the cathedral's dome, lighting up the sky for an instant. Everyone cheered and joined in singing 'Auld Lang Syne'. *The Times* wryly noted two days later that the composition of the crowd was changing: there were fewer Scotsmen, which meant fewer bagpipes, and more Cockneys, which meant more mouth organs. In the fashionable hotels, the Savoy, the Piccadilly, and the Carlton, extravagant celebrations were underway, with orchestras playing in brilliantly-lit ballrooms, dimmed at midnight, while several thousand people, elegantly attired, sat down to supper. For them 1910 had been a very good year; 1911 promised if not more, at least as much.

For Isaac Rosenberg in his parents' tenement flat in Oxford Street, 1910 had been a very bad year; 1911 promised nothing better. It is not recorded how he spent that New Year's Eve, but it would be reasonable to assume that his evening was lonely and probably depressing. If he surveyed his prospects for the New Year he would have confirmed the fact that the debits far outweighed the credits. He had a job which he hated, he was continually frustrated in his efforts to establish himself either as a painter or a poet, he still lived with his family but was disengaged from their lives, and he had only two friends, John Amshewitz and Winifreda Seaton, neither of them his peer. Their ages and life-styles precluded any sharing of experiences, aspirations, or disappointments. His depressions were increas-

ing and thoughts of suicide crept into his mind to reduce further the small stock of composure he had left.

In his despondency, Rosenberg wrote sometime late in 1910 a Keatsian sonnet entitled 'Death', opening with the lines 'Death waits for me — ah! who shall kiss me first? / No lips of love glow red from out the gloom / That life spreads darkly like a living tomb / Around my path' (*CW*, p. 199). Arguing that 'Death's gift is best' (*CW*, p. 199), Rosenberg concluded that he would much welcome the rest that comes after death. Was he serious about suicide? The answer is a qualified yes and no: yes, insofar as his prospects seemed hopeless, and his life was hard. Early in 1911 he wrote to Miss Seaton, 'All one's thoughts seem to revolve round to one point — death. It is horrible, especially at night . . .' (*PIR*, p. 13). And yet he was not serious about suicide in the sense that he made no total commitment to it; there is no evidence to suggest any attempted headlong rush into the abyss. His sonnet ironically employs the metaphor of pregnancy: 'Life's travailed womb / Is big with Rest' (*CW*, p. 199). However, despite his wretchedness, and his thoughts of suicide he stood resolute in the face of his calamities. In another letter to Miss Seaton, written about the same time, he said:

> One conceives one's lot (I suppose it's the same with all people, no matter what their condition) to be terribly tragic. You are the victim of a horrible conspiracy; everything is unfair. The gods have either forgotten you or made you a sort of scapegoat to bear all the punishment. I believe, however hard one's lot is, one ought to try and accommodate oneself to the conditions; and except in a case of purely physical pain, I think it can be done. Why not make the very utmost of our lives? . . . I'm a practical economist in this respect. I endeavour to waste nothing. . . .
>
> (*PIR*, pp. 13-14)

Even as he wrote this letter, the gods, far from forgetting Rosenberg, were finally moving on his behalf. The year 1911 would drive away his thoughts of death, give him sensitive, intellectually acute friends of his own age and class, and provide him with the patronage he needed to enter the Slade School. In retrospect these advances may seem small enough; to Rosenberg each bordered on the miraculous.

The first of the miracles occurred on Monday night, January 2. Rosenberg was out walking, taking one of his frequent long strolls through the East End. It was a custom of long standing; everyone in Whitechapel did it. Workers confined all day in the close, cramped sweat-shops rarely left their benches before 8:00 or 9:00 p.m. Short

of money, their diversions, like their leisure time, were limited. Walking provided them not only with various entertainments — chatting with relatives and friends, listening to street orators or Salvation Army bands — but with exercise and a sense of freedom. Except around the docks the streets were safe, and even there walkers came to no harm as long as they travelled in pairs. This had once been Jack the Ripper's territory but his last murder had been committed two decades earlier. Now he was only a legend; people took their walks late into the night.[8] While Rosenberg was strolling, he made two new friends.

One of the two young men he saw that night he had met some weeks before. He was 'Simy', or Simon Weinstein. With Weinstein was Joseph Lefkowitz. Both were Whitechapel boys, a year or two younger than Rosenberg, from similar backgrounds. Weinstein had just completed teacher-training and was a student-teacher in an East End board school. He later changed his name to Stephen Winsten, and became a writer and editor, the confidant and biographer of George Bernard Shaw. Lefkowitz also became a well-known writer and journalist. He changed his name to Leftwich, and is perhaps best remembered for his anthologies of Hebrew and Yiddish translations. Leftwich worked in a furrier's sweat-shop at the time. He and Winsten, along with a third Whitechapel boy, John Rodker — variously called Jimmy or Jack — made up a close-knit threesome. In 1911, Rodker, with a larger gold ring in one ear than Ezra Pound wore, was already displaying the flamboyance and extravagance that would later amuse and exasperate Pound and his other literary acquaintances. He was a minor Civil Service clerk, working in the London Customs House. He, too, was to become a writer, novelist, translator and publisher; one day he would list among his achievements the first publication of T. S. Eliot's *Ara Vos Prec*, Ezra Pound's *Hugh Selwyn Mauberley*, some of Wyndham Lewis's drawings, and the second and third English printings of James Joyce's *Ulysses*.

Winsten, Leftwich and Rodker were searching for a fellow-thinker. Indeed, only the day before the three had talked about two prospective additions to their circle, concluding reluctantly that the candidates under consideration were not similar enough in their interests to warrant invitations.[9] However, Rosenberg was to prove readily acceptable.

During 1911 Leftwich kept a detailed diary, recording in it a wealth of information about the group, their ideas and activities. Though he subsequently drew on the diary for short articles, it has

never been published. Of Rosenberg it has much to say. The entry
for January 2, the day they met, reads:

> Rosenberg talks to us about Poetry. Simy is very silent the
> whole of the time. Rosenberg has a great opinion of
> Shakespeare. He thinks that the sonnets are the greatest poetry
> in the language. In Whitechapel Road we meet Sofon. I am
> surprised to see that he and Rosenberg are acquainted, but that
> is soon explained — it appears that they are both photograph
> engravers, and have met in connection with their work.[10] When
> we get to the corner of Jamaica Street and Oxford Street,
> Rosenberg pulls a bundle of odd scraps of paper out of his
> pocket, and reads us his poems under a lamp-post. The fellow
> really writes good poetry.

Marvelling over Rosenberg's gifts as a poet, Leftwich consulted
with Winsten and Rodker. Winsten had been awed and depressed by
Rosenberg, and had found him awkward, plain of feature, and lack-
ing in personality. They were bothered by his stuttering and his
monotonous voice. Yet Rodker had thought well of him, and they
were all astonished by his grasp of poetry and the beauty of some of
his lines. He was invited to become the fourth intimate of the group.

Leftwich, Winsten, and Rodker realised at once that they were
both proud and envious of Rosenberg's talent. Part of their fascina-
tion with him lay in the extraordinary fact that the muse had chosen
to express herself through such a grotesque, pathetic figure. And as if
poetry were not enough, he could also draw and paint. They soon
concluded that he was undoubtedly a genius, but one seriously
deficient in the social graces. It was not long before they were simul-
taneously lavishing praises on his talent and ruthlessly criticizing his
manner. Probably their criticism underlay some of the 'confidences'
he sent to Miss Seaton about this time. Among them, he said, 'I've
discovered I'm a very bad talker: I find it difficult to make myself
intelligible at times; I can't remember the exact word I want, and I
think I leave the impression of being a rambling idiot' (PIR, p. 17).
However much the other Whitechapel boys wanted to help
Rosenberg improve his articulation, nothing changed; his difficulty
with the spoken word, born out of his childhood insecurities, re-
mained with him for life. To some he would always be 'a rambling
idiot'.

Though delighted with his new friends, Rosenberg was unable to
see much of them through most of January. He was sitting in his
spare time for Amshewitz who was doing a large full-length portrait
of him,[11] and also introducing him to influential people who might

advance his career. He sent Rosenberg to see Dr. David Eder, a psychiatrist and the writer Israel Zangwill's cousin, Holbrook Jackson, editor of the magazine *T.P.'s Weekly,* and Solomon J. Solomon, the Royal Academy artist. Eder, Jackson, and Solomon gave Rosenberg advice but no real help. For a time he was under the impression that Jackson was going to hire him as a literary critic, though no evidence exists to substantiate this belief. The problem was, of course, that the poems, drawings and paintings showed promise, but their positive impact — and this became a recurring pattern with Rosenberg — was offset by his ungainly appearance, inarticulateness, and self-effacing shyness. He was an anomaly, a figure marked for curiosity and sympathy but not for personal cultivation.

On Tuesday, January 24, Rosenberg ran into Winsten and Leftwich in Leadenhall Street. He told them about Amshewitz, his portrait, and his interview with Dr. Eder, at whose home he had met the writer, Arthur D. Lewis. He read them a sonnet he had just composed in gratitude to Amshewitz, asserting that his help could be compared favourably to Keats's regard for Chapman's translation of Homer (*CW,* p. 21); then he took his two friends to Oxford Street to show them his drawings and paintings. Later that night, recording the visit in his diary, Leftwich commented on Rosenberg's poverty, the 'stuffy and crowded' kitchen which served as his studio, and the decrepit table on which he worked. Leftwich was not impressed by Rosenberg's work: 'His drawings are of women mainly, big heavy women with very plain features, all the faces are alike, almost one face in all of them, and that a heavy, coarse, ugly face.'

Leftwich's observation on the similarity of Rosenberg's portraits requires little comment. His mother was dominant. His sisters had long before refused to sit for him. He was incapable of finding any substitute for Hacha. Unlike Mark Gertler, the brilliant young Whitechapel artist whom he had not yet met, and who had both girlfriends and models in abundance, Rosenberg could afford nothing, least of all a studio. Grim as his situation was in 1911, Rosenberg was still able to laugh through his tears at a private joke of several year's standing: the absurdity of trying to paint a nude in the tiny, crockery-filled kitchen as his mother bustled about. The boys continued to meet regularly, and on Sunday, January 29 they convened at Rodker's. His parents were out and they 'had a jolly evening'. The next night they went walking. On Wednesday, February 1, while they walked the streets, Leftwich discussed with Rosenberg 'the similarity and ugliness of all his female faces', eliciting the response that the lack of models was an insoluble difficulty. During the con-

versation Rosenberg realized that for the first time in his life he had
friends of his own age who really cared about him and his problems.
He now began actively to seek them out. On Friday night, February
3, he met Leftwich and Rodker, and to their two shillings and a
penny he willingly added his two and fourpence, making it possible
for the three of them to go to the theatre. They obtained standing
room for *Unwritten Law,* a dramatization based on Dostoyevsky's
Crime and Punishment, with Laurence Irving in the role of
Raskolnikov. They thought the acting was 'magnificent' but felt that
the stage-play was not faithful to the book. The next day, Rosenberg
called on Leftwich early, bringing with him an album belonging to
Amshewitz's sister. He was returning it to her, having added at her
request a drawing and a poem entitled 'In the Heart of the Forest'
(*CW,* p. 197). The poem was marked by insistent alliteration,
onomatopoeia, and a heavy reliance on sibilants which led first
Leftwich and then Rodker to remark that the poem reminded them
of Longfellow's 'Hiawatha'. Rosenberg protested that he had never
read 'Hiawatha', then, in a burst of articulate feeling, he told them
how glad he was to have gained them as friends and that they were 'a
tremendous help' to him. He had never been, Leftwich wrote, in
close contact before with boys of his own age. Having thus cemented
his new friendships, Rosenberg went on to Amshewitz who was ex-
pecting him.

Rosenberg's inclusion brought about a reshuffling of the relation-
ships within the group. Leftwich and Winsten, pragmatic and serious
but not without humour, composed the stable centre; on its outer
edges were the other two, with Rosenberg's sullen solemnity,
awkwardness and dependence counter-balancing Rodker's light-
heartedness, sophistication, and reckless independence. Though only
a month had passed since they had discovered Rosenberg, Leftwich
was giving considerable thought to the group's personality differ-
ences. Having described Rosenberg on the first night they met, he
now added thumb-nail sketches of Rodker and Winsten. Rodker, he
felt, was bright, superficial, and weak, while Winsten was 'steady and
stolid . . . deliberate and thoughtful'.

But it was Rosenberg who most intrigued Leftwich. Winsten and
Rodker were predictable; Rosenberg was not. The threesome had
never encountered anyone like him before, and Leftwich was com-
pelled to comment on Rosenberg's responses to the various situations
in which the group found itself. The entry for Sunday, February 12
is a good example. While they were out walking Winsten began sneer-
ing at Rodker and Leftwich for going hatless. The ribbing went too

far, Leftwich became angry and snatched Winsten's bowler, passing it back and forth to Rodker while Winsten made futile efforts to recover it. Rosenberg remained completely aloof from the dispute. His detachment and the preoccupations underlying it rather than the rupture in the group's hitherto harmonious relations were uppermost in Leftwich's mind when he wrote up his diary:

> It is strange that Rosenberg took no part at all in our little dispute tonight. He shuffled along very taciturn at one side, talking about Rossetti's letters and Keats and Shelley. He mumbles his words very curiously. Poor Rosenberg. His people are very unsympathetic to him. They insist on treating him as a little out of his mind. They consider him as an invalid, somewhat affected mentally. But he goes on in his own way, running away to the libraries whenever he can, to read poetry and the lives of the poets, their letters, their essays on how to write poetry, their theories of what poetry should be and do. . . . Poetry is his obsession — not literature but essentially, distinctively poetry . . . he says that his taste is very poor and he enjoys boys' magazines and his sisters' novelettes. It is only in poetry that he fills himself with something. . . . His strange awkward earnestness and single-mindedness have had their effect on us. I wish though it did not affect Jimmy with the love of the 'macabre'.

Leftwich was remarkably perceptive, particularly in his observation about Rosenberg's impact on Rodker. They stimulated one another, seeming to communicate in a private dimension beyond their other contacts. Between 1911 and 1918 Rosenberg nurtured his friendship with Leftwich and to a lesser extent with Winsten; with Rodker he had something of an undefined bond. During the First World War both Leftwich and Rodker refused to serve in the Army on moral grounds. The former went underground and the latter to prison as a conscientious objector. Rosenberg, on learning of Rodker's incarceration, became frantic with anxiety. His concern for Rodker's welfare in gaol was more like that of a brother than a friend.

As to Rosenberg's taste in literature other than poetry, it was as poor as Leftwich indicates. The deprivation and harshness of his life forced him to seek an escape through reading. Miss Seaton was urging on him the Russian authors, but he resisted. He wrote to her in the middle of February to say that he had read the Turgenev she lent him but that it had left him 'with a discouraging sense of the futility of life', adding that he preferred 'to read something joyous —

buoyant, a clarion call to life, an inspirer to endeavour, something that tells one life is worth living' (*CW,* pp. 327-328). In the same letter he reported hearing from Dr. Eder and quoted his letter to her. It was not exactly 'joyous' reading for Rosenberg, but it was certainly typical of the response he was getting from his contacts outside Whitechapel, in that it was to a degree sympathetic, but aloof. Eder had found much that he liked and much to criticize. Rosenberg was imitating other writers and not seeking his own voice. He was in his 'green days' (*CW,* p. 328).

This was the one criticism Rosenberg could not tolerate. To absorb it, and to assuage the pain it gave him, he had always to convince himself that he was a step ahead of the work under scrutiny, that he had moved on to another plateau. Ambitious and determined, he was glad to have any advice that came his way, but being stubborn and sensitive as well, he was always on the defensive. In sending Eder's letter to Miss Seaton he tempered its mildly negative tone: 'Of course,' he wrote, '[Eder's] criticism does not refer to the latest things I showed you; but I know he's right' (*CW,* p. 328). He had to acknowledge the superiority of those to whom he submitted his work for judgment, but he never learned to be entirely gracious about it. Indeed, he already showed signs of being a little too persistent, a little too ready to argue, a little too aggressive in defense of his ideas, images, and techniques.

When the Whitechapel boys got together on Sunday night, February 19, they decided to write prose compositions and read them to each other the next Sunday. By Wednesday Rosenberg had completed his essay, 'On A Door Knocker'. Other than letters and school pieces, he had not written much prose, yet he was inspired by the assignment to produce a lively, well-structured article. His intention was to describe the door knocker 'as a symbol of general tendencies and vitalities of the present', and as a potential 'symbol of the religion of the future' (*CW,* p. 285). A well-conceived mock seriousness pervades the essay, revealing in Rosenberg a natural whimsicality, enhanced by his strong attraction to Laurence Sterne. *Tristram Shandy* was more than a delight to Rosenberg, it was a book of faith. In Shandian style, Rosenberg attempts to demolish Christianity. His essay is thus of primary interest as an example of how he considered himself an English writer rather than a Jewish one. Judaism doesn't enter into his thinking at all; in the context of his essay it does not precede nor will it succeed Christianity. The dominant religion, however outmoded and decayed, *is* Christianity, and it is to be superseded by a religion founded in opportunity for

all, humanistically designed, waiting behind the door for every aspirant's knock.

Rosenberg left Hentschel's very early in March 1911.[12] The vigorous encouragement from the other Whitechapel boys, the reassurance Amshewitz gave him, the kindly interest of those from whom he sought advice, and his own faith in himself all combined to decide him not to be a photographic engraver but to become an artist, no matter what the sacrifice. Soon after he stopped working he wrote to Miss Seaton:

> Congratulate me! I've cleared out of the [bloody] shop, I hope for good and all. I'm free — free to do anything, hang myself or anything except work. . . . I'm very optimistic, now that I don't know what to do, and everything seems topsy-turvy.[13]

> (*PIR*, p. 13)

These moments were exuberantly happy ones for Rosenberg, rare in his otherwise despairing existence. Only nine weeks had passed since New Year's Eve when everything seemed bleak and hopeless. An odious past was behind him; the bright promise of the future loomed up before him.

6

Poor Rudolph
March-Sept. 1911

Freed from work, Rosenberg went into a frenzy of creative activity, drawing, painting, and writing. He now became a painter and a poet, keeping his mortal frame intact by obtaining commissions for portraits while seeking his immortal fame through writing poems. To symbolize his release from Hentschel's and to celebrate having crossed the frontier into a brave new world he bought 'a violently green broad-rimmed Tyrolean' hat. It was a grand gesture, full of significance.

The horseplay among the Whitechapel boys over hats had not gone unnoticed by Rosenberg. More to the point, however, was the fact that outlandish hats were a current rage among art students in London. Rosenberg's purchase replaced the black bowler he wore to work everyday; it was his ticket of admission to the art colony as well as his way of announcing his new image. Though it covered much of his face, it was an improvement over the bowler, and it did much to raise his spirits. He wore it at a rakish angle, and it gave him a jaunty air, with just a touch of Rodker's calculated bohemianism. Byron was still in his bloodstream. The hat was so inspiring that Rosenberg began painting a large self-portrait, which he intended to send to the Royal Academy. He worked on the canvas every day during the first week of March, exuding self-confidence, still revelling in his new-found freedom.

On Wednesday, March 8, Leftwich, Winsten and Rodker came to inspect the self-portrait. They were impressed. 'It is a very excellent likeness,' Leftwich wrote, 'and the painting is bold and outstanding. The face is in shadow. The pose is very striking. It is a three-quarter length — quite a big canvas. He is standing up, wearing his overcoat with the collar turned up and his broad-brimmed Tyrolean hat on his head. Simy and Jimmy are anxious as a Tic about it. We are quite

sure that the Academy will accept it.' Encouraged by his Whitechapel friends, Rosenberg took the portrait to Amshewitz to ask for his judgment and to borrow a frame. Amshewitz told him how he might improve the painting, but in attempting the changes, Rosenberg ruined the picture. By the time he reported the disaster to Leftwich on March 17, the Byron in him had regressed, his place taken by Gimpel the Fool, peering out from underneath the green hat.

Rosenberg was disgruntled but far from dismayed. The pace of his life had suddenly quickened. He was seeing a great deal of his friends at night. On their walks they often ran into Morris Goldstein and another poor East End art student, David Bomberg who had just entered the Slade School. Between these latter two and Rosenberg an abrasive competitiveness was asserting itself. Each bragged about his accomplishments and then gossiped to the others. Goldstein and Bomberg thought Rosenberg a good poet but no painter, while Rosenberg discountenanced their own claims with unabashed sarcasm.

Sunday, March 5 was the day designated for the reading of the essays. Rosenberg met Winsten, Rodker and Leftwich and solemnly delivered his piece on the door knocker. He discovered that he and Leftwich, who had written about a previous summer's evening spent in Hyde Park, were the only ones who had actually completed the assignment. Afterward, the four boys decided to collaborate on a novel, and having eaten peanuts all the while, ended the evening with a riotous shell fight, littering the floor and rolling about with laughter.

Out in the streets a few nights later, the boys met Goldstein with Sonia Cohen, a Whitechapel girl reared in an orphanage, a sentimental, naïve, pretty waif, suffering from malnutrition and a want of affection. After they left, Rosenberg told the boys that Goldstein had introduced him to Sonia, sometime before. As she wrote poetry, he had shown her his poems. Rodker was amused. The idea that Sonia Cohen was composing poetry was absurd and he scoffed at it. In time, he, Bomberg and Rosenberg would all be in love with her in their different ways. Bomberg would attempt unsuccessfully over a long period of time to seduce her; Rosenberg would write her love poems, paint her portrait and fantasize about her; and Rodker would make her pregnant. Between the extremes of Bomberg's aggressiveness and Rodker's suavity, Rosenberg, shy and awkward, was never in the contest.

The Whitechapel boys' sexual proclivities were just beginning to manifest themselves. How much they knew or thought about sex is

difficult to determine. There were certainly inhibiting factors: a crowded and active family life, long hours in the sweat-shops, years of schooling in the strictures of the Mosaic Code, and the lack of privacy. Still, the time had come for them to engage in the rites of passage.

Like any other society, the East End had its initiation rituals. For Rosenberg and his peers, the starting point was the Stepney chapter of the Young Socialist League. There, in the midst of endless politicizing, debate and indoctrination in socialist theory, flourished a healthy, boisterous camaraderie with both frivolous and serious erotic undercurrents. Friendships, flirtations and alliances abounded. When the political meetings ended, the romancing began. Couples walked to the Thames Embankment to lie down together in the dark. The part of the Embankment to which they directed themselves was known as Monkey Walk. Serious, high-minded young men and virtuous young women avoided the area. It was always crowded.

With the possible exception of Rodker, the Whitechapel boys kept to their politics in their associations with the Young Socialist League and left Monkey Walk to others. Leftwich was prudish, looking down on those he suspected of moral laxity. He had an understanding of sorts with Fannie Blanket, his employer's daughter, to the effect that they would one day become engaged. Their relationship was bathed in innocence. 'We are too young,' Leftwich said, 'to think of reducing our feelings to anything tangible and decided.' He thought that Winsten was not at all involved with girls; and he was reasonably certain that Rodker was also inexperienced despite his obsession with moral and sexual matters. He was fascinated by prostitution and was writing a play about it. As for Rosenberg, Leftwich wrote in his diary entry for March 22, 1911, that he was 'absolutely innocent of any contact whatever with any girls save his sisters'.

Leftwich's assessment of Rosenberg was probably accurate. He had flirted with the Young Socialist League itself, but not with any of its female members and, of course, there was his continuing devotion to the poetic muse. On Friday, March 10, he and Winsten went to a league meeting to renew their membership. Rosenberg had been induced to join at some earlier date, but had allowed his membership to lapse. The discussion that night caught his poetic fancy. By the next evening he had written a sonnet, an 'incitement to action' which he intended to send to the *Young Worker*. Although he was temporarily stirred by the discussions which at the time centred primarily on atheism, materialism, and Darwinian evolution, he postponed rejoining until Friday night, March 31. Leftwich was not involved

since he had been expelled earlier for advocating anti-socialist views. Curiously, Rodker made a vigorous speech opposing the re-election of Rosenberg and Winsten, but he was overruled. His opposition was not to Rosenberg; rather he was worried that Winsten's fundamental conservatism would undermine the League. This was the beginning of a rift between Rodker and Winsten which grew wider during the spring and summer and permanently affected the unity of the group. Rosenberg cared little about the outcome of the re-election. His preoccupation with himself left little room for other causes.

Free now to spend his time as he wished, Rosenberg devoted an increasing amount of it to copying the masters in the National Gallery. On Thursday, March 9, he was making a copy of Velásquez's 'Philip IV'. King George was due at the Gallery that day to open some additional rooms. When he arrived, the other students left their easels and crowded into the corridor to see him walk through. Rosenberg continued working. A few minutes later, the King came into the room where the Velásquez was hung. Whether out of shyness, disdain, absorption or ignorance of protocol, Rosenberg did not stop painting to acknowledge his presence, even though the King paused for a moment to watch him paint before going into the new wing.

Rosenberg hoped that his reproduction of 'Philip IV' would be sufficiently accurate and impressive to convince the Jewish Educational Aid Society of his talent and dedication. If that happened, the Society would give him funds to obtain models. Up to that time, it had been adamant in its refusal to support him. Naïve about its workings, Rosenberg saw the Jewish Educational Aid Society only as a distant, stern deity, capable of accelerating his artistic career but reluctant to take him seriously. Actually, the decision-making in this small but vital agency was fairly informal, though strict formalities were observed with the applicants. Two of the chief referees for aspiring artists were Solomon J. Solomon and William Rothenstein. A recommendation from either of them to the Society's secretary would remove all obstacles from the path of an indigent East End boy. Mark Gertler was enabled through Society funds to enrol in the Slade in 1908, David Bomberg in 1911. Rosenberg and Solomon had met through Amshewitz, and Solomon had seen some of Rosenberg's drawings. If he had any inclination to support Rosenberg's application, all he had to do was send a note to the Society's secretary, Ernest Lesser, advising help. Obviously he had been put off, either by a shrewd awareness that Rosenberg's artistic talent could not sustain itself or by Rosenberg's manner and bearing. Rosenberg continued to

apply to the Society; he did not know that Solomon — who had been urged by Amshewitz to consider whether Rosenberg was talented enough to be recommended for help — had already made a decision about his work and disposed of his case. Ironically, it was to be Solomon's sister, Lily Delissa Joseph, an established artist in her own right, who would arrange to give Rosenberg what the Society withheld.

Rosenberg was back at the National Gallery on Friday, March 17, putting the finishing touches to his reproduction of 'Philip IV'. In high spirits, he was satisfied that he had produced a faithful copy. While he painted he noticed that he was being observed by a lady. Lily Delissa Joseph introduced herself and within minutes they were arguing vigorously over the best masters to copy. In the course of their discussion, she explained to Rosenberg her technique of using only three colours, white, cobalt, and rose madder (sometimes substituting orange madder), in executing her London exteriors and interiors. She gave him her colours and asked him to attempt a landscape using them, adding that she had never been able to persuade her brother to try the method. She invited Rosenberg to call on her. The encounter left him speechless.

The chance meeting with Lily Delissa Joseph was Rosenberg's second miracle of 1911. Over the next few months she was to become his champion. Sensing her enthusiastic interest and perhaps also her influence, Rosenberg hastened to paint a picture for her. He sat out in the rain all day Sunday, March 19, using her colours for a landscape of Hampstead Heath looking toward Highgate Pond.

Though he was not composing much verse, Rosenberg's nervous energy, at an all-time pitch, kept him busy. He worked on his drawings and paintings, made fair copies of his poems to send to editors, considered doing a series of illustrations to his poems in the hope of securing a publisher, and searched out the names of influential people who might help him. One of these was Sir Adolf Tuck, the director of the Raphael Tuck art publishing house, who granted an interview on March 21. Rosenberg wanted him to buy his work on a continuing basis, but Sir Adolf was not in the least impressed by the paintings, though he thought the poems showed merit and asked that additional ones be sent for his editors to judge. Rosenberg posted them to him, but they soon came back rejected. The interview was a total failure. Worst of all, Rosenberg ruined his copy of 'Philip IV'. In his haste to include it among the works he was taking to the interview, he carried it wet from varnishing and it was spoiled.

On the last Wednesday in March Rosenberg was walking with a

well-known Whitechapel character, Reuben Cohen, otherwise called 'Tizer' or 'Crazy' Cohen or 'Cohen the Printer'. Tall and thin, with a flaming red beard, Cohen had pretensions to a career in journalism. He had worked for a number of the small makeshift printshops in the East End, and planned one day to set himself up as printer, newspaper publisher, poet and tycoon, but he could never make enough money to feed his wife and child, let alone buy machinery for his own shop. When and how Cohen and Rosenberg met is not known, but they had much in common and got on well: both were visionaries, hopelessly unsuited to coping successfully with the material world. They walked along the Mile End Waste and dreamed dreams of a future neither would live to experience.[14]

The Whitechapel boys continued to work on their novel, to walk together, to fight among themselves. Leftwich chronicled all their concerns: he worried about dietary problems during Passover; Rodker suffered from malaise, bored with working as a clerk and anxious about his admission to college; Winsten fretted over Rodker's political assaults; and Rosenberg flitted about inconsequentially, unable to get out of his rut despite his efforts. If he was distraught over Bomberg's admittance to the Slade while he himself was unsuccessful, he did not tell Leftwich. Some things he kept to himself. Close as he was to his friends, he did not give them frequent reports on his feelings or his movements. Rather, he tended to make announcements after the fact. Often he was not at home when the boys called on him; he had gone out without saying where. He could be very secretive, particularly where women were concerned.

A case in point was Annetta Raphael. On Thursday night, April 20, Leftwich suggested to Winsten and Rodker that they go to see *A Midsummer Night's Dream*. Winsten preferred to go to the House of Commons to listen to the debate. Instead, they went to Rosenberg's. He had gone out. They talked to his sisters, Minnie and Annie, who told them about Annetta, a close friend who lived near-by, a dressmaker by trade, art student at night, and part-time teacher of piano and violin. Her English was weak, and she needed a coach to prepare for an examination to qualify as a music teacher. Winsten offered to help and they all went to her house, where they spent the remainder of the evening talking to Annetta and her fiancé. Though Winsten was disappointed over the fee, he agreed to coach her at one shilling per lesson.

Now Rosenberg had known Annetta for a long time. They shared an interest in art, and to a lesser extent in music. Despite the absence of letters to her, or other evidence, Rosenberg and Annetta remained

in touch up to the time of his death. She did not marry the man to whom she was engaged in 1911 and remained single for many years. When she was told that Rosenberg had been killed at the Front she suffered a nervous breakdown. Beyond his fantasies and yearnings for Sonia Cohen, and any other young women he encountered in the Amshewitz circle or later at the Slade, beyond any chance liaisons with the models he could occasionally afford — notorious among the Slade students for their looseness — Annetta Raphael, a few years older than Rosenberg, lonely, sensitive, and a little awkward, must be considered as the most likely person to have initiated Rosenberg into sexual experience.[15]

The one woman certain to have been in Rosenberg's non-erotic thoughts in the spring of 1911 was Lily Delissa Joseph. Leftwich's diary records no mention by Rosenberg of his having visited her. Yet he almost certainly went to a formal dinner party at her invitation in mid-April. Thereby hangs a tale — that of 'poor Rudolph' (CW, p. 272-82). On Monday, May 1, Leftwich made the following entry in his diary:

> Rosenberg came. He showed me a story which he wrote the other day about an artist who met a wealthy lady-artist at the National Gallery where they were both painting copies from the old Masters, and was invited to her house. He had no dress-clothes however, and confided his difficulty to a friend, who promised to procure him a suit. The suit did not quite fit, but still, the artist went to the dinner . . . although he felt rather uncomfortable about the whole matter. Unfortunately the butler at the house recognizes the suit as his and there is a scene, which is not lessened by the discovery that the artist's friend is a boarder at the house of the butler's wife, who had lent him one of her husband's suits without his knowledge. The method of discovery of the identity of the suit too is very curious. There are three strangely-formed spots of paint on one of the lapels, gained from a careless housepainter's splashing his paint above, and the butler did not know how to remove paint-marks.[16] Is this a real happening at Mrs. Delissa Joseph's? Rosenberg says no — but I am not satisfied with his denial. The whole thing has the nature of fact, and not of an invented tale.

Rosenberg entitled his story 'Rudolph'. It is, so far as is known, the only prose narrative he ever wrote. Though stilted, sprawling, weak in the presentation of its central action, and shapeless at the end, the story is, surprisingly, not without merit. As in his essay on door knockers, Rosenberg's whimsicality surfaces and gives a jovial

Head of a Barrister, 1910

Self-portrait, 1911

cast to the plot. Rudolph is Rosenberg, laughing at his own self-portrait in words. The story is full of autobiographical insights, keys to Rosenberg's view of himself at the time. At the beginning he describes his protagonist-self as an artist, dreamer, and poet suffering from privation and neglect. He was

> ... one whose delight in the beauty of life was an effective obstacle to the achievement of the joy of living; whose desire to refine and elevate mankind seemed to breed in mankind a reciprocal desire to elevate him to a higher and still higher—garret. ... In this garret, in the dim waning light, God could see day by day the titanic wrestlings of genius against the exigencies of circumstances. ... But day after day of unrequited endeavour, of struggle and privation, brought depression, and in the heaviness of his spirit the futility of existence was made manifest to him. ... In his social and spiritual isolation, in his utter desolation, he felt as if he was God's castaway, out of harmony with the universe, a blot upon the scheme of humanity.
>
> (*CW*, p. 272)

Shaken out of a reverie one day while painting at the National Gallery by 'a pleasant faced lady of about thirty-five, rosy and buoyant' (*CW*, p. 273), Rudolph debates with her the influence of Van Eyck, whom she avows is her principal master. Countering her enthusiasm, Rudolph describes his own ideal in painting:

> Van Eyck is interesting to me just as a pool reflecting the clouds is interesting, or a landscape seen through a mirror. But it is only a faithful transcript of what we see. My ideal of a picture is to paint what we cannot see. To create, to imagine. To make tangible and real a figment of the brain. To transport the spectator into other worlds where beauty is the only reality. Rossetti is my ideal.
>
> (*CW*, p. 273)

Rosenberg knew that he could never follow the traditionalists. He had taken Rossetti as his starting point, but he had not in 1911 travelled far enough to determine his response to the Post-Impressionist, Fauvist, and Cubist currents flowing from France which would reshape English art before war broke out in 1914. Moreover, Rosenberg was not ready to make critical judgments about painting; he was far more at home with the criticism of poetry. With hardly a pause Rudolph is soon inveighing against his hard life as a poet:

> When one has to think of responsibilities, when one has to think strenuously how to manage to subsist, so much thought, so

much energy is necessarily taken from creative work. It might widen experience and develop a precocious mental maturity, of thought and worldliness, it might even make one's work more poignant and intense, but I am sure the final result is loss, technical incompleteness, morbidness and the evidence of tumult and conflict.

(*CW*, pp. 274-75)

His own troubles a constant backdrop. Rosenberg makes Rudolph first whimsically genial and then flippantly shallow. At the home of the lady's nephew, Rudolph opens his portfolio and arranges his drawings around the room:

... [he] then stood by to explain and elucidate where elucidation was necessary, which was not seldom; for he painted on the principle that the art of painting was the art of leaving out, and the pleasure in beholding a picture was the pleasure of finding out. Where he had not left out the whole picture, sometimes it was successful.

(*CW*, pp. 277-78)

Though Rudolph is talking tongue-in-cheek, he is wrapped in his own principles and takes them seriously. Appearing finely clad to himself he is to others the emperor without clothes. Through the mirror of fiction, Rosenberg as Rudolph reflects this condition and precisely describes this dominant trait in his own personality:

From this glimpse of Rudolph we might surmise he was one of those superficial wits who are like bottles of soda-water just being opened, and never open their mouths but to fizzle like a Chinese cracker. This apparent superficiality was the natural consequence of a super-self-consciousness, a desire not to frustrate expectation, and a lack of sustaining inspiration to keep up with desire. . . .

Brought up as he had been: socially isolated, but living in spiritual communion with the great minds of all the ages, he had developed a morbid introspection in all that related to himself, and a persistent frivolousness in relations with others; a dark book for his bedside and a gaudy one for the street. The development of temperament had bred a dissociation from the general run of the people he came in contact with, that almost rendered him inarticulate when circumstances placed him amongst those of more affinity to himself, from disuse of the ordinary faculties and facilities of conversation. Naturally these circumstances would be such where his vanity suggested he had a reputation to sustain, and he would be per-

petually on the strain to say something clever. He was totally lacking in the logic of what might be called common sense, but had a whimsical sort of logic of his own which was amusing until it became too clever. . . .

<div align="right">(CW, pp. 279-80)</div>

Not only did Rosenberg understand this much about himself, but he accepted it and in time would exploit it as a defence against the world. He was twenty years old when he wrote 'Rudolph'. As his coming of age approached, he came into his inheritance: the role of the clown crying, just as Gertler's role was the sentimentalist in despair and Bomberg's the martinet in pain. All three had their talent and ambition distilled through the acid vat of poverty, with the result that their personalities in young adulthood were permanently scarred by the deeply inbred conviction of certain failure.

'Rudolph' was for Rosenberg a little symphony in the ridiculous composed and conducted by himself. The symphony in turn produced a variation on the main theme — that of divine neglect. Rosenberg described Rudolph at the outset as a poet in spiritual isolation, convinced he was God's castaway. Among the poems that make up Rosenberg's first booklet, *Night and Day*, which appeared in 1912, there is an undated fragment entitled 'Spiritual Isolation' which fully develops the castaway theme:

> *My Maker shunneth me.*
> *Even as a wretch stricken with leprosy*
> *So hold I pestilent supremacy.*
> *Yea! He hath fled as far as the uttermost star,*
> *Beyond the unperturbed fastnesses of night,*
> *And dreams that bastioned are*
> *By fretted towers of sleep that scare His light.*

<div align="right">(CW, p. 26)</div>

Unlike many of his acquaintances in the Young Socialist League who proclaimed their atheism, Rosenberg still accepted the principle of a godhead, but he was perplexed and angered by the suffering he witnessed and by his own agonies, which he could attribute only to malice or indifference on the part of the deity. Rosenberg is further disturbed by God's refusal to give him the choice of acceptance or rejection — the latter is the only course open to him. In time he would write openly blasphemous poems.

To her credit, Lily Delissa Joseph was not put off by Rosenberg's clowning. She was in earnest about helping him. When he came to visit

her on Friday, May 5, she offered him employment as tutor in art and poetry to her young son. Rosenberg willingly accepted. He had earned no money since February, and his conscience was beginning to nag him. Tutoring Lily Delissa Joseph's son would not only keep him in paints and canvas, but, more importantly, would keep her in contact. He needed her friendship: his career hung by the slender thread of her interest in him. However, though slender, it was none-theless strong, for without telling him she decided that in the autumn he must enter the Slade School, and she began exploring the means of getting him there.

All in all, Rosenberg's spring had been productive. Although two good paintings had been ruined by his carelessness, he had several landscapes, another self-portrait in pencil, a charcoal drawing based on Keats's 'Titans', two other portraits in oil, an essay, a short story, and a handful of new poems. Apart from 'Spiritual Isolation', there were two occasional pieces: 'Lines Written in an Album' (*CW*, p. 193), and 'To Mr. and Mrs. Lowy, on Their Silver Wedding' (*CW*, p. 194). Three other poems dealt with the poet's plight, employing the standard themes: youth has fled, the world is harsh and unyielding, beauty is transient, love is absent, despair is dominant, but, in spite of it all, life is worth living. These poems he called 'The Dead Past' (*CW*, p. 198), 'My Days' (*CW*, p. 196), and 'The World Rumbles By Me' (*CW*, p. 195). This last poem, composed in ten couplets, is reminiscent of Yeats's rose poems, though Rosenberg does not mention Yeats in his correspondence until some years later.

Spring gave way to summer. Rosenberg painted the bridge at Blackfriars, commiserated with Leftwich who was either jobless or doing uncongenial work, ignored Winsten's and Rodker's arguments, and fell again into a deep depression. On Sunday, July 16, he un-burdened himself to Leftwich, who wrote in his diary, 'Rosenberg told me about his plans and about his ideas for future poems. But he spoke in a very melancholy and dispirited way about them. He is very disappointed. He seems able to do nothing about his work. No one will give him any real encouragement. He can't get anything printed anywhere.'

The only alternatives to Rosenberg's depressed state, as he saw it, were either to leave England or take any job he could find. He thought he might go to America by cattle boat and he asked Leftwich to accompany him. But America was too chancy and they abandoned the idea. As for a job, he preferred to remain idle, so long as it was not at home. 'I still have no work to do,' he said in a letter to Miss Seaton. 'I think, if nothing turns up here, I will go to Africa.

I could not endure to live upon my people; and up till now I have been giving them from what I had managed to save up when I was at work. It is nearly run out now, and if I am to do nothing, I would rather do it somewhere else. Besides, I feel so cramped up here, I can do no drawing, reading, or anything. . .' (*PIR*, p. 16).

Rosenberg endured his desperation and waited for some change to come about. Nothing happened. The general elections distracted him for a short time in late July as he went with the Whitechapel boys to hear the nightly speeches made by Victor Grayson, Cecil Chesterton, and Hilaire Belloc. The socialists had little success but, though his friends were very disappointed, Rosenberg could not have cared less. He forced himself to begin painting again, and completed a portrait of Lionel Woolf, a Whitechapel acquaintance. Although his mother was not keen on his going to America or Africa she was increasingly worried over his mental state. She and his sisters persuaded him to take a holiday. He decided on a boat trip to St. Helena. When he got to Jamestown, he sent his mother a postcard: 'Just got here, haven't looked around yet. Seems fine. Napoleon buried here.' (*CWL*, p. 20). He returned rested, his spirits higher. Lily Delissa Joseph asked him to call on her. During the visit he learned to his astonishment that she and two friends, Mrs. Herbert Cohen and Mrs. E. D. Lowy, were prepared to underwrite his study at the Slade. The third miracle of his miraculous year was upon him.

7

The Slade School
Oct-Dec 1911

On October 3, 1911, Rosenberg left his house in 159 Oxford Street and went to Gower Street, where he filled in the entry form for admission to the Slade School, Department of Fine Arts, University College, the University of London. Unlike Gertler and Bomberg who preceded him to the Slade, he would, as a painter, never outgrow his Whitechapel background. They could escape it, develop beyond it, put it into historical perspective, and live beyond its spatial and spiritual confines, though both had much more orthodox backgrounds than his. He might never leave because figuratively he had left earlier, forcing his departure vertically into a domain of poetry, substituting a microcosm of words and sounds for the political, social, and religious surfaces of the Mile End Waste. Rosenberg's suspended microcosm, energized by his as yet uncontrolled and unshaped imaginative power, was now to find its corollary in the larger world of literary and artistic activity in London. This activity, too, was thrusting upward out of its Edwardian lassitude, gathering momentum, throwing off its Victorian attitudes.

The Slade School had been founded in 1871, after Felix Slade, a patron of the arts, had left a bequest to University College establishing a practical chair in painting. The distinguished and far-sighted E. J. Poynter was the first professor to occupy the chair, during a time when few advances were being made in British art.[17] In 1876, he was succeeded by the French painter Alphonse Legros, who laid the foundation in drawing technique which was to give the Slade its great reputation for draughtsmanship. Frederick Brown, who studied under Legros, occupied the chair in 1893, bringing with him to the Slade a number of his own talented students, of whom the brightest luminaries were Augustus John and William Orpen. During Brown's tenure, Wilson Steer, Walter W. Russell, Henry Tonks, Ambrose

McEvoy, and Derwent Lees were added to the staff. Havard Thomas taught sculpture and Roger Fry, following D. S. MacColl, lectured on the history of art.

By the time Rosenberg enrolled, this faculty was strong-willed, independent, certain of its tasks and assured of its ability to carry them out. Standards were high. Brown, out of shyness, and Tonks, out of intense dedication to his profession, were notoriously autocratic but not rigid. So long as the students were serious and willing to work hard, they were given and indeed took considerable licence, especially in their private lives. That they were tacitly encouraged toward revolution in painting there can be no question.

However, the Slade remained for a long time on the periphery of the London art world. Politically, the Royal Academy dominated the scene. Its annual summer exhibition was the great art event of the year − in 1901, for example, *The Times* devoted four articles, totalling 14,000 words, to it. Much attention in the exhibition and the reviews was focused on portraiture. Portraits painted by contemporary artists Benjamin Constant and John Singer Sargent were much in vogue. Sargent personified the successful, highly competent but unimaginative Royal Academy artist, able to name his own figure for immortalizing on canvas the Edwardian *nouveau riche*. However little Rosenberg understood in his youth about success in the art world, he learned very early from Amshewitz that portrait painting was the one certain path to fame and fortune.

This is not to suggest that rigid battle lines existed between artists of the Royal Academy and those not associated with it. Both Sargent and Solomon and others were friendly with and helpful to young students whose views were clearly opposed to their own. Sargent had observed Bomberg copying a bust by Michaelangelo at the Victoria and Albert Museum in 1907, and had advised him to seek admission to the Slade since its drawing 'was the best in the world'. Sargent then arranged Bomberg's interview with Solomon, who took him in 1908 to talk to Brown, a meeting which in time led to Bomberg's entrance to the Slade.

The rivalry, however, intensified. The hatching of plots, more humorous than sinister, came to be a regular amusement of the Slade students, and occasionally their pranks were successful. In 1910, without regard for the interest and support he was receiving from Academy artists, before he was even admitted to the Slade, Bomberg accompanied a group of Slade students to the Royal Academy with the intention of collecting random visitors and lecturing to them. Having succeeded in organizing a small group for a tour of the

gallery, he began his lecture with extravagant praise of the Royal Academy and then, as they went from picture to picture, he launched into a scurrilous attack upon every principle the Academy held dear. On being discovered he was thrown out, and it was a long time before the Academy officials allowed the Slade to forget the outrageous prank. Bomberg learned a lesson in public relations on his foray: sufficient audacity combined with a modicum of talent could produce amazing results. Wyndham Lewis had already refined the principle; Ezra Pound would give it canonical authority. Rosenberg, for all his yearning toward recognition, would never master it.

While the Slade students amused themselves with such encounters, the Slade teachers quietly went about the more serious business of instilling into English painting an appreciation of French technique and experimentation. From the outset Legros had kept a sensitive and discerning eye on developments in Paris. Brown and Steer were also impressed, though the latter, who had studied in Paris in the 1880s, warned as early as 1891 that the French influence might become too pervasive. He thought it lacked depth, remarking that 'Impressionism is of no country and no period; it has been from the beginning; it bears the same relation to painting that poetry does to journalism.' Resisting submergence by Paris, Steer wanted to see a revitalization of English art. Brown had already recognized that this would have to occur independently of the Academy; five years before Steer's remark he had written the Constitution for the New English Art Club which from 1886 forward provided an alternative option for non-establishment exhibitions. Twenty years elapsed before its real impact was felt, but its continued presence was an irritant to the art establishment. Other exhibitions were also organized from time to time. In 1902 the one held at Wolverhampton suggested that revitalization was underway. The exhibitors were a loosely linked but strong group, including Steer, Tonks, Fry, Orpen, Rothenstein, Ricketts, and John.

D. S. MacColl attacked from a different direction. In 1903 he complained of the administration of the Chantrey Bequest, which since 1875 had made available the income from 100,000 guineas for the purchase of English paintings and sculpture. The fund was controlled by the Royal Academy. Between 1891 and 1904 the trustees had limited their purchases for the nation to works executed by Academy artists. MacColl's complaint produced an enquiry which eventually led to the creation of the Contemporary Art Society.

There was ferment in still other quarters. The same year that MacColl spoke out, the new *Burlington Magazine* described Van

Gogh as 'a great artist'. Two books dealing with the Impressionists were in circulation: Richard Muther's three-volume *History of Modern Painting* was translated from the German in 1895; and Camille Mauclair's *The French Impressionists* appeared in 1903. It was followed in 1904 by Dewhurts's *Impressionist Painting.* The collector and dealer Hugh Lane was already buying Manets and Renoirs. In 1905 the Durand-Ruel Exhibition of French painters at the Grafton Gallery was sufficiently large and imposing to make itself and its implications felt. It included 55 Manets, 59 Renoirs 40 Pissarros, 36 Sisleys, 19 Monets, 13 Morisots, and 10 Cézannes. George Moore's racy memoir, *Reminiscences of the Impressionist Painters*, was published in 1906, and significantly, Meier-Graefe's *History of Modern Art*, with its detailed critique of the aesthetics of Cézanne, Gauguin, and Van Gogh, was translated and published in 1908. In 1909 Orpen painted his 'Homage to Manet'.

The tide against the academically entrenched artists – and sculptors – was swelling. Jacob Epstein, a penniless American Jew who might have been a brother to Gertler, Bomberg and Rosenberg, had settled in London in 1905. His genius was soon recognized, and in 1907 he was commissioned to carve eighteen mammoth figures for the British Medical Association's headquarters in the Strand. Epstein set out to represent 'man and woman in their various stages from birth to old age'. A violent controversy ensued over the propriety of the sculptures. On June 19, 1908, Epstein was attacked in a leading article of the *Evening Standard and St. James Gazette*, which described his work as 'a form of statuary which no careful father would wish his daughter, and no discriminating young man, his fiancée, to see'. Epstein might well have taken heart at the names of those who defended him, but by the time the controversy ended and work resumed he was broke and unable to pay his workmen. Discussing the controversy, *The British Medical Journal* described the general state of public apathy toward new art forms: 'We are glad that a sculptor of genius awoke one morning to find himself famous, but we are sorry and not a little ashamed that he should owe the foundations of his fame to the hypocrisy with which other countries, and not without reason, reproach the British people.' Epstein's breakthrough was epoch-making. In 1911 Gaudier-Brzeska was to arrive from Paris. With T. E. Hulme and Ezra Pound at his elbow, he would help spread the revolution Epstein had begun, until he, too, like Hulme and Rosenberg and so many more, died on the Western Front.

Thus the Slade School, the New English Art Club, the *Burlington*

Magazine, and a few art critics — D. S. MacColl, Roger Fry and Frank Rutter — along with such informally organized coteries as the group gathered around Walter Sickert at his Fitzroy Street studio, all contributed to a growing awareness that a new school of English artists was emerging. Influenced by the Impressionists, these artists moved away from the accepted English standards which had long insisted that art, in order to be successful, must faithfully reproduce reality, and must seek to achieve the degree of perfection attained by the Renaissance masters. Under Roger Fry's tutelage, these new artists were already being urged to go beyond Impressionism. His sponsorship of the now-famous Post-Impressionist exhibition which opened on November 8, 1910 at the Grafton Gallery, gave them their cue. Cézanne, Denis, Herbin, Gauguin, Manet, Matisse, Seurat, Signac, Van Gogh, and Vlaminck were represented. Justifying the Post-Impressionists' underlying principles, Roger Fry wrote in the foreword to the catalogue:

> ... there comes a point when the accumulations of an increasing skill in mere representation begin to destroy the expressiveness of the design, and then, though a large section of the public continue to applaud, the artist grows uneasy. He begins to try to unload, to simplify the drawing and painting, by which natural objects are evoked, in order to recover the lost expressiveness and life. He aims at *synthesis* in design; that is to say, he is prepared to subordinate consciously his power of representing the parts of his picture as plausibly as possible, to the expressiveness of his whole design. But in this retrogressive movement he has the public, who have become accustomed to extremely plausible imitations of nature, against him at every step. . . .

These remarks opened the flood-gates to abstraction. It became the order of the day, manifesting itself first in Cubism. Fry theorized, while Wyndham Lewis and others projected the theories onto canvas. Inspired by the Post-Impressionists, Bomberg would soon be caught up in the new movement. For a brief time he would forge ahead of Lewis and the others with his experiments in abstract design. Hulme and Pound would shortly relate the new movement to literature.

Rosenberg went to the exhibitions and watched the developments. He understood the new movements, but his thinking about painting had long been circumscribed by the insularity of the Amshewitz circle and his own need to justify painting by earning money. With poetry he was willing to take risks; as far as painting was concerned

he thought only in terms of a comfortable niche. Whether he was jealous of the progress made by Bomberg and Gertler we do not know, though certainly it would have been in his nature to feel some chagrin over their access to high places and important figures while he was denied. It is conceivable that the Slade was not the appropriate school for him. One might make out a strong case for the view that by temperament and training he would have prospered at the Royal Academy School in St. John's Wood, where he could have taken his time making copies of the masters and concentrating on portraiture. He was, on the whole, uncomfortable with the Post-Impressionists but he was not put off by them; he would in his limited way imitate Gauguin. He took as his spiritual ancestors the Pre-Raphaelites whom, he argued, had never abandoned the great masters while anticipating the abstract designs of the Post-Impressionists. His comprehension of their artistic motives was obviously hazy. In time, the Slade helped him to clarify his understanding of the approaches to art, though he was determined to follow his own bent. Perhaps the Slade's greatest benefit was to make him a better poet. Its unrelenting, incessant emphasis upon the logic of the sharp, clear line, economical and spare, was a lesson he needed to have drummed home. Though he had a hard time learning it, that lesson was as important in composing verse as in drawing.

At the time of his arrival, the Slade was surcharged with new ideas entertained by an able and gifted student body, imbued with revolutionary spirit. Besides Bomberg and Gertler, other students included Stanley Spencer, Paul Nash, William Roberts, Dorothy Brett, C. R. W. Nevinson and Edward Wadsworth, Dora Carrington and Adrian Allinson. Jacob Kramer was shortly to join them; John Currie had been enrolled for part-time studies in 1910. Alvaro Guevara, the Chilean painter, enrolled in 1912. It was a diverse group made up of aristocrats, dandies, middle-class sons and daughters of tradesmen and craftsmen, one or two retired Army officers, plus 'two outsize Germans, who were dwarfed by a giant of a Pole', and a handful of working-class students uncertain of their survival on the course from one term to another. Among these latter were Stanley Spencer, a scholarship lad from Cookham, and the three ill-clothed, self-conscious Whitechapel boys, used to living by their wits.

Rosenberg did not record his initial impressions of the Slade and his first meeting with Brown and Tonks, though several of his fellow-students — Nash, Nevinson, Spencer, Allinson, Bomberg and Gertler — at one time or another publicly or privately recorded Gower Street's first impact on their fevered young minds. Spencer's

first interview with Brown was a forbidding affair — no doubt
Rosenberg anticipated and suffered similar terrors as he mounted the
steps:

> Waiting outside Brown's room could easily revive unhappy
> memories for those who had had their share of waiting to see
> their headmasters at other schools. And entering his room could
> deepen the feeling of utter gloom: the room sadly needed re-
> decorating, the walls were bare, and there was nothing any-
> where to suggest the glory of the place. Brown sat at the table,
> leaning back in his chair. Behind him stood Tonks and Steer,
> each with one arm on the mantelpiece. It all seemed so still and
> silent that they might have passed for a tableau at Madame
> Tussauds. Brown would be wearing an ageing black frock coat
> with here and there some smudges of paint on it. Being inter-
> viewed by him was not encouraging; one almost felt that he
> hated the sight of students. His face seemed flushed with anger,
> and it was only years later that I realized that he suffered from
> a distressing shyness.

George Charlton, who studied at the Slade from 1914 and joined the
staff in 1919, described Brown as 'a somewhat gruff, hard-bitten
man, of great feeling, with something of the Victorian military man
about him'.

Formidable as Brown was, he was mild in comparison with Tonks,
whom Charlton recalls as 'very tall and grim, with a distinct resem-
blance to the Iron Duke'. Brown had the authority but Tonks was
the authoritarian, a dragon of a man, dedicated to the point of
absolute ruthlessness. If he and Rosenberg had anything in common
it was a compulsion to cram two lives into one lifetime, for Tonks
was a practising surgeon when, at the age of thirty, he accepted
Brown's invitation to become his assistant. Entering thus late upon
his life's work, he had to compensate for lost time and spared neither
himself nor others. Paul Nash, who entered the Slade about the time
Rosenberg did, described Tonks's appearance at their first meeting:
'With hooded stare and sardonic mouth, he hung in the air above me,
like a tall question mark, backwards and bent over from the neck, a
question mark, moreover, of a derisive rather than an inquisitive
order. In cold discouraging tones he welcomed me to the Slade. It
was evident he considered that neither the Slade nor I was likely to
derive much benefit.'

Once past the initial encounter, students were exposed in class to
the possibility of a verbal assault from Tonks. His criticisms,
Charlton said, 'must be some of the most scathing in history. A

typical beginning, said in a slow, horrified voice, on seeing a student's drawing, would be like this: "What is it? . . . *What is it?* . . . Horrible! . . . *Horrible!* . . . Is it an insect?" ' Every student quaked before his onslaught. The men seethed in fury, the women wept openly. His criticism was devastating — but to be ignored by him was catastrophic. William Rothenstein in his *Men and Memories* said: 'There was a time when poor Tonks had to walk the streets not daring to go home, lest ladies be found at his door awaiting his arrival with drawings in their hands, whose easels had been passed by, and in whose hearts was despair.' It is no wonder the students used to chant, out of Tonks's hearing, of course, 'I am the Lord thy God, thou shalt have no other Tonks but me.'

Rosenberg's letters while he was a Slade student say little about his relationships with the staff, but there is one to Miss Seaton, undated, apparently written in the spring of 1912 after he had been out of touch with her, which mentions Tonks. 'I am studying at the Slade,' Rosenberg wrote, 'the finest school for drawing in England. I do nothing but draw — draw — You've heard of Professor Tonks — he's one of the teachers. A most remarkable man. He talks wonderfully. So voluble and ready — crammed with ideas — most illuminating and suggestive — and witty' (*CW,* p. 331). The inference is clearly positive: teacher and student were getting on together, and Tonks was being helpful. Underneath his fierce demeanour, Tonks was a kindly, interested man who was later profoundly saddened by the loss of young life in the First World War, to the extent of softening thereafter his verbal attacks on the students. In his later years he remembered Rosenberg, but thought of him primarily as the young poet who died in the 1914-18 war rather than as an art student. By contrast Brown remembered Rosenberg as a student but forgot him afterward. When Annie Wynick invited him to attend the Memorial Exhibition in 1937, Brown declined on the grounds that he was too old to travel, adding that he had 'entirely lost sight of [Rosenberg] and his work since. I am sorry to learn that he lost his life in the Great War and I send you my sympathy. . . .'

Almost twenty-one years old, Rosenberg satisfied his teachers that he was sufficiently advanced to be exempted from the universal requirement of spending anything from one to several terms drawing in the Antique Room, which Augustus John once described as 'furnished with numerous casts of late Greek, Greco-Roman and Italian Renaissance sculpture; no Archaic Greek, no Oriental, no "Gothic" examples were to be seen. The student was set to draw with a stick of charcoal, a sheet of "Michelet" paper and a chunk of

bread for rubbing out.' Instead, Rosenberg went immediately to the men's life-class, drawing on a full time basis. In this huge, gloomy, tomb-like room, with pipes lining one wall, and a stove on the model's platform, Rosenberg spent the bulk of his time until he left the Slade in 1914.

Unlike the Royal Academy schools, where students agonized for months over the same drawing or the reproduction of exact copies of famous paintings, the Slade followed the French method of employing models in a medley of poses. This greatly appealed to Rosenberg; however, he experienced the usual frustration of the new student over the rapidity with which the models changed their poses, especially since he was inclined to work very slowly. Rosenberg's feelings that first day in the life-class must have been somewhat akin to Adrian Allinson's:

> Timidly and apprehensively I shuffled to the rear of the serried rows of silent workers. The unexpected heat and tobacco fug and the sudden sight of a naked woman enthroned before forty men increased my discomfiture. With shaking fingers I arranged the paper on my drawing board and began sharpening the all too fragile sticks of vine charcoal, when a chorus of voices sang out, 'Change.' Whereupon, to my surprise, the model took up an entirely new pose before I had got a single line on to the paper. This was 'life drawing' with a vengeance. I had been unaware that the last hour of the day was devoted to short poses, the drawings of which should train the eye to quick reactions. Realizing that it was senseless for me yet to attempt drawing at high speed, I decided to make a dispassionate examination of the model, the first adult female I have ever seen stripped. . . . The figure before me with its pink and soft flesh, breathing and ever so slightly swaying, though like, was yet utterly unlike . . . sculptured replicas. Moreover, though the body and limbs were relatively immobile, the lady's eye roved and her glance as it rested on one or other of the men seemed to share dark and unholy secrets with them.

At twenty-one, Rosenberg was not as naïve as the considerably younger Allinson. He had painted nudes at Birkbeck College. His problem was the rapidity with which the poses changed, though in time he learned to work quickly. This fundamental approach was to make it possible for him to send with his letters from the Western Front an occasional bold line drawing, hurriedly sketched, either of himself or of other soldiers around him.

By October 13, 1911, Rosenberg's fees were paid, amounting for

the 1911-12 session to twenty-one pounds. He listed as his sponsor Mrs. Herbert Cohen, of 2 Orme Court, Kensington. Curiously, most of Rosenberg's subsequent dealings regarding patronage were with her. Lily Delissa Joseph appears to have dropped out of his life as casually as she had dropped into it. The Slade register reveals that Rosenberg attended class regularly during the session, even on Saturdays. It was not so much a matter of conscience; this was his one opportunity to become an artist and he was determined to exploit it to the full. Ruth Lowy, the daughter of Mrs. E. D. Lowy, another of his patrons, was enrolled, and they became friends. The differences in their social station and the fact of her mother's patronage prevented the friendship from deepening, although the view has been put forward that Rosenberg was in love with Ruth. In any case, her presence at the Slade meant that his patrons could always keep an eye on him. He turned out to be reliable enough, but no one could really gauge his progress, least of all himself. Problems were inevitable. In less than a year he was in trouble with Mrs. Cohen not only over his progress, but because he was forgetful, and she mistook his absent-mindedness for ingratitude.

Rosenberg also became friends with Adrian Allinson, who invited him home once in a while and visited him in the East End. Rosenberg got on well with Gertler, but he had, at best, only an uneasy alliance with Bomberg. Years later Bomberg spoke warmly of his friendship with Rosenberg, whom he called 'the poet-laureate less the title and the retaining fee', but when they were at the Slade they were too jealous and too critical of one another to become close friends. Yet they needed one another. Bomberg came to Rosenberg's home frequently, and Rosenberg visited and occasionally used Bomberg's one-room studio in St. Mark's Street. Outside Whitechapel each went his own way. Bomberg was petulant and aggressive. He and Gertler — in spite of the latter's delicate frame and girlish features — and later Jacob Kramer, were noted at the Slade for their boxing prowess. Rosenberg's parents had always been pacifists, and fighting was completely out of his character. Consequently he was bullied at the Slade, principally by Alvaro Guevara, who was given to crude anti-Semitic assaults, not all of them verbal. Once Bomberg blackened Guevara's eye, refusing to submit to his torments. Rosenberg endured them, philosophically resigned to his fate. Eventually, Kramer grew tired of watching Guevara pick on Rosenberg. One day he beat up the Chilean student, and Guevara troubled Rosenberg no more.

In short, Rosenberg made a few friends at the Slade but his life-

style remained unchanged. He was basically a solitary person and would always remain one. In an astonishingly short time Gertler's uncommonly good looks, conversational gift, and talent as an artist made him one of the darlings of the Bloomsbury Set: Lady Ottoline Morrell actually called on him in the East End. Bomberg, too, found his way into avant-garde circles, and Hampstead and Kensington drawing-rooms via T. E. Hulme and Wyndham Lewis, while Rosenberg went on walking the Whitechapel streets.

Late in 1911 Rodker introduced Rosenberg to another budding poet, Lazarus Aaronson, who was living in Whitechapel, working for his matriculation. His parents had left London a few months before to settle in the United States. From the time they met until early 1912, he and Rosenberg met each other frequently at night in the Whitechapel Public Library. This friendship, however, was soon complicated by their inverse maturities: Aaronson was Rosenberg's intellectual superior, but Rosenberg was the better poet. Aaronson has described the verses he wrote at that time as execrable, and he was convinced Rosenberg thought so as well. Both were intense. At his first meeting with Rosenberg, Aaronson was struck by the intensity which blazed out of the penetrating green eyes. 'More than anything else,' Aaronson said later, 'I remembered the eyes, greenish with a red fleck.' They read their poems to each other, and Rosenberg helped Aaronson with his imagery, in return for which Aaronson corrected Rosenberg's spelling. But their sensitivities got in the way. Aaronson was too conceited and arrogant; lacking charm, he had little more to impress people with in 1911 than his intellectual pretensions, which invited from Rosenberg a 'sneering trace of Irish malice'. It was not a happy friendship. They drifted apart, though circumstances occasionally brought them together. Several years later Aaronson was with Rosenberg and a number of Slade students and models at the Café Royal. Rosenberg talked on and on about his poetry — he could be as insistent as the Ancient Mariner when he had an audience — until the party grew annoyed and bored. Quietly they conspired to leave and one by one they went off to the telephone, the toilet, or the exit until finally Rosenberg was left talking to himself, sufficiently preoccupied not to realize he'd been landed with the bill.

Another friend of Rosenberg was a youth of his own age named Mitchell. He was half Scottish, half Japanese, an art student living alone in London. Rosenberg took him home and Hacha offered him lodging. Haronof, the Pakistani, had long since departed, other tenants had come and gone, one-half of Rosenberg's room was vacant.

Rosenberg and his fellow students at the annual Slade School of Art picnic, 1912. Rosenberg is kneeling on the far left. Front row, left to right: Dora Carrington, unidentified student, C. R. W. Nevinson, Mark Gertler, unidentified student, Adrian Allison with dog, Stanley Spencer. Back row, standing, third from left: David Bomberg; on his left is Professor Frederick Brown

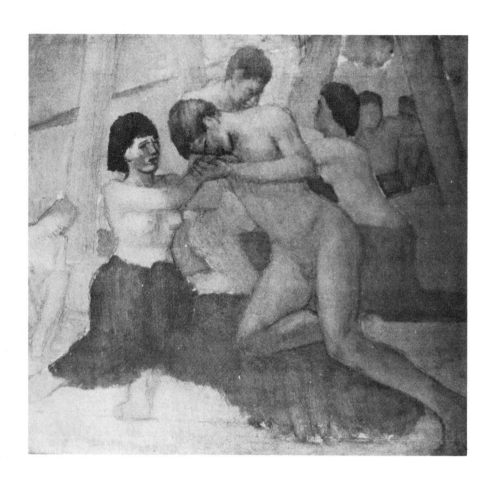

Sacred Love

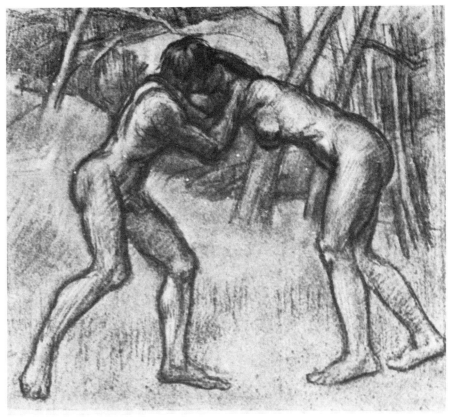

The First Meeting of Adam and Eve, 1912–13

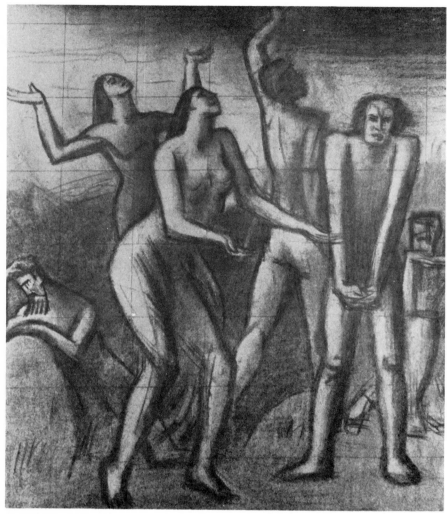

Hark, Hark, the Lark, 1912

Mitchell moved in. For a time he and Rosenberg were inseparable. After Rosenberg acquired his own studio, and later went off to South Africa and then to the war, Mitchell stayed on, reluctantly leaving the Rosenbergs only in 1919 when he realized that part of Hacha's inconsolable grief over Isaac's death was expressing itself in resentment towards him. Little is known about Mitchell,[18] but his may well have been the best and longest-lasting friendship of Rosenberg's adult years, notwithstanding his bond with Rodker, and his possibly more intimate relationship with Annetta Raphael.

And so the *annus mirabilis* ended. There had been frustrations and disappointments, but he had acquired lasting friends in Leftwich, Rodker and Mitchell. His long and miserable apprenticeship at Hentschel's was over, and he had gained a place at the Slade, which was then entering one of its most productive eras. Yet in his soul he was not happy. He ached to see his poems, which he cherished more than his friends or his studies at the Slade, in print. If no one else would publish them, he would find a way to do it himself.

8

Prose Into Art
1912

Gertrude Stein once remarked that 'It takes a lot of time to be a genius, you have to sit around so much doing nothing.' No one could accuse Rosenberg of inaction: 'I do nothing but draw — draw —' (*CW*, p. 331), he had written to Miss Seaton. If he was not drawing, he was painting, copying the masters at the National Gallery when he didn't have a class. At weekends he did landscapes. And when he was not drawing or painting, he was writing. Almost entirely dependent now upon patronage, he was even more at the mercy of his grim need to gain immediate, unequivocal recognition both in painting and poetry. His compulsion toward painting was selfless, finite, and external: he could not justify his existence to others unless he proved that he had the talent to support himself through painting so as not to burden his parents. His compulsion toward poetry was selfish, infinite, and internal: he could not justify his existence to himself unless he became known as a writer. He was trying to serve two masters, one more demanding than the other. Consequently, he served neither of them well and was miserable.

One way in which Rosenberg took his mind off his misery in the spring of 1912 was by writing prose. Spurred by the literary enthusiasms of the Whitechapel boys, he had produced the year before his essay on door knockers and his short story 'Rudolph'. Whether or not he was aware of it, his prose was showing signs of strength. He could organize sentences coherently and logically, and keep his thoughts moving at a graceful, steady pace. The small yet vibrant strain of humour in him surfaced easily in the prose and gave it a buoyancy he could not achieve in his poetry. The truth of the matter is that his prose in 1912 was better than his poetry. Excepting his letters, over which he took no pains, though they were expressive enough, his prose — unlike his poems — reflected an entirely English idiom:

The ultimate end of all the arts should be beauty. Poetry and music achieve that end through the intellect and the ear; painting and sculpture through the eye.

(CW, p. 262)

Life stales and dulls, the mind demands noble excitement, half-apprehended surprises, delicate or harsh, the gleams that haunt the eternal desire, the beautiful.

(CW, p. 263)

Whistler, exquisite, dainty and superficial, dandied through the slushy sentimentalism that had saturated English art, and taught Art not to despise the moods of nature; that a pigsty in twilight was a poem and even a church could be hallowed – by a fog.

(CW, p. 264)

These sentences are a direct product of Rosenberg's Baker Street School days and his Whitechapel Library nights. There is no distinctly Jewish element. That is reserved entirely for the poetry where his Jewish background fused with his English heritage to produce a peculiar tension from which sprang an original idiom. His prose remains free from that tension. It might not have been any easier to compose than the poetry, but it gives the impression of having been put to paper in a disinterested, almost casual manner, with imagination and competence balancing each other. One wonders what progress Rosenberg might have made in literary London if he had devoted the time he spent drawing to writing prose.

His several prose pieces are primarily on painting. Two are reviews of exhibitions, of which one was published. In the winter of 1911-12 the Baillie Galleries in Bruton Street exhibited the work of Rosenberg's friend Amshewitz, and another Jewish artist who had died a short time before, Henry Ospovat. Rosenberg submitted the review to *The Jewish Chronicle* which printed it with minor modifications on May 24, 1912. He had little to say about Ospovat other than to compare his illustrations for some of Shakespeare's sonnets, and Arnold's and Browning's poems, with Rossetti's and Fred Walker's illustrations, observing that Ospovat 'possessed in a great measure the poetic feeling and refinement of the Pre-Raphaelite school of illustrators [but] he lacked the tenderness and charm of their execution, their patient and honest endeavour for exactness.'

Naturally, Amshewitz is treated in greater detail. Rosenberg's admiration is to be expected, yet his appreciation is not without criticism. Commenting on his friend's series of illustrations for *Everyman,* Rosenberg cities them as evidence of 'the remarkable fertility of Mr. Amshewitz's versatile and extraordinary powers', but remarks

that his 'personal preference' would have been for a text 'illustrated in a purer and more fervid religious spirit'. He particularly liked the portrait of Amshewitz's mother for its sympathy, graciousness, and subtlety; a black and white study entitled 'The Hungry', for its power and intensity; and the landscapes, which 'all have the authority and air of experience, autobiographical records of moods, lovely and glad, tinged with the merest grace of melancholy — moods sunny and joyous, brooding and pensive, retiring and shy, or sombre with presentiment of storm and tragedy.' From a letter Rosenberg wrote to Alice Wright, one of his Birkbeck teachers, in September 1912, we know that he was reading Milton that year. His description of Amshewitz's landscapes certainly seems to echo 'L'Allegro' and 'Il Penseroso'.

The review is significant for two reasons. Though Rosenberg had sent poems to the editors of London's leading literary journals, none had given him column space. This was his first adult appearance in print. It was a beginning, a foundation upon which, had he been so inclined, he might have built. But he missed its implications for the future, and published no further reviews.

The other significant point about the review is its opening observation — one that in retrospect is little short of remarkable for the insight it gives into Rosenberg's thought. No one, he says, by looking at the pictures, could tell that the artists were Jewish, except for their names. This leads him to comment on Anglo-Jewish cultural fusion:

> Whether this is something to be deplored or not is beside the question here, as it is the inevitable result of ages of assimilation and its blame (if a defect) is to be placed on the causes that made us a race, and unmade us as a nation. Yet though these causes have deprived us of any exclusive atmosphere such as our literature possesses, they have given that which nothing else could have given. The travail and sorrow of centuries have given life a more poignant and intense interpretation, while the strength of the desire of ages has fashioned an ideal which colours all our expression of existence. We find this exemplified in the work before us. Where nature has inspired, the hold on life is strong, but there is an added vitality, the life of ideas, and, as all great and sincerely imaginative work must be, the result is more real. Life that is felt and expressed from the immediate fires of conception must naturally be more convincing than what is merely observed and described from without.

This premise underlies all of Rosenberg's work. In everything he was

to attempt from 1912 onward, he would begin with the conviction that for the Jewish artist or writer the inspiration of nature was necessary, as it was for all, but beyond nature there was an additional dimension from which the Jewish artist and writer could draw strength: 'the life of ideas' borne out of centuries of agony and struggle. His *modus operandi,* as he defined it further in a number of letters written from the Western Front, was to express out of nature the central idea at its still centre, creating images embodying that core of meaning. Out of his English experience he took, empirically, what life had to offer him from nature, and combined it with what he understood *a priori* from his Jewish heritage. This combination accounts particularly for the sculptural character of his poetry. Twenty-five years later Siegfried Sassoon would 'discover' and articulate for succeeding generations in his Foreword to Rosenberg's *Collected Works* this basic compositional method, without realizing, as apparently none had before him, that Rosenberg had explained his approach in print as early as 1912.

Rosenberg followed his informal, modest statement of method with a touch of humour. He began his specific comments on Amshewitz's paintings by calling attention to one he knew well:

First is the portrait of a young poet, gazing as if out of 'dream-dimmed' eyes, holding the pen in his hand, apparently waiting for an inspiration. This he doubtless does as a protest against the legendary unpractical habits of poets. With such prudence and foresight, so long-headed a precaution as the pen implies, no poet surely could incur the stigma of unpracticality. It is well studied, except for the mannered and unpleasant way the forms of the shadows repeat themselves, which makes it appear as though style were aimed at rather than exact interpretation.

The portrait, of course, was the one Amshewitz was painting of Rosenberg in January 1911. Both of them must have enjoyed the private joke, recognizing that Rosenberg's rather negative assertion on shadows and style was intended not only to tease Amshewitz but to veil the identity of the reviewer.

After visiting the Pre-Raphaelite Exhibition at the Tate Gallery in the winter of 1911-12, Rosenberg made some notes for a review-article.[19] They were fragmentary, and the article was never finished. In jotting down his impressions he was perhaps satisfying a recurring need to define and redefine for his own needs the Pre-Raphaelite essence. Moreover, he may have been somewhat on the defensive about the Pre-Raphaelites as some of the Slade students — particularly Bomberg — would have rejected and probably ridiculed his

extravagant claims. The Pre-Raphaelites represented a bright and hopeful development in an otherwise dismal period of English painting, but they could not, as Bomberg was to write years later, 'effectively stem the deterioration'. Bomberg and Roberts, who was now a frequent visitor to the former's studio, were both being drawn rapidly towards Cubism, attempting to distinguish their methods from the Post-Impressionists, developing an abstract theory of design which Ezra Pound and Wyndham Lewis would soon term 'Vorticist'. Rosenberg resisted, partly to save himself from influences which, though they might have advanced his reputation, would certainly have destroyed his independence. To preclude that possibility he used the Pre-Raphaelites as a barricade, drawing strength from the sympathy he felt with them, keeping in check from within his own urges toward abstraction, while holding at bay its insistent temptations from without. On the one hand he could not be certain what abstraction would amount to in England; on the other, he was convinced that the Pre-Raphaelites had signalled the true direction for English painting. He described their accomplishments in his fragments thus:

> Ingenuity of imagination is the prime requisite in their design. They recognised the limitations of the grand style of design and widened the possibilities of natural design. They imagined nature, they designed nature. They were so accurate in design that the design is not felt; and yet though it defies criticism from the naturalistic side we are projected into an absolutely new atmosphere that is real in its unreality.
>
> When I say the naturalistic I mean it in its absolute sense, in the sense that Velásquez painted and Rembrandt, in the sense that the post-impressionists paint. Each of these saw nature in their own way and interpreted it so. All are as truthful to nature and all are as unlike each other, in so much as the artist was bent more or less on a particular effect in nature which appealed more to his temperament. Velásquez aimed at realising light as affected by atmosphere, Rembrandt saw nature as one effective chiaroscuro which brought into relief the character and psychology, the post-impressionists paint nature according to the sensation a perception produced upon them, and the Pre-Raphaelites combine all these qualities.

(*CW*, p. 258)

If Rosenberg was expressing publicly such extravagant praise — and there is every reason to believe that he was — he must have drawn enemy fire. He would not have been able to keep his barricade

intact for very long. Moreover, he would have been forced to oppose the Slade's insistence on modernism. That is precisely what happened. In another set of prose fragments, to which Rosenberg's editors gave the general title, 'The Slade and Modern Culture', he questioned the Slade's revolutionary stance: 'If we consider the Slade as it stands related to modern culture we will find one fundamental principle exemplified — one guiding law, one fact that is of paramount interest in our endeavour. We find that the law of change only proves the futility of change, that it is a circle revolving round the rock of fixity' (*CW,* p. 264). Rosenberg had an idea where 'the rock of fixity' might be found. It was in the individual's own stance. This precluded his taking part in the revolution.

If Rosenberg was no revolutionary in art, neither was he a reactionary. He refused to throw in his lot with the Royal Academy artists whose successes he coveted. If anything, he was simply an iconoclast, an individualist who did not want any current imprint on his style. He could not accept the Slade point of view which for him amounted to a contradiction:

> This is the paradox of the Slade: to be ourselves we must not forget others — but forget ourselves. We must not look at nature with the self-conscious, mannered eye of a stylist, whose vision is limited by his own personal outlook, but assimilate the multifarious and widened vision of masters to widen our outlook to the natural, to attain to a completeness of vision, which simply means a total sinking of all conscious personality, a complete absorption and forgetfulness in nature, to bring out one's personality.
>
> (*CW,* pp. 264-65)

He was not one to forget himself; he could therefore not accept what his fellow students at the Slade regarded in 1912 as England's high road to artistic respectability. He rejected the Royal Academy's low road as well, and, convinced that his vision extended rather than limited his personal outlook he set out cross-country to make his own way, using his singular personality as a tool to cut through the critical undergrowth. In this context, his prose fragments on painting constitute an informal *apologia,* appropriate for him but not readily followed by his fellow students.

Try as he might, Rosenberg was unable to keep his individualism inviolate. Preaching was one thing, practising another. He produced, among other works, three important pictures in 1912 and one in 1913. These were 'Joy' (oil), 'Sacred Love' (oil and pencil), 'Hark, Hark, the Lark' (charcoal and pencil), and 'The First Meeting of

Adam and Eve' (chalk). Unfortunately, 'Joy', which had been painted for the 1912 Slade summer competition, disappeared after the Memorial Exhibition at the Whitechapel Art Gallery in 1937, where it had been offered for sale at one hundred guineas. Rossetti was Rosenberg's inspiration for this huge canvas, but the three smaller works indicate that the ferment in London and at the Slade over the Post-Impressionists was making an impact upon him, largely through his contact with Bomberg.

He was spending increasing amounts of time in Bomberg's studio. He met Leftwich and Winsten less frequently; the group, after its initial enthusiasm, was no longer so close, chilled by the disputes between Winsten and Rodker. Rosenberg continued to see Rodker, who had become interested in the new art — he was more conversant with it in the summer of 1911 than Rosenberg — and he now counted Bomberg and Gertler among his friends. Bomberg's studio at 20 Tenter Buildings became temporarily the rendezvous for the Whitechapel painters, and vigorous discussions went on amid Bomberg's experimental designs. Rosenberg saw these in their various stages of completion and listened to Bomberg's aggressive expositions of his aims and objectives. Bomberg was now flattening his figures and placing them in chequered and other architectural settings. The water-colour and charcoal compositions for his abstract paintings, including 'Interior', his studies for the 'Vision of Ezekiel', and the 'Island of Joy', which was Bomberg's entry for the 1912 Slade competition, must all have been thoroughly scrutinized by Rosenberg. Their impact was not overwhelming, but it was pervasive and persistent, kept at bay only by Rosenberg's stubborn resolve not to be engulfed.

'Sacred Love', 'Hark, Hark, the Lark', and 'The First Meeting of Adam and Eve' reveal nonetheless that Rosenberg was experimenting with representational figures in the continental mode. Before 1912, he had done few studies of figures, preferring to devote his efforts to portraits and landscapes. Except for evening classes at Birkbeck College he had no access to models and nowhere to draw them until he entered the Slade. Hence it was not until 1912 that he began seriously to incorporate figures into his studies. The several that are still extant do not derive from the Pre-Raphaelites; they are much closer to Gauguin's studies of the Polynesians in Tahiti. Rosenberg did not date these pictures, but it is reasonably certain they were composed in 1912 and 1913. 'Sacred Love' probably came first, 'Hark, Hark, the Lark' second, and 'The First Meeting of Adam and Eve' last. For this latter work, several dates have been offered.[20]

Both 'Sacred Love' and 'Adam and Eve' are studies of primal innocence. In 'Sacred Love', simple, non-profane affection in an Edenesque setting is the theme. Like Gauguin's figures, Rosenberg's are full-bodied, but with a slight stiffness as though the gestures are unfamiliar. The impression is one of awkwardness, resulting perhaps from his lack of experience in drawing figures — or perhaps it was intentional. The painting is reminiscent of those by D. H. Lawrence in the same period, where innocence is the passion and awkwardness in human contact its method of expression.

The same awkwardness pervades the study of 'Adam and Eve', but unlike 'Sacred Love', where the lines tend to be blurred or uncertain, here they are strong and sure. Rosenberg's control is absolute, the awkwardness in the couple's pose is deliberate, conveying innocence before the fall. The bodies are well drawn, graceful and rhythmic. There is passion in the embrace, and Adam differs from his predecessor, the detumescent male of 'Sacred Love', by virtue of a carefully shaded, somewhat modest but perceptible semi-erection. Maurice de Sausmarez has described 'Sacred Love' as 'the most mature' of Rosenberg's works (CWL, p. 29), but Adam and Eve are his most realistically drawn figures. Yet both compositions are little more than the efforts of an anxious young man in a hurry, discovering how exhausting and agonizing the search can be for an elusive ideal of individual perfection. In one of his remonstrations to Mrs. Cohen in 1912 he told her, 'Art is not a plaything, it is blood and tears, it must grow up with one; and I believe I have begun too late' (CW, p. 335).

For Rosenberg the search for individual perfection in art led him toward an ideal of 'intensification and simplification of life', as he would subsequently describe it in 1915 (CW, pp. 244-45). He sought, de Sausmarez maintains, to move 'towards compression of experience rather than towards the schematic [in order to produce] a design which is not arbitrarily imposed . . . but is distilled and inseparable from the content' (CWL, p. 29). Yet in the same year when he was coming closer to this 'compression of experience' he was also trying his hand at schematic designs. His 'Joy', for example, used a dozen people for its arms, hands, and faces in a fantasy of ecstatic representations. Though little is known about the composition of 'Joy', it is recorded that his sitters included his sisters, Rachel and Annie, Annie's friend, Sara Maunter, Sonia Cohen, Ruth Lowy, and several Slade models. He had great expectations for the picture. On July 15, 1912 he wrote to Alice Wright, telling her he was starting 'a fairly big picture' for the Slade competition (CW, p. 329). He asked her to

come and see it and give him her advice. Earlier that spring he had
taken a room at 32 Carlingford Road in Hampstead, finally acquiring
his own studio where he could bring models, work without distrac-
tion, and occasionally welcome guests.

Hacha had not wanted Rosenberg to leave home. She was not
convinced that he needed his own quarters until in desperation he
resurrected his old Birkbeck joke about having a model pose in
Hacha's kitchen and made it a reality. He arranged for Perry, one of
the most popular of Slade models, to come down to the East End.
He set her up in the kitchen, semi-draped, where Hacha was ironing,
and there he fiddled while Hacha burned.

It is my belief that 'Hark, Hark, the Lark' was the first composi-
tional study for 'Joy'. It was intended to represent a group of nude
figures of both sexes responding to the song of the bird winging
overhead. But the study is practically devoid of joy; the visual impact
is rather one of uninformed primitives aghast at the approach of
some threatening object hurtling through the skies. Rosenberg
despised the study and soon discarded it. 'I have started my picture
again,' he told Alice Wright on August 6, 1912, 'having taken a
violent dislike to my first design — it is absolutely another thing now,
though the literary idea is the same' (CW, p. 329).

'Hark, Hark, the Lark' is almost entirely Post-Impressionist in
style. The figures are not realistic: rather, like those in 'Sacred Love'
they are imaginary; they represent Rosenberg's *conception* of primi-
tive people listening to the bird's song. There is a slightly conscious
move towards Cubism in the angles and lines of the figures. If this
picture were placed side by side with the compositional studies
Bomberg was doing for the same competition, it would not be
seriously challenged as out of place. The picture has no beauty,
though it is not displeasing, nor is its impact weak. Several of the
figures are mildly distorted; the grace and rhythm of 'Adam and Eve'
is nowhere present. The absence of rhythm is especially noticeable:
Rosenberg froze these figures into their positions. The result is a
still-life, consistent with the emerging abstract intention of catching
and holding motion frozen on the canvas.

Why did Rosenberg hate 'Hark, Hark, the Lark?' The question is
intriguing. Did he reject it because he saw that it had neither joy nor
beauty and would invite derision from his class-mates and teachers,
or because he realized that he was succumbing to a forbidden
temptation? Assuming that he was communicating with Gertler at
that time, he would have known that he was in a similar predica-
ment, still searching for his authentic mode of expression, frustrated

at not finding it. In despair, Gertler wrote to Dora Carrington that he wanted to give up painting and be a tailor or a baker — anything but a painter. Unlike Rosenberg, while deprecating himself he was nonetheless able to look around, and recognize that others were worse off than himself. He, too, would find his own way, and it would not be the path of the Post-Impressionists.

Gertler was prone to pessimism, Rosenberg, ironically, to periods of optimism. In high spirits he conceived a new approach to 'Joy' and worked frantically to develop it. 'I have the working fever this week' (*CW*, p. 329), he wrote to Alice Wright. His progress was subject only to the punctuality of his models. 'My colour conception,' he went on, 'is a wonderful scheme of rose silver and gold — just now it is all pink, yellow and blue — but I have great hopes for it' (*CW*, p. 329). Three days later, on August 10, 1912, he wrote to Alice Wright again to tell her he had not seen by daylight a particularly beautiful pearl she referred him to, but that he had seen it at night, and it had 'the shimmering quality' of the irridescent gem that he wanted 'to make the whole scheme of [his] picture' (*CW*, p. 330). His model had turned up that day and his picture was coming along: 'I had Miss Grimshaw this afternoon and we both worked hard — She is a very good sitter — though her figure was much too scraggy for my purpose — I practically finished the drapery, and the upper part I will do from some more titanic model if I can get the type' (*CW*, p. 330).

It is unfortunate that the canvas has been lost. It might have answered many questions. As it is, we cannot know if Rosenberg was entirely successful in subduing his mild Post-Impressionist fervour, rechannelling its energies into Pre-Raphaelite symbolism. Though many people saw the painting, only one, as far as is known, recorded his impressions, and only then after ten years had passed. Laurence Binyon, in his sympathetic yet somehow forbidding introduction to Rosenberg's *Poems*, spoke of seeing a picture which could only have been 'Joy':

> [Rosenberg] once showed me at his studio a large, ambitious composition — an oil-painting — which I fancy was never completed. I cannot recall the nominal subject, but it was saturated with symbolism and required a good deal of explanation. I liked the mysteriousness of it, and the ideas which inspired the painting had suggested figures and groups and visionary glimpses of landscape which had passages of real beauty, though the whole work had grown impossibly complex with its convolutions of symbolic meaning. It reminded me of his poetry; and I think

that represented his natural bent in art. Had he been born half a century earlier, he would have been an ardent disciple of Rossetti.

<div style="text-align: right;">(PIR, pp. 7-8)</div>

That comment is all that remains of 'Joy', save the preparatory red chalk study Rosenberg did of Ruth Lowy's head, reclining on a pillow, curls cascading down on either side, eyes closed in a delicately subdued rapture. The drawing is a subtle melody of joy, vastly different from the grim countenances in 'Hark, Hark, the Lark'.

The judging of the competition took place soon after the 1912-13 Slade session began in October. Rosenberg's 'Joy' did not win, but, according to his editors, the picture was awarded a first-class certificate (CW, p. vii). This is surprising since the painting was never finished, as Binyon rightly surmised. Yet Rosenberg's teachers praised it, observing that it 'had great charm' and 'showed a hopeful future', though he 'wanted more study' (CW, p. 335). His failure to finish the painting subsequently involved him in a serious dispute with Mrs. Cohen. Nonetheless, he had ended his first year at the Slade with one first-class certificate from Brown and Tonks; and he began his second year by winning another, if his editors are to be believed.

In the midst of all the effort expended to produce 'Joy', he was writing poems and sending them off. He sent several to Austin Harrison in the hope of seeing them printed in The English Review. He might yet have become an artist, had it not been for his continuing obsession with writing.

9

The Gospel of Beauty
1912

Although he was not totally convinced that he would succeed as a painter, Rosenberg's belief in himself as a poet remained absolute. He was deterred neither by the intransigence of editors nor by the general indifference of those around him. He was aware, as he proclaimed in an apostrophe to the world, that it would sneer at him and label him a mad fool (*CW*, p. 261). His reply to the anticipated rejection is brash, confident, and determined: 'But my quiet serenity rebukes your despairs and vexations and the joys that pass. I go to meet Moses who assuredly was a suicide, and the young Christ who invited death, I who have striven to preach the gospel of beauty' (*CW*, p. 261). Fully conscious of the obstacles, he would fight to the end. Moses and Jesus became personal heroes. He cared not a jot for their gospels, but was inspired by their willingness to sacrifice their lives in order to spread their beliefs. If it were necessary, he would do the same. In the meantime, however discouraging his prospects he would continue to seek out the help of influential people, and find a way to get his poems into print.

Early in 1912 Rosenberg wrote to Laurence Binyon, then Keeper of the Prints and Drawings Room of the British Museum, critic, poet, and a major force among the *cognoscenti*, asking him to criticize some verses. Binyon was impressed: 'It was impossible not to be struck by something unusual in the quality of the poems,' he said. 'Thoughts and emotions of no common nature struggled for expression, and at times there gushed forth a pure song which haunted the memory' (*PIR*, p. 2). Unlike the other literary figures Rosenberg had approached, Binyon replied to his letter immediately, praising the poems and asking Rosenberg about himself. Rosenberg responded with a long letter detailing his thoughts on art and his preferences in literature. He enclosed an autobiography which he had written the

year before.[21] After reading it, Binyon invited Rosenberg to talk to
him.

Recalling their first meeting in his Introduction to Rosenberg's
Poems, he described the youth who stood before him thus: 'Small in
stature, dark, bright-eyed, thoroughly Jewish in type, he seemed a
boy with an unusual mixture of self-reliance and modesty. Indeed,
no one could have had a more independent nature. Obviously sensi-
tive, he was not touchy or aggressive. Possessed of vivid enthusiasms,
he was shy in speech. One found in talk how strangely little of
second-hand (in one of his age) there was in his opinions, how fresh a
mind he brought to what he saw and read. There was an odd kind of
charm in his manner, which came from his earnest, transparent
sincerity' (*PIR*, pp. 3-4).

Binyon offered Rosenberg his friendship. He was the first notable
literary figure to take him seriously. However, they communicated
infrequently. From time to time, Rosenberg sent Binyon his poems
or came to show him his drawings and paintings. Binyon visited his
studio to view 'Joy'. Later, Rosenberg wrote to him from the
Western Front. Still, there was something luke-warm about the rela-
tionship. When Rosenberg subsequently met Marsh, and when he
began corresponding with Gordon Bottomley, R. C. Treveylan, and
Lascelles Abercrombie, they warmed to him in a way that Binyon
never did. Perhaps he spoke to others on Rosenberg's behalf, perhaps
he did not. One suspects that Binyon, though genuinely interested in
Rosenberg, kept the young poet at a distance — possibly because of
their class differences. There is a certain coldness in his Introduction
to the *Poems* which cannot be overlooked. Whatever Binyon's true
feelings, he did not help Rosenberg get into print. And when
Rosenberg's hopes in this respect faded, he decided there was only
one course left open to him: he would have to publish the poems
himself.

Reading Milton and Blake in the spring of 1912, Rosenberg had
composed 'Night and Day', a long, rambling poem in imitation of
'L'Allegro' and 'Il Penseroso' and the 'Songs of Innocence and
Experience'. Into it he wove verses written as early as 1910. He was
desperate to publish it, but he knew all too well that since no editor
would print a short lyric he would stand no chance with a poem that
ran to 370 lines. One night he showed the manuscript to 'Crazy'
Cohen, who worked for Israel Narodiczky, a printer with a shop at
48 Mile End Road. Narodiczky's rich story has never been fully told.
An ardent Zionist, an idealist, hardworking, gentle and intelligent, he
was a deeply compassionate man with a soft spot for philosophical

anarchists, indigent writers, and rebels of various stamp.[22] Rosenberg went to see him, and Narodiczky agreed to publish a pamphlet of twenty-four pages.

From his pile of manuscripts Rosenberg selected nine poems: 'Aspiration', 'To J. H. Amshewitz', 'Heart's First Word', 'When I Went Forth', 'In November', 'Lady, You Are My God', 'Spiritual Isolation — Fragment', 'Tess', and 'O! In a World of Men and Women'; these, together with the title-poem 'Night and Day', made up the booklet. For approximately fifty copies, Narodiczky charged Rosenberg two pounds. It scarcely covered his printing costs but he knew the young, intense poet had no money. Rosenberg went to Mrs. Herbert Cohen and told her his plans. She lent him the money, which he promised to repay from the sale of copies.

No one knows for certain, but it is likely that 'Crazy' Cohen set the type for *Night and Day*. The booklet had a soft grey cover, a table of contents, and no imprint though British law required one. Narodiczky was aware of the requirement, having already been in trouble over it in 1911,[23] but he preferred his printing to be known and remembered only by the pamphlets and occasional books he printed in Yiddish and Hebrew. However, it is unlikely that he produced anything else that year as valuable as *Night and Day*, so rare now that the whereabouts of only one copy is known.[24]

Rosenberg followed the booklet's simple progress through the press with anxious excitement. Rather than making him more careful about details, his anxiety increased his carelessness. When he received the copies he found that some alterations were necessary. He pencilled in substitutions in three lines,[25] and added four more, so as to introduce the special songs sung by Desire and Beauty. In a few copies he added a poem by hand on the blank page after the table of contents.[26] He sent some copies to editors, gave a few to his family and friends, and offered the rest for sale. Leftwich tried to sell copies outside the Toynbee Hall one night without success. By the end of the summer all the copies had been disposed of without bringing in a penny. When Alice Wright asked for a second copy, Rosenberg had to tell her on September 5, 1912 that there was none left, though he thought Narodiczky might have a few and offered to try to get one for her (*CW*, p. 330). But Narodiczky's supply was exhausted and it was three weeks before Rosenberg managed to locate another copy (*CW*, p. 333).

'Night and Day' was Rosenberg's adieu to his young poethood. This highly romantic title-piece, with its stale themes and conventional excesses, does not deserve extensive comment, and had

Rosenberg survived the Great War, he would probably have suppressed the poem. Indeed, his prose introduction is as interesting as any of the lines which follow. His 'Argument' is to present the poet in search of the infinite; 'Night and Day' is Rosenberg's 'Intimations of Immortality' ode. The poet questions the stars in order to 'discover the secret of God' (*CW*, p. 5). Receiving no answer, he walks through the city out into the woods, where, communing with Nature, he finds his soul exalted and his intelligence widened. Desire sings him a song of immortality, Hope a song of love, and Beauty a song of the eternal rhythm, bringing the poet to the realization that by striving for the perfection which is God one comes closer to its attainment.

The title-poem contains vestiges of Thompson and Keats, with traces of Browning.[27] Its structure is derived from Milton, but it owes its main impetus to Blake, with whom Rosenberg was now infatuated:

> *I saw the face of God to-day*
> *I heard the music of his smile,*
> *And yet I was not far away,*
> *And yet in Paradise the while.*
> *I lay upon the sparkling grass,*
> *And God's own mouth was kissing me.*
> *And there was nothing that did pass*
> *But blazèd with divinity.*
>
> (*CW*, pp. 12-13)

It was not the easily imitated rhythms or the expression of an uncomplicated, personal attachment to a still benevolent Omnipotence that drew Rosenberg to Blake. Rather, Blake was England's first truly accomplished poet-painter, giving Rosenberg cause to idolize him even more than he did Rossetti. Even if he did not fully understand Blake, he sensed and appreciated his passion for honesty, his independence, the depth of his mysticism and the imaginative use he made of religious symbolism.

In addition, Blake was outspoken, concrete in his diction, and explicit in his imagery (however abstruse the meanings behind the images), especially in his treatment of physical love. Blake's sexual imagery gave Rosenberg a frame of reference through which his sensuousness could find its proper expression. Moreover, Rosenberg could respond whole-heartedly to Blake's distaste for industrialism, urban injustice and intolerance. He felt for Blake the kinship of the outlawed. Both were passive aliens in their native land, ridiculed,

Narodiczky's print shop in the Mile End Road

My songs.

Deep into the great heart of things
My mood passed, as my life became
One with the vasty whisperings
That breathe the pure ineffable name.

A pulse of all the life that shot
Through still deeps had, and wavering light
The flowing of the wash of years
From out the starry infinite.

And flowing through my soul, the skies,
And all the winds & all the trees
Mixed with its stream of light to rise
And flow out in these melodies.

NIGHT AND DAY.

ARGUMENT.

NIGHT. The Poet wanders thro' the night and questions of the stars but receives no answer. He walks through the crowds of the streets, and asks himself whether he is the scapegoat to bear the sins of humanity upon himself, and to waste his life to discover the secret of God, for all.

DAY. He wakes, and sees the day through his window. He feels endowed with a larger capacity to feel and enjoy things, and knows that by having communed with the stars, his soul has exalted itself, and become wiser in intellectual experience. He walks through the city, out into the woods, and lies under the trees dreaming through the sky-spaces.

He hears Desire sing a song of Immortality,

Hope, a song of love,

And Beauty, a song of the Eternal rhythm. Twilight comes down and the poet hearkens to the song of the evening star, for Beauty has taught him to hear, Hope to feel, and Desire, a conception of attainment

By thinking of higher things we exalt ourselves to what we think about.

Striving after the perfect—God, we attain nearer to perfection than before.

Night.

When the night is warm with wings
Invisible, articulate,
Only the wind sings
To our mortal ears of fault,
And the steadfast eyes of fate

First page of *Night and Day* with 'My Songs' copied in Rosenberg's hand

buffeted, misunderstood, subjected to abuse for going their individual ways. Men might shake their fists at them, but they could shake their fists only at God, who, they discovered to their lasting discomfort, was the ultimate enemy. Following Blake, Rosenberg would search for his archetypal figures not among the pagans but among both the inlaws and the outlaws of the Bible.

When an exhibition of Blake's drawings was held in 1913 Rosenberg viewed it with ecstasy. 'The Blakes at the Tate', he told Miss Seaton, 'show that England has turned out one man second to none who has ever lived' (*CW*, p. 340). Rosenberg admired Blake's drawings for the same qualities he found in the work of the Pre-Raphaelites: they were decorative, remote, and literary. This high praise, however, was not given to all the drawings. Even Rosenberg was sensitive to Blake's weaknesses, though he tried lamely to excuse them: 'The drawings are finer than his poems, much clearer, though I can't help thinking it was unfortunate that he did not live when a better tradition of drawing ruled. His conventional manner of expressing those astounding conceptions is the fault of his time, not his' (*CW*, p. 340). Rosenberg's enthusiasm for Blake clouded his judgment. Perhaps he should not be blamed too much. He had searched a long time for his spiritual godfather; Blake suited him ideally.

In spite of the general mediocrity of 'Night and Day', it is to Rosenberg's credit that he organized and sustained that theme in a very long poem, presaging a growing confidence and fluency. Characteristically, he was aware of his sentimental excesses but was too stubborn to abandon them: 'I said, I have been having some fits of despondency lately; this [referring to a verse fragment of the period] is what they generally end in, some Byronic sublimity of plaintive caterwauling' (*CW*, p. 235).

The other poems in the booklet elaborate the theme of love. Using Blake as his guide he moved with developing finesse between the sacred and profane aspects of love, forced by his own physical urges to deal honestly with the subject. The inspirational force behind these love poems was most likely Sonia Cohen. From the time he had met her in the spring of 1911 until early 1913 she remained unattached. First Bomberg and then Rodker competed with Rosenberg for her attentions. She also went out with Goldstein. Young, pretty, lonely and inexperienced, she needed and sought companions. Her father had died at the age of twenty-six when she was two years old, and she was brought up in a charity home. She had never seen men and women living together and remained extraordinarily innocent

about sex. She came into contact with the growing women's move-
ment, half absorbing its surface admonitions and slogans. She pursued
friendships based on equality with men, naively unprepared for the
consequences. Working in a sweat-shop twelve hours a day, she
longed for night to come when she could go to the Whitechapel
Library to read and talk. There she was likely to find Goldstein,
Bomberg, sometimes Rodker, more often Rosenberg.

One evening she was sitting reading in the library opposite
Rosenberg and Bomberg. After a while she realized that both were
sketching her. On another evening Bomberg pushed a poem across
the table which he had asked Rosenberg to write for him to give to
her. Rosenberg printed this poem in *Night and Day:*

> *Lady, you are my God —*
> *Lady, you are my heaven.*
>
> *If I am your God*
> *Labour for your heaven.*
>
> *Lady you are my God*
> *And shall not love win heaven?*
>
> *If love made me God*
> *Deeds must win my heaven.*
>
> *If my love made you God,*
> *What more can I for heaven?*
> (*PIR,* p. 150)

His reasons for writing it for Bomberg were not wholly altruistic: he
knew all too well that the only advantage he had over Bomberg was
his ability to compose verses. Neither he nor Bomberg was hand-
some; both were short and Sonia preferred tall men.

Nevertheless, in the summer of 1911 Rosenberg and Sonia began
going for long walks along the Thames Embankment, continuing
them through the winter in bitter cold weather. Their conversations
on porches and in doorways lasted far into the night. Occasionally,
Rosenberg would take Sonia home with him to sit and talk in the
kitchen. They shared their frustrations and depressions. But Sonia
was also seeing Bomberg, waiting for him in his studio, subjecting
herself to his endless propositions. When Rosenberg was there,
Bomberg would order him to leave as soon as Sonia arrived. He left,

knowing that the next time he and Sonia were out walking she would describe Bomberg's clumsy attempts at seduction.

The five love poems in *Night and Day*, all brief, are not as imposing as the long title-poem but they indicate Rosenberg's subsequent thematic progression. Increasingly explicit sexual images occur throughout the lyrics written in the latter months of 1912. 'Bacchanal', 'The Cage', and 'Like Some Fair Subtle Poison' come to grips with the physical world. In the first poem the poet yearns for life to bring him 'sweet breasts for my bed' (*CW*, p. 185); in the second poem he describes the lady's 'radiant flesh' with 'heavy hair uncurled' (*CW*, p. 186); and in the third one he develops his metaphor around her beauty, which is fatal for him. Invoking all the senses save sound, he describes her scent as a net luring his thoughts and pulses, leaving him with 'insatiate longing wet'.

His body hungers for her 'mystic rapture', but she is the one who feeds off him: 'flesh and spirit your robe's soft stir sucks in'. Viewing the 'shining hollow of [her] dream-enhaunted throat', he knows he may never touch her, thereby crowning with 'tender thoughts' his 'fiery dreams' of the 'sinuous rhythms and dim languors' of her breast (*CW*, p. 174).

For the first time in his life, Rosenberg was preoccupied with thoughts of someone other than himself. His motivation, to be sure, was personal: he was approaching his twenty-third birthday, lonely, in love, and unable to obtain any sexual satisfaction. He exchanged one set of frustrations for another. In the process, his perspective of the poet's function was enlarged. He was still essentially the Romantic, but he no longer looked for God in nature — he did not look for God at all. His mission was to preach from his own perverse pulpit, in bits of prose as well as in his poems, the gospel of beauty:

An age that believes in Blake and tolerates Tennyson, that has forgotten Pope and worships Shelley, to whom Keats is simply sensuous and Shakespeare not subtle or intense enough — this is our age of poetry. Rossetti I think is the keynote of the demand, and in the 'Monochord' and 'The Song of the Bower'. [sic] In the first all poignancy — a richness and variety, a purity of imagination — a truth, far beyond wit or thought. There are poets who delight in the morbid, for whom life always is arrayed in crape; whose very vigour and energy find their outlet in a perverse and insistent plucking at the wings of death. The poet is so not because he is weak but because he is perverse. His life is a paradox — he does not live, if what other men do is life. This poet will make a song out of sorrow and find in a tear a

jewel of perpetual delight. Love is his theme, life is the back-
ground, and the beauty of woman stands to him as the mani-
festation of the beauty of spiritual nature and all outer aspects
of the workings of nature.

(*CW*, p. 265)

For the poet, convention had to be avoided at all costs. In
establishing this principle, Rosenberg precluded for himself any deep
involvement in the emerging Georgian movement.

Discovering Emerson in 1912, as he had discovered Blake shortly
before, Rosenberg found in the American writer's poems the singular
stance he admired: 'That ebullition of the heart that seeks in novel
but exact metaphor to express itself, the strong but delicate apoca-
lyptical imagination that startles and suggests, the inward sanity that
controls and directs — the main spring of true poetry — is Emerson's'
(*CW*, p. 254). Emerson's nature, sensitive, vigorous and solid, spoke
to his own individuality, defying convention and the kind of tradi-
tion which vitiated originality:

We have here no tradition — no tricks of the trade. Spontaneity,
inspiration, abysmal in its light, is the outer look these poems
have to the eye. The words ebulliate and sparkle as fresh as a
fountain. But we are always near a brink of some impalpable
idea, some indefinable rumour of endlessness, some faint savour
of primordial being that creeps through occult crevices and is
caught back again.

(*CW*, p. 254)

Rosenberg then quoted the one passage in English literature he had
singled out as the ultimate poetic achievement — the song from *The
Tempest,* 'Full fathom five thy father lies'.

By this time Rosenberg was demonstrating an ever-sharpening
critical acuity. Never formally educated beyond the age of fourteen,
he read widely, ranging outside literature to Darwin and Nietzsche;
and he absorbed and pondered the ideas he encountered. Yet, for all
his interest in things modern, his personality held him back. Still, by
1912, Rosenberg's development as a poet was more noticeable than
his development as a person. Outwardly he appeared the same man:
solemn, preoccupied, over-assertive, difficult. His parents still did not
understand him; they had merely grown accustomed to his ways. He
was in love with Sonia Cohen; she did not return his love. His *Night
and Day* went out of print as rapidly as it had come into print, but
with no startling results. He had not awoken one morning to find all
London at his feet. The booklet's only discernible impact was on his
fellow students at the Slade, who now believed what Bomberg had

been telling them all along — that Rosenberg was a good poet but a bad painter. The copies were gone and he had not yet repaid Mrs. Cohen the two pounds she had advanced for publication.

Wherever Rosenberg turned he met trouble. His most serious problem, though he would not have recognized it, was with Mrs. Cohen. There was still something of the talented, truculent schoolboy in Rosenberg, but Mrs. Cohen was not as indulgent as Mr. Usherwood. She had no intention of putting up with his carelessness, his absent-mindedness, or any other foolishness. Possibly she did not like Rosenberg from the beginning, though she believed in his ability and pushed him hard. Her exacting standards soon came into conflict with his independence.

When the Slade opened for the 1912-13 session, a problem arose over the payment of fees. Mrs. Cohen sent Rosenberg a cheque which he held onto, as it was five shillings short of the sum required. Shortly after, the Secretary at the Slade contacted Mrs. Cohen for the money, as his records indicated she was Rosenberg's guardian. At the same time, Rosenberg wrote to her to request the five shillings, accidently smudging the letter. She was mortified over the Slade's having to approach her and incensed over Rosenberg's sloppiness. In the latter instance her anger was justified. Granted that the felicity of his phrasing and the information conveyed in the letters were more important than their appearance, the fact is that in general they were abominably untidy and slap-dash.

Mrs. Cohen returned Rosenberg's letter accompanied by a missive of her own. Rosenberg was momentarily cowed and properly apologetic, but the tone of his reply indicated that he would stand his ground:

I am sorry if there was any confusion about paying the Slade fees. I still have the cheque and was waiting for the other 5 shillings so as to pay it all. I thought I could pay it out of this week's money but I have had extra expenses — mending boots and other little necessities, which made it awkward. I must thank you for returning my letter as it gives me a chance of doing that which you said ought to be done — of throwing it in the fire. I am very sorry that you noticed it as of course I did not, or I shouldn't have sent it. I said what I had to say, and had done with it, it must have been quite an accident its smudging. I don't think any other letters of mine are in that state. No stranger could receive such a letter of mine as I never write to strangers.

(*CW*, pp. 333-34)

From that time forward, the relationship deteriorated amid charges and counter-charges. It is hard to say which of the two parties was more aggrieved, particularly since Rosenberg burnt Mrs. Cohen's letters. Her advantages of wealth, experience and maturity incline one's sympathy towards Rosenberg, but on the other hand he could be extremely difficult and perverse.

Their antagonism did not keep Mrs. Cohen from coming to Rosenberg's studio to look at 'Joy' just before he took it to the Slade for the judging. Her visit was a mistake. Having heard a good deal about his progress on the picture, she was astounded to find that it was not even ready. Late into the painting, Rosenberg made some fundamental changes. On September 26, 1912, he told Alice Wright that his picture was undergoing transformation. 'It is,' he said, 'in the frying pan — not quite raw — nor yet quite done', adding casually, 'I think in another week I shall be quite decided on the arrangement — then I hope it will be plain sailing' (CW, p. 333). However, to continue his mixed metaphor, his frying pan sank. Mrs. Cohen was exasperated. Rosenberg was behaving as though he had several months instead of only days to finish the work. She expressed acute disappointment, wondered how he had spent his time, scolded him for his bad manners, hinted that he was ungrateful, and told him he would get no further support after the autumn term ended.

Though the argument was growing as tedious as a lover's quarrel, Rosenberg wrote to Mrs. Cohen, chiding her for her impatience and lack of understanding: 'I am very sorry I disappointed you. If you tell me what was expected of me I shall at least have the satisfaction of knowing by how much I have erred.' He felt constrained to express his appreciation: 'I feel very grateful for your interest in me — going to the Slade has shown possibilities — has taught me to see more accurately. . . .' He concluded the letter by acknowledging the end of his patron's support: 'I suppose I go on as I am till Xmas. Till then I will look about. I should like all the money advanced on me considered as a loan — but which you must not expect back for some years as it takes some time settling down in art' (CW, pp. 334-35).

Rosenberg's circumstances steadily worsened. He had to give up his studio in Hampstead and, unable to find another suitable room, he went home to 159 Oxford Street. Mrs. Cohen reduced his living allowance. He wrote to Alice Wright about his 'very serious situation'. 'I have,' he told her, 'thrown over my patrons they were so unbearable, and as I can't do commercial work, and I have no other work to show, it puts me in a fix' (CW, p. 338). He swallowed his pride and went to see Ernest Lesser to request help from the Jewish Educational Aid Society.

Uncertain whether the Society would rescue him Rosenberg wrote to Mrs. Cohen to make his peace with her. He was past further disputation, and made excuses for the unfinished state of 'Joy'. 'When I was at Hampstead I worked all day and walked about in the rain all the evening until I was wet through and tired out — that was the only amusement I got. The isolation there so preyed on my spirits that I don't think I'd be far wrong if I attributed the unfinished state of my picture to the mental and physical looseness so caused' (*CW*, p. 337). One of his pictures, 'Sanguine Drawing', shown in the Winter Exhibition of the New English Art Club, had been sold for four pounds and he ended his letter to Mrs. Cohen by telling her he would send her the two pounds he owed her when he was paid.

In late December 1912, Rosenberg learned that his request for support had been approved, and that the Jewish Educational Aid Society grant would terminate after the second term in March 1914. It was a year's grace. His battles over for the time being, he composed a little inconsequential poem called 'Peace' (*CW*, p. 182). Its value is nil; his 'mental and physical looseness' had not yet passed. Being a rebel, he found, was hard and unrewarding work.

10
Once More in Despair
1913

With the exception of his fateful meeting with Edward Marsh, and a less important but still significant one with T. E. Hulme, both on the same night in November, Rosenberg made precious little progress either as a painter or a poet in 1913. He had gone into the worst decline he had experienced since late 1910, when he was still apprenticed to Hentschel's. His letters written between October and December 1912, indicate that he was not just depressed; he was rattled and disoriented. Lacking recognition as either a painter or a writer, he had only his self-confidence to rely upon, and it was shattered.

Penury accounted for part of his discomposure, but he had known deprivation since birth. His break with Mrs. Cohen, despite the Jewish Educational Society's grant, had been traumatic. He had always been self-assertive, but he had never quarrelled harshly and continuously with anyone, least of all a benefactor.[28] He had spoiled paintings before, but he had never previously been unable to finish one. His 'Joy' made him miserable. And then there was the problem of his unrequited love for Sonia, to which there was no solution. There was no one to whom he could turn in this crisis.

In terms of productivity, 1913 was his least successful year. He did no major drawings or paintings until late autumn. There is no evidence that he wrote any prose, and, allowing for loss, the number of letters extant for 1913 do not add up to the fingers on one hand. The number of poems he composed is insignificant, and what he lacked in quantity was not recovered in quality. Over half of the seventeen poems written in 1913 seem trivial compared to the vitality and cohesion that distinguish his love lyrics of the previous year. The images are stale and repetitive. It is apparent that he had little worth saying through most of that year, and what little there was seemed tortured into existence.

While Rosenberg floundered in despondency a whole new era in poetry was beginning. By 1913, the Georgian renaissance was in full swing. Past its Edwardian doldrums, English poetry was rapidly shedding its Romantic inheritance, sweeping away Victorian formalism and *fin de siècle* dilettantism. Everywhere there was an urge to recover vitality, and invigorate poetry with the same freedom and realism already manifest in fiction and drama. A plurality of movements sprang up, coinciding with the noisy, widespread acclaim accorded John Masefield's *Everlasting Mercy,* published late in 1911 just as Rosenberg was settling into his first term at the Slade. Manifestos appeared in rapid succession: their ideas were confluent though their labels differed.

T. E. Hulme's attack on Humanism inspired many of these manifestos. Single-handedly, he set out to extinguish the spirit of Romanticism and have done once and for all with its yearning after the infinite. He did not live to finish the task, but he gave it so much critical momentum that he soon won to his cause powerful disciples, including Pound, Lewis and Eliot. Pound was grinding his own axes, promoting Imagism largely on behalf of H. D. Doolittle, calling for an approach to writing poetry that was hard, precise, clear and finite. Attracted by the drum-beating dynamism of Marinetti and the Italian Futurists, Pound conspired with Lewis to formulate an English response to which he gave the name Vorticism, launching it with a flamboyance unparalleled in English literary history. New poetry journals came into existence, and with every issue, proponents as diverse as Lascelles Abercrombie, Laurence Binyon and D. H. Lawrence signalled the advent of the 'new' and the 'modern'. And in the midst of all the frantic activity, there arose those two great middlemen of the Georgian era, Edward Marsh and Harold Monro, determined in the name of poetry to find and develop the markets for the produce of this remarkably fruitful new era. Marsh, particularly, moved with rapidity and assurance in putting together and publishing the first anthology in his series of *Georgian Poetry.* Appearing in October 1912, it was introduced in a short Preface which affixed to the age, for good or ill, its name:

> This volume is issued in the belief that English poetry is now once again putting on a new strength and beauty. . . .

> This collection drawn entirely from the publication of the past two years, may if it is fortunate help the lovers of poetry to realize that we are at the beginning of another 'Georgian Period' which may rank in due time with the several great poetic ages of the past.

Time alone would determine whether or not Marsh's prediction was sound. However conventional the excesses of some of the poets represented in succeeding editions of *Georgian Poetry* may seem now, Edward Marsh's enthusiasm must be seen in the perspective of his own time. The Great War buried the movement along with Imagism, Futurism and Vorticism. Yet apart from the movements, the decade 1910-20 brought into prominence in England not only those transplanted Americans, Pound, Eliot and Robert Frost (temporarily resident in Britain), but D. H. Lawrence, Joyce and Virginia Woolf; Edward Thomas, Owen and Rosenberg. Together their work combined to influence strongly the peculiar literary image of the twentieth century.

The same spirit that launched the new poetry was simultaneously launching the new art. There was 'a healthy cross-pollination among the arts'. Evidence of hybridization is abundant; its best known example was the cross-breeding of Cubism — transmitted from Picasso and Braque by Bomberg — with Futurism, to produce Vorticism. Given the plurality of movements, coteries, approaches and beliefs, separate and in combination, and the fact that a whole new breed of young poets was busy inveighing against 'Academism', one might have thought that Rosenberg, who, in his prose pieces had privately sounded his own call for freedom, and whose life was its own stubborn manifesto of independent action, would have some-where found a compatible allegiance. He knew what was happening, but he was too much of an individual to join any movement.

Rosenberg went his own way. At the beginning of 1913 he rented a room at 1 St. George's Square in Chalk Farm and converted it into a studio. His family also moved about this time from 159 Oxford Street to 87 Dempsey Street in Stepney East. In an effort to regain the respect of his patrons which he had lost in the autumn over 'Joy', he submitted some paintings for the Prix da Roma competition (*CW*, p. 340). The second term began at the Slade and Rosenberg went to his drawing classes, accomplishing little. How much of his inertia he recognized, it is impossible to say. The weather was bad, his room was draughty and his physical health began to reflect his emotional disquietude. He had trouble with his eyes and sought treatment, for which the Jewish Educational Aid Society paid (*CW*, p. 339). He began to develop a cough, but managed to ignore it, apparently with the same ease that he ignored everything else around him. Doggedly, he kept to himself. Notified that his entries in the Prix da Roma competition had not won, he assuaged any disappointment he might have felt with the knowledge that no other Slade entry had

been successful either. He took perhaps too much comfort in the fact that 'Professor Tonks was disgusted with the decision' (*CW*, p. 341).

Rosenberg's meetings with Sonia became infrequent and tapered off.[29] Though he wrote a few love poems, they were no longer inspired. One, entitled 'Twilight II', he gave to her. The title seems to reflect the eventide of his love and the poem itself concedes defeat in the prevalence of its morbid images: the withering rose, the moon's decay, the stars fainting away. In the second and final stanza he acknowledges the illusory nature of the romance:

> I have seen lovely thoughts forgot in
> wind, effacing dreams;
> And dreams like roses wither leaving
> perfume not nor scent;
> And I have tried to hold in net like
> silver fish the sweet starbeams,
> But all these things are shadowed
> gleams of things beyond the firmament.
> (*CW*, p. 164)

In another poem called 'A Warm Thought Flickers', he speaks of 'one forsaking face' ever in hiding, ostensibly from an 'opaque thought' that tires the 'weary lids of grief'. That flickering, opaque thought, (his love?) is now beyond articulation: 'One thought too heavy/For words to bear,/For lips too tired/To curl to them' (*CW*, p. 153).

Sometime late in 1913, John Rodker took a second-floor room at 1 Osborne Street. Sonia was in love with him and moved in. Bomberg refused to visit them, but Rosenberg went, sometimes taking Kramer with him. He accepted what he could not change, and kept Sonia and Rodker among his small circle of close friends. Gertler was no longer at the Slade. Bomberg was there less and less. Before he stopped attending altogether, he drew a striking portrait of Rosenberg which he called 'Head of a Poet', for which the Slade awarded him the Henry Tonks Prize for 1913.[30] Rosenberg grew close to Kramer and confided in him. He also saw more of Goldstein. Still unsure of himself, he seems to have been far more open with Kramer and Goldstein than he had been with Leftwich, Winsten and Rodker. According to Kramer, Rosenberg had a penchant for buying little toys that were sold in the street. He had a collection of them and would show his acquisitions to Kramer, who kept his confidence in this child-like caprice as well as in other more adult matters. There was an affair, Kramer recalled, but not with a model. He did not remember, in 1960, the name of the woman with whom Rosenberg

was involved. Goldstein, however, did remember, and very clearly. He knew the woman; it was Annetta Raphael.

Presumably, Rosenberg turned to Annetta Raphael sometime in 1913. Goldstein surmises that Rosenberg saw her very often, recalling that Annetta once told him how much she liked the poet. They had much in common; and she was older than Rosenberg and lonely. It is reasonable to assume that their relationship became intimate between late 1913 and the time Rosenberg sailed for South Africa in 1914. Internal evidence in the love poems, for what it is worth, supports such a view. While allusions to music occur rarely before 1913, after that date there is a decided increase in their frequency. Annetta was a music teacher who occasionally entertained Rosenberg by playing the piano or violin and singing to him. The use of the term 'music' as opposed to 'songs' in reference to poems, is found in 'Walk You in Music, Light or Night' (*CW*, p. 156); 'Glory of Hueless Skies' (*CW*, p. 159); 'Creation' (*CW*, pp. 160-62); and 'On a Lady Singing' (*CW*, p. 151), a poem which is in itself significant. Moreover, the love poems composed after late 1913 are again inspired and are more explicitly physical than their predecessors of 1912.

Perhaps the most erotic poem Rosenberg ever composed was 'Sacred, Voluptuous Hollows Deep' (*CW*, p. 139). Undated, the poem is assigned by Bottomley and Harding in the *Collected Works* to the period 1914-15. In terms of thematic progression it would appear to have been composed in 1914 before Rosenberg went to South Africa. It is similar to but goes far beyond his other love lyrics in its use of *double entendre*, directing the reader's attention to his beloved's mouth and chin while in fact the poet's gaze is levelled at her crotch. His message is that the sacredness of love is implicit in its profane realization. This argument is as old as poetry itself; however, Rosenberg's explicitly orgasmic imagery in presenting it is unusual for his time and circumstance:

> *Warm, fleshly chambers of delights,*
> *Whose lamps are we, our days and nights.*
> *Where our thoughts nestle, our lithe limbs*
> *Frenzied exult till vision swims*
> *In fierce delicious agonies;*
> *And the crushed life, bruised through*
> * and through,*
> *Ebbs out, trophy no spirit slew,*
> *While molten sweetest pains enmesh*
> *The life sucked by entwining flesh.*
>
> (*CW*, p. 139)

There seems to me to be no doubt that this is the work of a sexually experienced person. The proof may never be obtainable, but it is reasonable to assume that the same sensuousness which motivated the love poems would also have urged Rosenberg into sexual activity.

Whatever the state of his erotic life, his health in the spring of 1913 continued to deteriorate. He kept his studio in Chalk Farm but moved to Dempsey Street where Hacha could give him the care he needed. When his cough could no longer be ignored he went to see a doctor who examined him, prescribed some medicine, and told him to come back in a few days for another examination. Following that visit Rosenberg wrote to Ernest Lesser at the Jewish Educational Aid Society asking for money to go south to recuperate:

> Last week I saw a doctor and though at first he thought it was serious and said I had a very bad chest, the next time he said it wasn't so bad but I needed to go away for a couple of weeks and be out in the open. I have been sleeping here while unwell. Do you think the Society would let me have some money to go away so that I would be fairly comfortable and I could go somewhere on the South Coast.

<div align="right">(CW, p. 340)</div>

Rosenberg persevered until summer. When Bomberg returned from a trip to Paris with Jacob Epstein to search out paintings and sculpture for an exhibition of modern art planned for the Whitechapel Art Gallery in 1914, he agreed to take a holiday with Rosenberg at Sandown on the Isle of Wight. They stayed at the home of a Mrs. Haydon, who for many years had bought draperies from Rosenberg's father. Her house was close to the island's military fortifications, which Rosenberg and Bomberg discovered were a good subject to paint. In due course, they were arrested, interrogated on suspicion of being spies, and kept in gaol until Mrs. Haydon convinced the senior police officer that they were students on holiday. They were released, and did their painting elsewhere for the rest of their trip, which did much to restore Rosenberg physically and emotionally.

Back in London Rosenberg returned to his quarters in St. George's Square. He was relaxed, and less harassed than usual. Minnie was getting married on August 24 and when he was not otherwise occupied he went to Dempsey Street to share in the mounting excitement. He was closer in age to Annie yet he and Minnie had always had a special affection for each other. In the severe early years she had been a second mother, and as he grew up she was always patient, tender and understanding. The wedding was properly celebrated.

Rosenberg wrote no poem to mark the event, although his father composed one in Yiddish. Rosenberg rarely wrote occasional verse. Happy though the family was for Minnie, they were saddened by the knowledge that she and her new husband, Wolf Horvitch, were leaving shortly for South Africa where they planned to make their home. They sailed on September 2, 1913, amid tearful farewells. Barnett wrote another poem in Yiddish to commemorate that occasion.

A month later, Rosenberg's Slade fees of five pounds, five shillings were paid by Lesser, whom Rosenberg named as his guardian. He was back in the huge life-class, doing what he had done for six terms. The routine suited him, and his tempo, after nine months of inertia and depression, picked up. This was reflected in his drawing. His hand was under control, his lines were quick and sure. The exhibition of Blake's drawings opened at the Tate that October, eliciting high praise from Rosenberg. He started reading again; a letter from Miss Seaton revived one of their long-standing friendly arguments over the merits of Donne's poetry. Donne was important to Rosenberg, but he was determined to assimilate him in his own good time:

> I have not been reading Donne much as I am drawing a lot, and when I'm not drawing my mind is generally occupied that way. A great deal of Donne seems a sort of mental gymnastics, the strain is very obvious, but he is certainly wonderful. 'The ecstasy' is very fine, but F. Thompson's 'Dream tryst' to me is much finer. There is a small book of contemporary Belgian poetry like the German you lent me (which by the way I don't feel inclined to open) some Materlincks [sic] seem marvellous to me, and Verhaern [sic] in the 'Sovran Rythm' knocks Donne into a cocked hat. I mean for genuine poetry, where the words lose their interest as words and only a living and beautiful idea remains. It is a grand conception — Eve meeting Adam. Materlink [sic] has a superb little thing 'Orison' — a most trembling fragile moan of astonishing beauty.
>
> (*CW*, pp. 339-40)

Rosenberg found in his reading of the Belgian poets the theme for one of his finest drawings, 'The First Meeting of Adam and Eve', which he did in chalk through the next few weeks. He succeeded in capturing that 'grand conception'; beginnings were always the most exciting part of any work for Rosenberg. Verhaeren was also his likely inspiration for 'Creation', the only long poem he wrote in 1913.

'Creation' is a quasi-philosophical statement, attesting to Rosenberg's independence in the creative act. Anticipating the open-

ing passage of Eliot's *The Wasteland*, Rosenberg develops the theme
of burial and rebirth in a memorable passage:

> *Moses must die to live in Christ,*
> *The seed be buried to live to green.*
> *Perfection must begin from worst.*
> *Christ perceives a larger reachless love,*
> *More full, and grows to reach thereof.*
> *The green plant yearns for its yellow fruit.*
> *Perfection always is a root,*
> *And joy a motion that doth feed*
> *Itself on light of its own speed,*
> *And round its radiant circle runs,*
> *Creating and devouring suns.*
>
> (*CW*, p. 161)

Once born, man must move from innocence to experience.
Rosenberg welcomes the loss of virginity; the sin lies in trying to
preserve it. Virginity weakens 'Where the flesh merges', for the soul
will have its freedom. If the soul's striving is seen in dionysian terms,
that 'revel in the dark delight' (*CW*, p. 161) is vitally necessary to
growth. Out of such change comes fulfilment, and an independent
constancy when man has achieved his own godhood:

> *This universe shall be to me*
> *Millions of years beneath the sea*
> *Cast from my rock of changelessness,*
> *The centre of eternity.*
> *And uncreated nothingness*
> *Found, what creation laboured for*
> *The ultimate silence – Ah, no more*
> *A happy fool in paradise,*
> *But finite – wise as the All-wise.*
>
> (*CW*, p. 162)

Rosenberg would find and reach his own still-centre of existence.
When he wrote the poem, however, he was by no means ready to
divest himself of his romantic inheritance in favour of a predomin-
antly classical stance. His rhythms in the 'Moses-Christ' passage and
his images in the 'universe-rock' passage recall the Wordsworth of
The Prelude. Yet a compulsion toward the 'finite' was slowly urging
its way into his consciousness, perhaps transmitted from Hulme via

Bomberg. Hulme had become Bomberg's mentor, and it would have been quite in character for Bomberg to repeat the principles Hulme had expounded in his presence. Or Rosenberg may have heard it from Hulme's own lips; though he was never included in Hulme's Frith Street gatherings, he had, through Gertler, an entrée of sorts — nothing formal, at best only a peripheral attachment which suited his needs — to the Camden Town Group,[31] and in general it had accepted his theories about classicism. Rosenberg might have heard Hulme at several of the meetings of the group, in company with Gertler, at the Bevan/Karlowska or Sickert households. It was at the Café Royal on the night of November 10 that Rosenberg actually met Hulme. Currie and Roberts were there, and Edward Marsh. In the space of one evening, through Gertler's friendly offices, Rosenberg met the two men who symbolized the opposite poles of Romanticism and Classicism, between which he would always be suspended.

No personal relationship developed with Hulme, but I believe nonetheless that he was the midwife to the pronounced classical strain that became evident in Rosenberg's later verse. With Marsh, who had already been captivated by Gertler's charm and talent, it was different. He was particularly responsive to Gertler's friends, and he extended himself immediately. Marsh was riding the crest of his own successful involvement in the Georgian renaissance. He enjoyed his discoveries and here was another find from the East End, an artist *and* a poet.

Rosenberg, for his part, was not one to miss an opportunity of this kind — they came all too rarely. He seized upon Marsh's interest in him, and before the month was out they were together again, with Gertler, attending a Yiddish play. One wonders what Marsh's thoughts were, sitting in the crowded theatre in Whitechapel. He did not come to the East End often, his most memorable trip having been with Winston Churchill when Churchill took command of the Sydney Street Siege in January 1911. At the same time, Rosenberg sent Marsh some of his poems, asking for his criticism.

On this hopeful note, the bad year ended. Not only was Marsh willing to look at his poetry, he had offered to buy a painting. There was still one term remaining at the Slade. When that ended, Rosenberg would make his own way in the world. Only one thing made him uneasy: when the winter set in, his hacking cough and ill-health returned.

11

Drifting Out To Sea
Jan-June 1914

The Christmas holiday ended and Rosenberg returned to the Slade for his classes, scheduled on Mondays, Tuesdays, and Thursdays. Kramer and Goldstein were there on the same days, and they often drew side by side. Not infrequently Rosenberg would pass them fragments of paper on which he had scrawled some verses.

Poetry was beginning to supersede painting in Rosenberg's priorities. He had learned all he was going to learn at the Slade. Everyone there, including the staff, knew him as a poet. Bomberg was of the opinion that because Rosenberg's interest lay in poetry rather than painting, he had been asked to leave the Slade, but had resisted the attempt to oust him. The records of the Slade neither confirm nor deny the validity of Bomberg's assertion.

Rosenberg, however, was accomplishing very little. He had no master design under way, no accumulation of works to exhibit or sell. He tinkered a lot with words, and worried about his health. The weather was severe, and his coughing began to cause him real concern. On a doctor's advice, he took a holiday from February 20 until March 1. On Tuesday, February 24 he sent a postcard to his mother from Bournemouth: the weather was bad but he felt the air was good for him, adding that he was coughing much. He described the town as a 'big sanitorium' (*CW*, p. 341).

While he was in Bournemouth he allowed the son of an Irish politician named Redmond to use his studio in Chalk Farm. One night Redmond had a party, got uproariously drunk, and smashed all the furniture in the room. Rosenberg came back to find his meagre possessions in ruins. There was nothing he could do about the vandalism except complain. He told Leftwich, among others, that 'It is all very well for them to play the Bohemian. They can afford to run riot for a couple of years. And then they go back to their roots;

the old life is waiting for them, good homes, family, connections. But we poor Whitechapel boys have nothing to go back to, we dare not let go.'

The room had not been much use to him. It was as much a status symbol as a studio — indeed, when he wrote to Marsh he changed the address on his letter, substituting the more fashionable 'Regent's Park, N.W.' for 'Chalk Farm' (*CW*, p. 289). St. George's Square at that time straddled the two areas. He moved back to his home in Dempsey Street a little earlier than he had intended. It was only a matter of weeks until the Slade term ended and his support from the Jewish Education Aid Society terminated.

On March 2 he returned to the Slade to finish the last few weeks. Bournemouth had reduced but not relieved his lung congestion. It was apparent that his lungs were weak but not tubercular, although that prospect was real enough, and the fear it engendered demanded a more drastic solution. After much discussion, he and Hacha agreed that he should go to South Africa and stay with Minnie until he was able to support himself. The idea appealed to him; he had several reasons other than poor health for wanting to leave London. Writing to Miss Seaton about his decision to go away, he revealed a prejudice for which he was, of course, largely at fault, a weakness he was prepared to acknowledge: 'I dislike London for the selfishness it instils into one, which is a reason of the peculiar feeling of isolation I believe most people have in London. I hardly know anybody whom I would regret leaving (except, of course, the natural ties of sentiment with one's own people); but whether it is that my nature distrusts people, or is intolerant, or whether my pride or my backwardness cools people, I have always been alone' (*CW*, pp. 367-68). Though he was capable or reaching out to others, he would never escape his loneliness, for his sense of self was absolutely governed by the singularity of his mission. The right woman might have changed him, but perhaps Hacha, the overwhelming and possessive mother figure, had precluded that possibility much earlier.

It was nice enough to contemplate a trip to South Africa, but the cost of such a journey was a stark reality. The fare alone was twelve pounds. Even if Marsh, who had promised to buy paintings from him, bought everything he had, the sum total would scarcely cover his expenses. He turned again to Ernest Lesser and the Jewish Educational Aid Society. The threat to his health was real; neither he nor Lesser could ignore it. Promising to work hard once there, he wrote asking for funds (*CW*, p. 341). In due course Lesser told him the money would be forthcoming.

In the meantime, Rosenberg heeded the doctor's warning not to overtax himself. Except for his prolonged depression in 1913 he had never been either lazy or idle. He was too conscientious to be slothful; and had always felt guiltily conscious of the burden imposed on his family by his long preparation for a career as a painter. Morris Goldstein's mother had become a close friend of Hacha's and they often commiserated with one another; they knew young tailors in the neighbourhood with regular earnings of fifteen to twenty pounds while their sons brought in nothing. With time on his hands Rosenberg 'visited' the Slade, returning even to his old haunt, the Bolt Court Art School. There, an acquaintance, H. C. Hammond, did an exceptionally fine drawing of his head.[32]

Afraid to be too long out of Marsh's sight and mind, Rosenberg sent him an insistent note in April, simultaneously apologizing for his forwardness and reminding him that he had offered to buy something. He enclosed a short love poem, introducing it with the deprecating remark: 'How's this for a joke?' (CW, p. 291). He had learnt in their first exchange of letters that Marsh was capable of stringent criticism and he was sensitive to it, particularly as he was not in a position to defend himself against someone so urbane, well-informed, powerful, and at the same time interested in him. Marsh replied, asking him if he would like to see his collection of modern pictures and telling him about the possibility of his compiling a book of Georgian drawings, which would include Rosenberg's own. Its publication was contingent upon obtaining enough advance subscriptions to cover costs.[33] Rosenberg thought Ruth Lowy's mother might subscribe and sent her name to Marsh. In the same letter he told him he would not be leaving for South Africa for several weeks, that he was showing some works in the forthcoming Whitechapel Art Gallery's Exhibition of Twentieth Century Art, and that he could call on him any evening Marsh was free (CW, p. 290). Marsh's patronage was superseding that of the Jewish Educational Aid Society. The young poet was not the most ideal emigrant: he was without funds or means of support, and his health was deteriorating. Marsh contacted friends in the Emigration Office and smoothed the way for him.

He invited Rosenberg to breakfast with him at his lodgings on the morning of May 8, 1914. True to his word, he bought Rosenberg's 'Sacred Love', which he much admired, and hung it prominently in his guest room where it was viewed by his many distinguished visitors for more than two decades. Though quick to approve the painting, he reserved his praise about the poems, finding them flawed. He

wrote Rosenberg a detailed critique of 'Midsummer Frost', highlight-
ing the poem's weaknesses. Rosenberg was flattered, grateful, and
annoyed. His meanings were clear enough to him; he could accept
rationally but not emotionally that this was not true for others.
Packing for his voyage, he stopped to write a reply. 'Your criticism
gave me great pleasure; not so much the criticism, as to feel that you
took those few lines up so thoroughly, and tried to get into them.
You don't know how encouraging that is' (CW, p. 294). He then
tried at some length to explain and defend his meaning.

In the same letter he angled for another sale, telling Marsh he had
come across 'a little painting of a boy' (CW, p. 295), but Marsh did
not take the bait. He had other things on his mind. The Admiralty
Office was suddenly becoming busier. War was only ten weeks away.

Rosenberg said goodbye to his few friends and waited to hear
from the Union Castle Steamship office about the departure date. He
was travelling by tramp steamer and was told to be ready on short
notice whenever space became available. The years at the Slade were
behind him; London would soon be several thousand miles away.
Preoccupied with his hopes for the future, he seems to have dis-
sociated himself completely from the community of painters among
whom he had spent three critical years. It was not just his independ-
ence which separated him from that community, for he no longer
had any monopoly on iconoclasm. Gertler had refused to identify
with any of the radical movements; Kramer, sometime during the
same year would write an essay entitled 'Form and Shape', taking his
stand along individual lines;[34] and Bomberg, who had identified him-
self with the English avant-garde, was preparing a one-man show for
July at the Chenil Gallery in Chelsea, which was his way of announc-
ing not only his rejection of Hulme, Lewis, the Futurists and the
embryonic Vorticist movement, but his intention of striking out
entirely on his own. Like Kramer, he was determined to express a
concept of 'Pure Form',[35] an idea which had grown out of long
discussions over the preceding year to which Rosenberg had been
privy. Whether they identified with coteries or went their separate
ways was of little importance, however, to Rosenberg. He had never
set his sights as high as they had, and wanted only a living from
painting, nothing more.

Rosenberg was therefore able to ignore the spectacular theatri-
cality of the avant-garde in May 1914, when it noisily set forth to
stop the Italian Futurist, Marinetti, and his English accomplice,
C. R. W. Nevinson, from making further inroads into their movement.
Since November 1913, Marinetti had publicly and privately assaulted

the ears of literate Londoners with his booming recitations. In the public appearances, he was accompanied by Nevinson, simulating off-stage the sounds of cannon and machine-gun fire. When Marinetti and Nevinson issued a manifesto which, in effect, proclaimed themselves as leaders of the avant-garde, Lewis, Epstein, Bomberg and a number of other artists signed a statement published in the papers denouncing and brusquely dismissing the usurpers.

While Rosenberg was capable of ignoring these antics, his thoughts were not so removed from the activities of the English avant-garde as to preclude his reaching some conclusions respecting their worth. He was fully aware of the skirmishing between Marinetti and the avant-garde and was prepared to discuss it in a lecture he gave on art within weeks of his arrival in Cape Town.[36] Tracing the history of art from ancient to modern times, he arrived at the Post-Impressionists, paused briefly to give them a favourable nod, and then proceeded rapidly to a description of the rise and progress of the futurist movement:

Hitherto all art has been an attempt to reconcile the present with the age of artists, the standard has always been the highest achieved. The forms have always remained the same though the content has changed. But the futurist, the last spark struck from this seething modernism, this mechanical age of speed and convulsive machinery, must create a new form to completely express this entirely new and changed humanity. The old forms to him are useless, they served for the outworn creed that made the beauty of woman, or some quietist searching for ideal beauty its object, always taking some commonly recognized symbol to express this. This quietist detachment from life to watch from the outside is not for the futurist. Violence and perpetual struggle — this is life. Dynamic force, the constantaneous [sic] rush of electricity, the swift fierce power of steam, the endless contortions and deadly logic of machinery; and this can only be expressed by lines that are violent and struggle, that are mechanical and purely abstract. Theirs is an ideal of strength, and scorn. The tiger must battle with the tiger. The world must be cleansed of the useless old and weak; for the splendour of battle must rage between the strong and the strong. Theirs is the terrible beauty of destruction and the furious energy in destroying. They would burn up the past; they would destroy all standards. They have wearied of this unfair competition of the dead with the living.

To express these new ideals, they have invented forms abstract and mechanical, remote from and unassociated with

natural objects, and by the rhythmic arrangement of these forms, to convey sensation.

This presupposes a sympathetic intuition — an understanding of the symbol in the spectator.

(CW, pp. 249-50)

'Sympathetic intuition', Rosenberg hastened to say, was not possible:

We can only see ingenuity. The forms are not new, but dead and mechanical. There is no subtlety nor infinity. The only sensation I have ever got from a futurist picture is that of a house falling — and however unlike the pictures were, that has always been the sensation. We can never strip ourselves completely from associated ideas, and art, being in its form at least, descriptive, the cubes and abrupt angles call to mind falling bricks. It is too purely abstract and devoid of any human basis to ever become intelligible to anybody outside the creator's self. The symbols they use are symbols of symbols . . .

Art is now, as it were, a volcano. Eruptions are continual, and immense cities of culture at its foot are shaken and shivered. The roots of a dead universe are torn up by hands, feverish and consuming with an exuberant vitality — and amid dynamic threatenings we watch the hastening of the corroding doom.

(CW, p. 250)

Rosenberg delivered his lecture to a small gathering of Cape artists in the studio of Madge Cook (later Madge Tennant). Her mother, Mrs. Agnes Cook, the editor of *South African Women in Council,* in which the lecture was soon to be printed, felt that she had been in the presence of a genius, but one whose subtleties and cleverness would go unappreciated. Probably no one took seriously his prophecy of chaos; Cape Town was too remote and too well insulated in its provincialism, despite its busy seaport, to respond to the sensitivities of a cosmopolitan poet. Even the most perceptive of the artists in his audience could not have grasped from Rosenberg's comments the intensity of his past experience, which convinced him that Western civilization faced an imminent catastrophe. His message of doom was perfectly timed, coinciding as it did with the eve of the outbreak of hostilities in Europe. In later poems Rosenberg would forecast several times over the disintegration of life in the metropolis. His observations, made when they were, are nothing less than remarkable.

Also impressive is Rosenberg's early recognition of Stanley

Spencer's genius. In the closing paragraph of his lecture, he considered the accomplishments of his contemporaries:

Henry Lamb is shy, a tremulous and ever-shaken life in shadow. Compared to Lamb, John is the broad ocean with the sun on it, and Lamb the sea with the moon. Innes paints landscapes very much like the Chinese and Mantegna. They have the vague beauty of perfumes and luxuriant reverie. Mark Gertler has a deep understanding of nature and sometimes achieves to [sic] that intensity we call imagination. John Currie has painted lovely things without being very convincing as a draughtsman. David Bomberg has crude power of a too calculated violence — and is mechanical but undoubtedly interesting. Roberts, who is yet a boy, is a remarkable draughtsman in a stodgy academic way, clear, logical, and fervent. But the finest of all is Stanley Spencer. He is too independent for contemporary influence and goes back to Giotto and Blake as his masters. He strikes even a deeper note than John, and his pictures have that sense of everlastingness, of no beginning and no end, that we get in all masterpieces. (*CW*, p. 253)

By the time Rosenberg had uttered these remarks — to this day a valid summary of the achievement of Gertler, Bomberg, and Spencer — the Whitechapel Art Gallery's Exhibition of Twentieth Century Art was over. It had counted for little in his thinking, he was too much obsessed by his strong antipathy for London and his imminent escape from it to dwell on the show's possibilities for him. Of the works he submitted, five were accepted: a self-portrait; the portrait of his father, completed in 1911; two 'literary' studies -- the 'Murder of Lorenzo (Keats)', and 'The Judgment of Paris'; and the 'Head of a Girl'.[37] Of the fifty-three works hung in the Jewish Section of the exhibition, these five pieces constitute the largest public showing Rosenberg was to have during his life. As far as the critics were concerned, he might as well have kept his work stacked at home, for he received only scant notice. The reviewer in *The Jewish Chronicle* wrote, 'Knowing that Mr. Rosenberg has done better work, we cannot praise his "Portrait of my Father" (260), for the colouring is muddy and the characterization weak. Much as we should have liked to speak favourably of his drawings, we are afraid the artist has given us little opportunity to do so.'

Even if had Rosenberg been in London instead of on the high seas when the review appeared, it would have mattered little to him. He intended to paint, but it was poetry that now occupied his serious attention.

12

A Glimpse of Paradise
June 1914-Feb 1915

Rosenberg's dreams about South Africa were full of possibilities. He would paint and write, and in addition lecture, teach, and perhaps even work on a farm. He had written to Marsh in mid-spring about farming, feeling that he was young enough to spend a year or two in a rural setting, getting 'ideas for real things'. He had been 'cramped up' in London, convinced that if he stayed he would be forced to 'do Cubism', and he was determined 'to avoid the rut'.

Having embraced his parents, he went to St. Pancras Station, took a train to Tilbury and boarded his Union Castle boat to Cape Town. Ahead of him lay a long sea voyage, behind him many frustrations, many memories. Once at sea, he relived in his thoughts the preceding years, composing a few sea poems as records of a life in transit. As a child he had written a sea poem for a magazine competition, and all his life had been spent close to the London docks. He had been to Elba. The broad expanses of the Atlantic Ocean were nonetheless a new experience, leaving him temporarily suspended both in time and space, and he was impressed. 'Far Away', 'Have We Sailed and Have We Wandered' (*CW*, p. 141), 'Wistfully in Pallid Splendour' (*CW*, 142), and 'At Sea-Point' (*CW*, p. 148) contain related images of oceans, journeys, hopes and disappointments. 'At Sea-Point' recalls his lost love, and is the least successful of all, its poignance spoilt by a pervasive bitterness in which he calls for the earth's disintegration, the heavens' fading, the seas' vaporizing and the hills' dying. In image after image he finds decay everywhere, the corollary to his overwhelming disappointment in one woman:

> *Gone, who yet never came.*
> *There is the breathing sea,*
> *And the shining skies are the same,*
> *But they lie — they lie to me.*

For she stood with the sea below,
Between the sky and the sea,
She flew ere my soul was aware,
But left this thirst in me.

(*CW*, p. 148)

After an uneventful voyage, Rosenberg reached Cape Town toward the end of June 1914. Once settled in at his sister's in Hill House, 43 De Villiers Street, he began almost immediately to seek commissions. He needed money for paints and canvas, and most of all for a studio where he could live in some privacy as well as work and teach. He had lived in crowded quarters for most of his life and though he had grown used to limited space he was not accustomed to having a baby around, and Minnie's first child was only a few months old.

Within a week he had his first commission — ironically, painting two babies. Going about in the streets, he experienced surges of pleasure, relieved to be away from the chilling competition and frustrations of London, and warmed by the Cape summer sun and the natural beauty of the city. He wrote off a short note to Marsh telling him of the commission, and that he would write him a long letter the following week. 'The place is gorgeous,' he concluded, 'just for an artist' (*CW*, p. 295). Almost overnight his sombre mood disappeared and he acquired a new perspective on his thwarted love. In 'O Heart, Home of High Purposes' he asks himself why he allowed a 'meagre dalliance' to inhibit his heart with its 'high purposes' and stall his hand with its 'craft and skill' (*CW*, p. 147).

By the time he wrote to Marsh the following week his mood had become angry. The natural beauty of the Cape was inspiring enough: 'Across the bay the piled up mountains of Africa look lovely and dangerous. It makes one think of savagery and earthquakes — the elemental lawlessness' (*CW*, pp. 296-97); but the people were philistines, worse than any he had encountered in London: 'I am in an infernal city by the sea. This city has men in it — and these men have souls in them — or at least have the passages to souls. Though they are millions of years behind time they have yet reached the stage of evolution that knows ears and eyes. But these passages are dreadfully clogged up, — gold dust, diamond dust, stocks and shares, and heaven knows what other flinty muck' (*CW*, p. 296). What was to be done? Rosenberg thought that perhaps art might lead some of these people away from their worship of Mammon. 'I've made up my mind,' he told Marsh, 'to clear through all this rubbish' (*CW*, p. 296). He de-

cided on a series of lectures, partly out of altruism and partly out of an awareness that the more attention he called to himself the more likely he was to obtain commissions. He asked Marsh for help. He wanted to borrow reproductions of the Impressionists, along with a book on the Post-Impressionists. With uncharacteristic rapidity, he had given one lecture on ancient and medieval art, and it had gone well. However, for his review of contemporary art he needed to show lantern slides of new work and these were, of course, non-existent. He would have his own made once Marsh sent him reproductions.

In addition to his lecture, he had already done his first painting of a Kaffir, and wanted to paint a second. He was fascinated by these people, and did a number of studies of them in which he took a good deal of pride. But in spite of all his activity and plans, he soon found that he missed the ferment of the London art world. Though he had steered away from the several coteries he still felt very much involved, and he was surprised at his need to keep abreast of what was happening to his artist friends. 'Do write to me — think of me,' he said plaintively to Marsh, 'a creature of the most exquisite civilization, planted in this barbarous land. Write me of Spencer Lamb Currie and the pack of them' (*CW*, p. 297). He would write to Gertler himself. If he felt any urgency in contacting Bomberg, Kramer or Goldstein, he did not reveal it to Marsh.

While Rosenberg acted with unusual energy, July in South Africa lazed along, the sun giving way to storm clouds. Storm clouds were also gathering in Europe as the month sped by. On June 28 the Archduke Franz Ferdinand, heir to the Austro-Hungarian Empire, was assassinated in Sarajevo, the victim of a Serbian conspiracy. By July 5 Kaiser Wilhelm had sent his assurances to Austria that Germany would stand by her against Russia. Germany's armies were prepared for combat. Thus assured, Austria drew up an ultimatum to Serbia and delivered it on July 23 at 6:00 p.m. Just before the forty-eight hour deadline expired, Serbia acquiesced to Austria's demands except for two clauses, clearly violating Serbian sovereignty, which had been inserted to intimidate Russia. Despite Serbia's capitulation Austria had determined to fight and declared war on July 28, though strenuous efforts were made on the part of the other major powers to head off the conflict. Messages flew back and forth across Europe while prime ministers and generals argued over mobilization orders. On August 1 Germany declared war on Russia; for two days before that her military patrols had been crossing the French border. Germany went to war officially against France on August 3. The next morning the invasion of Belgium

began. With the German thrust into the Low Countries on August 4, England took up arms to fight in a war that no one wanted except the war parties in Austria, Germany, and Russia. Thousands of miles away in South Africa, Rosenberg's plan to support himself by teaching children to paint became one of the first minor casualties of the war. Like London, Cape Town was gripped with war fever, and art suddenly became expendable.

On August 8 Rosenberg sent Marsh a typed copy of his lecture on art, remarking that he knew his 'poor innocent essay' would hardly stand a 'chance by the side of the bristling legions of war scented documents' on his desk (*CW*, p. 297). In the same letter he stated his loathing of war and expressed the hope that 'Kaiser William will have his bottom smacked — a naughty aggressive schoolboy who will have *all* the plum pudding'. Yet his maiden poem on the war reveals, as Bernard Bergonzi has observed, that Rosenberg saw 'the catastrophic nature of war much more clearly than most of his contemporaries . . . inclined to regard it as a possibly regenerative disaster', as Rilke had in 'Fünf Gesang.' Perhaps it was his great distance from the hostilities which gave him a measure of detachment rarely achieved in his previous work, for there is an uncharacteristic reserve in 'On Receiving News of the War':

> *Snow is a strange white word;*
> *No ice or frost*
> *Has asked of bud or bird*
> *For Winter's cost.*

> *Yet ice and frost and snow*
> *From earth to sky*
> *This Summer land doth know;*
> *No man knows why.*

> *In all men's hearts it is:*
> *Some spirit old*
> *Hath turned with malign kiss*
> *Our lives to mould.*

> *Red fangs have torn His face,*
> *God's blood is shed.*
> *He mourns from His lone place*
> *His children dead.*

> *O ancient crimson curse!*
> *Corrode, consume;*
> *Give back this universe*
> *Its pristine bloom.*
> (*PIR*, pp. 84-85)

Once again Rosenberg assumed the role of the prophet anticipating the destruction of civilizations. This theme now became more prominent in his writing. The experience of his trip to South Africa and the outbreak of war combined as catalysts to sharpen his focus of certain themes and images: the sickness of western civilization; the symbolic use of roots; the alienation of the poet from society; the rejection of the traditional God accompanied by the elevation of the poet to omnipotence; and the subsequent usurping of power by matriarchal figures, the daughters of Eve. Taken together, these themes are interrelated, in some respects resonant with the circumstances of Rosenberg's own life. His ability to express himself in his poems now matched and — despite continuing lapses of logic — occasionally surpassed his prose, which circumstance would henceforth confine to his letters.

Though Rosenberg seemed preoccupied with the problem of the poet's alienated status in society, the image that most obsessed him was that of the all-powerful feminine principle. In the first days of the war, he composed 'The Female God' which, unlike many of the poems Rosenberg was composing at the time, was tightly controlled. Its images were consistently appropriate, and its ending strong. Until he came to South Africa, Rosenberg's endings tended to trail away or give an impression of syntactical wrenching into place. Many of his lyrics were flawed by this mild distortion, which resulted either from an impatience to complete a poem or, more likely, from an over-conscious attempt to conclude on a strong note. Neither 'On Receiving News of the War' nor 'The Female God' suffer from these defects. Taking his cue from the 1912 poem 'Lady, You Are My God' (composed for Sonia as a gift from Bomberg), he expanded and developed its theme into what was to be a recurring motif of female power:

> *We curl into your eyes —*
> *They drink our fires and have never drained;*
> *In the fierce forest of your hair*
> *Our desires beat blindly for their treasure.*

In your eyes' subtle pit,
Far down, glimmer our souls;
And your hair like massive forest trees
Shadows our pulses, overtired and dumb.

Like a candle lost in an electric glare
Our spirits tread your eyes' infinities;
In the wrecking waves of your tumultuous
 locks
Do you not hear the moaning of our pulses?

Queen! Goddess! Animal!
In sleep do your dreams battle with our
 souls?
When your hair is spread like a lover on
 the pillow
Do not our jealous pulses wake between?

You have dethroned the ancient God,
You have usurped his Sabbath, his common
 days;
Yea, every moment is delivered to you,
Our Temple, our Eternal, our one God!

Our souls have passed into your eyes,
Our days into your hair;
And you, our rose-deaf prison, are very
 pleased with the world,
Your world.

(*PIR*, pp. 180-81)

This poem, like 'Sacred, Voluptuous Hollows Deep', operates consistently on both the sacred and sexual levels. Stanzas one, three and four are particularly emphatic in their double meanings. Rosenberg told Marsh after quoting the poem, 'This is the best thing I've written. . . .' The pleasure he took in his poem was based partly on his ability to sustain his image of woman as god. Yet I feel that the major appeal of the poem to Rosenberg must have lain in its precise expression of his personal situation vis à vis the women in his life. Since 1911, when Rosenberg composed 'Spiritual Isolation' (*CW*, p. 26), he had resented and rejected the arbitrary and capricious authority of the Old Testament God, arguing that the poet had an

obligation to himself and to suffering mankind to fill the vacuum created by the dismissed deity. Rosenberg subscribed fully to his own theory of the divine right of poets to be kings and more. He nonetheless found that the assumption of godhood carried with it only a nominal investiture of power. His experience of life convinced him that the true wielders of power were women. In his own home, his father had been weak and ineffectual, while his mother controlled and manipulated the destinies of her children with firm assurance. The same circumstance prevailed in Bomberg's home and in Gertler's. By nature sensuous and awkward, once Rosenberg had fallen in love with Sonia, he accentuated his need for her but was incapable of winning her. Having acquired some sexual experience, he was able to gauge accurately the imbalance between the pleasure of sexual gratification and the pain of Sonia's reticence, followed by rejection. Women had the ultimate power, and so held a higher place than poets in Rosenberg's quasi-mystical hierarchy.

'The Female God' succeeds largely because of its utilization of tree mythology. Diverse as Rosenberg's reading had been in the White-chapel Public Library, there is no evidence that he was familiar with the theories regarding tree mythology and its connexion with the White Goddess myths, though poems about trees and concomitant adoration of the poet's muse were common enough. Yet Rosenberg's use of tree mythology is consistent with the twentieth century's emphasis on trees as female symbols rather than male ones. It would be interesting to discover how he came to adopt and use by 1914 what had been a minor but persistent view of tree symbolism in its female manifestation as the container for the soul or spirit in life and ultimately the body in death, and as the provider of food and shelter, in preference to the widely-accepted, more obvious external phallic symbolism.[38]

Rosenberg expected Marsh to be critical of 'The Female God'. He sent it to him with the remark, 'Here's a chance to exercise any blood-thirsty and critical propensities.' This time, however, he was not cowed by the prospect of Marsh's objections. In the weeks he had been in Cape Town a transformation had occurred: 'this coming away,' he told Marsh, 'has changed me marvellously, and makes me more confident and mature'. Though he was forced to give up his plan to teach art, he busied himself painting and writing: 'I painted a very interesting girl, which I'm rather pleased with,' he told Marsh. 'Its very quiet and modest and no fireworks. I may send it to the New English if I don't bring it back myself in time. Also a self portrait, very gay and cocky, which I think will go down very well.

Im waiting for better weather to paint the kaffirs against characteristic landscapes.' His letter was full of news, he had written more poems and was sending them, his health had improved, and he was spending a lot of time in the open air. He had written to Spencer and Gertler, but wanted news of Currie.[39]

The war was much on his mind, and his immediate inclination was to sit it out and produce as much as possible in anticipation of a triumphant, ministering return when hostilities ended: 'By the time you get this things will only have just begun Im afraid; Europe will have just stepped into its bath of blood. I will be waiting with beautiful drying towels of painted canvas, and precious ointments to smear and heal the soul and lovely music and poems. But I really hope to have a nice lot of pictures and poems by the time all is settled again; and Europe is repenting of her savageries.'

These are the words of a contented man: Rosenberg was quietly happy. How sad it is that this was the first and last time he would know serenity. His contentment grew out of his escape from London and all its attendant miseries: his frustration over his painting and poetry, the cold wet weather, the continual strife between his parents, Sonia's alliance with Rodker. More than escape, he had achieved a measure of attention through his lectures and their subsequent publication along with several of his poems. This attention bordered on adulation.

In the early winter when he went to confer with Mrs. Agnes Cook, the editor of *South African Women in Council*, about the publication of the lecture and several poems,[40] he met an admirer, the daughter of Sir John Molteno. She invited him to spend two weeks in her palatial home in Rondebosch, a suburb of Cape Town. He went and for a fortnight found himself lionized. In a manner reminiscent of the wide-eyed wonder Wilfred Owen expressed at the same time in his letters to his parents from Bordeaux, where he was tutoring some French children,[41] Rosenberg wrote to his mother and father about his fortnight:

> . . . I'm here at Rondebosch having a happy time . . . living like a toff. . . . Early in the morning coffee is brought to me in bed. My shoes (my only pair) are polished so brightly that the world is pleasantly deceived as to the tragedy that polish covers. I don't know whether there are snakes or wild animals in my room, but in the morning when I get up and look at the soles of my shoes, every morning I see another hole. I shan't make your mouths water by describing my wonderful breakfasts -- the unimaginable lunches — delicious teas, and colosal [sic] dinners.

You would say all fibs. I wont tell of the wonderful flowers that look into my window and the magnificent park that surrounds my room.

(*CW*, p. 342)

This brief glimpse of paradise climaxed a happy autumn during which time Rosenberg was welcomed into the tiny art colony on the Cape. The provincials looked upon its few artists and theatre personalities as bohemians, and they in turn tried to live up to their billing. Edward Rowarth, the Dutch artist, a giant of a man, befriended Rosenberg, towering over him as they marched down the street deeply engrossed in conversation. Madge Cook lent him her studio, and out of gratitude he did a pencil portrait of her. Of this gift, she later said, 'I am ashamed to confess, being young and vain I excused myself from accepting because I (privately) did not think it flattering enough.' He was also associated with the *enfant terrible* of the theatre crowd, Margueretha Van Hulsteyn, who later achieved fame on the London stage as Marda Vanne. She sat for a little pencil study (*CW*, opposite p. 140).

Curiously, Rosenberg's social acceptance in Cape Town was the reverse of his situation in London. He was accepted and admired outside the Jewish Community but not within it. In 1922, David Dainow, the brother of the Whitechapel librarian who had befriended Rosenberg in 1905, was in South Africa and enquired about Rosenberg's visit eight years earlier. 'I asked the Reverend A. P. Bender, the minister of the Garden Synagogue in Cape Town, whether he came across Rosenberg. Bender remembered him, adding that "he was a blooming nuisance who didn't know what he wanted".' There were those who would never let him forget he was an alien among his own people. However, he saw his alienation differently. He wrote a poem entitled 'The Exile' but its message was that he was a fugitive from Sonia, his trip to South Africa prompted by the now 'dried-up waters of deep hungering love' (*CW*, p. 138).

In his letters to England during the autumn Rosenberg declared his intention to return home. For all its vexations, he could not stay away any longer from London. He left Cape Town in February 1915, his happy interlude concluded. Underneath the veneer of confidence South Africa had given him, he was still the same forlorn, lonely, awkward, absent-minded person. He took his paintings and drawings on board ship, but having tied them carelessly, he lost most of them overboard before the vessel cleared harbour. Even if the war had been over, he would not have reached England with any 'beautiful drying towels of painted canvas'.

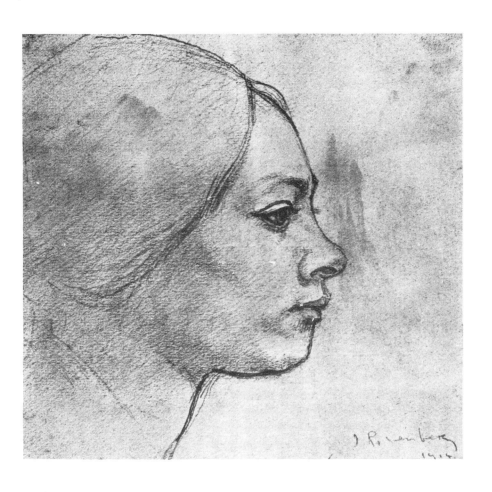

Pencil Study of a Girl, 1914

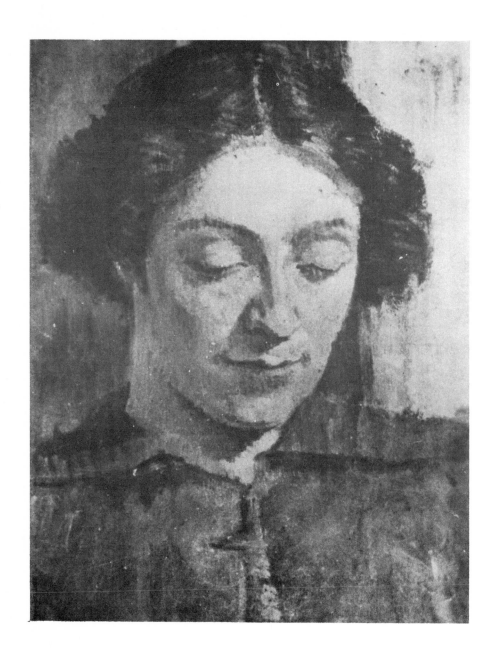

Portrait of Rosenberg's sister Minnie, painted in South Africa, 1914

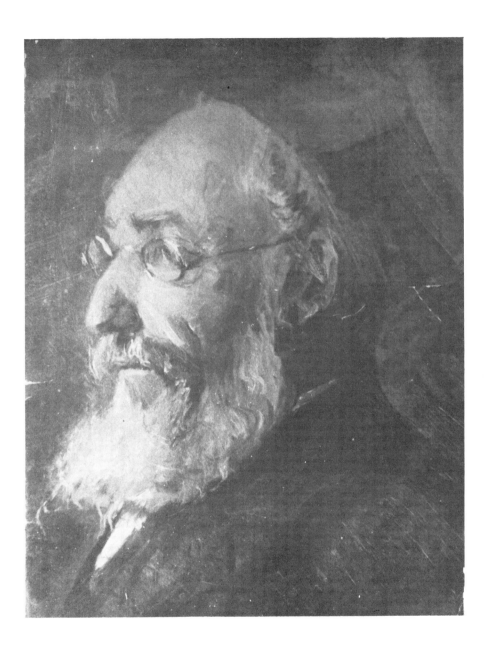

Portrait painted in South Africa, subject unknown

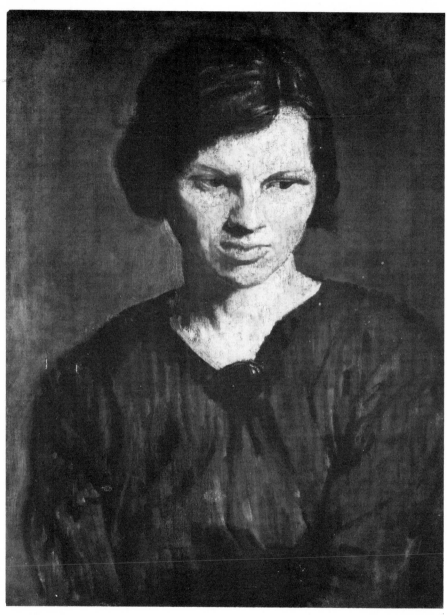

Portrait of Sonia

13

A Real Burglar
March-Nov 1915

In February 1915, Rosenberg returned to London, taking with him to 87 Dempsey Street his Kaffir sketches, a few portraits, and such other pictures as had not fallen into the sea, and a handful of poems. He found nothing changed. His two sisters, Annie, 23, and Rachel, 21, and his two brothers, David, 18, and Elkon, 16, were all working. Annie tended to be serious and responsible, Rachel was the quiet one, David was moody, and Elkon full of gaiety and humour. Elkon was so wild that Annie worried about him, telling Isaac that he would have to help hold him in check. Hacha kept house, ministering to her children and her friends, and Barnett went for long walks when the weather was not too severe, sitting and musing by the fire when it was too cold and wet to go out. Estrangement and hostility hung heavy in the atmosphere of the household. After a bitter exchange on February 25, Barnett added a note in Yiddish to the bottom of a sheet of paper on which earlier he had composed a poem on his happy childhood. Tersely, he castigated Hacha for her refusal to heed his good and pleasant words. He contrasted the sweetness of a good woman to the cruelty of a bad one who was 'leprosy to her mate'. He would not wish his wife on anyone. Isaac, now 25, was jobless and hence at home more than his sisters and brothers to mediate hopelessly in his parent's disputes.

One by one he sought out his friends. Gertler had just moved into a new studio in Hampstead, having been offered by Marsh ten pounds a month until the war's end for the first option on his pictures. Gertler had been dividing his time in late 1914 between London and Cholesbury, going for long visits with Gilbert Cannan[42] and his wife, where he was often in company with John Middleton Murry, Katherine Mansfield, D. H. Lawrence and Frieda. Lawrence liked him enormously and would use him as a model for the sculptor

Loerke in *Women in Love*. Bomberg was following his constructivist bent, still trying to achieve his ideal of pure form. When the war broke out he sought to enlist but was rejected, partly because of his accent and his beard. Kramer, Goldstein, Leftwich and Aaronson were in London pursuing their careers, uneasy about the extent to which the war might disrupt their lives. Sonia was with Rodker, who had turned to writing poetry, having privately published in April 1914 from his Osborne Street address a thin, unimpressive volume called *Poems*. Its only mark of distinction was Bomberg's 'The Dancer' on the cover. As for Annetta Raphael, she remained the mysterious dark lady.

Shortly after his return to England, Rosenberg began sending the new poems he had composed in South Africa to London editors. A new monthly art magazine had begun publication in August 1914, while he was away. It was called *Colour*, and its purpose, according to its editor, T. M. Wood, was to reproduce lavishly the new art. For the few years that it was in print it made no attempt to court the avant-garde, preferring a safe middle-ground, publishing the work of popular Edwardian artists including Frank Brangwyn and William Strang. Perhaps the outbreak of the war in the same month as the first number was issued forced the editor to be conservative, since the magazine's survival was tenuous. Whatever the editor's reasons, it was not very often that a 'contemporary' artist was included, although occasionally a work by Augustus John or Gertler or Gaudier-Brzeska would find its way into *Colour's* pages. As the journal also printed stories, poems, and light, 'safe' essays — for example, Zangwill on the religious motif in Rodin — Rosenberg sent several of his lyrics to Wood. They were accepted.

Rosenberg's pleasure at finally appearing in a London magazine was marred somewhat by the knowledge that *Colour* was not held in the highest repute by many painters or poets, and certainly not by those who considered themselves avant-garde. Indeed, the popular *Colour* artists had already been blacklisted by Lewis and Pound in *Blast*. *Colour*, in short, was a chic, bourgeois, coffee-table publication. Few poets could have been more out of place in its pages than Rosenberg, except for the fact that his little romantic poems were well suited to the magazine's indulgence in polite fantasies. Rosenberg's appearances were concentrated in the Summer 1915 issues: 'Heart's First Word II' was printed in June beneath a seascape by Sydney Pavière; 'A Girl's Thoughts' in July, beneath a portrait of Frank Brangwyn by Joseph Simpson; and 'Wedded' in August, below a nude bending over two swans, by Maurice Langaskens. Rosenberg

may not have been ashamed of his appearances in *Colour,* but it is noteworthy that he made no mention of them in his correspondence.

As usual, Rosenberg's most immediate problem was money. He contacted Marsh, who invited him to bring his pictures and poems to Raymond Buildings. When they met, Marsh found a few pictures he liked but reserved judgment on the poetry. In subsequent letters to Marsh Rosenberg kept him up to date with his creative efforts: 'I'm doing a nice little thing for Meredith's "Lark ascending" ' (*CW,* p. 298),[43] and argued with him over obscurity in the poems. He sent Marsh a new poem entitled 'God Made Blind' (*CW,* p. 41), which again treated the theme of Rosenberg's rejection of God and substitution of the poet in His stead. Marsh could not comprehend its meaning. Reading his criticism, Rosenberg replied testily: 'If you do find time to read my poems, and I sent them because I think them worth reading, for God's Sake! don't say they're obscure. The idea in the poem I like best I should think is very clear' (*CW,* p. 298). These differences of opinion grew more frequent; indeed, it was rare for Marsh and Rosenberg to agree where poetry was concerned. It did not seem either to upset or endanger their relationship, for Marsh was accustomed to, and therefore did not take too seriously, the cavilling of his headstrong, tempestuous, intense young artists. For his part, Rosenberg respected and needed Marsh's wealth and influence, and he had no wish to antagonize him.

Jon Silkin, the poet and editor of *Stand,* has shown in the most comprehensive and penetrating essay yet written on Rosenberg, that Marsh's involvement in the prevailing literary fashions precluded an affirmative response to Rosenberg's highly individualized verses. One example of this is manifest in Marsh's decision to show Rosenberg's manuscripts to Lascelles Abercrombie, a thorough-going Georgian, and simultaneously acquaint Rosenberg with Abercrombie's poetry in the hope that Rosenberg might move in the only direction Marsh thought he should go. Rosenberg enthusiastically endorsed the contact and embraced Abercrombie's poetry. To Miss Seaton he posed the question 'Who is your best living poet?' and then answered it, announcing his new 'discovery': 'I've found somebody miles and miles above everybody — a young man, Lascelles Abercrombie — a mighty poet and brother to Browning' (*CW,* p. 368). Yet this enthusiasm basically changed nothing in Rosenberg's style. Marsh would go on underestimating Rosenberg's determination to be himself, and Rosenberg would continue to be perverse.

At about the same time Rosenberg was introduced to Gordon Bottomley's poetry. Bottomley was among the best of the Georgians,

with a fine ear, vision and imagination. Rosenberg's admiration for Abercrombie notwithstanding, he wrote to Miss Seaton, 'I like Bottomley more than any modern poet I have yet come across' (*CW*, p. 345). In the same letter he said he had 'been writing better than usual . . . lately' though 'the things are slight — they all have the same atmosphere and I may be able to work them into one [longer composition], if I can hit on an episode to connect them' (*CW*, p. 345). Marsh's small purchases combined with Hacha's pleasure in having Rosenberg at home temporarily allayed his financial concerns, and in mid-spring he had several weeks of high productivity. He completed an outline for a play — it would ultimately develop into his verse-drama *Moses* — sketched his father in pencil, did a small self-portrait of himself in oil, sketched Aaronson in pencil on the blank leaf of a copy of Francis Thompson's *Poems,* wrote letters to his friends, and searched his mind for a theme to connect his verses. He wanted to publish another pamphlet. Exchanging copies of poems[44] and books with Miss Seaton, he read her copy of Goethe's autobiography — which he liked — and Lord Alfred Douglas' sonnets — which he dismissed.

That spring, Rosenberg met Sydney Schiff, a well-to-do English Jew who after the age of fifty began writing novels, published under the pseudonym of Stephen Hudson. A highly social but very private person, Schiff had contacts equal to those of Marsh. Among his closest friends at various times in his life were Katherine Mansfield, T. S. Eliot and Marcel Proust, whose *A la recherche du temps perdu* he translated. Like Marsh, Schiff became Rosenberg's 'absentee' patron, in the sense that he put no pressure on him to produce works in return for occasional support, and he was available whenever Rosenberg needed him. How Schiff and Rosenberg met is unknown. After their introduction, Rosenberg wrote to him offering to show him his pictures, reassuring him that 'Buying pictures of me is the last thing in the world I expect people to do, in the best of times' (*CWL*, p. 7). He was having some poems printed and would send them when they were ready. Schiff acknowledged his invitation, to which Rosenberg replied, announcing that his poems were at the printer's and would be ready in two weeks. He enclosed his only remaining copy of *Night and Day,* asking for its safe return.

Rosenberg had now found his connecting theme and put together his most recent as well as earlier poems for an eighteen-page pamphlet called *Youth.* Narodiczky agreed to publish it for two pounds ten shillings, still an enormous sum to Rosenberg. Writing to tell Marsh that he would bring him the next day a copy of a da Vinci he had

just finished,[45] Rosenberg described his 'scheme for a little book called "Youth" ', in three sections: (1) Faith and Fear: the idealism of the youthful poet and his aspirations toward purity; (2) The Cynic's lamp: through harsh experience the poet loses his aspirations and is content simply to absorb external reality; and (3) Sunfire: A change occurs. The poet, now without any illusions, moves from cynicism to a spiritual plane via the imagination responding to 'real intimacy' or 'love' (*CW*, p. 293).

In order to pay Narodiczky, Rosenberg sold Marsh three life drawings for the sum of two pounds and ten shillings. Rosenberg was grateful: 'You don't know how happy you have made me by giving me this chance to print,' he told Marsh, sending in the same letter 'The One Lost', his latest poem on the theme of rejection of God and substitution of the poet (*CW*, p. 293). Marsh replied immediately, 'I'm glad you hit it off with the printer. Will you come to breakfast on Thursday? I'll expect you unless you say no. I can then give you the cheque if you want it now — I will very gladly have the drawings in exchange.' On Thursday, April 15, Rosenberg came to breakfast and gave his drawings to Marsh. A happy occasion, it was also the last time Rosenberg and Marsh were to meet for some months. Eight days later Rupert Brooke died. Marsh was inconsolable, and the loss was compounded a few weeks later by Winston Churchill's abrupt removal from his position as First Lord of the Admiralty, because of his handling of the Dardanelles Campaign.

As soon as Rosenberg heard about Brooke's death he sent Marsh his condolences:

I am so sorry — what else can I say?

But he himself has said 'What is more safe than death?' For us is the hurt who feel about English literature, and for you who knew him and feel his irreparable loss.

The remarks were appropriate but not heartfelt. Rosenberg did not respect Brooke as a poet and he mildly resented Marsh's adoration of him. He was jealous — it would have been unnatural for him not to have been. These negative feelings he apparently put in a letter to Miss Seaton, which Bottomley later saw but chose not to print in the 1922 *Poems* or the *Collected Works* in 1937, extracting from it only a brief, innocuous comment on Emerson (*CW*, p. 368).

Narodiczky printed about one hundred copies of *Youth*. The eighteen pages, in their wrappers, contained a title-page identical to the cover, which this time carried an imprint, and a table of contents. Six poems were reprinted from *Night and Day*.[46] Rosenberg managed to sell ten copies at half a crown each. Although his compilation in-

cluded a few more recent poems composed just before and after his visit to South Africa, it contained little to enhance his reputation. Among the important poems he chose not to include were three of his most advanced pieces: 'Sacred, Voluptuous Hollows Deep', 'The Female God', and 'On Receiving News of the War'. If there was any logic to his omissions it is hardly discernible. His title was *Youth*, and, as *Night and Day* had rounded off one period of his life, so *Youth* rounded off another. Perhaps the omissions were too mature to fit into his scheme.

On June 4, 1915, Rosenberg sent Schiff a copy of *Youth*, minus one page which he removed as 'the poems were very trivial and I've improved the book by taking them out' (*CWL*, p. 7). Schiff replied on June 7. He was sending *Youth* to Herbert Trench, an Irish-born poet and playwright, for an opinion; and he asked Rosenberg to post one to the critic, Arthur Clutton-Brock. Enclosed in his letter to Rosenberg were ten shillings and the outline of the play Rosenberg was attempting to write. Schiff said it interested him but it was 'a little difficult to follow'.

Rosenberg answered Schiff's letter the following day. Enclosing another copy of *Youth*, he thanked his new patron for the money and for mentioning his work to Arthur Clutton-Brock, to whom he was also sending a copy of the booklet. He noted with deep satisfaction that Schiff had read his poems seriously, since 'most people find them difficult and wont be bothered to read into them'. He compared 'technique' in poetry and painting, observing that Rossetti had mastered well his writing but 'had no command of form whatever' in his painting. Comparing himself to Rosetti by inference, Rosenberg added that his own technique in poetry continued to be 'very clumsy'. Thinking out loud, he wondered whether Clutton-Brock could help him obtain commissions for articles on art. Then he revealed to Schiff his increasing preoccupation with a possible solution to his many problems: dependency on his parents for support, his lack of success in establishing himself either as a portrait painter or as a poet, his aimless drifting. He was considering enlistment, although he believed going into the army 'the most criminal thing a man can do'. He was opposed to military service and, moreover, he dreaded the effect that his enlistment would have on his mother (*CWL*, p. 8). Apart from the fact that his attitude towards Rosetti had now been modified considerably, his thoughts of enlistment revealed the return of his deep-seated depression, aggravated by the increasingly dismal news of the war. Several days before he sent *Youth* to Schiff, a bomb fell within yards of 87 Dempsey Street, burning down a factory and

killing several people (*CWL,* p. 7). Casualty lists were growing longer. The Lusitania had been sunk on May 7, 1915, and Rosenberg was moved to write a poem on the ' "earnest malignancy" of the war' (*CW,* p. 71). One by one the Georgian painters and poets were either joining up or leaving London. Brooke was dead; word would reach London soon after June 5, 1915, that Gaudier-Brzeska had been killed in a charge at Neuville St. Vaast.[47] Throughout the summer and into early autumn Rosenberg struggled with his conscience about enlisting until the emotional turmoil almost destroyed his sanity.

He resumed his long Whitechapel walks, deliberating silently or debating his problems with his few friends. His greatest fear was his mother's reaction if he enlisted. She would count it a betrayal. He was as close to his mother as Wilfred Owen was to his, though Rosenberg was more independent, less acquiescent. If he was out walking the Whitechapel streets on Saturday night, June 12, he might well have passed Owen, who was also out walking. Owen was in London on a combined business trip and holiday from his tutoring post in Bordeaux. Writing to his mother after his return to France, he told her that on June 12 he had been seized with a desire to see again the East End which he had not visited since childhood.

> ... being now tired of the West End, I thought a little ugliness would be refreshing; and striking east ... walked down Fenchurch St. and so into the Whitechapel High Street, & the Whitechapel Road. Ugliness! I never saw so much beauty, in two hours, before that Saturday Night. The Jews are a delightful people, at home, & that night I re-read some Old Testament with a marvellous great sympathy & cordiality!

Predictably *Youth* did not turn out to be a success. Clutton-Brock was interested briefly but he made no effort to help Rosenberg get published. By printing his own poems, and unimpressive ones at that, Rosenberg reduced his chances of securing publication. Marsh received a copy; so did Ezra Pound, to whom Rosenberg also sent some manuscripts. How Rosenberg contacted Pound is unknown.[48] Bomberg seems the most likely contact, though it is possible that Rosenberg wrote to Pound directly. As was his custom, Pound sent his acquisitions straight to Harriet Monroe in Chicago, sometimes commenting and advising her as to what she should print in *Poetry Magazine,* at other times saying nothing. Rosenberg's *Youth* and the manuscripts were sent, apparently with no comment.

Since the post took over a month crossing the Atlantic, Pound and Harriet Monroe wrote to each other without waiting for replies. Thus on June 28, 1915, Pound sent her a long letter lamenting Gaudier-

Brzeska's death, and arguing that even though she did not like Eliot, he was 'vigorous' and 'male' and would 'go a long way'. He added two postscripts. One of them read, 'Don't bother about Rosenberg, send the stuff back to him direct unless it amuses you.' Monroe held the poems; whether or not she was amused we do not know.

The summer wore on. Rosenberg went to the New English Art Club's exhibition and probably the Vorticist Exhibition. Bomberg and Kramer were exhibiting their work at the latter show by invitation. Rosenberg liked one of Gertler's pictures at the New English show and placed him next to John in his estimation (CWL, p. 8); his response to Bomberg's and Kramer's pictures is not recorded. He still had nothing to exhibit and no desire to be involved. The summer before, in Cape Town, he had looked forward to exhibiting at the New English; now, it seemed unimportant. Visiting Sonia and Rodker, he asked Sonia to sit for him. He began to paint her, spreading the sittings over a long period of time. He appeared to be in no hurry. He was in torment, though it would be hard to gauge to what extent seeing her contributed to his unhappiness. Comparing her portrait with others that he did, it is immediately obvious that he put all the feelings of which he was capable into it. It may well have been the last oil portrait he painted. De Sausmarez has suggested that Rosenberg never finished the portrait (CWL, p. 32); it seems complete, but if it was unfinished there are many plausible explanations.

Through the spring Rosenberg had spent a lot of time with his friend 'Crazy' Cohen. Just as Rosenberg never mentioned Annetta Raphael so he kept his association with Cohen rather private. He occasionally mentioned in his letters leaving his poems with an unnamed friend. It might have been Annetta; it was usually Cohen, who still worked for Narodiczky and had set the type for Youth. He wanted to start his own newspaper, but had no money and could obtain no support. Ambitious nonetheless, he decided to found a monthly magazine, hoping subscriptions and advertising would eventually enable it to become a fortnightly, and then a weekly magazine. He and Rosenberg collaborated on the idea, and Cohen persuaded Narodiczky to agree to the use of his press. On July 1 the first number of The Jewish Standard appeared. Its eight pages were filled primarily with editorials, solicitations, sermons, and a poem, all by Cohen; with one and a quarter pages given to the opening paragraphs of Rosenberg's South African lecture on art. It was to be continued in the next number, but the venture failed and the second issue never materialized.[49] Cohen was in debt and Rosenberg's involvement with the venture ended.

His pockets empty, Rosenberg's energies and spirit flagged. He became increasingly absent-minded. He asked Schiff to send some manuscripts to Clutton-Brock as he had mislaid his letter and did not know the address. He could not even remember the number of Marsh's flat in Raymond Buildings. Desperate for money, he took a parcel of pictures to Marsh, but was forced to leave them at the porter's lodge. He then sent a hurried note to ask if Marsh had received them, as he could not afford to lose them. He began a letter to Pound, but failed to finish it and never sent it: 'Thank you very much for sending my things to America. As to your suggestion about the army I think the world has been terribly damaged by certain poets (in fact any poet) being sacrificed in this stupid business. There is certainly a strong temptation to join when you are making no money' (*CW*, p. 346). He had now reached the point where he was incapable of thinking about anything but the army's guaranteed one shilling a day for his services.

In America, Harriet Monroe did not know what to make of Rosenberg's poetry. She wrote to Pound in July asking his advice. He sent her the following reply in August:

> I think you may as well give this poor devil a show. Yeats called him to my attention last winter, but I have waited. I think you might do half a page review of his book, and that he is worth a page for verse.
>
> 'At night' seems good enough. if only for the sake of the phrase 'the sun spreads wide like a tree'. The Svage [sic] Song is crammed with Blake, you might or might not use it to fill out the pages. I have sent him bak [sic] the rest of his mss.
>
> He has something in him, horribly rough but then 'Stepney, East' . . . we ought to have a real burglar . . . ma che!!![50]

Harriet Monroe did not always take Pound's advice. Rosenberg would have to wait more than a year to be published in the United States.

Meanwhile, Rosenberg considered his options. He could try to recover his peace of mind, draw and write, living off his family and what he could get from Marsh and Schiff, or find some work, or enlist in the army, though he knew his parents were adamantly opposed to this. As summer waned into autumn, he tried first one and then the other of the alternatives. He went unannounced to see Marsh, catching him in a low mood — one of many he had experienced since Brooke's death and Churchill's dismissal. Marsh received him, gave him a cheque and a lecture, with a resumé of his own dismal fortunes, and sent him away. Rosenberg returned home in misery. He immediately sent Marsh an apology: 'I am very sorry to

have had to disturb you at such a time with pictures. But when ones only choice is between horrible things you choose the least horrible. First I think of enlisting and trying to get my head blown off, then of getting some manual labour to do — anything — but it seems I'm not fit for anything. . . . You would forgive me if you knew how wretched I was. I am sorry I can give you no more comfort in your own trial but I am going through it too' (*CW*, pp. 299-300).[51] Marsh's anger and self-pity passed. He wrote to tell Rosenberg that he was showing his pictures and poems to Abercrombie, and invited him to come to breakfast. Rosenberg, ashamed but no less desperate, asked Marsh to forgive his outburst and said he would come the following Tuesday (*CW*, p. 300). Though they remained friends Rosenberg realized he had lost much of Marsh's goodwill.

Rosenberg turned to Schiff. He sent him two drawings, hoping for a cheque by return of post. He told Schiff he wanted to paint something for him but was unable because of the terrible condition of his mind. He was ready to put painting aside until he gained his independence by learning an 'honest' trade (*CWL*, p. 9). Incredibly, Rosenberg went back to Hentschel's to ask for a job. He was told he needed more training, but he was given no assurance he would be hired. He wrote again to Schiff to ask him for help in paying his evening class fees. Schiff sent Rosenberg ten shillings at once. He acknowledged the gift, adding that he had once more reversed his decision about enlisting and he would not sign up. 'I feel about it,' he told Schiff, 'that more men means more war, — besides the immorality of joining with no patriotic convictions' (*CW*, p. 10).

Schiff did not mind sending Rosenberg money whenever he asked for it. He was, however, growing weary of Rosenberg's self-pity and indecision, and told him that he was not as badly off as many others were as a result of the war. Rosenberg was not convinced:

As to what you say about my being luckier than other victims I can only say that one's individual situation is more real and important to oneself than the devastation of fates and empires especially when they do not vitally affect oneself. I can only give my personal and if you like selfish point of view that I feeling myself in the prime and vigour of my powers (whatever they may be) have no more free will than a tree; seeing with helpless clear eyes the utter destruction of the railways and avenues of approaches to outer communication cut off . . . crippled from other activities and made helpless even to live. It is true I have not been killed or crippled, been a loser in

the stocks, or had to forswear my fatherland, but I have not
quite gone free and have a right to say something.

(*CWL*, p. 19)

Rosenberg's strident letter to Schiff was written in late October.
The next letter Schiff received from him carried the heading Priv. I.
Rosenberg, Bantam Regt. 12th Suffolk, New Depot, Bury St.
Edmunds. The long-suffering painter, the indecisive pacifist, the
pensive dreamer had disintegrated, and in his place stood an English
private who had signed on for general service though he knew himself
to be unfit even for home duty. In a critical moment, when he could
tolerate his adversities no longer, Rosenberg gave in to his long-
suppressed death-wish.

14

A Shilling Shocker
Nov 1915-May 1916

When Rosenberg's father was a young man, his whole life had been
altered by the threat of conscription into the Russian army. Not
unnaturally, he nursed a deep and abiding hatred of the military for
the rest of his life. Hacha's feelings were much the same. With the
onset of the pogroms her family had lived in fear until they could
leave Russia. She had heard her share of atrocity stories and had read
about them almost continuously in the Yiddish papers since coming
to England. Her fear of the military had been born early in life; she
knew what soldiers were like at close hand. Her parents had run an
inn which was close to an army barracks. She had observed them
drunk and sober, serious and light-hearted, but most of all she had
known them as agents of terror, always coarse, always threatening.
She vowed that her sons would never bring upon themselves and
upon her such humiliation.

For both Barnett and Hacha the issues were simple. Murder was a
violation of God's Commandment, and soldiers were trained to com-
mit murder. Whoever the participants, Jews were certain to be killed.
Patriotism never entered into the question: there had been much in
the Russia of the past to love, but as a country it was hostile; there
was nothing in England to become attached to, but it was safe. Even
the strenuous efforts of the London School Board to Anglicize its
thousands of immigrant pupils and inspire them with a love of
country were without avail, certainly as far as Isaac was concerned.
He was an alien in his own country. Thus the most unspeakable
crime as far as the Rosenberg household was concerned was to join
the army. Rosenberg committed it and the knowledge of the blow to
his parents weighed heavily on his conscience. He had always given
them respect in full measure, and his devotion to his mother ran
deep. He had no wish to hurt either of them; but enlistment seemed

the only consistent solution to his gloomy assessments of his predicament. He had read a lot of 'shilling shockers' in his youth; now, with this melodramatic action, he seemed to be taking a role in one of those cheap, sensational novels. Fearing that the shock to Hacha might be fatal, he decided to enlist without telling anyone at home. He knew they would dissuade him or that his nerve would fail him.

At the very end of October 1915, he went to Whitehall and joined up. Like Francis Thompson arriving penniless in London years before, Rosenberg had a book in both his coat pockets. One was a copy of Donne's poems, the other was Sir Thomas Browne's *Religio Medici*. Opposed to killing, he requested service at Whitehall with the medical corps. Although on examination he was found to be physically fit, he was too short to qualify either for the medical corps or for any regular regiment. However, some six weeks before he enlisted, the government, aware that it was losing the services of men who were healthy but small in frame, authorized the formation of a 'Bantam' battalion to be part of the newly-created Fortieth Division. Not only was the regulation height reduced, the overall physical requirements were relaxed from the outset in order to provide a means of absorbing men 'whose general physique was obviously unequal to the strain of military service'. From Whitehall Rosenberg was sent to the Depot at Bury St. Edmunds. He had left home with a comb and a handkerchief, purposely taking nothing that would arouse his mother's suspicions. Besides, he assumed that the army would issue uniforms and provide for all his immediate needs.

As soon as he had been sworn in and he knew that his enlistment was irrevocable, he wrote a hurried letter to his parents. Hacha was used to Isaac's comings and goings ever since he'd had a studio, so she was not unduly worried at his being away overnight. However, his letter confirmed her instinctive fear. Tragedy had struck, and, from her point of view, needlessly. She raged and sobbed and would not be comforted. To reassure her, Rosenberg wrote that he had signed on for home service only, but it was a lie which they soon took the trouble to discover. At one point she seemed near collapse, but she pulled herself together and listened, in deep despair, to her children and her friends who advised her to seek his release. Barnett was angry, perplexed and helpless. Neither he nor Hacha ever recovered from this blow, which led ultimately to the final calamity.

Rosenberg also sent a letter to Marsh. The Draconian reality of army life had forced itself on Rosenberg from his first hour: 'I have just joined the Bantams and am down here amongst a horrible rabble.

Falstaff's scarecrows were nothing to these. Three out of every 4 have been scavengers, the fourth is a ticket-of-leave.[52] But that is nothing; though while Im waiting for my kit Im roughing it a bit, having come down without even a towel. I dry myself with my pocket-handkerchief' (*PIR*, p. 25). The rigours of induction, however, could not daunt the poet in him: 'I meant to send you some poems I wrote which are better than my usual things but I have left them at home where I am rather afraid to go for a while — I left without saying anything' (*CW*, p. 301).

A third letter, to Schiff, gave additional details of army life in the Recruiting Depot. He could put up with sleeping rough and with the gruelling long marches, but he was utterly revolted by the behaviour of his fellow soldiers. The last straw was having to eat out of the same basin as 'some horribly smelling scavenger who spits and sneezes into it etc'. This was truly 'unbearable'. His Jewishness as well as his fastidiousness made things difficult for him among these 'wretches', and he was gloomily prepared for 'a bad time altogether'. However, he was sending some of his old pictures to the New English Art Club, and hoped Schiff might see them there (*CWL*, p. 10).

Some ten days before Rosenberg began to suffer these indignities to his body and spirit, Wilfred Owen, having returned from France, enlisted in the Artist's Rifles. His first days in the army as an officer candidate were in marked contrast to Rosenberg's: he kept his room in a boarding house in Tavistock Square, had complete mobility, and after his inoculations was given three days' sick leave, a portion of which he spent at Harold Monro's Poetry Bookshop a few minutes away in Devonshire Street. After his inoculations, Rosenberg asked for, and by army rules was entitled to, forty-eight hours' sick leave, but he was refused a pass to spend it with his parents. While he waited weeks for his kit and khakis, training continuously in his one civilian suit, Owen's uniform was issued immediately, though he had to buy his own belt and swagger cane.

Owen was exhilarated by his new experiences; Rosenberg was depressed but not defeated. The difference was in their life-styles. Owen had been reared as a gentleman. Though he was poor and asked for money perhaps more frequently than Rosenberg, his station in English life was secure and not without its comforts. He was an Englishman doing his duty, with honour, stoic reserve, and a well-tempered optimism nurtured by his English heritage. Instant camaraderie was his for the asking. Both he and Rosenberg would demonstrate their bravery, but Rosenberg's courage sprang from a different source. He enlisted without illusions and without un-

warranted expectations. He had been familiar throughout his life with the type of men he was now associated with, and while their manners were repulsive to him, he had no cause for surprise. They were no more and no less oppressed than he was. His problem was his acute sensitivity; he faced up to this new experience boldly, as he always did, but willingness to open oneself to experience is not necessarily concomitant with any unusual cushion of strength to absorb the painful aspects of the experience. Rosenberg suffered, finding endurance in his own faith in himself as a man and as a poet, in his stubbornness, in necessity, and in his determination to make his mark on his age. He was miserable and he complained, he was frustrated and he cried out for relief, he brought punishments upon himself and cursed his luck, and he persevered. Though Silkin sees his struggle largely in terms of his Jewishness and working-class origins, I am convinced that ethnic and class limitations were only part of the central dilemma of his life. His peculiar personality, his iconoclasm, and his image of himself as a poet were primarily responsible for his embattled position against external opposing forces which were protean in their manifestations. Going to war was not for him a new dimension of life, it was simply an extension of the old one; the only difference was that the handicaps were greater and the stakes higher. Writing to thank Schiff for his understanding and his moral support, Rosenberg acknowledged the danger of the enterprise upon which he was now engaged, but emphasized his strong belief that the war experience might bring about in him a much-to-be-desired spiritual and physical transformation; he might 'be renewed, made larger, healthier' (*CWL*, p. 12).

It is true that Rosenberg's military service made him more conscious of his Jewishness. He encountered anti-Semitism both from his fellow-privates and from his superiors. '. . . I have a little impudent schoolboy pup for an officer, and he has me marked,' he wrote Marsh, 'he has taken a dislike to me: I don't know why' (*PIR*, p. 28). Before he joined up Rosenberg was keen to write a play about Moses. Being reminded continually of his own Jewishness brought the Moses theme to the forefront of his mind and influenced the nature of the characterization. Among the first poems he composed in barracks was a short protest which he called 'The Jew':

> *Moses, from whose loins I sprung,*
> *Lit by a lamp in his blood*
> *Ten immutable rules, a moon*
> *For mutable lampless men.*

The blonde, the bronze, the ruddy,
With the same heaving blood,
Keep tide to the moon of Moses.
Then why do they sneer at me?
 (*PIR*, p. 103)

This Moses, the law-giver, however, was not the one who began to take form in Rosenberg's mind as he snatched a few minutes here and there from his duties to piece his play together. Rosenberg envisaged him in his young manhood, in much more forceful guise.

His new friendship with Schiff also contributed to his growing consciousness of being a Jew. They communicated easily; both responded sympathetically to their ethnic origins and cultural heritage; neither was concerned about institutional appurtenances, liturgy or ritual. They were never overwhelmed, never obsessed, with the religious aspects of Judaism. To Schiff Rosenberg could say things which would have been inappropriate for Marsh. Rosenberg continued to see himself as an English poet in the making, and the boundaries of his precise view of himself would be reflected in a letter of high praise that Bottomley wrote to him on July 4, 1916. 'There is nothing,' Bottomley avowed, 'you cannot do when you have once made firm your hold on the qualities within your reach. There is a great field still almost untouched in the Old Testament stories; the right way of handling them has scarcely been found yet in English Poetry, but I believe you have it in your means if you care to go on with it.'

Rosenberg's bad luck followed him into camp. Though he was prepared to endure privations, he soon found he had to contend with a multiplicity of unanticipated troubles. At the end of the first week of training his poor physical coordination landed him in the camp hospital. While doing running exercises in front of the Colonel he 'started rather excitedly and tripped . . . coming down pretty heavily in the wet grit' (*PIR*, p. 26), badly cutting both his hands. Moreover, he was hungry — rations were inadequate and poorly prepared. In hospital, he was on smaller rations still. Schiff had sent some money in answer to his first letter, and this Rosenberg used for 'some shaves and suppers' (*CWL*, p. 12). To relieve the enforced boredom he asked Schiff for water-colours and did sketches of the other patients which he was obliged to give to them. Confined, he was restless, and he wanted to be out working, particularly as the hospital had its own tyrant equal to any he had ever encountered: 'The doctor here too, Major Devoral, is a ridiculous bullying brute and I have marked him

for special treatment when I come to write about the army' (*CWL*, p. 11).

Rosenberg did not hesitate to confide in Schiff, and in hospital he needed his help. Though he was writing home regularly he had said nothing about his poor rations, and his letters bore his regular address rather than the hospital's. He had hurt his mother too much already, and he wanted to spare her any more pain. Being unaware of his needs his family made no immediate effort to send him parcels, though Hacha was soon in the habit of posting food and clothing packages regularly, sending anything he requested: sweets, rolls, tinned goods — even eggs, butter, and borsht. As it was he relied on Schiff and Marsh, whom he asked to send chocolates and a novel. Meanwhile he had plenty of time to think, and in his reflections he admitted to himself that he would never achieve any real success as a painter. This self-truth he communicated to Marsh who had taken individual poems of his seriously but had not thought of him principally as a writer:

> I believe in myself more as a poet than a painter; I think I get more depth into my writing. I have only taken Donne with me and don't feel for poetry much in this wretched place. There is not a book or paper here; we are not allowed to stir from the gate, have little to eat, and are not allowed to buy any if we have money, and are utterly wretched (I mean the hospital.)
>
> (*PIR*, p. 27)

In the same letter Rosenberg apologized for the near-hysterical pressures his family had put on Marsh to secure his release when Hacha learned he had signed up for general service (*CW*, p. 303).

Out of hospital, Rosenberg returned to his duties. Winter was coming on; it grew dark in the afternoons. The work and the bullying complemented each other and seemed never-ending. Rosenberg was issued his uniform and began to look something like a soldier. Now he had a new problem; this time with his feet. Owen in London and Rosenberg in Bury St. Edmunds both had their army boots issued about the same time. However, Owen's officers told him how to soften them so they could be worn: 'This morning I have massaged my new boots with Castor Oil. We were told to *pour* it inside the boot! The stench resulting is perhaps the very first inconvenience I have yet endured.' Rosenberg's officers did not pass this information on to him. He reported to Marsh that he was doing 'coal fatigues and cookhouse work with a torn hand, and marching ten miles with a clean hole about an inch round in [his] heel' (*PIR*, p. 29), because no officer had told him the boots had to be soaked in oil before they

could be worn. He wrote to tell Schiff that the most recent money sent had been used to buy boots as those he was issued had 'rubbed all the skin off [his] feet' and he was 'marching in terrible agony' (*CWL*, p. 11). The boots he bought with Schiff's money plus some from home and his first several weeks' pay were three to four sizes too large as his feet were swollen. They were all he could wear, and then only for a short time.

He liked the drill and managed the routine satisfactorily as long as he kept his mind on his simple tasks.[53] He never once gave up or fell out of a march. His only real pleasure was that Abercrombie had finally written to him. He had given up hope of hearing from him, not knowing that Abercrombie, himself not well, was preoccupied in 1915 with his wife's serious illness. Rosenberg was astonished when he wrote 'A good many of your poems strike me as experimental and not quite certain of themselves. But on the other hand I always find a vivid and original impulse; and what I like most in your songs is your ability to make the concealed poetic power in words come flashing out. Some of your phrases are remarkable; no one who writes poetry could help envying some of them' (*CWL*, p. 11). Abercrombie's praise signalled a turning point in Rosenberg's luck, His circumstances were no better but his spirits were higher and his troubles passed.

By late November and early December Rosenberg had adjusted to his routines and made a few friends among his fellow soldiers, mainly by giving them the cigarettes he was sent and by sketching them. They respected this talent. Somewhere, mounted in dusty scrapbooks or lying in unopened attic draws there must be a few faded water-colours of soldiers who served in the Great War, painted by an unidentified hand. Probably they will never be recovered. For the most part, Rosenberg kept to himself and used his free time on Sundays to work on his draft of *Moses*. It was coming along slowly. His sergeant had noticed he was more intelligent, conscientious and hard-working than the majority of the other recruits, and he recommended him to the commanding officer for promotion to lance corporal. When it was offered to Rosenberg, however, he declined (*CW*, p. 305). It was one thing to serve in the army during wartime, it was quite another to accept and become part of it by moving up through the ranks.

The one thing that really mattered to Rosenberg was Christmas leave, and this he got. He had not seen his family since he joined up, and he was out of touch with his friends, unable to keep any correspondence going apparently, except to his parents and his two

patrons. Next to his family, he worried about Sonia and Rodker and Gertler, about whom he had heard nothing though he had asked Marsh for news of him several times. He was unaware that Gertler had sent Marsh a formal letter rejecting his support and breaking with him completely over the war.[54] Just before going on leave Rosenberg heard that Bomberg had enlisted in the Royal Engineers in November and subsequently had been transferred to the King's Royal Rifles.[55]

Rosenberg had four days' leave. Hacha wept for joy and practically turned his homecoming into a state occasion. Neither he nor his mother admitted their fears for the future. He stayed in the house, going out only to see the friends he needed to contact. These included Sonia and Rodker; 'Crazy' Cohen, with whom he made plans for the eventual publication of *Moses;* Schiff; and probably Annetta Raphael. Though by arrangement half his pay had been deducted since his enlistment, Hacha had received nothing. If Schiff purchased one of his oils, he would be able to leave some money with her and this he wanted desperately to do in case anything happened to him. He took what he had for Schiff's inspection. He apparently missed Marsh, who was not only extremely busy at Christmas, but more depressed than ever. The War Council had been reconstituted in November and Winston Churchill had not been recalled. After making a moving farewell address in the House of Commons, and arranging for Marsh to have a secretaryship — which Marsh did not want with the Prime Minister — Churchill left immediately for the front to serve as an officer in the Grenadier Guards. Marsh was at a loose end. One suspects that while they remained close, neither Marsh nor Rosenberg felt any special need to see one another. As long as Gertler was around and Rosenberg had drawings to repay Marsh for his kindnesses, their relationship achieved a kind of balance. Now it was awry.

His leave ended, Rosenberg returned to camp. He was in high spirits. There were rumours of a move before Christmas and in early January 1916 he was transferred to the 12th South Lancashires at Blackdown Camp near Aldershot. It was not much of an improvement, since the other Bantams were transferred with him, the food was just as bad and the rations were scantier than before. He had to rely upon Hacha to send parcels of food regularly. He lost five shillings in the post. His spirits dropped again when he caught a severe cold from sleeping on a damp floor, and despite his feeling unwell, he was assigned to coal-shovelling fatigues (*CW,* p. 306). He sustained himself with thoughts of his past leave, knowing that all

was well with Hacha and he no longer need feel any guilt. He was also cheered by the fact that he was now known in the battalion 'as a poet and artist'. The 'second in command,' he wrote Schiff, 'is a Jewish officer who knows of me from his people' (*CWL,* p. 14). Schiff, moreover, was considering the purchase of one of his paintings for five guineas.

With his verse-drama *Moses* almost ready, Rosenberg started thinking again of writing short poems. He had composed one poem just prior to going on leave, called 'Marching, (As Seen From the Left File)', which he sent to Marsh. As usual, Marsh did not like it so Rosenberg revised it, adding several more lines. He kept firm control of his images, moving from the particular cadence of soldiers marching to a universal awareness of the war's destructive force:

> *My eyes catch ruddy necks*
> *Sturdily pressed back —*
> *All a red-brick moving glint.*
> *Like flaming pendulums, hands*
> *Swing across the khaki —*
> *Mustard-coloured khaki —*
> *To the automatic feet.*
>
> *We husband the ancient glory*
> *In these bared necks and hands.*
> *Not broke is the forge of Mars;*
> *But a subtler brain beats iron*
> *To shoe the hoofs of death*
> *(Who paws dynamic air now).*
> *Blind fingers loose an iron cloud*
> *To rain immortal darkness*
> *On strong eyes.*
>
> (*PIR,* p. 88)

The poem was not acceptable to Marsh because of its modern idiom couched in severely classical terms. But perhaps there was another reason too. When Rosenberg sent it to him, he enclosed it in a letter that must have irritated his patron. Intensely patriotic and deeply involved through Churchill in the war effort, Marsh fretted at being debarred from an effective role in England's time of need. In that mood he received Rosenberg's letter asking him to contact the War

Office to straighten out the deduction allowance. The request was prefaced by the words, 'I never joined the army from patriotic reasons. Nothing can justify war' (*CW*, p. 305). Rosenberg's knack of saying the inappropriate thing to Marsh was uncanny.

However, Marsh wrote to the War Office and the matter was resolved. Rosenberg's urgency grew out of fear for his own safety. He had been thrown into the midst of ruffians who, as part of their preparation for combat, were being methodically goaded, through bullying and hunger, into violence. Their elemental responses were constantly threatening. He was receiving packages of food from home several times a week, and he always appeared to have a few pence on him. The tension in his battalion was such that he knew these men would kill to obtain the little that seemed to come easily to him. Drunkenness and brawls were common; rumours of removal to the war zone were rampant, and these aggravated the strong undercurrent of recklessness that Rosenberg sensed. He told Schiff he had enough to eat, 'but as for the others, there is talk of mutiny every day. One reg[iment] close by did break out and some men got bayoneted' (*CWL*, p. 14). Thievery was a routine occurrence: 'Every other person is a thief,' he wrote to Miss Seaton, 'and in the end, you become one yourself, when you see all your most essential belongings go, which you must replace somehow' (*PIR*, p. 30). He related to Marsh his real fear of personal harm when he wrote to thank him for contacting the War Office: 'I believe my people are getting my 6d a day deducted from my 1s, but not the allowance [of 16 shillings, 6 pence allotted on induction]. We get very little food you know and sometimes none so if one has only 6d (and often for unaccountable reasons it is not even that) you can imagine what it is like. If I had got into a decent reg[iment] that might not have mattered, but amongst the most unspeakably filthy wretches, it is pretty suicidal' (*CW*, p. 306).

Fortunately, the army itself rescued Rosenberg from his fears. Having lowered the physical requirements for Bantams, the military authorities were forced to recognize during their training over the winter that large numbers of them were physically and psychologically unsuited to be soldiers. Ironically, Rosenberg was not among them. In March 1916, a drastic weeding-out was initiated in the Fortieth Division, reducing through medical rejections the number of recruits in Rosenberg's battalion from more than one thousand men to little over two hundred. The worst offenders were gone. Rosenberg and those who remained were transferred to the Eleventh King's Own Royal Lancasters — the regiment with which he was to

spend most of his remaining months — still in training in Aldershot.
As this was a regular army unit, the food was both ample and better.

On his first day in the new regiment, Rosenberg allowed himself to
think about *Moses* with the result that he forgot to carry out orders.
He was severely reprimanded and subjected to 'a rotten and unjust
punishment' (*CW*, p. 369). *Moses* occupied his thoughts continually
now that he was relieved of the fear of personal attack, and he was
anxious to get the verse-drama into print before he left England. He
wanted desperately to be home for the Passover holiday to complete
his arrangements for *Moses*. His punishment and the fact that target-
practice was scheduled for his company over the holiday kept him
from obtaining a pass.

While he was working on *Moses* in the first months of 1916 he
composed a poem, entitled 'Spring 1916'. Like 'Marching' it was
more advanced than his previous work. In it he developed a meta-
phor of the spring as a woman in a grotesque mask, far different
from the happy creature with whom he had consorted two years
before. Rosenberg thought that 'Marching' and 'Spring 1916' were
his 'strongest work' (*CWL*, p. 14) and he sent copies to Schiff,
Abercrombie, and also to several London papers in the hope that one
poem or the other might be accepted. They were not, and he sur-
mised correctly that his 'public [was] still in the womb'. 'Marching',
however, was under consideration in America. When Rosenberg
visited Rodker during his Christmas leave, the latter, still living with
Sonia in unbridled poverty, had told him of Harriet Monroe and
Poetry Magazine. She had accepted a few of Rodker's poems and he
wrote to her shamelessly detailing his destitutions, begging for their
early appearance, for payment, and for the acceptance of large
batches of other poems. Though impecunious, he posed as a person
of influence and wide contacts. Whether he offered or Rosenberg
asked him to, he sent two of Rosenberg's poems including 'Marching'
to Harriet Monroe in January 1916, with a long letter in which he
wrote to her shamelessly detailing his destitution, begging for their
Rosenberg. His poems are rare & remarkable gems & have won
approval from most eminent men of letters in England. But I will not
dilate on their quality — though the form is conventional, the matter
is ultra-modern & I am sure it will appeal to you. Myself I am
convinced — It is great work'.

Harriet Monroe decided to print 'Marching', but she was uncertain
of the punctuation in one line and wanted permission to delete
another. She wrote back immediately asking Rodker to contact
Rosenberg. Rodker either did not know where Rosenberg was sta-

tioned — though he could have discovered his whereabouts easily enough — or could not be bothered to write to him. In March he wrote to Harriet Monroe: 'I return Rosenberg's poem as requested. I have not been able to get hold of him as he has enlisted & is moved over the country with such rapidity that letters do not get forwarded. I think the punctuation is all right but there should be a full stop after "... hoofs of death" and certainly the line "Who paws dynamic air now?" should be kept. It is very fine.' He added a note on Rosenberg's age, mentioning that he had attended the Slade and won prizes. When the typescript reached Chicago Harriet Monroe prepared it for press and marked it 'Print soon'.[56] That was in April 1916. The poem appeared in December.

By May 1916, the Fortieth Division had completed its basic training and was preparing to be transported to the war zone. Preembarkation leave began on Monday, May 15. Rosenberg had six days' furlough shortly afterward. He was anxious to go to London and help 'Crazy' Cohen prepare his verse-drama *Moses* for the press. He spent most of his time with Cohen, since Hacha, though still worried, was now more relaxed about him. She did not know he was leaving the country and Rosenberg decided to keep the bad news from her as long as possible. Schiff was away, and he missed seeing Marsh, having arrived at Raymond Buildings very late for his appointment, after overstaying a meeting with Cohen. He talked to Sonia and Rodker who told him that Harriet Monroe would most likely publish 'Marching'; and that the poets R. C. Trevelyan and Gordon Bottomley had read *Youth* and thought it 'startlingly fine' (*CWL*, p. 15). Though Rosenberg had hoped to distribute copies of *Moses* himself before he returned to camp, there was no time and Annie agreed to undertake the task. Even she did not know he was bound for the front. Rosenberg quietly put his affairs in order and returned to camp.

He was back in barracks by Thursday, May 25, when the King came to inspect his regiment and ceremoniously proclaim its readiness for action. The next day the advance party of the Fortieth Division moved out, going first to Folkestone and thence to Lillers to arrange for billets and supplies. On Monday, May 29, the first units left Blackdown for Southampton to embark for France. Rosenberg turned in his camp gear, was given a routine physical check-up which he passed, and waited. Having missed Schiff while on leave, he wrote to him to inform him that he was at last on his way overseas and that he would write from his new post. He announced that he'd had another pamphlet of poems printed (*Moses*), and told Schiff that he

would have a copy sent to him. If Schiff liked it, wrote Rosenberg, he might also like to have bound copies for himself and friends. These had been prepared to help defray the expenses more speedily, for, as usual, the printing had been undertaken on the promise of future payment. Thinking Schiff might order copies, he gave him Annie's address, admonishing him not to reveal to her the information that he was no longer in England. He would spare his mother that news as long as possible. Summing up, he told Schiff he was in good health and good spirits and felt 'ready for the rotten job' facing him (*CWL,* p. 15).

Rosenberg waited until the last possible moment to write and tell Annie that he was going overseas. He sent a card to her at the office where she worked, on Wednesday, May 31. Recalling the event, Annie said 'I asked my boss for the day off [Thursday, June 1] and went to Aldershot. It was bleak. I didn't see a soul except Isaac coming towards me from the other side of the high fence. Talking to him through the wire I said, "But Isaac you're not fit." He said, "I've been examined, and passed." I asked him to let me go and see the medical officer. He wouldn't let me do it. I asked him how much money he had, and he replied "One shilling." I didn't know whether he needed anything, but had ten shillings with me, which I gave him. I wasn't with him more than an hour. I stood there begging him not to go. He said goodbye and disappeared into the distance. I just stood at the fence feeling as if somebody had given me a good hiding.'

The last letter Rosenberg wrote before he sailed was to Abercrombie, whom he sent a copy of *Moses,* with the request that if he contacted Annie for more copies, he should not mention Rosenberg's departure for the Front (*CW,* p. 347).

By nightfall on Saturday, June 3, Rosenberg was on French soil. Although filled with apprehension, he was determined to record his new experiences. He made a sketch of himself on board the transport and wrote a poem describing his crossing, called 'The Troop Ship':

> *Grotesque and queerly huddled*
> *Contortionists to twist*
> *The sleepy soul to a sleep.*
> *We lie all sorts of ways*
> *And cannot sleep.*
> *The wet wind is so cold,*
> *And the lurching men so careless,*
> *That, should you drop to a doze,*

Winds' fumble or men's feet
Are on your face.

(*PIR*, p. 87)

Two days later, when the last units reached France, the Fortieth Division began to move toward the Somme battlefields.

15

Moses
1916

By the time Rosenberg crossed the English Channel to France, seven
months of infantry training had broadened his experience of life. He
had slept on hard, damp floors, mastered drill, gone hungry for long
periods of time, familiarized himself with small arms, become an
authority on army boots, performed extended cookhouse duty and
cleaned latrines. He had stood guard and inspection, dug trenches,
and shovelled a lot of coal. In between his endless tasks and his
frequent punishments, he had learnt the technique of violence and
the meaning of power, lessons which he used in great measure in his
verse-drama *Moses*.

When he gave his draft of *Moses*, composed mainly in the pages of
a diary, to Cohen, the latter was eager to print it, even though
Rosenberg had no money to pay the costs. With access to
Narodiczky's machines, but operating from his own tenement flat,
Cohen established the Paragon Printing Works; and it is his imprint
that appears on the bright yellow soft-card covers of the little book-
let. Besides the play, which occupied eighteen of the pamphlet's
twenty-six pages, Cohen printed a title page and nine of Rosenberg's
poems. Of these, 'Spring 1916' followed the title page, with the
remaining eight poems coming after the play. Several poems were
reprinted from *Youth*.[57] How many copies were printed is not
known, but Cohen took a quantity of them to an East End character
known as Mendel the Bookbinder, who bound them in a thin, dark,
wine-coloured cloth. These were to be sold at four shillings and six
pence, while the unbound copies were priced at one shilling.[58] If
Rosenberg recovered his costs or ever paid Cohen, it is not on record.
To my knowledge Rosenberg's booklet was the only item ever pro-
duced by the Paragon Printing Works — certainly neither it nor any
other publication by Cohen found its way into the British Museum.

Cohen went back to Russia in 1917 and was not heard of again. Like *Night and Day,* copies of *Moses* rarely come onto the antiquarian market and they are consequently extremely valuable.

The play until recently has been regarded as a challenge by critics. Though it has been praised and condemned through the years, looked upon with awe, and invoked as the prime evidence of Rosenberg's Jewishness, only two critics, Jon Silkin and Dennis Silk, have attempted at any length to come to grips with its meaning. Yet it is a natural progression of Rosenberg's development as a poet. It not only pulls together several key motifs in his thinking, but also provides a foundation for what was to follow. This is not to invest Rosenberg's work with any sustained cohesiveness or to suggest that the verse-drama is manifestly successful. It could not, for example, ever be produced on stage, but then, there is no indication that Rosenberg thought of it in terms of the theatre. The simple stage directions are nothing more than notices to the reader. While it would not long interest an audience — except a highly specialized one, sympathetic to its origins — it has much literary worth to commend it, not the least of which are its several levels of interpretation.

Both Silkin and Silk see the play as a *moral* study in the application of power and violence to eradicate an evil authority and advance civilization in the direction of individual and collective freedom. Another commentator, E.O.G. Davies, in his unpublished thesis on Rosenberg, takes the opposite view that 'Moses . . . is a force lacking a moral definition'. Davies's view, though it reinforces the position taken originally by Marsh and more recently by Bernard Bergonzi, that Rosenberg lacked sufficient control to clarify and present effectively his protagonist's thought processes, is by comparison with the work of Silkin and Silk no longer tenable. On the other hand, Silkin goes further than is necessary in speculating that Rosenberg was depicting a 'class struggle', since the Hebrews comprised in Egypt a 'proletariat', oppressed both as an ethnic entity and a socio-economic class. He comes closer, it seems to me, to Rosenberg's true impulse when he mentions in passing Rosenberg's rejection of the 'rotting God' and the decayed authority which that arbitrary Old Testament deity represented.

Silk interprets the play as Rosenberg's effort to free his co-religionists in England from their own entrapment in 'commercial brutality' and 'pointless over-sensitivity'. Rosenberg, however, was never much concerned about the mores of the Anglo-Jewish community. Much more to the point is Silk's analysis of Rosenberg's Jewishness through his use of language in *Moses* and his other mature

poems. 'Rosenberg,' Silk avers, 'is nowhere more Jewish, or rather Hebraic, than in the active and dynamic quality of his thinking', using a definition of Thorlief Boman in his contrast between the Hebrew and Greek modes of thought: 'If Israelite thinking is to be characterized, it is obvious first to call it dynamic, vigorous, passionate, and sometimes quite explosive in kind: correspondingly, Greek thinking is static, peaceful, moderate and harmonious in kind.' This description of 'Israelite thinking' does, indeed, describe Rosenberg's poetry, particularly *Moses*. Perhaps this also explains why Marsh, who took first class honours in the classics at Cambridge, could never sympathize with Rosenberg's idiom.

These several interpretations give us valuable insights into the meaning of *Moses*, but they tend to be over-specialized. It seems to me that *Moses* is simply an extension of the poet Rosenberg; in it, practically every aspect of his life, from his own character to his rejection of God, from the dominant influence of his mother to his unrequited love for Sonia, from his hatred of army life to his need to prove himself as a soldier, coalesce. *Moses* is his culminating poem on the theme of his rejection of God; it goes back to and incorporates the ideas he struggled with in 'Creation', his admiration for Coleridge's 'Sole Positive of Night', his successively defined image of the baleful God in 'Spiritual Isolation', 'The Blind God', 'The One Lost', 'Invisible Ancient Enemy of Mine', and 'God Made Blind'. It was composed amid the throes of a dying civilization, tyranically oppressed by a harsh, spiteful omnipotence whom he described in 'God', the first poem following the play (and incorporating lines from it), as possessing a 'malodorous brain' filled with 'slugs and mire', and a body lodging a rat (*PIR*, pp. 182-83) — the most loathsome image he ever encountered. In 'Creation' and 'God Made Blind' Rosenberg substituted a concept of Aristotelian growth for the poet who then superseded God and in *Moses* this motif is fully expressed. Rosenberg invests Moses with a 'giant frame' facilitating his rejection of the despised omnipotence:

> *I am sick of priests and forms,*
> *This rigid dry-boned refinement:*
> *As ladies' perfumes are*
> *Obnoxious to stern natures,*
> *This miasma of a rotting god*
> *Is to me.*
>
> (*PIR*, p. 60)

As Moses grows larger and more powerful, his 'rotting god', characterized by the Egyptian taskmaster Abinoah, shrinks in size. Rosenberg transfers to Abinoah the attributes of the deposed God, who busies himself inventing new tortures for his slaves. Moses mockingly addresses him as his father, as he has been sleeping with Abinoah's daughter, Koelue, who represents the earth goddess. Throughout the play Rosenberg's symbols are consistent: just as Moses masters Abinoah and consorts with Koelue, so Rosenberg the poet manages to reject God and embrace the earth goddess. The latter union, however, is soon terminated. In the army, Rosenberg was removed from his normal associations with women. As his energies were heavily drained by his labours, he contracts this aspect of his life by ending Moses' affair with Koelue, and modifying her role from that of a simple bed-mate to an incarnate sexual power:

> *Ah, Koelue!*
> *Had you embalmed your beauty, so*
> *It could not backward go,*
> *Or change in any way,*
> *What were the use if on my eyes*
> *The embalming spices were not laid*
> *To keep us fixed,*
> *Two amorous sculptures passioned end-*
> *lessly?*
> *What were the use if my sight grew,*
> *And its far branches were cloud-hung,*
> *You small at the roots like grass;*
> *While the new lips my spirit would*
> *kiss*
> *Were not red lips of flesh,*
> *But the huge kiss of power?*
> *Where yesterday soft hair through my*
> *fingers fell*
> *A shaggy mane would entwine;*
> *And no slim form work fire to my thighs,*
> *But human Life's inarticulate mass*
> *Throb the pulse of a thing*
> *Whose mountain flanks awry*
> *Beg my mastery — mine!*
> *Ah! I will ride the dizzy beast of the world*
> *My road — my way.*
>
> (*PIR*, pp. 61-62)

The speech acknowledges the poet's re-direction of his energies to the requirements of war. When Marsh read the play he was sufficiently moved by the beauty of these lines to include them in *Georgian Poetry 1916-17*, though this one passage was all Rosenberg was ever to have in Marsh's five Georgian anthologies.

Though Rosenberg was opposed to killing, he showed no hesitation at the close of the verse-drama in having Moses violently dispatch Abinoah. Denys Harding, Rosenberg's editor in the 1930s, explains the poet's justification for violence as 'a necessary aspect of any effort to bring back the power and vigour of purpose which he [Rosenberg] felt the lack of in civilized life'. In Blackdown Camp violence infused 'civilized life' and Rosenberg was forced daily to confront its reality.

Moses, then, is Rosenberg in the winter of 1915-16, fulfilling himself as a poet in a quickened, over-energized moment in history, corresponding mythically to its parallel moment in ancient Egypt. Not only Blackdown Camp but the Recruiting Depot at Bury St. Edmunds as well, revealed to Rosenberg more clearly than ever had either his poverty or his ethnic origins what it meant to be a slave, a term he used repeatedly in his camp letters. Constantly hungry, it is not surprising that his play is marked by the famine in Egypt.

Having said this much, it remains to be observed that neither my remarks nor those of Silkin, Silk, Davies, or Harding, all taken together, constitute a full mining of the verse-play's rich ore. In its five hundred lines there are other treasures: commentaries by Rosenberg on his craft and his condition, and allusions to poets and artists. One example will suffice: 'I have seen splendid young fools cheat themselves/ Into a prophet's frenzy; I have seen/ So many crazèd shadows puffed away,/ And conscious cheats with such an ache for fame/ They'd make a bonfire of themselves to be/ Mouthed in the squares, broad in the public eye' (*PIR*, pp. 67-68). Rosenberg's splendid young prophet would have been Rupert Brooke; the 'crazèd shadows puffed away', John Currie and Maxwell Lightfoot, the artists who killed themselves over their faithless models; the 'conscious cheats', Bomberg and Rodker, for both had in a sense made bonfires of themselves in public, one with his outrageous designs and utterances, the other with his shameless, flamboyant devices for attracting attention to himself. Rodker was already near hysteria over conscription, and in announcing himself at the time as a conscientious objector must well have appeared to Rosenberg as a 'conscious cheat'.

There are other subtleties similar to these yet untracked in *Moses* and in Rosenberg's other poems. The quality of subtlety has not yet

been adequately recognized in Rosenberg's work, but it is as funda-
mental to an understanding of his poetry as irony is to an under-
standing of Owen's. What has often been regarded as obscurity in
Rosenberg is in fact a multi-layered subtlety where the treasures of
meaning lie in chambers behind the several doors of his own assimi-
lated experiences. The keys to these doors are the principal aspects
of his life coupled with his formula for the construction of images,
evolving them whole and multi-faceted in a linguistic creative spasm
intended to convey a complete idea. Denys Harding defined
Rosenberg's method as an approach in which words are not found
and utilized one by one to piece together the idea, but where the
idea 'manipulate[s] words almost from the beginning, often without
insisting on the controls of logic and intelligibility'. Yet this is no
lazy formlessness, for Rosenberg, under continuing pressure from
Marsh and Binyon, to say nothing of his own self-criticism, agonized
over the charges of structural looseness he received. Marsh and Binyon
wanted relaxed illustrations and examples; Rosenberg's mental
endowment could produce only an accelerated, complex tumbling of
metaphors one on top of the other, through which a conglomeration
of images expanded and then conveyed the idea, perhaps over-
abundantly expressed. Perceptively, Harding noted that Rosenberg's
method led to 'a habit of reworking phrases and images again and
again', and that the 'more interesting images [thus modified] carried
with them a richer or subtler meaning than Rosenberg could feel he
had exhausted in one poem, and he would therefore use them again
in another'. Harding traces several of these images to prove his point,
without insisting, however, that obscurity is effectively eliminated
once the reader is cognizant of the subtlety.

Two poems printed in *Moses* and composed during the same
period give further evidence of Rosenberg's subtle multi-layering of
images to express an idea. The short lyric 'First Fruit' read at its
surface level seems simply to be a poem of resignation over missed
sexual opportunities:

> *I did not pluck at all,*
> *And I am sorry now:*
> *The garden is not barred*
> *But the boughs are heavy with snow,*
> *The flake-blossoms thickly fall*
> *And the hid roots sigh, 'How long will*
> *our flowers be marred?'*

Strange as a bird were dumb,
Strange as a hueless leaf.
As one deaf hungers to hear,
Or gazes without belief,
The fruit yearned 'Fingers, come!'
O, shut hands, be empty another year.
 (*PIR*, p. 163)

The imagery is familiar: the open-gated garden, intricate snow flakes, flowers unfertilized, silent birds, colourless leaves, deafness and blindness, accompanied by yearning for fulfilment. Apart from unfulfilled passion, what meanings inhere in the poem? From Rosenberg's experience, the poem could be a reflection on his not getting into the avant-garde art movement, or it could represent his reluctance to take the easy path into Georgian verse. More likely it is a reflection on his lack of boldness as a suitor to Sonia before she chose Rodker. Another possible explanation, based on the use of the present tense in the line 'The garden is not barred', is the realization that while he has shared intimacies with Annetta Raphael, he has not, out of his lingering passion for Sonia, reciprocated Annetta's offers of love. Deprived of both Sonia and Annetta, the poet poignantly acknowledges the prospect of emptiness he must face indefinitely. Whatever the true nature of the circumstances underlying his relationships with the two women, they give the poet an almost inexhaustible range of possibilities, permitting him to sculpt his images from different points of view. This may be perplexing to some, too quick to charge Rosenberg with obscurity, but those who are willing to piece together the life and the work can only luxuriate in the richness of Rosenberg's subtleties.

His 'Chagrin' uses precisely the same technique and amplifies the same theme of resignation. At the obvious level the poem, which employs as its principal image David's renegade son, Absalom, caught by his hair on the boughs of a tree, appears to be an effective portrayal of the poet trapped between his dual inheritances of Judaism and Christianity. The critic Horace Gregory, Avner Fellner (who wrote a master's thesis on Rosenberg in 1960) and Jon Silkin interpret 'Chagrin' from that point of view. Gregory quotes a stanza from it as a realization of Rosenberg's intention 'to write out of and within the Jewish tradition'; Fellner sees the poet as an 'outcast', suspended 'between an older Jewish society he no longer accepts, and a Christian ethical society which, even in decay, will not accept him'; and Silkin describes the poem as Rosenberg's articulation 'of

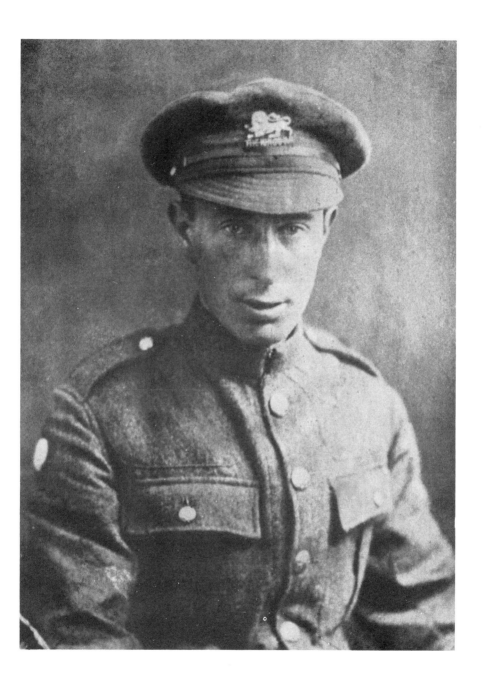

Private Rosenberg

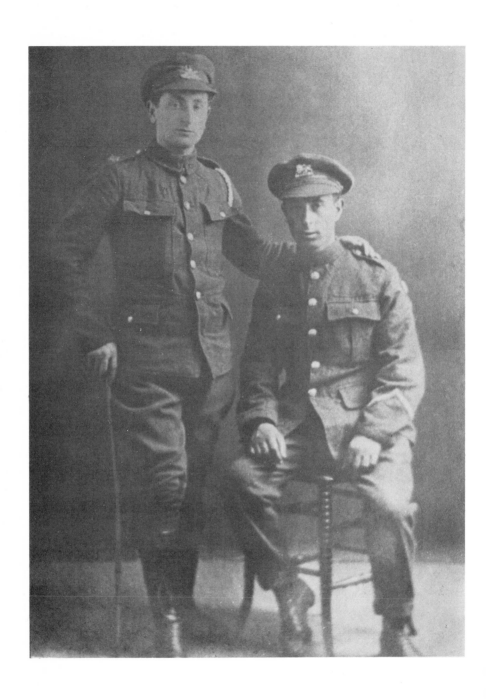

Elkon and Isaac, home on leave in September 1917

the rootlessness of the Diaspora (and English) Jew'. These readings are all valid, yet underneath the obvious, there is another more subtle interpretation to which the British poet and critic Philip Hobsbaum has called attention. Hobsbaum's emphasis is not on Absalom's hanging so much as on the nature of hair, a well-developed sexual symbol widely employed by Rosenberg in his love poems, and the use to which Rosenberg puts it in 'Chagrin'. From Absalom, the poet, by extension, finds himself hanging 'from implacable boughs' (*PIR*, p. 178), seeking to discover the meaning of life, given the vantage of viewing it from high above the earth:

> *(Our eyes holding so much),*
> *Which we must ride dim ages round*
> *Ere the hands (we dream) can touch,*
> *We ride, we ride — before the morning*
> *The secret roots of the sun to tread —*
> *And suddenly*
> *We are lifted of all we know,*
> *And hang from implacable boughs.*
> (*PIR*, pp. 177-78)

Hair is the first key, eyes are the second one; the desire for hands that can touch, equivalent to the yearning fingers of 'First Fruit', is the third key, and the riding image, equivalent to Moses' plan to ride the dizzy beast, is the fourth. Taken together these may be used to unlock the meaning of the poem and confirm it as another divagation on sexual love. Of the eye image, Hobsbaum asks whether this is not 'surely . . . the famous and archetypal locked eyebeam of two lovers', and of the hands he asks 'is this not the belief . . . that love can be struggled for, that the pains one goes through *deserve* the final reward, of one's loved one?' Raising these questions, Hobsbaum unequivocally concludes that 'savage disappointment . . . is at the core of this remarkable poem'. It hardly needs stating that this interpretation corresponds precisely to Rosenberg's experience in love. Indeed, the final five lines of the quoted passage can be legitimately interpreted as another of Rosenberg's metaphors for orgasm. Going beyond Hobsbaum, I suggest that the strength and the beauty of 'Chagrin' evolve out of the unresolved tension Rosenberg experienced between Sonia's deeply painful rejection, and Annetta's possibly ardent yielding. Unable to resolve that tension except through poetry, Rosenberg came to the full meaning of sexual power, a motif that dominates three of his greatest poems, written in

the last year of his life: 'Daughters of War', 'Returning, We Hear the Larks', and 'The Unicorn'.

Though space cannot be given here to a comparison between 'Chagrin' and Owen's 'The Show' (also a poem about heightened suspension), that comparison would convincingly demonstrate why Rosenberg was far more than a war poet and Owen was not. In this context, Professor W. W. Robson's recently stated view is worth quoting: 'Just as Owen is one of the few poets worthy to be compared with Keats, Rosenberg is one of the few worthy to be compared with Shakespeare. He had no opportunity — genius apart — to write anything on the scale of one of Shakespeare's great plays. But his work shows that the spirit of Shakespeare can be revived without imitating Shakespeare.'

16

Summer Interlude
June-Sept 1916

In June 1916, the Fortieth Division reached the Somme just as heavy summer rain began to turn the trenches and the support areas into one enormous sea of mud. The Eleventh King's Own Lancasters spent more time fighting the sucking, stinking mud than the enemy. The combat was not intense along Rosenberg's sector of the line, but snipers were active, shelling was frequent, and both sides were continually sending out raiding parties to test each other's frontal defences. Rosenberg was acutely aware of the danger, 'playing,' as he wrote to R. C. Trevelyan, 'this extraordinary gamble' (*CW*, p. 352) with his life.

Along with his fellow soldiers of the third platoon, A Company, Rosenberg spent his first weeks in France adjusting to trench life — scrounging for the larger dugouts in order to stretch out when he was permitted to sleep, learning to keep his feet dry, keeping his equipment intact, with rifle oiled, and when possible foraging for extra food — a frustrating experience for someone who knew no French. Behind the lines there were endless work details, involving mainly the transport of supplies, complicated by the quagmires.

Rosenberg's life was made even more difficult by his absent-mindedness. Eighteen months earlier, he had been depressed over the loss of his canvases when they slipped into the Cape waters, but that loss was as nothing compared with the mishap he'd had on leaving Blackdown Camp. Writing to Miss Seaton about the rain in the trenches he said that he had been 'wet through for four days and nights', his discomfort compounded by his carelessness: 'I lost all my socks and things before I left England, and hadn't the chance to make it up again, so I've been in trouble, particularly with bad heels; you can't have the slightest conception of what such an apparently trivial thing means. We've had shells bursting two yards off, bullets

whizzing all over the show, but all you are aware of is the agony of your heels . . .' (*PIR*, p. 31). It was through this loss that Hacha learned that her son was in France, for socks, underwear, and items for his kit had to be dispatched at once. She packed the parcel without anger but profoundly saddened, her tears falling on the clothing as she bundled it up.

Though Rosenberg was physically uncomfortable, his spirits were high. In the first weeks of June 1916, he received a letter full of praise from Trevelyan:

> It is a long time since I have read any new thing that has interested and impressed me so much as your Moses and several of your short poems. It quite reminds me of the time when I first read Abercrombie's Interludes. There are some really first-rate things in Moses; and the main idea too seems to me a really fine and dramatic one. I shall have to read it again several times, as parts do not yet seem quite clear to me, and I am not sure yet whose fault it is, mine or the language. I like a number of the poems, 'In the Park', 'Wedded', 'If you are fire', 'Lady, you are my God', 'Expression', and others too. Your best phrases and ideas have something very real and compelling about them.

Rosenberg answered Trevelyan's letter at once, expressing his elation over the comments, acknowledging his shortcomings: 'I know my faults are legion; a good many must be put down to the rotten conditions I wrote it in — the whole thing was written in barracks, and I suppose you know what an ordinary soldiers life is like' (*CW*, p. 350). Because parts of *Moses* had been unclear to Trevelyan, Rosenberg defined the play: 'Moses symbolises the fierce desire for virility and original action in contrast to slavery of the most abject kind' (*CW*, p. 350). Optimistically he added, 'If I get through this affair without any broken bones etc, I have a lot to say and one or two shilling shockers, that'll make some people jump' (*CW*, p. 350). From his first days in France, Rosenberg consciously determined to assimilate every experience in order to use it as grist for his postwar mill. Writing to Trevelyan, Rosenberg thought of Rodker who had first acquainted Trevelyan with Rosenberg's poems. He was worried. 'If you see Mrs. Rodker,' he told Trevelyan, 'please ask her to write to me about R. as I believe R is in prison' (*CW*, p. 350). When Rosenberg was on furlough in London he had learned that Rodker had made known his position as a conscientious objector and was likely to go to gaol. Rodker was subsequently imprisoned, but he was not incarcerated for some months. After making enquiries,

Trevelyan wrote to tell Rosenberg later in the summer that Rodker was all right.

Momentarily, Rosenberg's situation improved. Though his commanding officers knew he was a poet, they did not take him seriously. But a poet could write and perform clerical duties. Rosenberg was pulled out of the line in July and spent that month and the next one reassigned to a desk job in the Fortieth Division Salvage Office. For the first time since his enlistment, he was comfortably situated, well fed and billeted, with spare time. His letters home were the most cheerful he ever wrote. Annie kept in close touch with him and he knew that *Moses* was being read by some important people. Trevelyan had asked for additional copies of both *Moses* and *Youth* to give to his friend Desmond McCarthy, the writer and reviewer; and Schiff had similarly interested the novelist, Trevor Blakemore, in his work. Israel Zangwill had written Annie to acknowledge receiving a copy of *Moses:* 'Will you kindly thank your brother for the little volume of poems he sent me. . . . You can tell him from me that I think there are a good many beautiful and powerful lines, but that I hope his experiences of war will give his next book the clarity and simplicity which is somewhat lacking in this.'[59] Whatever Rosenberg felt about Zangwill's condescending attitude, he was buoyed up by Trevelyan's encouragement and the knowledge that Bottomley also approved his work. Aware that Bottomley was unwell, he waited to hear from him. Binyon had not yet written, but it was Marsh's unusual silence that most disturbed him.

In a letter postmarked June 30, 1916, Rosenberg told Marsh he had sent him a copy of *Moses* but feared that it had gone astray. He summarized Trevelyan's praise and added, 'Bottomley admires my work too, and that has pleased me more than if I were known all over the world' (*CW*, p. 310). He was sketching himself in various trench poses and enclosed one for Marsh, having sent others to Trevelyan and Schiff. He implored Marsh to respond: 'If you have anything to say about my poem do write me as soon as you get time' (*CW*, p. 310).

Marsh, of course, had received the copy of *Moses*, had read it, and reacted ambivalently. He was struck with the perfection and accomplishment of the 'Ah Koelue' speech, and annoyed and dismayed to the point of anger over most of the rest of the play. He put off writing to Rosenberg while he fumed over the abominations in this latest work of his promising young poet, which in some way he seemed to regard as a personal insult.

On the other hand, Bottomley marvelled over Rosenberg's achieve-
ment, and as soon as his health improved, wrote him a long letter,
full of extravagant praise both for *Youth* and *Moses:*

> I have read both your books with delight. There is no doubt
> there was never a [more] real poet in the world than you are; to
> have such a gift as yours is a great responsibility, for you are
> called on to develop [sic] it to the highest advantage, and to
> learn as time goes on to separate with increasing sureness of
> touch the pure gold from its flux. . . .
>
> I cannot tell you the deep pleasure in which I read 'Moses'. It
> is a prodigious advance; I understand you have done it lately
> under distracting conditions, and this seems to me the best
> promise that you are going on to other fine things. It is not only
> that it has so much of the sureness of direction of which I have
> just been speaking, but it has the large fine movement, the
> ample sweep which is the first requisite of great poetry, and
> which has lately dropped out of sight in the hands of exquisite
> lyricists who try to make us believe there is a great virtue in
> being short of breath. Such speeches as 'Had you embalmed
> your beauty' and 'I am sick of priests and forms' and most of
> 'The Royal paunch of Pharoah' speech are the very top of
> poetry, and no one ever did better; but I value still more the
> instinct for large organization which holds the whole to-
> gether. . . .

Bottomley's unstinting plaudits surpassed Abercrombie's, and
Rosenberg valued the letter beyond any poem he had himself ever
written. He read and re-read Bottomley's words many times, until he
convinced himself, as he told Bottomley in his reply, that the
Georgian poet and playwright was not 'pulling [his] leg' (*PIR*,
p. 32).[60] He was so proud of the letter that after memorizing its con-
tents, he sent it home for the pleasure his family would take in it and
for its safekeeping.

Goaded by the information Rosenberg sent that Bottomley was
praising him, Marsh's paternal anger flared anew. He wrote to
Rosenberg to set him right on the profound defects he found in
Moses, and in a second letter, he told Bottomley what he had said and
expressed the hope Bottomley would temper his encouragement:

> I wrote him a piece of my mind about Moses; which seems to
> me really magnificent in parts, especially the speech beginning
> 'Ah Koelue' which I think absolutely one of the finest things
> ever written — but as a whole it's surely quite ridiculously bad. I
> hope you mix plenty of powder with your jam. I do want him to

renounce the lawless and grotesque manner in which he usually
writes and to pay a little attention to form and tradition.

Bottomley answered Marsh agreeing in principle but without reveal-
ing the extent of his praise of *Moses:*

> I told [Rosenberg] it was worth his while to be intelligible and
> that an especial obligation is on a dramatic poet to meet his
> audience at least half-way. He interests me because in *Moses* I
> felt some assurance that in him, at last, has turned up a poet *de
> longue haleine* among the youngsters; he has paid the customary
> allegiance to Poundisme, Unanisme, and the rest with an energy
> and vividness which distinguishes him from the others.

Marsh was still put out but he was incapable of remaining angry, and
he replied to Bottomley more moderately:

> I wrote to [Rosenberg] with the utmost brutality, telling him it
> was an outrage on humanity that the man who could write the
> Koelue speech should imbed it in such a farrago. I wouldn't
> have been such a beast but that I wanted to counteract the
> praise he'd had from you! . . . he seems to me entirely without
> architectonics — both the shaping instinct and the reserve of
> power that carries a thing through. It's the same in his painting,
> he does a good sketch of a design and leaves it there. However,
> let's hope for the best. No one can write a Koelue by accident.

Rosenberg received Marsh's strictures without annoyance. What
Marsh considered 'brutal' was for Rosenberg no more than 'a blur on
the window'.[61] In a long letter dated August 4, 1916, he devoted
only six sentences to a justification for having *printed* the verse-play,
which, in retrospect, appears to have been Rosenberg's crime in
Marsh's eyes rather than having composed it. Composing was for
promising poets, printing for arrived ones. As far as Marsh was con-
cerned Rosenberg would never arrive. Rosenberg's reply to Marsh
was moderate and detached: 'You know the conditions I have always
worked under, and particularly with this last lot of poems. You
know how earnestly one must wait on ideas . . . and let as it were a
skin grow naturally round and through them. If you are not free you
can only, when the ideas come hot, seize them with the skin in
tatters raw, crude, in some parts beautiful in others monstrous. Why
print it then? Because these rare parts must not be lost' (*CW,* pp.
310-11).

This is no apology and no concession. Rosenberg respected Marsh
but no longer feared him. Almost in the same breath he went on to
say that given the time he would 'write a great thing'; his faith in
himself was stronger than ever. However, Rosenberg was still capable

of improvement and Marsh was not a villain, only a misguided friend, and he was not alone. Binyon wrote to Rosenberg, too, to tell him there were good lines in *Moses* but that his poetry came out 'in clotted gushes and spasms' (*CW*, p. 312).

Marsh's influence, by now already minimal, was reduced even further by the kinship Rosenberg felt with Trevelyan and Bottomley who, unlike Marsh, were practising poets. Encouraged by their letters, he considered writing another verse-play about Adam and Lilith and composed some opening lines. He also wrote some short poems: 'From France', 'Home Thoughts From France', and 'August 1914'. The first two contrasted the traditional view of France as gay and carefree with the country's far more sombre mien under the heel of war; while 'August 1914', though slight, contrasts the past with the present in powerfully compressed, forceful images:

> *What in our lives is burnt*
> *In the fire of this?*
> *The heart's dear granary?*
> *The much we shall miss?*
>
> *Three lives hath one life —*
> *Iron, honey, gold.*
> *The gold, the honey gone —*
> *Left is the hard and cold.*
>
> *Iron are our lives*
> *Molten right through our youth.*
> *A burnt space through ripe fields*
> *A fair mouth's broken tooth.*
>
> (*CW*, p. 70)

Rosenberg had not been in France long before he developed beyond his earlier loosely-evolved images, often wrought with extraneous appendages, to the hard, clear images, complete in themselves, shorn of inessentials. With 'August 1914' (composed in the summer of 1916), his emergence as a war poet was complete.

He had continued writing to Schiff, who sent him newspapers and books which he now had the leisure to read. Included among them was the second volume of Marsh's *Georgian Poetry*. Rosenberg declined Schiff's offer of one of D. H. Lawrence's books (*CWL*, p. 17). To his surprise he received a package from Mrs. Herbert Cohen containing *Rhythmic Waves*, a volume of poems she had just published

under the pseudonym J. C. Churt, and the reviews of her book which had appeared in the papers. Rosenberg sent her a long, friendly reply, complimenting her modest achievement and commenting on the copy of *The Poetry Review* which had been included. He was not impressed by some war poems in it, which he felt were commonplace. He had not liked 'Rupert Brooke's begloried sonnets for the same reason' (*CW*, p. 348). Walt Whitman, he was convinced, had said in ' "Beat, drums, beat", the noblest thing on war' (*CW*, p. 348). He included 'August 1914' with his reply, and told Mrs. Cohen he was thinking about writing a play with Judas Maccabeus as his protagonist. 'I can,' he said, 'put a lot in I've learnt out here' (*CW*, p. 348). Though he was never to get the chance to write a play about the legendary Jewish warrior, it is interesting to observe the natural progression of his logic. *Moses* had fulfilled his need to deal with his humiliating slavery in camp, and Judas Maccabeus would stand for his military exploits in the field. At the end of his letter to Mrs. Cohen he mentioned that he had another 'good' poem 'in the anvil . . . but it wants knocking into shape' (*CW*, p. 348). Probably this was an early version of 'Break of Day in the Trenches'.

After his exchange of views with Marsh, Bottomley wrote to Rosenberg urging more restraint in his composition. His letter reached Rosenberg on July 23, 1916, the same day that a letter from Trevelyan arrived. Bottomley's advice was mild, and in comparison with Trevelyan's letter, even less stringent. The issue was *simple* poetry. Replying to Bottomley, Rosenberg defined as a working principle and a goal what simple poetry meant to him. It was, he said, 'where an interesting complexity of thought is kept in tone and right value to the dominating idea so that it is understandable and still ungraspable. I know it is beyond my reach just now, except, perhaps, in bits' (*CW*, p. 371). Long past Keats and Francis Thompson, past Browning, Swinburne, and Blake, Rosenberg had reached up to Donne, and his absorption in the seventeenth century metaphysical poet was beginning to be reflected in his verse. 'August 1914' met Rosenberg's own requirement of the 'understandable', 'Break of Day in the Trenches' would also fulfil that requirement and yet remain elusive enough in its positive ambiguity to be 'ungraspable'.

Rosenberg grew anxious about Rodker again, and in August he wrote to Sonia for information. 'I've been anxious to hear from you about Rodker. . . . Write me any news — anything' (*CW*, p. 352). Commenting on his difficulties in making himself understood in French, he added that the struggle for expression even in English had become 'a fearful joke' (*CW*, p. 352); he closed the letter with an

early version of 'Break of Day in the Trenches'. He put all his energies into refining this new poem. By early September it was vastly different.

Unable to find out if he had yet been published in America, he decided to write to Harriet Monroe and send 'Break of Day in the Trenches' and 'The Troop Ship' in the hope that she would print them: 'Could you,' he asked her, 'let me know whether a poem of mine 'Marching' has been printed by you, as I understood from J. Rodker, it was accepted. I have no means of knowing, or seeing your magazine out here, I have lost touch with Rodker. . . . I am enclosing a poem or two written in trenches. . . .' Harriet Monroe received Rosenberg's letter on November 3, 1916. About the same time she also had a letter from Rodker, asking if 'Marching' had yet appeared. His letter was written from R. C. Trevelyan's home in Dorking — he had left London to escape arrest by the military authorities. Harriet Monroe had scheduled 'Marching' for the December 1916, issue of *Poetry Magazine,* and she liked 'Break of Day in the Trenches' enough to find room for it in the same number.

'Break of Day in the Trenches' has become Rosenberg's most widely anthologized poem. It is probably still true — certainly in America — that his reputation rests largely on this one poem. It succinctly captures the inverse values of the front, where rats may live and thrive, but men, like poppies, must die.

> *The darkness crumbles away —*
> *It is the same old druid Time as ever.*
> *Only a live thing leaps my hand —*
> *A queer sardonic rat —*
> *As I pull the parapet's poppy*
> *To stick behind my ear.*
> *Droll rat, they would shoot you if*
> *they knew*
> *Your cosmopolitan sympathies.*
> *(And God knows what antipathies).* [62]
> *Now you have touched this English hand*
> *You will do the same to a German —*
> *Soon, no doubt, if it be your pleasure*
> *To cross the sleeping green between.*
> *It seems you inwardly grin as you pass*
> *Strong eyes, fine limbs, haughty athletes*
> *Less chanced than you for life,*
> *Bonds to the whims of murder,*

Sprawled in the bowels of the earth,
The torn fields of France.
What do you see in our eyes
At the shrieking iron and flame
Hurled through still heavens?
What quaver — what heart aghast?
Poppies whose roots are in man's veins
Drop, and are ever dropping;
But mine in my ear is safe,
Just a little white with the dust.

(*PIR*, pp. 89-90)

Rosenberg's ending is a splendidly restrained study in resignation. There is no appeal, only the realization that beauty and the awareness of having lived are of ultimate significance, even in the imminent presence of death.

Rosenberg had succeeded in escaping from the war for a while in the summer of 1916, but it was still close enough to remind him of its perils. Writing to Marsh on August 17, 1916, he told him, 'We had an exciting time today, and though this is behind the firing line ... there were quite a good many sent to heaven and the hospital I carried one myself in a handcart to the hospital (which often is the antichamber to heaven)' (*CW*, p. 311). The German artillery attack on the Fortieth Division's headquarters was a prelude to change. Casualties were mounting, and with autumn came orders. Rosenberg returned to the trenches, and to bad weather, mud, lice — and the enemy. Though the most dangerous, the latter was the least annoying.

17

Up the Line at Night
Oct 1916-Feb 1918

From October 1916 to September 1917, Rosenberg's situation was one of static exposure. He moved between the trenches and the support areas, performed his duties, grumbled, endured the winter's cold, wet weather, and worked, when he had the time, energy, and inclination, on his poems. Though he faced daily the threat of death, he achieved a peculiar stability at the front which he had never experienced at home. He was neither a financial burden to anyone nor under mental pressure to be doing work other than that which was occupying his time. After months of gruelling privations in the trenches he could write to Laurence Binyon, 'I am determined that this war, with all its powers for devastation, shall not master my poeting; that is, if I am lucky enough to come through all right. I will not leave a corner of my consciousness covered up, but saturate myself with the strange and extraordinary new conditions of this life, and it will all refine itself into poetry later on' (*PIR*, p. 38).

At this time the war was of less concern to him than the officer responsible for censoring letters, who forbade his sending home any more poems because he could not be 'bothered with going through such rubbish' (*CW*, p. 312). After a few weeks Rosenberg ignored the order and sent his poems off as usual.

Now in his twenty-seventh year, he had done all he could in the way of approaching luminaries, submitting his poems to journals, and printing his own pamphlets, to establish his reputation as a poet, though to be sure he still had a handful of important poems to compose. He had an idea about putting together a small volume of trench poems but that would have to wait until he had composed enough to make up a book.

He had seen a lot of living and a lot of dying, and he had absorbed it all. He had read widely in English literature and knew well his

Shakespeare, Milton, Donne, Blake, Keats and Browning. He was familiar with the work of some of his contemporaries: Flint, Masefield, Brooke, Sassoon, D. H. Lawrence, and Pound. He had read Yeats and Hardy, and found that Shaw's plays were the only ones he enjoyed watching. To Bottomley, Trevelyan, and Abercrombie he attached too much significance, for understandable reasons. Poe, Emerson and Whitman were important to him and he held them in higher esteem than Turgenev, Dostoyevsky and Chekhov. He knew his Ibsen, Flaubert, Balzac, Stendhal, and Baudelaire. He had read the Belgians and the Germans, and was particularly fond of Heine. He knew Eliot by name only; he had no occasion to read his poetry. He apparently did not know of T. E. Lawrence, James Joyce, or Wilfred Owen.

Rosenberg's thoughts of the future were tentative, but in 1916 he planned after the war to teach art in a school for a few days each week, leaving himself leisure to read and to write; at other times he thought he might live away from London and take up poultry farming. The war had sharpened his interests in country life and animals.

He corresponded infrequently with Leftwich, but he was no longer in touch with Aaronson, Gertler, Kramer or Goldstein. Rodker surfaced infrequently. If he received a letter, it would have no return address. Exasperated, Rosenberg answered one such letter asking 'What on earth is happening to you and why are you so secret about things. Your letter made me quite wild to know what was up. However perhaps you've got to be quiet' (CW, p. 350). He closed his letter to Rodker with a 'patriotic gush' entitled 'Pozières', a version of which he submitted unsuccessfully in a competition for the regimental Christmas card.

His twenty-seventh birthday came and went on November 25; Christmas approached and he yearned for home leave but did not get it; New Year's Eve and Day were like all the others, cold and merciless. He wondered whether he could qualify for a transfer to the army's special camouflage unit, whose chief was Colonel Solomon J. Solomon. He was certain Solomon would remember him. He mentioned it in a letter to Marsh but did not pursue the matter further (CW, p. 312). He was beginning to feel unwell, and he reported sick.

Though Rosenberg appeared to be no worse off than any other infantryman who'd been a time in the front lines, the doctor who examined him recommended that he be relieved of trench duty and reassigned temporarily to less hazardous work. Rosenberg wrote

home that he had influenza. His letter produced instant hysteria. At Hacha's urging, Annie contacted Marsh and asked him to use his influence to get Rosenberg away from the Front. 'Make up any tale,' she pleaded with Marsh, 'but do see what can be done at once. What to do with my mother, I really don't know, as she is worried to death.' Marsh had already heard from Rosenberg and had written to A. J. Creedy, a friend in the War Office. Creedy was unable to help. 'I am sorry for the Hebrew bard,' he replied to Marsh, 'but as you can imagine it is not easy to do anything from the W.O. as he is within the jurisdiction of G.H.Q.' He advised Marsh to write to Rosenberg's adjutant privately, unofficially and without invoking the power of his connections, 'telling him what you know of R and what you think of his budding genius, and ask him whether R is really fit for trench work and not more suitable for some clerical job.' Marsh wrote to Rosenberg's commanding officer, Captain O. G. Normoy, who reported that Rosenberg had been examined thoroughly and was fit. Captain Normoy said he would watch the situation closely and make a change if it seemed necessary. Rosenberg was not unduly disappointed at the outcome; he had not expected to get a desk job.

Nevertheless, he was reassigned in February 1917, to the Fortieth Division Works Battalion well behind the lines. Though the threat of death was lessened, the work was hard and exposed Rosenberg as much to the winter weather as did trench duty. He convinced himself he was now susceptible to tuberculosis and told Marsh he expected it to manifest itself at any time (*CW*, p. 314). He also thought that he had strained his abdomen, though the doctor could find nothing (*CW*, p. 374). The nightmare of life in the trenches was beginning psychologically to tell on him.

From November the fighting in his sector of the line had been sporadic, slowed down by the onset of winter. The Eleventh King's Own Lancasters were spread out thinly since no major attacks were anticipated. However, to give the enemy the impression of heavily-manned defences, the units of the Fortieth Division had commenced training behind the lines, including a series of long marches begun in the late autumn and kept up into winter. It was hoped German ground and air observers would interpret all this movement as a build-up for a spring offensive. Relieved only by watches in trenches that were now flooded by icy water, these marches wore down Rosenberg's health. Moving to the divisional works battalion, he was spared both the marches and the trench tours.

However, nothing could rid him of lice. Faced with a choice

between wearing layers of lice-infested clothing or shivering, Rosenberg discarded the clothing. He went through delousing whenever he could and had disinfectants mailed from home. Bottomley sent him advice about exterminating compounds but nothing helped (*CW*, p. 374). If he got any satisfaction at all it was in sketching an impromptu delousing that took place in a barn one night, and writing two poems on the subject. One, entitled 'Louse Hunting', depicted the 'lurid glee' of the glistening, naked men, shouting imprecations and burning shirts to punish the vermin. The second poem, 'The Immortals', developed a personal image of the poet fighting a losing battle with the pests, forced to resign himself to their torments.

Though Rosenberg was still in the combat area doing manual labour, he was now able to turn his thoughts more to poetry. The feminine principle courted him. From Koelue he moved to Lilith and composed, as had been his practice in piecing *Moses* together, fragments of plays around her blond beauty and fertility. The first fragment he called 'The Amulet', eventually changing the title to 'The Unicorn'. When he had energy left over from writing his verse-drama, he devoted it to composing shorter poems. One of these, related in theme and image to 'The Unicorn', he had struggled over since the previous summer. He called it 'Daughters of War'. He now returned to it, completed a draft and in May posted a copy to Annie for typing. On June 3, 1917, she sent it to Marsh. He liked the poem but found in it the usual obscurities, which Rosenberg attempted to remove. In time 'Daughters of War' emerged not only as Rosenberg's favourite poem but his definitive statement of the feminine principle. He would invoke the principle in five poems to follow, but nowhere is its imagery more explicit than in this one.

Apart from two short leaves Rosenberg had now been in the service for eighteen months. Away from normal concourse with women, it is reasonable to surmise that in his loneliness and deprivation his dreams by night and day were occupied considerably by sexual fantasies. Three years of drawing nudes, his despair over Sonia, and his encounters with Annetta Raphael, had produced in him an awareness of female power. 'The Female God', composed in 1914, had been his first full statement on this motif. Somehow, he had gleaned the essence of meaning in the several roles of the earth-goddess. She gave birth to males, nurtured them to manhood, accepted them and rejected them as lovers and husbands, and ultimately buried them. Deprived of women and facing death constantly, Rosenberg's thoughts were occupied with these two dominant activities of the goddess, loving and laying-out. In 'Daughters of War' he

combined the roles partly in order to obtain vicarious relief for his tormented desires, and partly to define his sexual resignation.

Rosenberg's Amazons are immortal. In his dreams they perform their fertility dances while awaiting the arrival of their lovers, who can come to them only after being slain in battle. In sadness and yearning, one Amazon articulates the despair of her sisters:

> *My sisters force their males*
> *From the doomed earth, from the doomed*
> *　glee*
> *And hankering of hearts.*
> *Frail hands gleam up through the human*
> *　quagmire, and lips of ash*
> *Seem to wail, as in sad faded paintings*
> *Far-sunken and strange.*
> *My sisters have their males*
> *Clean of the dust of old days*
> *That clings about those white hands*
> *And yearns in those voices sad:*
> *But these shall not see them,*
> *Or think of them in any days or years;*
> *They are my sisters' lovers in other*
> *　days and years.*
>
> (*PIR*, p. 83)

Rosenberg indicated in a letter to Marsh that he intended the voice of this daughter to be both 'spiritual and voluptuous at the same time' (*PIR*, p. 42), the latter because the continuity of life begins with desire, and the former because these males are dead, and procreation is at an impasse. It is in this impasse that the real devastation of war occurs. Rosenberg added that 'the end [of this poem] is an attempt to imagine the severance of all human relationship and the fading away of human love' (*PIR*, p. 43). From his own circumstances suffused by his personal sense of loss he moves to a general vision of the termination of all life.

In late February 1917, Rosenberg was reassigned to the 229 Field Company, Royal Engineers, attached to the Eleventh King's Own Lancasters, a unit he was to remain with until he went home on leave in September 1917. This assignment, too, enabled him to escape from sustained tours of duty in the trenches, but it exposed him at night to the perils of No Man's Land. His task was to help load barbed wire on limbers in the afternoon, and haul it by mule train up to the front line

at night to reinforce the wire barricades in the areas extending outward from the front line. Going up at night, the limbers occasionally rolled over the unburied bodies of dead soldiers. It was hard, dirty, nightmarish work, performed under the most difficult conditions imaginable,[63] but it was better than trench duty. On the mornings when Rosenberg was off-duty, he slept, wrote letters or composed verse, unless he was serving punishment for absent-mindedness. The mules he tended now began to figure prominently in his work. Though they were dumb, plodding, and grotesque when caked with the winter's mud, they brought back to his mind his earlier reading about unicorns.

Riding the limbers into No Man's Land prompted Rosenberg to compose a companion piece to 'Daughters of War', which he called 'Dead Man's Dump':

> *The wheels lurched over sprawled dead*
> *But pained them not, though their bones*
> * crunched;*
> *Their shut mouths made no moan.*
> *They lie there huddled, friend and*
> * foeman,*
> *Man born of man, and born of woman;*
> *And shells go crying over them*
> *From night till night and now.*
>
> (*PIR*, p. 105)

Employing his combined image of the earth goddess as both lover and layer-out of men, Rosenberg sees these disfigured soldiers absorbed into her. At the same time, he demands to know who is responsible for this enormous waste of human life:

> *Earth has waited for them,*
> *All the time of their growth*
> *Fretting for their decay:*
> *Now she has them at last!*
> *In the strength of their strength*
> *Suspended — stopped and held.*
>
> *What fierce imaginings their dark*
> * souls lit?*
> *Earth! Have they gone into you?*
> *Somewhere they must have gone,*

> *And flung on your hard back*
> *Is their soul's sack*
> *Emptied of God-ancestralled essences.*
> *Who hurled them out? Who hurled?*
> (*PIR*, pp. 105-106)

Beyond the anger, an overwhelmingly compassionate tenderness, deeper than the ironical pity Owen expresses in his war poems, infuses 'Dead Man's Dump' with infinite sadness:

> *None saw their spirits' shadow shake*
> *the grass,*
> *Or stood aside for the half used life*
> *to pass*
> *Out of those doomed nostrils and the*
> *doomed mouth,*
> *When the swift iron burning bee*
> *Drained the wild honey of their youth.*
> (*PIR*, p. 106)

The balance of the poem moves back and forth between the generalized image of the war and the particularized images of the suffering of individual soldiers. In lines which compare favourably with the best composed this century, Rosenberg reinvests the dead with human dignity:

> *Burnt black by strange decay*
> *Their sinister faces lie,*
> *The lid over each eye;*
> *The grass and coloured clay*
> *More motion have than they,*
> *Joined to the great sunk silences.*
> (*PIR*, p. 107)

To convey the ultimate monstrosity of the war, Rosenberg describes one soldier who has died only moments before, his arms still raised, imploring help. The limber rolls over him, its weight forcing the last air from his chest in a weird cry that sums up the colossal brutality and the sheer madness that makes it possible to kill a man already dead:

'Will they come? Will they ever come?'
Even as the mixed hoofs of the mules,
The quivering-bellied mules,
And the rushing wheels all mixed
With his tortured upturned sight.

So we crashed round the bend,
We heard his weak scream,
We heard his very last sound,
And our wheels grazed his dead face.
 (PIR, p. 108)

When Rosenberg sent 'Dead Man's Dump' to Marsh on May 8, he told him he did not think the poem 'very good though the substance is' (*CW*, p. 316). Yet 'Dead Man's Dump' has emerged as one of the masterpieces of twentieth-century literature. Only Owen's 'Strange Meeting', Herbert Read's *The End of a War*, and a few passages from David Jones's *In Parenthesis* approach the grandeur of Rosenberg's poem.

In the several weeks that Rosenberg was working on his masterpiece, the Front suddenly became active again. The Eleventh King's Own Lancasters were entrenched opposite the German Siegfried sector, regarded as the strongest section of the Hindenburg Line. Fighting was intense and casualties were heavy. Rosenberg felt fortunate to be out of battle, for he had suffered agonies with his feet through the winter and spring, and as late as the end of April he complained to Marsh that the continued cold weather, along with his heavy boots, kept his feet 'in a rotten state' (*CW*, p. 315). He had written to thank Marsh for getting extra copies of *Moses* and giving them to friends who were discussing the poem's merits. Marsh told him a healthy debate had ensued, but did not name the participants. '. . . it greatly pleases me,' Rosenberg told Marsh, 'that this child of my brain should be seen and perhaps his beauties be discovered' (*CW*, p. 315). But he felt his output was declining: '[Moses'] creator,' he said, 'is in sadder plight; the harsh and unlovely times have made his mistress, the flighty Muse, abscond and elope with luckier rivals, but surely I shall hunt her and chase her somewhere into the summer and sweeter times' (*CW*, p. 315).

Heavy fighting had continued all through April and into May. The Germans had withdrawn to the Hindenburg Line, yielding their two forward trenches to the Eleventh King's Own Lancasters. Now the British objective was to pierce what appeared to be an impregnable

defence. Moving forward, the units of the Fortieth Division came into undulating country with good cover. In the distance the spires of Cambrai could be seen. On April 21 and again on April 24 the division attacked, taking more ground, but it had not yet reached the Hindenburg Line. The support areas, too, were now east of No Man's Land. With May, the sun returned. Rosenberg's feet healed and his complaints 'dwindled down to almost invisibility' (*CW*, p. 316).

Marsh returned 'Dead Man's Dump' to Rosenberg, but not before he had made a copy to keep lest it should be lost. His criticism of it was mild. Only one bone of contention now existed between the two: Marsh objected to Rosenberg's mixing rhymed lines with free verse. Rosenberg was well aware of his inconsistency but had no intention of changing. He did not like regular rhythms but employed them when they suited his purpose. Defending himself, and perhaps with tongue in cheek, he told Marsh that Andrew Marvell 'would have been considered a terrific poet' if he 'had broken up his rhythms more' (*CW*, p. 317).

By the end of May the fighting on the Fortieth Division's sector had ended as the British were concentrating their efforts in an attempt to break out from the Ypres Salient about forty-five miles to the north. The Eleventh King's Own Lancasters moved into a rest area. Rosenberg still had his work to do, but he had a little more time to read and to write. Bottomley sent him his new poem, 'Atlantis', and Trevelyan wrote him long newsy letters filled with comments on his own reading. Though he felt pressed for time, Rosenberg answered his correspondence and worked on his new verse-play. He composed 'In War', a lesser poem which attempted to capture the emotions of a soldier who, with the indifference engendered by war-blunted feelings, digs a grave — only to learn at the last moment that his brother, killed three days before, is to be buried in it. Possibly the poem was prompted by the fact that his brothers David and Elkon were now both in the army. He worried continually about David who, though more serious and mature than Elkon, had signed on for tank duty.

Rosenberg spent the summer of 1917 in relative safety. He was still going up the line at night, but the routine was fixed, and so far nothing had happened. The possibility of death had not been minimized; he simply grew accustomed to it. He had become more a creature of the field than of the city. The oppressiveness and degradation of urban existence that he had known earlier, and his forebodings arising from it, were transformed into part of his literary landscape:

A worm fed on the heart of
 Corinth,
Babylon and Rome:
Not Paris raped tall Helen,
But this incestuous worm,
Who lured her vivid beauty
To his amorphous sleep.
England! famous as Helen
Is thy betrothal sung
To him the shadowless,
More amorous than Solomon.

(*CW*, p. 74)

The war had made England vulnerable. She was betrothed to 'that incestuous worm' Satan, and Rosenberg prophesies her downfall if the marriage is consummated. In this fragment Rosenberg again followed his technique of pulling together the disparate elements of a motif developed earlier, reinforcing it with his new power, operating mythopoeically. Of this poem Frank Kermode and John Hollander have written: 'this prophecy of the fall of empire ranks perhaps highest among Rosenberg's visionary fragments.'

But Rosenberg had much more to say on the subject, and in the summer months he tried hard to gather his scattered thoughts and feelings into a coherent artifact which would both signal and record the end of a civilization. Death, he realized, had long stalked the cities and, through the war, had spread to the countryside, devastating the normal intercourse of life, rooting out and eradicating the sustaining force of human love. He wanted to instil this generalized concept in 'The Amulet', but on piecing it together he was unable to give it the proper aesthetic distance. He strove to achieve universality by setting it in the biblical past, but he could not keep out the present, with the result that it was over-particularized. After composing the playlet, he abandoned it, incorporating some of its material into 'The Unicorn', which had a broader design nearer his concept. Few critics have attempted to wrest from 'The Amulet' Rosenberg's meaning, though Silkin's remarks are instructive, particularly where he observes that it is 'a covert parable concerning war', and that 'Rosenberg's principal efforts are towards shaping the passions of men and women as they affect society.'

Rosenberg completed a draft of 'The Amulet' early in June and sent it home to be typed and returned to him for further revision. Shortly afterward he asked Annie to show it to Marsh. Then he

wrote to Marsh asking him not to look at it since he was changing the whole idea (*CW*, p. 317).

The play's grand design excited Rosenberg but it was becoming too complex and he found it difficult to sort out the poem's several distinct motifs. Preoccupied with the problems of its structure, he grew careless and was one day caught without his gas helmet. The punishment was a familiar one to him — seven days' pack-drill. After this chastisement, he returned to his play. Toward the end of July, he had the idea firmly in mind, but knew it would take time to develop the speeches and the action.

Writing to Bottomley in a letter postmarked August 3, 1917, Rosenberg outlined his revised scheme for the play:

> ... Now, it's about a decaying race who have never seen a woman; animals take the place of women, but they yearn for continuity. The chief's Unicorn breaks away and he goes in chase. The Unicorn is found by boys outside a city and brought in, and breaks away again. Saul, who has seen the Unicorn on his way to the city for the week's victuals, gives chase in his cart. A storm comes on, the mules break down, and by the lightning he sees the Unicorn race by; a naked black like an apparition rises up and easily lifts the wheels from the rut, and together they ride to Saul's hut. There Lilith is in great consternation, having seen the Unicorn and knowing the legend of this race of men. The emotions of the black (the Chief) are the really difficult part of my story. Afterwards a host of blacks on horses, like centaurs and buffaloes, come rushing up, the Unicorn in front. On every horse is clasped a woman. Lilith faints, Saul stabs himself, the Chief places Lilith on the Unicorn, and they all race away.
>
> (*PIR*, pp. 45-46)

This decaying race, led by their black chief, corresponds symbolically to Rosenberg's Amazons in 'Daughters of War'. Both groups of people are faced with extinction but are unwilling to capitulate. In some of the most powerful lines Rosenberg ever composed, he describes the plight of the decaying race:

> *Behind impassable places*
> *Whose air was never warmed by a*
> * woman's lips*
> *Bestial man shapes ride dark impulses*
> *Through roots in the bleak blood, then*
> * hide*

In shuddering light from their self
 loathing.
They fade in arid light —
Beings unnatured by their craving, for
 they know
Obliteration's spectre. They are few.
They wail their souls for continuity,
And bow their heads and knock their
 breasts before
The many mummies whose wail in dust
 is more
Than these who cry, their brothers who
 loiter yet.
Great beasts' and small beasts' eyes
 have place
As eyes of women to their hopeless
 eyes
That hunt in bleakness for the dread
 might,
The incarnate female soul of generation.

(*CW*, p. 114)

The play ends with the suicide of Saul and the abduction and rape of Lilith. Only one other poet of the Great War was to see the absolutely devastating impact of rape as a symbol of the horror of war. Herbert Read used the theme in 'The End of a War' which, however, was composed much later, in 1931-32.

This version of 'The Unicorn' was completed in the late summer of 1917. Rosenberg regarded it merely as a sketch. That it was unfinished is the first point which must be emphasised. In the last letter he sent to Miss Seaton, dated March 8, 1918, he wrote, 'If I am lucky, and come off undamaged, I mean to put all my innermost experiences into the "Unicorn". I want it to symbolize the war and all the devastating forces let loose by an ambitious and unscrupulous will. Last summer I wrote pieces for it and had the whole of it planned out, but since then I've had no chance of working on it and it may have gone quite out of my mind' (*PIR*, p. 49). The second point is that the play was to contain *all* of Rosenberg's 'innermost experiences'. The third is that, for what little there is, 'the Unicorn' succeeds as an artifact, short but complete in itself, whereas 'The Amulet' does not. 'The Unicorn' can be read as a playlet symbolically depicting an 'unscrupulous will' tearing up an old universe in

order to give continuity to a new one; that continuity is exemplified
in the fecundity of the earth goddess. These two motifs, the destruc-
tiveness of war and the power of women, as we have observed, were
deeply imbedded in Rosenberg's 'innermost experiences'; and he was
unafraid to attempt combining them in what was projected as a
full-blown drama since they were the most powerful forces he knew.
That the combination does not satisfy us as much as it does in
'Daughters of War' is due to the fact that the verse-play is unfinished.

It is significant that the process we have previously observed was
again at work: the poet took the literal facets of his life and
reworked them into poetry. The characterization of Lilith, for ex-
ample, grew directly out of Rosenberg's experiences with Sonia and
Annetta Raphael. He fused Sonia's blond tormenting beauty and
Annetta's comforting music into twin polarities of the same person.
This accounts for the emphasis upon music and its restorative power
in both 'The Amulet' and 'The Unicorn'. But it is Sonia's aspect
which dominates Rosenberg's thought. While his information was
sketchy, he knew that she was now alone, as he believed Rodker
either to be in hiding or in gaol as a conscientious objector.[64] Sonia's
life was disrupted, and Rosenberg, in his loneliness, with his con-
tinuing passion for her, would have yearned to console her. Con-
solation is a basic undercurrent in both versions of Rosenberg's
poem. In fashioning this survival myth, it is possible that Rosenberg
was giving expression to a long-cherished wish to recover Sonia.
When the protagonist Tel abducts Lilith, it is already clear that his
vitalizing force will be welcomed. On one level, her anticipated rape
is intended to be negative and destructive — an appropriate symbol
of the war — yet in terms of Rosenberg's attraction to Sonia, the
rape mythopoeically becomes a positive symbol, since it ensures
continuity. Thus the conclusion to 'The Unicorn' may be read in a
context similar to that designed by Yeats in 'Leda and the Swan'.
What appears to be a contradiction in the play's conclusion is, in
fact, complementary. If, additionally, it reveals the extent of
Rosenberg's sexual fantasies after two years in the army, it is under-
standable enough that he would fashion a myth removing Rodker
entirely through Saul's suicide and take Sonia for himself.

Perhaps all that Rosenberg was trying to cram into his playlets was
better said in a short lyric he composed that summer, which he called
'Returning, We Hear the Larks'. In this poem, he combined success-
fully the motifs of the futility and destruction of war with both the
affirmative and negative powers of human sexuality, joined together
in a striking series of images of vulnerability:

Sombre the night is:
And though we have our lives, we know
What sinister threat lurks there.

Dragging these anguished limbs, we
only know
This poison-blasted track opens on our
camp —
On a little safe sleep.

But hark! Joy — joy — strange joy.
Lo! Heights of night ringing with
unseen larks:
Music showering on our upturned list'ning
faces.

Death could drop from the dark
As easily as song —
But song only dropped,
Like a blind man's dreams on the sand
By dangerous tides;
Like a girl's dark hair, for she dreams
no ruin lies there,
Or her kisses where a serpent hides.

(PIR, p. 92)

The poem is a sublime evocation of the profoundly intricate relationship between death and sex, and has been widely praised: Beth Zion Lask said, 'Had [Rosenberg] written nothing else, this one poem could have stood to serve his fame'; Marius Bewley wrote that 'Rosenberg's poised indecision in this poem constitutes a brilliant examination of the bases of the spiritual quality he was endeavouring to construct for himself'; Robert Ross sees in the poem Rosenberg's ability 'to mould raw experience into moments of transcendent beauty';[65] while Philip Hobsbaum acclaims the two lines on the image of the blind man as 'among the most haunting in the language'.

After fifteen months in France, Rosenberg was granted ten days' leave beginning on September 16, 1917. Arriving at the station, he took a bus to Whitechapel. He caught sight of Leftwich walking, and jumped off the bus to greet him. Leftwich recalled that he 'looked well and fit', and was 'more boisterously happy than I had ever known him before, and he was noisily indignant because he had

heard that some people had been saying that he hated the army and wanted to wangle his way out.' At home, after the hugs and kisses, the tears, the feasts, and the tales, he caught up on his sleep and then began to make the rounds. He went to the Slade, to Bolt Court and to the Café Royal. There he saw Aaronson and met Jack Isaacs, who later became Professor of English Literature at St. Mary's College, London. He called on Schiff, but he was out of town. Schiff wrote to him, enclosing a pound to spend during his leave. Apparently he also missed Marsh, who had been reappointed private secretary to Winston Churchill when the latter was recalled from the front to become the Minister of Munitions. Churchill and Marsh had been to France but returned to London on September 18. Rosenberg said nothing of seeing him, and Marsh's biographer, Christopher Hassall, is silent on the subject of Rosenberg's leave, though he reports that when *Georgian Poetry 1916-1917* appeared later that month, Edmund Gosse wrote to Marsh about the book and asked 'Who is Rosenberg? I feel sure he is a Dane, his verses are so like those which come to me in Danish from young bards in Copenhagen.'

Rosenberg's youngest brother Elkon also came home on leave, adding to the family's celebration. Hacha insisted that the two of them go to the photographer to have their picture taken in uniform. Happy as he was to be at home, Rosenberg found he could not stay still a minute. Trevelyan sent him a play which Rosenberg read with great pleasure, and his newly issued *Annual.* But he was too restless and too unsettled to do anything calmly. In one respect, the war had already claimed him; he belonged more to the trenches and the support areas than he did to Whitechapel or the Café Royal. One suspects he spent as much time as possible with both Sonia and Annetta. That he saw the former is confirmed by a letter to Trevelyan, written on October 18, commenting on Rodker's involuntary servitude (*CW*, p. 356); that he saw the latter may be deduced from two poems he wrote after he returned to France, 'Soldier: Twentieth Century', and 'Girl to Soldier on Leave'. In the second poem, the girl is the speaker:

> *I love you, Titan lover,*
> *My own storm-days' Titan*
> *Greater than the son of Zeus*
> *I know whom I would choose.*
>
> (*PIR*, pp. 100-101)

The burden of the poem is an all-pervading sense of loss, for the

woman realizes she can not compete with Death despite the one old bond between her and the soldier

> *One gyve holds you yet.*
>
> *It held you hiddenly on the Somme*
> *Tied from my heart at home.*
> *O must it loosen now? I wish*
> *You were bound with the old, old*
> * gyves.*
>
> *Love! you love me — your eyes*
> *Have looked through death at mine.*
> *You have tempted a grave too much.*
> *I let you — I repine.*
>
> (*PIR*, p. 100)

In the particularized context of this poem, it is the woman who acknowledges the loss. Since Rosenberg always had a frame of reference for his poems, it is reasonable to presume that Annetta Raphael is his speaker here.

Bottomley wrote to Rosenberg at home and in his answer the young poet expressed his regrets that they were not to meet: 'I wish I could have seen you, but now I must go on and hope that things will turn out well, and some happy day will give me the chance of meeting you' (*PIR*, p. 46).

On September 26, 1917, Rosenberg said goodbye to his family and returned to the front. His departure was sad, but he was not unhappy: the war and his trench experiences were too much a part of him for regrets. He did not know that his assignment with the Royal Engineers, carrying wire to the front at night, had terminated and that he was going back into the line.

By autumn British casualties in the attempt to break out of the Ypres Salient numbered over 400,000 men killed, wounded, and missing, and the army had gained only five miles and one ridge fifty feet higher than the original line at Ypres. The German line had not been broken. Sir Douglas Haig decided to shift his attack to the enemy's defences in front of Cambrai, and the brunt of the offensive fell on the Third Army. The Fortieth Division, including the Eleventh King's Own Lancasters, faced Cambrai at the time that decision was reached.

'Immediately after Rosenberg's return to the trenches it rained hard and he was drenched for three days and nights. He caught cold and felt run-down. On October 10 he reported sick, and following a physical examination was found to be suffering from influenza. He was sent to the 51st General Hospital where he remained until the middle of December. Trevelyan sent him *Lucretius* to read and he acquired other books as well. He re-read Shakespeare's comedies and *Macbeth*, Bottomley's poems, some H. G. Wells, and Sturge Moore. In his letters to Miss Seaton, he got into a serious argument over past obscurities in his poems and stubbornly argued his case to the point of rudeness.[66] He thanked her for a book and chocolates but obstinately held his ground:

> You will persist in refusing to see my side of our little debate on criticism. Everybody has agreed with you about the faults, and the reason is obvious; the faults are so glaring that nobody can fail to see them. But how many have seen the beauties? And it is here more than the other that the true critic shows himself. And I absolutely disagree that it is blindness or carelessness; it is the brain succumbing to the herculean attempt to enrich the world of ideas.

(*PIR*, pp. 37-38)

He amused himself doing sketches. Apparently he produced no new poems, although he had another look at 'The Unicorn', and added bits here and there. The war temporarily receded from Rosenberg's life. October passed into November.

Toward the end of November new casualties began to arrive at the hospital, confirming the rumour of a large-scale British offensive. On November 20, General Haig initiated his plan to take Cambrai. The Eleventh King's Own Lancasters were in reserve. On November 21 they were ordered into the line and marched forward, and for the next three days engaged in heavy fighting and suffered considerable losses. Before they could consolidate their gains the Germans counter-attacked, and by December 1, the enemy had recovered all the ground yielded earlier.

In hospital, Rosenberg received a letter from Leftwich with an application form inviting him to join the recently organized Jewish Association of Arts and Sciences; Mrs. Herbert Cohen was one of the vice-presidents and Lazarus Aaronson was a secretary. The invitation amused Rosenberg, and he filled it in, giving his address as 'The Chatty Chateau', listing his occupation as 'Picture-maker', and his active interest as 'live stock', an appropriate response, considering the amount of time he had spent that year working with mules and

thinking about unicorns. He wrote a letter to Leftwich on the back of the form, telling him he was lucky to be in hospital since it kept him from being involved in the hapless British offensive. He reported that both of his brothers were also in army hospitals, one of them with a bullet in his leg. With time to spare, Rosenberg continued his chatty letter:

> I have written a few war poems but when I think of 'Drum Taps' mine are absurd. However I would get a pamphlet printed if I were sure of selling about 60 at 1s each — as I think mine may give some new aspects to people at home — and then one never knows whether you'll get a tap on the head or not: and if that happens — all you have written is lost, unless you have secured them by printing. Do you know when the Georgian B. will be out? I am only having about half a page in it — and its only an extract from a poem — I dont think anybody will be much the wiser. Whats the idea of my joining your J affair, its no use to me out here, is it? Besides after the war, if things go well — I doubt whether Id live in London. But you can put me down if you like.

(*CW*, p. 358)

In the middle of December Rosenberg's leisure ended. Pronounced fit by the hospital doctors, he was discharged and returned immediately to the trenches. There he stayed until late January. His letters to Marsh, Miss Seaton and Bottomley became more and more despondent. Back in the reserve brigade in March, he wrote two poems, both on biblical themes, 'The Burning of the Temple' and 'The Destruction of Jerusalem by the Babylonian Hordes'. Both were competent, clear, hard and precise. They drew on his war experience but were motivated more by a hope that he might obtain a transfer to the Jewish Battalion in the Near East and once and for all get out of the hell-hole the Western Front had become. The war was beginning to break him and he knew it. Most of his fellow soldiers in the Eleventh King's Own Lancasters were now dead. Those few who remained were transferred with Rosenberg to the First King's Own Lancasters. Before he was settled into this new regiment, his new captain was marking his mail 'Deceased' and returning it to England.

18

The Struggle for Recognition
1918-73

It was not until middle-late April 1918, that the news of Rosenberg's death reached his family. 'The light is gone out of our home', Annie wrote Marsh, imploring him to use his influence to bring one of the other brothers home on compassionate leave. Hacha was alone most of the day, since Annie and Rachel both worked, and Barnett was off peddling in the country. Surrounded by Isaac's pictures and mementos, she agonized inconsolably over his loss. She wrote to Barnett in Cinderford, and in his silent grief he composed a prose poem 'April 1, 1918', which began, 'This is a day of tears/ For on it, my dear son, Isaac, the Levite/ Fell on the fields of battle.... If you have understanding, you will understand'. Marsh, Bottomley, and Trevelyan sent their condolences. Trevelyan's letter was especially moving: 'For me,' he said to Annie, '[your brother's death] will be one of the cruellest things which this cruel war has done.... None of the younger writers, so far as I know, were his equal in imaginative power.... His feelings about the war, so far as he expressed them to me, seem to have been worthy of a man of imagination and genius. The war could crush his body, but could not crush what was best and most human in him.'

The responsibility of acknowledging condolences and enquiries fell upon Annie. Neither Barnett nor Hacha was capable of dealing with Isaac's literary estate, and, though she was inexperienced, Annie shouldered the task from the beginning with dedication and determination.

The struggle to establish Rosenberg's reputation after his death paralleled his own efforts during his life. At times, it appeared that no meaningful recognition would ever be achieved; and to this day, he has not had the full attention his work deserves. Yet there have been many occasions when his name and work were introduced to

ever-widening audiences. From the very beginning serious writers have recognized his importance and lamented the lack of sustained interest, often contrasting it with the steady growth of Wilfred Owen's popularity. In 1959, when Sir Herbert Read opened the Leeds Memorial Exhibition, he talked about the semi-oblivion into which Rosenberg had fallen. Others, recognizing Rosenberg's worth, have both half- and wholeheartedly ascribed the slow development of his reputation to those traits which I have tried to bring out in this study: his iconoclasm, stubbornness, and his refusal to imitate his contemporaries. Even his most ardent admirers have not yet thoroughly explored his subtleties as a means both of understanding him and of refuting the charge of obscurity. He was a complex person who lived a difficult, sometimes harrowing life, but it was nonetheless rich for all that. He brought to it his own imaginative power, creating fantasies of beauty out of the realms of despair through which he travelled, adding to experience and fantasy what he gleaned from his reading. His poetry reflects these complexities and it is all the more substantial for them. They have cost his reputation much in the short term, but in the long run will prove that he is one of the signal voices of the twentieth century.

My purpose here is to survey the growth of his reputation, focusing primary attention on several critical years and events that have been significant in the erratic progression of Rosenberg's popularity. Those of particular interest are the publication of Rosenberg's *Poems* in 1922; the publication of Wilfred Owen's *Poems* in 1931; the issue of Rosenberg's *Collected Works* and the Memorial Exhibition of his drawings and paintings in 1937; the outbreak of World War II in 1939; the re-issue of the *Collected Poems* in 1950; the acceptance by the British Museum of a selection of Rosenberg's manuscripts in 1953; the Leeds and Slade Memorial Exhibitions in 1959; and the death of his devoted sister Annie in 1961. She, more than anyone else, carried his spirit forward during the lean years and the few fat ones, and her passing marked the end of an era. No literary executor was ever more faithful. While she had typed his poems and managed his correspondence with intelligence and sisterly affection when he was in France, her real work began after he died on that cold, grey dawn of April 1, 1918.

Almost immediately she was in touch with Rodker and Binyon about the prospect of publishing Isaac's work, and they offered their assistance. For a time they were handicapped by Hacha who asked Annie not to do anything since it only increased the pain.

Early in 1919 Sydney Schiff contacted Annie and asked her to

allow him to print some of Isaac's work with a memoir by her in *Art and Letters.* The journal was edited by Frank Rutter and Osbert Sitwell; Schiff was the publisher though he remained reticent about his sponsorship. Annie complied and five of Rosenberg's poems, a pencil study, and Annie's memoir, which Schiff shortened considerably, appeared in the Summer 1919 number. This was Rosenberg's principal appearance in 1919 though *Colour,* which had published three of his poems in 1915, printed a poem called 'Killed in Action', by Joseph Leftwich, attributing it to Rosenberg. No one seems to know how it got there.

At Annie's insistence, Binyon quietly began organizing an edition of Rosenberg's poems. Concurrently, T. E. Lawrence on his own initiative began to collect subscriptions to issue privately a book of Rosenberg's poems. He had liked *Moses* so much he is said to have carried a copy of it with him for months. Winifreda Seaton sorted all her letters and manuscripts into order and offered them to Binyon, who was now in touch with Bottomley. Together they began to look for a publisher.

Little transpired in 1920, though other poets of the war were getting attention in the press. A slender volume of Wilfred Owen's poems appeared, edited by Sassoon, but most of the work was done by Edith Sitwell while Sassoon was on a lecture tour in America. In the United States, B. W. Huebsch, at Sassoon's urging, brought out Owen's poems, having purchased sheets from his London publisher, Chatto and Windus. T. Sturge Moore's *Some Soldier Poets* was issued, but it made no mention of Rosenberg.[67] Horace Brodzky, already well-known for his woodcuts, and Boris de Tanko, started *Rainbow* in New York, financed by John Gould Fletcher. Before the U.S. postal authorities stopped the circulation of the magazine because of A. R. Davies's nudes, two of Rosenberg's poems, the 'Savage Song' from *Moses* and an early version of 'God' had been printed. Beyond these appearances Rosenberg's reputation gained little impetus except from a passing remark by T. S. Eliot, in one of Harold Monro's *Chapbooks,* deploring the sad state of contemporary criticism which left Rosenberg in neglect: 'Let the public, however, ask itself why it has never heard of the poems of T. E. Hulme or of Isaac Rosenberg, and why it has heard of the poems of Lady Precocia Pondoeuf and has seen a photograph of the nursery in which she wrote them.' The Reverend Michael Adler became editor of a huge memorial volume called the *British Jewry Book of Honour,* and he wrote Barnett asking for a photograph of Isaac. Annie sent the picture. When Adler replied, thanking her, he said he had 'frequently

met [Rosenberg] in France and corresponded with him', and that Rosenberg had sent him a copy of *Moses*. Adler's papers were destroyed during World War II, so that little is known of this relationship.

By June 1921, Binyon and Bottomley had persuaded Heinemann to publish Rosenberg and they worked through October putting the manuscripts into order. Bottomley, with more leisure than Binyon, became the principal editor, and he prepared a full volume which Heinemann required him to reduce by one-third. Binyon was anxious to include a selection of drawings, but Heinemann refused. It was expected that the book would appear in time for the 1921 Christmas season; Heinemann declined to hurry it. But by the end of the year the reading public had been surfeited with memorial volumes and books on the Great War and was turning its interests elsewhere. Instead of gaining recognition, Rosenberg was losing it.

Early in June 1922, Heinemann published the *Poems* in an edition of five hundred copies in black cloth with a plain blue dust-jacket, selling at six shillings. *Moses* was printed first, followed by the war poems. 'The Amulet' and fragments of 'The Unicorn' were substituted for the final version of the verse-play, which Bottomley had misplaced. A selection of pre-war verses concluded that volume. Binyon's memoir contained many of the extracts quoted in this book, from Rosenberg's letters, principally to Bottomley, Marsh, and Miss Seaton. Those letters to Bottomley and Miss Seaton from which the extracts were taken were either mislaid, lost or destroyed after the edition appeared for they have never been recovered. Their disappearance is an irreparable loss.

Rosenberg's family was delighted with the book, and Marsh, Bottomley and Binyon were content that Rosenberg's accomplishment was now adequately served. Sales were slow, however, and Heinemann was unsuccessful in finding an American publisher to launch it in the United States. The book received generally favourable notices, particularly in the Jewish community's papers; and the *Times Literary Supplement* gave it a column. It began, 'The name of Isaac Rosenberg must be added to the long list of those whose promise was cut short by the war.' Both his strengths and his weaknesses were examined. Among the latter there is the charge that once his mind caught fire it led him into incomprehensibility. ' "Daughters of War",' the reviewer wrote, 'reads a little like one of the obscurer passages from Blake's prophetic books. . . .' On the other hand, he 'had a genius for the vivid phrase, for illumination in flashes; if he could have learned co-ordination, and calmness, the

broad handling of the texture of his art, he must assuredly have won a lasting place in the annals of our literature'. While *The Manchester Guardian* entitled its review 'An Obscure Poet', Edith Sitwell said in her review in the *New Age* that Rosenberg was 'one of the two great poets killed in the war, the other being Wilfred Owen'. From that time forward she championed both poets at every turn.

On February 15, 1923, Bottomley wrote Annie that 286 copies of *Poems* had been sold and admonished her not to be disappointed. She had wanted to share any royalties with Bottomley and Binyon, but both declined. Bottomley explained: 'I should not like to be paid for work that was a tribute of respect and sympathy. Your brother gave his life for my country; he was threatened with consumption as I have been for half my life; he was a poet, and unhappy because he could not give himself to poetry: for all these things, and because I was proud of his regard for me and confidence in me I wanted to serve him; and to help with his book was all I could do.' That same year a revised and expanded issue of Jacqueline Trotter's popular anthology of war poetry, *Valour and Vision* appeared, and though Brooke, Sassoon, Owen, Graves, and a whole host of now forgotten poets are included, Rosenberg was left out.

After 1923 the sales of *Poems* declined steadily. Annie was disappointed, but not resigned. She sent copies wherever she thought some tiny market might develop. In June 1927, she sent one to Henry Tonks, who thanked her on behalf of the Slade, commenting that 'it is very touching reading his last letters knowing all his hopes were going to be shattered.' That same year the famous John Quinn Collection Sale was held in New York, and Bomberg's fine little portrait of Rosenberg, 'Head of a Poet', passed into unknown hands for $10.00. His name, too, was nearly in limbo, except for a few angry admirers who refused to see him eclipsed. Among these were Laura Riding and Robert Graves who said that the 'whole reading public' was 'so cautious and suspicious' that Rosenberg could 'pass them by altogether. . . . He was one of the few poets who might have served as a fair challenge to sham modernism'; and despite much to recommend him he remained uncelebrated because his editors had introduced him 'merely as a poet of promise killed in defence of his country'.

In the autumn of 1928, the Imperial War Graves Commission notified Rosenberg's family that his permanent headstone had been put in place in France. That same autumn, *Poems* went out of print. Heinemann had left one hundred bound copies plus a small number unbound at the bindery. These were bound up and the lot was sold

to Annie at one shilling each. At least, she realized, she had been spared the ignominy of their being remaindered. The only notice given to Rosenberg during that year was in Beth Zion Lask's lecture on December 3, delivered before the Jewish Historical Society of England. Well-meaning in their intentions, the Society simply confirmed the fact that Rosenberg had become a museum piece. Bottomley was hoping to save him from that fate, and thought that a private press — he had in mind either the Franfrolico Press or the Coq d'Or Press — would issue a small book if someone could be found to underwrite costs. Nothing came of it.

All through the early 1930s Annie and Bottomley consoled each other and hoped for a revival of interest. Edmund Blunden's edition of Owen's poems was published by Chatto and Windus in 1931, with a touching memoir and a fuller selection than had appeared in 1920. Owen forthwith became the poet of the war, and if Rosenberg was mentioned at all, it was mainly because his obscurities provided an effective contrast to Owen's easily-perceived ironies. As Patric Dickinson was to note later, the publication dates of the two poets influenced their reputations. Owen was published first in 1920 when war poets were still heroes, and again in 1931 when W. H. Auden, Stephen Spender, Louis MacNeice and Christopher Isherwood were first starting out, and Owen, along with Gerard Manley Hopkins and T. S. Eliot, became one of their gods. Rosenberg was first published in 1922 when war-poets were out of fashion, and was out of print when the new generation of poets emerged in the 1930s.

At the end of 1931, Maxine Piha wrote to Annie from Paris to tell her that Edouard Roditi was publishing a long article on Rosenberg in *Illustration Juive*. A revised translation of the essay in English under the title 'Judaism and Poetry' appeared in the autumn number of *The Jewish Review*. It discussed the poetry of Rosenberg, Aaronson, and A. Abrahams. Long out of print, the essay is one of the cornerstones of Rosenberg criticism, for it accurately defines one fundamental element of Rosenberg's Jewishness in respect to his poetry. Because he was 'concerned with purely poetic, that is to say human, values — as opposed to the literary, theological or metaphysical — his poetry was more in touch with the purely human and contemporary, in fact eternal, aspects of Judaism, and therefore more purely Jewish. . . .'

'Purely Jewish' in Roditi's refined sense, Rosenberg intrinsically remained an English poet; and his reputation depended on recognition or the lack of it from English critics. A powerfully vociferous one now emerged and set in motion a chain of events which led to

the publication in 1937 of the *Collected Works*. F. R. Leavis had discovered Rosenberg and proclaimed in 1932 that while Owen was a 'remarkable poet' and his verse 'technically interesting', Rosenberg was 'equally remarkable' and 'even more interesting technically'. As in his other literary judgments, Leavis brought an abundant energy and an enlightened though dogmatic authority to his estimate of Rosenberg. One day he would be criticized for his 'exaggerated admiration' of the poet. He taught Rosenberg's poems to his students and interested his disciples — among them Denys Harding — in him.

Through Harding's enthusiasm a new effort to revive interest in Rosenberg developed. On August 30, 1934, he visited Annie and came away fascinated by Rosenberg's manuscript poems and letters. He undertook at once to find a new publisher, writing to Gordon Fraser of the Minority Press in an effort to get the rest of Rosenberg's poetry into print; and he selected six poems and one prose fragment for an article in *Scrutiny*. Meanwhile, Cecil Day Lewis's *A Hope For Poetry* came out, extolling Owen and ignoring Rosenberg, as did Geoffrey Bullough's *The Trend of Modern Poetry*. Only a fragment of Rosenberg's verse that year reminded readers of him. No. XIX 'Where the Heart's Rock Is Hidden. . . .' (*CW*, p. 221), was printed in the July 27, 1934 issue of *The Spectator*. In France, Louis Bonnerot translated and published several poems by Rosenberg, Owen, and Sassoon in the September, 1934 number of *Poésie*.

Harding called on Marsh early in January 1935 to look at his Rosenberg pictures. After that visit he conferred with Leavis and decided to stop at nothing short of a definitive edition issued by a commercial press. On February 14 he wrote to tell Annie that he had just concluded a meeting with Ian Parsons of Chatto and Windus. Parsons agreed to publish the book and decided to ask T. S. Eliot to write an introduction. But Eliot had a cold and the meeting was postponed. Harding had written to Bottomley; together they moved toward the co-editorship, with the latter serving principally as an adviser. In March, Harding published in *Scrutiny* six Rosenberg poems and the prose fragment on Emerson with explanatory notes, followed by his article 'Aspects of the Poetry of Isaac Rosenberg'. For the first time a perceptive and distinguished analysis of Rosenberg's craft was on record. It, too, remains a cornerstone of Rosenberg criticism.

With the drive and the ability of both Harding and Parsons, the planning for the volume moved steadily forward. Parsons thought Yeats might do the introduction but he declined. At the time, Yeats

was compiling *The Oxford Book of Modern Verse* and was besieged with requests to include the war-poets. He did not, and the publication of his anthology touched off one of the most famous literary controversies of the century. His judgment of Owen as 'all blood, dirt, and sucked sugar stick' has been widely quoted, but what he thought of Rosenberg is less well-known: he described him as 'all windy rhetoric'. Following Yeats's refusal, Parsons decided to contact Sassoon, and if he demurred, to ask Robert Graves. Sassoon accepted, and on January 3, 1936, Parsons wrote to give Annie the good news. Sassoon's strongly affirmative response to Parsons closed with the conviction that, 'The only thing that matters is that Rosenberg should be given his due as one of the best of the young poets who perished in the war.'

While Harding, Bottomley, and Parsons worked on the book, Annie urged a memorial exhibition. Marsh was not over-enthusiastic but offered his pictures if the show materialized. He subsequently conferred with Binyon and they both decided an exhibition would be a mistake. Annie was not deterred by their advice. Her father died that year, and after a period of mourning she resumed her campaign for a show, with the result that the Whitechapel Art Gallery agreed to hold the exhibition in the early summer of 1937. Elsewhere, Rosenberg's name turned up in a number of the reviews of Yeats's Oxford anthology as being among the slighted poets. In South Africa, John Amshewitz lectured on Rosenberg before the Johannesburg Women's Zionist Society. He told Annie that the audience was big and enthusiastic, and he predicted a large sale of the *Collected Works* when it was released there.

The *Collected Works* was issued early in June 1937, in an edition of 500 copies, with an additional 900 sets of sheets stored at Chatto's bindery. The book's 416 pages were bound in light red cloth. Eight plates were included. The handsomely-produced jacket bore Rosenberg's self-portrait in his helmet. The sale price was twelve shillings and sixpence. Parsons's costs came to three hundred pounds. He was confident that he would recover his expenses and had high hopes of securing an American publisher. Unfortunately, not only did an American publisher not materialize, but there were no impressive sales anywhere in the British domain, though the book was reviewed in papers in South Africa, Australia, India and Palestine.

The English reviews were, on the whole, complimentary. Everyone was pleased that justice had been done to the poet's memory; the *Collected Works* had given Rosenberg a kind of official niche in English literary history which the *Poems* had failed to achieve. *The*

Times Literary Supplement noted the 'magnificence' of Rosenberg's kaleidoscopic imperfections, which is another way of saying he wrote memorable lines in spite of his obscurities; and, of course, that charge dogged him through many of the reviews. Cecil Day Lewis, who was later to become one of Owen's editors, recognized Rosenberg as the one poet of the war equal to Wilfred Owen in promise though not in achievement. Owen's 'genius was summoned up and summed up by the War', whereas Rosenberg's was 'delayed and distracted' by it. Though scarcely perceptive, Day Lewis's remarks were nonetheless representative. Perhaps the most acute review was William Plomer's in *The Spectator*. He argued that Rosenberg was not simply a war poet but a 'highly imaginative artist . . . more concerned with love than war'. He questioned Sassoon's assertion in his Foreword that there was 'a fruitful fusion between English and Hebrew culture'; and while Plomer thought the 'Jewish strain' more pronounced, it is interesting to observe his reasons for saying so: 'It shows itself especially in his choice of themes and colours, his sensuousness and eroticism, and it provides a particular richness and warmth not to be matched among . . . his contemporaries.' Emphasizing Rosenberg's debt to Swinburne, Plomer asserts again the significance of Rosenberg's sensuality which, however, 'is something specially his own'. Herbert Read's review in *The Criterion* is noteworthy for another reason. He found the book 'in every respect . . . a worthy memorial', except for the editing. He thought 'the arrangement of the text . . . exasperating', pointing out that the poems 'are printed in ten sections, beginning in 1912, jumping to 1915, continuing 1916, 1916-18, falling back to 1914-15, 1913, 1912, and ending with a section of fragments which are mostly dated 1914 and 1915. The ninety pages of letters are arranged in a similar jumble. It needs all a reader's agility to reconstruct the sequence!' What Harding and Bottomley had done, of course, was to follow the publication dates of Rosenberg's three pamphlets first. While this may have seemed sensible to them in 1937, it has since precluded the possibility of the reader's achieving any chronological view of Rosenberg, and has thus made his development seem more fragmented than it was. This rather contributed to the charge of obscurity and added dimension to a weakness Rosenberg's editors did not consciously intend to exploit.

Edwin Muir praised Rosenberg strongly: 'He used language as only the great poets have used it; as if he were not merely making it serve his own ends; but ends of its own as well, of which it had not known.' And in *Scrutiny*, F. R. Leavis said 'genius is the word for

Rosenberg, who has all the robustness of genius. . . . His interest in life, in fact, is radical and religious in the same sense as D. H. Lawrence's. It has to be added that we must credit him, on the evidence of his best work, with an extraordinarily mature kind of detachment such as is not characteristic of Lawrence — to say this first gives the right force to the observation that of the two Rosenberg was much more an artist.' In concluding his review Leavis wrote ' . . . the total effect [of the *Collected Works*] should be, not only the recognized enrichment of the English language by a dozen pages of great poetry, but also the enrichment of tradition by a new legend.'

Meanwhile, the Memorial Exhibition of Paintings and Drawings was opened on Tuesday June 22, 1937, running till July 17. Leftwich and Bomberg organized the exhibition and took care of the hanging arrangements. Leftwich wrote the introduction to the catalogue, which carried the helmeted self-portrait on the cover, and listed forty works, of which a number were for sale ranging in price from ten to one hundred guineas. The inside back leaf had two memorial poems: Leftwich's 'Killed in Action', which had been previously printed three times as Rosenberg's own work, and 'To Isaac Rosenberg', a tribute from A. Abrahams.

Annie had written to a number of literary personalities asking them to speak either at the opening or during the exhibition, and had received one refusal after another. Marsh reluctantly agreed to make the opening address though he had a horror of public speaking. The list of those who were invited but unable to be present for the opening included some of Rosenberg's most ardent admirers: Trevelyan, Abercrombie, and Binyon had prior engagements, Harding and Bottomley were ill, Edith Sitwell was in France and Robert Graves was in Switzerland, while Marda Vanne and Mrs. Lily Delissa Joseph were on holiday. The opening was nonetheless crowded and successful. Marsh's remarks were warm, but they amounted to a parading of all his old ambivalences. Though he called Rosenberg an 'inheritor of unfulfilled renown' he also described him as 'an Aladdin whose lamp was a strong but slender searchlight which lit up now and then, but only for a moment, some jewel in the cave of darkness in which he groped'.

The year 1937 was a landmark for Rosenberg's reputation. Annie was elated. In addition to the largely favourable reviews, it appeared at first that sales of the book would go well. By August 18, 330 copies had been sold, and Parsons believed that the sales figure would climb to the 700 copies necessary to cover costs. Despite the strong

start and the good publicity, however, sales declined so that by March 10, 1938, with only 403 copies sold, Parsons was constrained to ask Annie to allow anthology fees to be applied toward the remaining one hundred pound deficit. This she agreed to do.

With the outbreak of the Second World War in 1939, there was some revival of interest in the poets of the Great War; but it was soon realized that this was a different kind of war, and the rising generation of poets needed to respond to it in their own way. Among the best of the new poets soon to be killed was Keith Douglas, who acknowledged in 'Desert Flowers' his debt to Rosenberg:

> *Living in the wide landscape are*
> *the flowers – .*
> *Rosenberg I only repeat what you*
> *were saying –*
> *the shell and the hawk every hour*
> *are slaying men and jerboas, slaying*
> *the mind. . . .*

If World War II brought Rosenberg to the attention of more readers, it also put him out of print. The nine hundred sheets of the *Collected Works* were destroyed in April 1941, when Chatto's bindery was bombed during the Blitz. As had been the case with Rosenberg's pamphlets, the *Collected Works* now became exceedingly scarce, and today it is impossible to obtain.

The end of World War II in 1945 brought with it a spate of new anthologies of war poetry. When World War I poets were included, Rosenberg was represented, though not to the same extent as Owen. Patric Dickinson omitted him from his *Soldiers' Verse,* which included Blunden, Owen, Sassoon, C. H. Sorley – a fine young poet killed in World War I, also often neglected, and Edward Thomas. Dickinson, who relates in his autobiography, *The Good Minute,* the incredible impact Owen had on his life, had not yet discovered Rosenberg, though he was to add him to his pantheon of heroes in the 1950s.

Just as Bottomley had done before him, Harding kept up a friendly and hopeful correspondence with Annie urging patience and explaining to her why Rosenberg's fame in the 1940s remained insecure. America had always been the big disappointment. It therefore came as a surprise to everyone when Schocken Books proposed to Parsons in 1949 a reissue of the collected poems only, offering to purchase one thousand copies. Annie and Parsons were delighted,

particularly as the stereos had been preserved in Edinburgh and reprinting would be simple. Parsons decided to prepare two thousand copies, sending half to the United States and keeping the other half for the English market. That same year, the American critic Marius Bewley published a long, informative article on Rosenberg in *Commentary*.

The 1950s began with the publication of the *Collected Poems*, which was well received in the United States though sales were not impressive. David Daiches reviewed the edition in *Commentary*. He referred in passing to Rosenberg's 'mythopoeic manner'; described 'The Unicorn' as his 'Waste Land'; and speculated on the future of which he was deprived: 'Had Rosenberg lived to develop further along the lines on which he had already moved, he might have changed the course of modern English poetry, producing side by side with the poetry of Eliot . . . a richer and more monumental kind of verse, opposing a new romantic poetry to the new metaphysical brand.'

In 1951, three of Rosenberg's paintings were shown in the Ben Uri Art Gallery's Festival of Britain Anglo-Jewish Exhibition 1851-1951. In 1952 Dora Sowden published an interview with Annie in *Jewish Affairs*, a Johannesburg journal, conducted when Annie was in Cape Town visiting Minnie. In London that year the sales of the *Collected Poems* finally covered all costs and showed a profit, out of which Annie received a royalty of £18. 9s. 7d. In 1953, after negotiations between Harding, Parsons, Professor Isaacs and A. J. Collins, the British Museum accepted a small quantity of Rosenberg's manuscripts including the draft of *Moses*. In 1954 Patric Dickinson wrote 'The Real Voice, A Study of Isaac Rosenberg 1890-1918', a perceptive and warm hour-long tribute, broadcast on the BBC's Third Programme on December 15 and repeated on December 18. In 1956 Jacob Sonntag's *Jewish Quarterly* published a number of Rosenberg's poems, initiating the first of many continuing references to him in that magazine's pages; and in 1958 Jon Silkin and Maurice de Sausmarez began to plan the 1959 Memorial Exhibition at Leeds University.

The Leeds Exhibition was opened on May 27 by Sir Herbert Read. Silkin, de Sausmarez, and Annie made an intensive and exhaustive effort to gather material. Some new fragments of verse, plus the important series of letters Sydney Schiff, came to light. The handsomely printed *Catalogue with Letters* was produced in an edition of three hundred copies containing brief essays by Silkin and de Sausmarez and the previously unpublished materials. Sixty-three

exhibits consisting of 128 manuscripts, letters and memorabilia were listed along with art works. It was a monumental undertaking, particularly for Annie, who was now sixty-seven years old, widowed and ill. Yet her resourcefulness and her devotion to her brother's memory and reputation were stronger than ever. In October a smaller showing was held at the Slade School. Both exhibitions were well received and the *Catalogue with Letters* was widely reviewed.

Not the least of the advances made in these exhibits was the bringing together of the most comprehensive collection of Rosenberg artifacts ever to be assembled. Rosenberg's generation is now all but gone; with the apparent unrecorded dispersal of Annie's once sizable collection,[68] it is unlikely that this much material can ever be amassed again, especially since it is now dispersed over three continents: Marsh's papers were sold to the New York Public Library, and other works of Rosenberg are in Philadelphia and New Orleans, and in South Africa. Fortunately, two of the self-portraits are now in the permanent collections of the National Portrait Gallery and the Tate Gallery.

Since 1959 a number of graduate theses have been written on Rosenberg, and, increasingly, critical assessments have been made which realistically attempt to come to grips with the essential meaning and ultimate significance of the poems. In 1960, Silkin devoted an entire issue of *Stand* to the war poets with the same self-portrait of Rosenberg on the cover that had appeared on the *Catalogue with Letters*. That same year I published an essay on Rosenberg and subsequently read papers in 1962 before sections of the South-Central Modern Language Association and the Modern Language Association of America on, respectively, the feminine principle motif and the bibliographical facets of Rosenberg's reputation. In 1964 John H. Johnston's *English Poetry of the First World War* appeared with a chapter on Rosenberg. The year 1965 produced four important studies: Dennis Silk's essay in *Judaism;* Parsons's anthology of World War I poems, *Men Who March Away,* with an introduction as charming as it is illuminating; Frederick Grubb's *A Vision of Reality,* which provides a fresh, vibrant and impressive assessment of both Rosenberg and Owen; and Bernard Bergonzi's *Heroes' Twilight,* which also combines Rosenberg and Owen in a chapter-long assessment.

In 1967 the New York Public Library put its Marsh Collection on view in a show entitled *Letters to an Editor: Georgian Poetry, 1912-1922, An Exhibition from the Berg Collection.* Rosenberg's letters and manuscripts were fully displayed. Since 1967, other

assessments, some brief, others extensive, have been made by Philip Hobsbaum, W. W. Robson, C. H. Sisson, and Martin Seymour-Smith. Silkin's *Out of Battle* appeared in 1972, with its long, complexly-knit evaluation, which despite an over-emphasis on Rosenberg's Jewish, working-class background, is of the first importance in providing insight into Rosenberg's multi-faceted experience. Against these works it now seems inconsequential that in 1958, Blunden, who should have known better, could dismiss Rosenberg with a fleeting reference in his British Council monograph *War Poets 1914-1918;* or that Mildred Davidson could publish a 160-page book, *The Poetry is in the Pity,* in 1972 on twentieth-century war poetry with no mention of Rosenberg at all.

Beyond these latter aberrations, it would be fair to observe that insofar as Rosenberg's reputation is concerned, we have come to the good years. His place in twentieth-century literature is as assured as it is significant. But during Annie Rosenberg Wynick's lifetime this was not so. With brief exceptions, hers were the hard years, the disappointing ones. Yet to her more than any other single individual, and I am not unmindful of the impressive contributions of Marsh, Bottomley, Binyon, Harding, Parsons, Silkin and de Sausmarez, goes the real credit for keeping Rosenberg before the public. Perhaps with the 1959 Leeds Exhibition she knew that he had 'arrived', though she was not content to rest on any laurels. It is a pity that when she died in 1961 she could not have known how highly regarded Rosenberg was to become in the next fifteen years. And how tragic it is, that like her brother, Isaac, she died needlessly and violently. Convalescing in Brighton after an illness, a frail little old lady, she was one day walking along the promenade when a sudden fierce gust of wind blew her into a moving cement-mixer below her. She was horribly mangled, and died instantly.

Because of her, Rosenberg's memory and work is well known. Through his achievement, and her dedication to it, she, too, will be remembered and revered.

References and Notes

The documentation and supplementary data which follow have been divided into two sections: References and Notes. Under References I have identified my sources, except for citations from *Poems by Isaac Rosenberg,* 1922 (*PIR*), *The Collected Works of Isaac Rosenberg,* 1937 (*CW*), and *Isaac Rosenberg Catalogue With Letters,* 1959 (*CWL*), which are included in the text after quotations of primary material. Information beyond the identification of the source is detailed in the Notes section.

Quotations from Rosenberg's letters, prose pieces and poems are reproduced in the same form in which they were published. His punctuation and spelling left much to be desired. Laurence Binyon apparently corrected the extracts from letters he used in his introductory memoir in *Poems by Isaac Rosenberg,* whereas Gordon Bottomley in that volume followed Rosenberg's punctuation in editing the poetry. In the *Collected Works,* Denys Harding and Bottomley left Rosenberg's spelling and punctuation as they found it in his letters and manuscripts; and Maurice de Sausmarez and Jon Silkin have apparently done the same in *Isaac Rosenberg Catalogue With Letters.* While I have scrutinized the extant manuscripts, I have followed the published text of the above-named editors when quoting; and, where unpublished material by Rosenberg or other writers is included, I have transcribed this material as faithfully as possible. Obvious errors in quoted matter are thus to be ascribed to the writer or editor of the work, not to the printer.

The chief published materials consulted are included in the Bibliography. The unpublished material consulted is contained for the most part in two library collections and in the papers formerly in the possession of Annie Wynick. Library repositories include (1) the Edward Marsh Papers in the Henry W. and Albert A. Berg Collection

of English and American Literature of the New York Public Library; and (2) the Harriet Monroe Papers in the Regenstein Library of the University of Chicago. A few of Rosenberg's letters to Edward Marsh and some letters of other correspondents concerning Rosenberg were not included or referred to in the *Collected Works*. Where quotations or references to these letters occur they are identified in the References and Notes by the word BERG.

Annie Wynick put at my disposal all the papers acquired under her executorship of her brother's estate. Because she was convinced that my interest in Rosenberg would one day result in a biography, she insisted on giving into my ownership some materials from her collection. I required only copies, and urged her to arrange for the final acquisition of the papers by an English university. My insistence in this matter is on record. However, she preferred to entrust some things — not many, but a few significant items, among them her father's papers — to me, and it is my expectation that these materials will one day be placed in an appropriate library where they may be preserved for future generations. References to these materials are designated by the abbreviations BRP, for the Barnett Rosenberg Papers, and AW, for Annie Wynick.

Other initials used are as follows:

GB	Gordon Bottomley
DH	Denys Harding
JLD	Joseph Leftwich Diary
EM	Edward Marsh
IP	Ian Parsons
AR	Annie Rosenberg [to 1919; afterward Wynick]
IR	Isaac Rosenberg

Hearsay evidence is identified in the References and Notes section by the abbreviation *p. b.* (provided by), followed by the name or initials of my informant. Unless otherwise indicated, all evidence of this kind was obtained in interviews and discussion during 1959-60.

The most complete listing of Rosenberg's art work is in the *Catalogue With Letters*. Pressed for time and not domiciled in England, I have had to forego my intention of tracing to their present owners as many of Rosenberg's paintings, drawings, and sketches as could be located. I hope this worthy project will one day be undertaken. I have indicated the present whereabouts of several pictures in discussing them.

References

CHAPTER ONE

Page
1 Despite the ferocity . . . the day. J. M. Cowper, *The King's Own, The Story of a Royal Regiment*, Vol. III (Aldershot, 1957), p. 200.
3 'what is happening . . . me completely'. IR to EM, January 26, 1918 (BERG); the edited version: *CW*, pp. 320-21.
3 In the same hour . . . the German advance. Cowper, *op. cit.*, p. 202.
4 'Rupert Brooke is . . . will linger'. *London Times*, April 26, 1915.
5 was interred in . . . his body was. *p. b.* AW.
5 Rosenberg's family still . . . his corpse. *p. b.* AW.
5 By the end . . . were unknown. Letter, December 19, 1919, to AR.
5-6 The War Graves Commission . . . East Cemetery. Letter to Barnett Rosenberg.
6 By October 1928 . . . thruppence. Imperial War Graves Commission notice, October 11, 1928, to Barnett Rosenberg.

CHAPTER TWO

Page
7 He was born . . . from Vilna. *p. b.* AW.
7 Dovber Rosenberg uttered . . . his forefathers. BRP.
7 Of his brothers . . . and Johannesburg. *p. b.* AW.
7 Dovber's boyhood . . . the countryside. BRP.
8 In 'This Was My Youth' . . . the fishing tackle. BRP.
8 Obviously his happy . . . south-western England. *p. b.* AW.
8-9 By 1870, when . . . among hypocrites'. BRP.
9 He was soon . . . their own cow. BRP.
9 Hacha was not . . . medicinal cures. *p. b.* AW.
9 These good qualities . . . a sizable dowry. BRP.
9 That she was . . . to perceive. *p. b.* AW.
9-10 The dowry was . . . but a virgin'. BRP.
10 The marriage was . . . newly married. *p. b.* AW.
10 Saddled now with . . . guarded optimism. BRP.
10-11 One night while . . . Hacha and Minnie. BRP.
11 Soon after he . . . however meagre. *p. b.* AW.
11-12 The small sums . . . outskirts of Bristol. BRP.
12 After a time .`. . a kosher home. *p. b.* AW.
12-13 Nevertheless, Hacha . . . living in Bristol. *p. b.* AW.
13 Of this particular . . . were few Jews'. BRP.
13 In later years . . . in a jug'. *p. b.* AW.
13 Hacha refused to . . . place to live. *p. b.* AW.

CHAPTER THREE

Page
15-16 The Jewish Quarter . . . than Cable Street. Lloyd P. Gartner, *The Jewish Immigrant in England 1870-1914* (London, 1960), p. 146.
16 All these struck . . . Rosenberg children. *p. b.* AW.
16 Taking one room . . . train from Bristol. BRP.
16 Their new home . . . Barnett's weakness. *p. b.* AW.
16-17 This institution, founded . . . 3,500 children. Gartner, *op. cit.,* p. 224.
17 'As soon as I . . . in my face'. BRP.
17 The London School Board . . . of Religious Knowledge. Gartner, *op. cit.,* p. 229.
18 . . . Isaac's truancy . . . lessons started. *p. b.* Sidney Scott.
19 A kindly man . . . and water colours. *p. b.* Sidney Scott; AW.
19 . . . he saw Isaac . . . other boy's presence. *p. b.* Joe Rosenberg, later Rose.
20 . . . when the final bell . . . bright red coats. *p. b.* Sidney Scott.
20 From the moment . . . sixpence. *p. b.* AW.
21 'The money you sent . . . well in business'. BRP.
21-22 Business, indeed, was . . . living in London. *p. b.* AW.

CHAPTER FOUR

Page
23 After three misery-begotten . . . with her neighbours. *p. b.* AW.
23 Jubilee Street was . . . meat from him. *p. b.* Joe Rose; AW.
24 Except that he . . . Barnett never changed. *p. b.* AW.
24 He did a charcoal . . . saw your picture'. *p. b.* Rachel Lyons.
24 At the close of . . . school authorities. Tower Hamlets Division, Baker Street School Certificate, July 31, 1902, formerly in the possession of AW.
24 Two years later . . . to Animals. RSPCA Certificate of Merit, May 14, 1904, formerly in the possession of AW.
24 Hacha derived enormous . . . toward strangers. *p. b.* AW.
24-25 One day while . . . kitchen table. *p. b.* AW; Joe Rose.
25 A few of her neighbours . . . London painter. *p. b.* AW.
26 Hacha managed the . . . pay handsomely. *p. b.* AW.
26 When he took a . . . room, crying. *p. b.* AW.
27 Among his acquaintances . . . his reaction. *p. b.* Morris Goldstein.
27 His only consolation . . . lunch breaks. Laurence Binyon in *PIR,* p. 5.
27 One day he brought . . . auction sale. *p. b.* AW.
28 'In the National . . . Book prize'. Vol. IV, No. 1 (December, 1908), p. 3.
28 'three hours' study . . . in oils'. Vol. VI, No. 1 (1910), p. 3.
29 Along with Goldstein . . . Cecil Rea. *p. b.* Morris Goldstein.
30 'Only write' . . . Light Brigade" '. Letter to IR, undated [September, 1905], formerly in the possession of AW.
30 'a real pleasure . . . tyrannical orthodoxy'. Letter to Barnett Rosenberg, October 6, 1905, formerly in the possession of AW.
30 'Now for a few . . . vague in parts'. 'The Children's Page', p. 379.

CHAPTER FIVE

Page
33 On December 31, 1910 . . . down to supper. 'Ushering in the New Year', *The Times,* No. 39,471 (January 2, 1911), p. 12.
36 Though delighted . . . portrait of him. JLD.
37 For a time he . . . a literary critic. JLD.

37 On Tuesday, January 24 . . . ugly face'. JLD.
37 Grim as his situation . . . bustled about. *p. b.* AW.
37 . . . on Sunday, January 29 . . . jolly evening'. JLD.
37 'the similarity and . . . female faces'. JLD.
38 On Friday night . . . was expecting him. JLD.
38 Rodker, he felt, was . . . and thoughtful'. JLD.
40 When the Whitechapel boys . . . next Sunday. JLD.

CHAPTER SIX

Page
42 'a violently green . . . Tyrolean' hat. March 3, 1911, JLD.
43 By the time he . . . on March 17, JLD.
43 Goldstein and Bomberg thought . . . but no painter. April 14, 1911, JLD.
43 Rosenberg discountenanced their . . . unabashed sarcasm. March 3, 1911, JLD.
43 . . . Leftwich, who had written . . . in Hyde Park. February 23, 1911, JLD.
43 Afterward, the four boys . . . with laughter. JLD.
43 . . . a Whitechapel girl . . . of affection. *p. b.* Sonia Cohen Joslen.
43 The idea that Sonia . . . scoffed at it. March 8, 1911, JLD.
43 Bomberg would attempt . . . make her pregnant. *p. b.* Sonia Cohen Joslen.
44 'We are too young . . . and decided'. March 22, 1911, JLD.
44 By the next evening . . . *Young Worker.* March 12, 1911. JLD.
45 Curiously, Rodker made . . . was overruled. April 1, 1911, JLD.
45 Rosenberg did not stop . . . the new wing. March 9, 1911, JLD.
45 Two of the chief referees . . . William Rothenstein. John Woodeson, *Mark Gertler Biography of a Painter, 1891-1939* (London, 1972), p. 48.
45-46 Rosenberg continued to apply . . . of his case. *p. b.* AW.
46 She gave him her . . . call on her. March 17, 1911, JLD.
46 He sat out in the . . . Highgate Pond. March 19, 1911, JLD.
47 . . . he worried about . . . despite his efforts. April 13, 1911, JLD.
48 She did not marry . . . nervous breakdown. *p. b.* AW; Morris Goldstein.
51-52 When he came to . . . young son. May 6, 1911, JLD.
52 Rosenberg painted . . . Blackfriars. May 28, 1911, JLD.
52 He thought he might . . . accompany him. June 7, 1911, JLD.
53 The general elections . . . Hilaire Belloc. July 24, 26, 1911, JLD.
53 He forced himself . . . Whitechapel acquaintance. September 18, 1911, JLD.

CHAPTER SEVEN

Page
54-55 The Slade School had been . . . history of art. *p. b.* George Charlton. I have also used his article 'The Slade School of Fine Art 1871-1946'. *The Studio* (October, 1946).
55 Sargent had observed Bomberg . . . in the world'. William Lipke, *David Bomberg A Critical Study of his Life and Work* (London, 1967), p. 29.
55-56 In 1910, without regard . . . the outrageous prank. *Ibid.,* p. 34; also *p. b.* George Charlton.
56 'Impressionism is of no country . . . to journalism'. John Russell in 'Art', *Edwardian England 1901-1914,* edited by Simon Nowell-Smith (London, 1965), p. 341.
56 In 1903 he complained . . . by Academy artists. *Ibid.,* p. 346.
56-57 The same year that MacColl . . . great artist'. *Ibid.,* p. 348.
57 Epstein set out to . . . to old age'. *Ibid.,* p. 341.
57 'a form of statuary . . . to see'. Quoted by Jacob Epstein in *Let There Be Sculpture* (London, 1940), p. 35.
57 'We are glad that . . . the British people'. John Russell, *op. cit.,* p. 342.
58 . . . there comes a point . . . at every step. 'The Post-Impressionists', *Manet and the Post-Impressionists* (London, 1911), p. 12.

59 'two outsize Germans . . . of a Pole'. C. R. W. Nevinson, *Paint and Prejudice* (London, 1937), p. 23.
60 'Waiting outside Brown's room . . . distressing shyness'. Gilbert Spencer, *Stanley Spencer* (London, 1961), p. 103.
60 'a somewhat gruff . . . man about him'. George Charlton, *op. cit.*, p. 4.
60 'very tall and grim . . . Iron Duke'. *Ibid.*
60 'With hooded stare and . . . much benefit'. *Outline* (London, 1949), p. 89.
61 'What is it? . . . an insect?' George Charlton, *op. cit.*, p. 6.
61 'There was a time . . . was despair'. Vol. II (London, 1932), p. 166.
61 'I am the Lord . . . Tonks but me'. Gilbert Spencer, *op. cit.*, p. 104.
61 'entirely lost sight of . . . my sympathy'. Letter, undated (1937), formerly in the possession of AW.
61-62 'furnished with numerous . . . rubbing out'. John Russell, *op. cit.*, p. 340.
62 'Timidly and apprehensively . . . with them'. From unpublished memoirs, quoted by John Woodeson, *op. cit.*, p. 55.
63 . . . although the view . . . with Ruth. E. O. G. Davies, 'Isaac Rosenberg', unpublished master's thesis, University of Nottingham.
63 'the poet-laureate less . . . retaining fee'. Lipke, *op. cit.*, p. 37.
63 Bomberg was petulant . . . no more. *p. b.* Jacob Kramer.
64 'More than anything . . . a red fleck'. *p. b.* Lazarus Aaronson.
64 'sneering trace of Irish malice'. *Ibid.*
64 Several years later Aaronson . . . the bill. *Ibid.*

CHAPTER EIGHT

Page
66 'It takes a lot . . . doing nothing'. *Everybody's Autobiography* (Random House, 1937), p. 70.
67 'possessed in a great . . . for exactness'. *The Jewish Chronicle* (May 24, 1912); also (*CW*, pp. 269-71).
68-69 'Whether this is something . . . from without'. *Ibid.*
69 'First is the portrait . . . exact interpretation'. *Ibid.*
70 . . . 'effectively stem the deterioration'. Lipke, *op. cit.*, p. 125.
74 Hacha had not wanted . . . Hacha burned. *p. b.* AW.
75 In despair, Gertler . . . than himself. Woodeson, *op. cit.*, p. 95.

CHAPTER NINE

Page
79 Leftwich tried to sell . . . without success. *p. b.* Joseph Leftwich.
79 By the end of the summer . . . in a penny. *p. b.* AW.
81-82 She also went out . . . to give to her. *p. b.* Sonia Cohen Joslen.
82-83 Nevertheless, in the summer . . . attempts at seduction. *p. b.* Sonia Cohen Joslen.
84-85 The booklet's only . . . bad painter. *p. b.* AW; Jacob Kramer.

CHAPTER TEN

Page
89 By 1913, the Georgian . . . full swing. See Robert H. Ross, *The Georgian Revolt 1910-1922 Rise and Fall of a Poetic Ideal* (Carbondale, Ill., 1965). My survey here draws much from this work.
89 Attracted by the drum-beating . . . literary history. See Stanley K. Coffman, *Imagism* (Norman, Okla., 1951), *passim;* and Hugh Kenner, *The Pound Era* (Berkeley, 1971), pp. 173-91.

89 New poetry journals . . . the 'modern'. Lascelles Abercrombie, 'John Drinkwater: An Appreciation', *Poetry Review,* I (1912), p. 169; Laurence Binyon, 'The Return to Poetry', *Rhythm,* I, No. 4 (Spring, 1912), 1-2; and D. H. Lawrence, 'The Georgian Renaissance', *Rhythm,* II (March, 1913), Literary Supplement, XVII-XX.

90 'a healthy cross-pollination among the arts'. Ross, *op. cit.,* p. 18.

91 One, entitled 'Twilight II', he gave to her. *p. b.* Sonia Cohen Joslen.

91 Sometime late in 1913 . . . of close friends. *p. b.* Sonia Cohen Joslen; Jacob Kramer.

93 They stayed at the home . . . of their trip. *p. b.* AW.

96 Rosenberg might have heard . . . met Hulme. A. R. Jones, unpublished letter, June 8, 1960, to JC.

96 . . . before the month . . . Yiddish play. Christopher Hassall, *A Biography of Edward Marsh* (New York, 1959), p. 253.

CHAPTER ELEVEN

Page

97 Not infrequently Rosenberg . . . some verses. *p. b.* Jacob Kramer; Morris Goldstein.

97 Bomberg was of the opinion . . . oust him. *p. b.* AW.

97-98 'It is all very well . . . let go'. Joseph Leftwich, 'Isaac Rosenberg', typescript of an article which appeared, much reduced in length, in the 'Literary Supplement', *The Jewish Chronicle* (February, 1936).

99 Morris Goldstein's mother had . . . in nothing. *p. b.* AW; Morris Goldstein.

99 . . . hung it prominently in . . . two decades. Hassall, *op. cit.,* p. 281.

101 When Marinetti and Nevinson . . . the usurpers. See *The Letters of Wyndham Lewis,* edited by W. K. Rose (London, 1963), pp. 62-63; also William C. Wees, *Vorticism and the English Avant-Garde* (Toronto, 1972), pp. 103-12.

102 Rosenberg delivered his lecture . . . go unappreciated. *p. b.* Agnes Cook, transcribed by Wolf Horvitch and relayed to AW.

103 'Knowing that Mr. Rosenberg . . . to do so.' No. 2,354 (May 15, 1914), p. 10.

CHAPTER TWELVE

Page

104 . . . he was young enough . . .avoid the rut'. IR to EM (Spring, 1914), BERG.

107 'the catastrophic nature of . . . 'Fünf Gesang'. *Heroes' Twilight* (London, 1965), p. 112.

109 'This is the best thing I've written . . .'. IR to EM (August, 1914), BERG.

110 'Here's a chance to . . . critical propensities'. *Ibid.*

110 . . . 'this coming away . . . and mature'. *Ibid.*

110-11 'I painted a very . . . characteristic landscapes'. *Ibid.*

111 'By the time you . . . her savageries'. *Ibid.*

112 'I am ashamed to . . . flattering enough'. Madge [Cook] Tennant, *Autobiography of an Unarrived Artist* (New York), p. 46.

112 'I asked the Reverend . . . he wanted" '. *p. b.* David Dainow.

112 He took his paintings . . . cleared harbour. *p. b.* AW.

CHAPTER THIRTEEN

Page

113 He found nothing . . . the household. *p. b.* AW.

113 After a bitter exchange . . . on anyone. BRP.

114 Indeed, the popular . . . in *Blast. Blast,* No. 1 (1914), p. 21.

114 Rosenberg's appearances were concentrated . . . Maurice Langaskens. *Colour,* Vol. 2, No. 5, p. 164; No. 6, p. 203; Vol. 3, No. 1, p. 7.

115 . . . Marsh's involvement in the . . . individualized verses. 'Isaac Rosenberg', *Out of Battle* (London, 1972), pp. 255-56.

117 'I'm glad you hit . . . in exchange'. EM to IR, April 12, 1915, now in my possession.

117 'I am so sorry . . . irreparable loss'. IR to EM, undated (late April, 1915), BERG.

117 Rosenberg managed to sell . . . crown each. *p. b.* AW.

118 . . . it interested him but . . . difficult to follow'. Unpublished letter, formerly in the possession of AW.

119 '. . . being now tired of . . . & cordiality'. *Collected Letters,* edited by Harold Owen and John Bell (London, 1967), p. 341.

120 . . . and arguing that even . . . a long way'. Unpublished letter, June 28, 1915, in the Regenstein Library, University of Chicago.

120 'Don't bother about Rosenberg . . . amuses you'. *Ibid.*

122 Incredibly, Rosenberg . . . a job. *p. b.* AW; Morris Goldstein.

CHAPTER FOURTEEN

Page

124 Not unnaturally . . . rest of his life. *p. b.* AW.

124 She vowed that her . . . such humiliation. *p. b.* AW.

125 'whose general physique was . . . military service'. F. E. Whitton, *History of the 40th Division* (Aldershot, 1926), p. 7.

125 She raged and sobbed . . . final calamity. *p. b.* AW.

126 . . . he kept his room . . . Devonshire Street. *Collected Letters, op. cit.,* pp. 359-60.

127 Though Silkin sees his . . . working-class origins. Silkin, *op. cit.,* p. 271.

128 'There is nothing . . . with it'. Unpublished letter, formerly in the possession of AW.

129 Being unaware of his . . . and borsht. *p. b.* AW.

129 'This morning I have . . . yet endured'. *Collected Letters, op. cit.,* p. 363.

133-34 In March 1916, a drastic . . . in Aldershot. Whitton, *op. cit.,* p. 9.

134 'I am sending you . . . great work'. Unpublished letter, undated (January, 1916), in the Regenstein Library, University of Chicago.

135 'I return Rosenberg's poem . . . very fine'. Unpublished letter, March 14, 1916, in the Regenstein Library, University of Chicago.

135 Though Rosenberg had hoped . . . the front. *p. b.* AW.

135 . . . when the King came . . . for France. Whitton, *op cit.,* p. 12.

CHAPTER FIFTEEN

Page

139 . . . only two critics . . . its meaning. Silkin, *op.cit.,* pp. 256-307, *passim;* and Dennis Silk, 'Isaac Rosenberg (1890-1918)', *Judaism,* Vol. 14, No. 4 (Autumn, 1965), pp. 462-74, *passim.*

139 . . . and more recently by Bernard Bergonzi . . . thought processes. Bergonzi, *op. cit.,* p. 120.

139 . . . Silkin goes further than . . . socio-economic class. Silkin, *op. cit.,* p. 262.

140 'If Israelite thinking is . . . in kind'. *Hebrew Thought Compared With Greek* (Philadelphia, 1960), p. 27.

142 'a necessary aspect of . . . civilized life.' 'Aspects of the Poetry of Isaac Rosenberg', *Experience Into Words: Essays on Poetry* (London, 1963), p. 93. (The essay is reprinted from *Scrutiny A Quarterly Review,* Vol.III, No.4 (March, 1935), pp. 358-69.)

143 'manipulate[s] words almost from . . . and intelligibility'. *Ibid.,* p. 99.

143 'a habit of reworking . . . in another'. *Ibid.,* pp. 101-2.

144 'to write out of and within the Jewish tradition'. 'The Isolation of Isaac Rosenberg', *The Dying Gladiators* (New York, 1968), pp. 44-45.

144 ... as an 'outcast', suspended ... accept him'. 'The Life and Poetry of Isaac Rosenberg', unpublished master's thesis, George Washington University (1960), pp. 82-83.

144-45 'of the rootlessness of ... English) Jew'. Silkin, *op. cit.*, p. 264.

145 ... there is another more subtle ... called attention. 'Two Poems by Isaac Rosenberg', *The Jewish Quarterly*, Vol. 16, No. 4 (Winter, 1968-69), pp. 24-28.

146 'Just as Owen is ... imitating Shakespeare'. 'Poetry in the Early Twentieth Century', *Modern English Literature* (London, 1970), p. 69.

CHAPTER SIXTEEN

Page

148 It was through this loss ... it up. *p. b.* AW.

148 'It is a long time ... about them'. Unpublished letter, June 5, 1916, formerly in the possession of AW.

150 'I have read both ... whole together'. Unpublished letter, July 4, 1916, formerly in the possession of AW.

150-51 'I wrote him a piece ... and tradition'. Hassall, *op. cit.*, p. 402.

151 'I told [Rosenberg] it ... from the others'. *Ibid.*

151 'I wrote to [Rosenberg] with ... by accident'. *Ibid.*

154 'Could you ... written in trenches'. Undated letter (c. September, 1916), in the Regenstein Library, University of Chicago.

CHAPTER SEVENTEEN

Page

158 'Make up any tale ... to death'. Unpublished letter, January 12, 1917, BERG.

158 'I am sorry for ... clerical job'. Unpublished letter, January 8, 1917, BERG.

158 ... who reported that Rosenberg ... seemed necessary. Unpublished letter, January 28, 1917, BERG.

159 On June 3, 1917, she sent it to Marsh. Unpublished letter, June 3, 1917, BERG.

163-64 Heavy fighting had ... No Man's Land. Cowper, *op. cit.*, p. 162.

165 'this prophecy of the fall ... visionary fragments'. *The Oxford Anthology of English Literature: Modern British Literature* (New York, 1973), p. 550.

165-66 'a covert parable concerning ... affect society'. Silkin, *op. cit.*, p. 308.

169 Had [Rosenberg] written nothing ... his fame'. Quoted by Marius Bewley in 'The Poetry of Isaac Rosenberg', *Commentary*, Vol. 7, No. 1 (January, 1949), p. 41.

169 'Rosenberg's poised indecision ... for himself'. *Ibid.*, p. 42.

169 'to mould raw experience ... transcendent beauty'. Ross, *op. cit.*, n. 28, p. 264.

170 'among the most ... the language'. Hobsbaum, *op. cit.*, p. 25.

170 'looked well and ... way out'. Leftwich, 'Isaac Rosenberg', *op. cit.*

170 Schiff wrote to him ... his leave. Unpublished letter, September 20, 1917, formerly in the possession of AW.

170 'Who is Rosenberg? ... in Copenhagen'. Hassall, *op. cit.*, p. 434.

CHAPTER EIGHTEEN

Page

175 'The light is gone ... compassionate leave. Hassall, *op. cit.*, p. 439.

175 'This is a day ... will understand'. BRP.

175 'For me,' he said ... in him'. Unpublished letter, May, 1918, formerly in the possession of AW.

176 For a time, they were. ... the pain. Annie Rosenberg to R. C. Trevelyan, unpublished letter May 14, 1918, formerly in the possession of AW.

177 Annie complied and five ... 1919 number. Pp. 106-111.

177 ... printed a poem called ... to Rosenberg. (October, 1919), p. 61.

177 ... two of Rosenberg's poems ... been printed. Vol. 1, No. 1 (October, 1920), pp. 20-21.

177 'Let the public, however, ... wrote them'. 'A Brief Treatise on the Criticism of Poetry', *The Chapbook*, Vol. 2, No. 9 (March, 1920), p. 2.

177-78 'frequently met [Rosenberg] ... of *Moses*. Unpublished letter, February 4, 1920, formerly in the possession of AW.

178 ... he prepared a full ... Heinemann refused. GB to AW, unpublished letter, December 27, 1921, formerly in the possession of AW.

178 'The name of Isaac Rosenberg ... by the war'. No. 1,065 (June 15, 1922), p. 393.

178-79 ' "Daughters of War",' the reviewer ... our literature'. *Ibid.*

179 While *The Manchester Guardian* ... Obscure Poet'. (August 1, 1922).

179 'one of the two great ... Wilfred Owen'. 'Readers and Writers', XXXI (July 27, 1922), p. 161.

179 'I should not like ... could do'. Unpublished letter, February 15, 1923, formerly in the possession of AW.

179 That same year a revised ... left out. (London, 1923).

179 'it is very touching reading ... be shattered'. Unpublished letter, June 30, 1927, formerly in the possession of AW.

179 'whole reading public ... his country.' *A survey of Modernist Poetry* (London, 1927), p. 220.

179-80 Heinemann had left ... shilling each. Heinemann's unpublished letter, November 26, 1928, formerly in the possession of AW.

180 Bottomley was hoping to ... underwrite costs. GB to AW, unpublished letter, October 8, 1928, formerly in the possession of AW.

180 ... the publication dates of ... their reputations. 'The Real Voice, A Study of Isaac Rosenberg 1890-1918', BBC transcript, pp. 15-16.

180 At the end of 1931 ... *Illustration Juive*. Unpublished letter, December 16, 1931, formerly in the possession of AW.

180 'concerned with purely poetic ... purely Jewish'. No. 2 (September-December, 1932), p. 46.

181 that while Owen was ... interesting technically.' *New Bearings in English Poetry* (London, 1932), pp. 72-73.

181 ... 'exaggerated admiration' ... Vincent Buckley, *Poetry and Morality* (London, 1961), p. 188.

181 ... he visited Annie ... poems and letters. DH to AW, unpublished letter, August 30, 1934, formerly in the possession of AW.

181 He undertook at once ... into print; DH to AW, unpublished letter, September 11, 1934, formerly in the possession of AW.

181 ... and he selected six ... in *Scrutiny*. DH to AW, unpublished letter, November 7, 1934, formerly in the possession of AW.

181 No. XIX 'Where the ... *The Spectator*. 'An Unpublished Fragment', No. 5,535 (July 27, 1934), p. 135.

181 In France, Louis Bonnerot ... of *Poésie*. 'Poètes Anglais Contemporains', XIII (September, 1934), pp. 163 ff.

181 Harding called on Marsh ... Rosenberg pictures. DH to AW unpublished letter, January 7, 1935, formerly in the possession of AW.

181 Parsons agreed to publish ... was postponed. Unpublished letter, February 14, 1935, formerly in the possession of AW.

181 In March, Harding published ... Isaac Rosenberg'. 'Unpublished Poems of Isaac Rosenberg', and 'Aspects of the Poetry of Isaac Rosenberg', *Scrutiny*, Vol, III, No. 4 (March, 1935), pp. 351-57, 358-69.

181 Parsons thought Yeats might ... he declined. IP to AW, unpublished letter, January 1, 1936, formerly in the possession of AW.

182 ... publication of his anthology ... the century. See my article 'In Memory of W. B.

Yeats — and Wilfred Owen', *Journal of English and Germanic Philology*, Vol. LVIII, No. 4 (October, 1959), pp. 637-49.

182 His judgment of Owen . . . sugar stick' Dorothy Wellesley, *Letters on Poetry from W. B. Yeats to Dorothy Wellesley* (London, 1940), p. 124.

182 . . . he described him as 'all windy rhetoric'. Ian Parsons, 'Introduction', *Men Who March Away* (London, 1965), p. 26.

182 . . . Parsons decided to contact . . . Robert Graves. IP to AW, unpublished letter, January 1, 1936, formerly in the possession of AW.

182 'The only thing that matters . . . the war'. Quoted by IP to AW, unpublished letter, January 3, 1936, formerly in the possession of AW.

182 Marsh was not over-enthusiastic . . . show materialized. EM to AW, unpublished letter, January 12, 1936, formerly in the possession of AW.

182 He subsequently conferred with . . . a mistake. EM to AW, unpublished letter, July 22, 1936, formerly in the possession of AW.

182 . . . the audience was big . . . released there. John H. Amshewitz to AW, December 2, 1936, formerly in the possession of AW.

182 Parsons's costs came to three hundred pounds. IP to AW, unpublished letter, August 18, 1937, formerly in the possession of AW.

182 . . . the book was reviewed in . . . and Palestine. See *Zionist Record*, Johannesburg, August 7, 1937; *Sunday Times*, Johannesburg, October 3, 1937; *Rand Daily Mail*, Witwatersrand, South Africa, October 9, 1937; *South African Jewish Chronicle*, October 29, 1937; *Melbourne Argus*, Melbourne, Australia, August 28, 1937; *The West Australian*, Perth, September 7, 1938; *Auckland Star*, Auckland, New Zealand, November 20, 1937; *The Statesman*, Calcutta, September 5, 1937; *Illustrated Weekly of India*, Bombay, September 12, 1937; and *Palestine Post*, September 5, 1937.

182-83 *The Times Literary Supplement* . . . kaleidoscopic imperfections. 'Painter-Poet', No. 1848, July 3, 1937, p. 492.

183 Owen's 'genius was summoned . . . distracted' by it. 'Isaac Rosenberg', *London Mercury* (August, 1937).

183 He argued that Rosenberg . . . his own'. 'Iron, Honey, Gold', No. 5,689 (July 9, 1937), p. 70.

183 . . . 'in every respect . . . the sequence!' 'Books of the Quarter', Vol. XVII, No. LXVI (October, 1937), p. 136.

183 'He used language as . . . not known'. 'Two Poets', *Scots* (July 22, 1937), p. 15.

183-84 . . . 'genius is the word . . . more an artist'. 'The recognition of Isaac Rosenberg'. Vol. VI, No. 2 (September, 1937), pp. 229, 231.

184 . . . the total effect . . . new legend'. *Ibid.*, p. 234.

184 Leftwich and Bomberg organized . . . hanging arrangements. *p. b.* AW.

184 The inside back leaf . . . A. Abrahams. *Isaac Rosenberg Catalogue of the Memorial Exhibition of Paintings and Drawings*, June 22-July 17, 1937.

184 Marsh reluctantly agreed . . . public speaking. EM to AW, unpublished letter, May 8, 1937, formerly in the possession of AW.

184 'inheritor of unfulfilled . . . he groped'. 'Isaac Rosenberg Memorial Exhibition of Paintings and Drawings', *The Jewish Chronicle* (June 25, 1937), p. 41.

185 . . . to allow anthology fees . . . pound deficit. IP to AW, unpublished letter, March 10, 1938, formerly in the possession of AW.

185 'Living in the wide . . . the mind . . .'. *Collected Poems*, edited by John Waller, G. S. Fraser, and J. C. Hall (New York, 1966), p. 129.

185 The nine hundred sheets . . . the Blitz. Harold Raymond to AW, unpublished letter, May 4, 1943, formerly in the possession of AW.

185 . . . when Schocken Books proposed . . . thousand copies. IP to AW, unpublished letter, April 12, 1949, formerly in the possession of AW.

186 . . . the American critic Marius . . . in *Commentary*. Bewley, *op. cit.*

186 'Had Rosenberg lived to . . . metaphysical brand'. 'Isaac Rosenberg: Poet', Vol. 10, No. 1 (July, 1950), pp. 91-93, *passim*.

186 . . . three of Rosenberg's paintings . . . Exhibition 1851-1951. *Catalogue of the Festival*

of Britain Anglo-Jewish Exhibition 1851-1951 (July 9-August 3, 1951), p. 10.

186 In 1952 Dora Sowden . . . visiting Minnie. 'Isaac Rosenberg, the Anglo-Jewish Poet An Interview with his Sister', Vol. 7, No. 12 (December, 1952), pp. 21-24.

186 . . . sales of the *Collected* . . . £18. 9s. 7d. IP to AW, unpublished letter, May 30, 1952, formerly in the possession of AW.

186 . . . the British Museum accepted . . . of *Moses;* A. J. Collins to AW, unpublished letter, December 23, 1953, formerly in the possession of AW.

186 . . . Jacob Sonntag's *Jewish Quarterly* . . . magazine's pages; 'Anglo-Jewish Poetry An Anthology', with notes by Joseph Leftwich, Vol. 4, No. 1 (Summer, 1956), pp. 8-9.

187 In 1960 Silkin devoted . . . *Catalogue with Letters.* 'The War Poets', Vol. 4, No. 3.

187 . . . I published an essay . . . Rosenberg's reputation. 'Isaac Rosenberg: From Romantic to Classic', *Tulane Studies in English,* (1960), pp. 129-142; 'Isaac Rosenberg's White Goddess'; 'Isaac Rosenberg: The Poet's Progress in Print'. The latter paper subsequently appeared in *English Literature in Transition,* Vol. 6, No. 3 (1963), pp. 142-46.

187 In 1964 John H. Johnston's . . . on Rosenberg. 'Poetry and Pity: Isaac Rosenberg', *English Poetry of the First World War* (Princeton, 1964), pp. 210-49.

187 In 1967 the New York Public Library . . . fully displayed. John D. Gordan, *Letters to an Editor: Georgian Poetry, 1912-1922, Catalogue of an Exhibition from the Berg Collection* (New York, 1967).

188 Silkin's *Out of Battle.* . . multi-faceted experience. Silkin, *op. cit.,* pp. 249-314.

188 . . . could dismiss Rosenberg with . . . *1914-1918;* (London), p. 39.

Notes

CHAPTER ONE

1 Isaac Rosenberg to Edward Marsh, letter dated March 28, 1918, in *The Collected Works of Isaac Rosenberg* (London, 1937), p. 322. All subsequent quotations of Rosenberg's poems, letters, and prose pieces from *The Collected Works* are indicated by *CW* in the text.

2 This apparently is the only instance of Rosenberg's ever volunteering for extra duty, and was related to me by Annie Wynick. Much of what she told me provides the substance for this biography. Little of it can now be confirmed from other sources; however, those particulars of Rosenberg's life made available to me both from her memory and her files, that were capable of documentation, have all checked out accurately. I am therefore satisfied that other particulars, allowing for normal lapses of memory in the assignment of dates to actions and events that took place decades ago, are also accurate. With respect to Rosenberg's final hours, Annie Wynick told me that there was another Jewish soldier in his company who was with him that morning. She talked to this soldier on the day he returned to his home in the Mile End Road following his demobilization. He had heard Rosenberg volunteer, and never saw him afterward.

3 Isaac Rosenberg to Laurence Binyon, in an extract from a letter written in 1916, printed in *Poems* by Isaac Rosenberg, edited by Gordon Bottomley, with an introductory memoir by Laurence Binyon (London, 1922), p. 38. Subsequent quotations from this volume are indicated by *PIR* in the text.

CHAPTER TWO

4 The account of Dovber (later Barnett) Rosenberg's early life is taken from an undated autobiographical fragment given to me along with other family papers by Annie Wynick. It covers, informally, without specific dates, the period from Dovber Rosenberg's birth through his young manhood in Russia and England. Subsequent references to these papers are indicated by the abbreviations BRP.

CHAPTER THREE

5 Born Solomon Schieffer, he changed his surname to Scott during World War I when Lord Northcliffe asked him to make speeches in Yiddish on the objectives of the war to Jewish immigrant workers in the East London factories.

CHAPTER FOUR

6 While Dainow's encouragement was useful, his reading, particularly of Byron, helped Rosenberg most. In another early poem, 'Zion', composed in 1906, Rosenberg draws on both Byron's 'She Walks in Beauty' and 'Oh! Weep for Those'. He also incorporates in 'Zion' the same sense of loss that pervades the 'Hebrew Melodies'. Writing in a Jewish children's magazine in 1928, Beth Zion Lask, one of Rosenberg's commentators, reinforces the chauvinistic view that Rosenberg set out 'to become the poet of the Jewish nation', by arguing that ' "Zion" tells of the glories that once were ours . . .' ['Isaac Rosenberg: Poet', *The Jewish Youth* (June 7, 1928), p. 6]. At the same time, Rosenberg was writing verse on other subjects. In 1906 he composed a poem about the seemingly endless barriers he encountered in his striving for success in the field of art. He left it untitled, and it has never before been published:

> *In art's large paths, I wander*
> *deep*
> *And slowly, slowly, onward*
> *creep.*
> *I seek, I probe each deep recess*
> *To reach the secret of success.*
> *In vain, tis hidden from my gaze*
> *I still must hail its glowing*
> *rays.*

> *Cold time shall drag the weary*
> *hours*
> *And slowly tint the blooming*
> *flowers;*
> *The flowers shall fade the flowers*
> *shall bloom*
> *Yes many a time shall fade to gloom,*
> *Ere I can burst thro' the wild bounds*
> *That the pure realm of art surrounds.*

> *I see of art its dazzling star*
> *In glorious splendour shining far,*
> *It dims my eyes, but year by year*
> *To enter in its flaming sphere*
> *I wildly try; tis vainly tried*
> *For e'en its drudgery I'm denied.*

Rosenberg wrote out a fair copy of this poem on a small piece of cardboard, initialled and dated it and inscribed it to Frank L. Emanuel, a young painter whom he had met through Amshewitz. On the back of the card is a pencilled self-portrait in left-profile, serious, slightly romanticized, more reminiscent of a death-mask than a living adolescent. The only known copy of this poem is in my possession. It was discovered by Charles Emanuel in September 1959 among his brother's papers and given to AW, who requested that it appear in this study.

7 The most obvious example of Shelley's minor influence occurs in Rosenberg's poem, 'Dawn Behind Night' (*CW*, p. 205).

CHAPTER FIVE

8 This is not to suggest that there was no danger or violence in the East End when Rosenberg lived there. It was during this first week of January 1911, that the Siege of Sydney Street occurred. Sydney Street was next to Jubilee Street and only round the corner from Oxford Street.

9 Joseph Leftwich, unpublished diary for 1911. The entry for January 1 reads: 'Simy again suggested enlarging our circle — adding Dave and Zimmerman. Jimmy is against; so am I. It is decided that no additions be made. Jimmy sums it up by saying that no one will fit in well enough — we three are unique.' Subsequent citations from this diary are indicated in 'References' by the abbreviation JLD.

10 Leftwich's reference confirms that Rosenberg was still serving his apprenticeship at the beginning of 1911.

11 The portrait is now is the possession of Amshewitz's heirs. It was first exhibited in 1912 at the Baillie Galleries where Amshewitz held a one-man show. It was shown at the London Portrait Society Exhibition (No. 46), in 1936, but was not included in the Rosenberg Memorial Exhibition in 1937. It appeared in the Leeds University and Slade School exhibitions of Rosenberg's works in 1959, and is listed in *Isaac Rosenberg 1890-1918 Catalogue with Letters* (Leeds, 1959), p. 36. All subsequent quotations from this publication are noted in the text, designated by the abbreviation *CWL*.

12 In the absence of other evidence I have placed the time of his leaving Hentschel's in March 1911. From Leftwich's diary it is clear he was still serving his apprenticeship when the year began. However, other entries in Leftwich's Diary for March 1911, indicate that Rosenberg's weekdays had become free for his own pursuits. It is therefore reasonable to assume that the apprenticeship ended at the time suggested above.

13 The printed text shows a cancellation between 'the' and 'shop'. I have restored for a less inhibited readership the term obviously intended by Rosenberg in his exultation over leaving Hentschel's.

CHAPTER SIX

14 Cohen is said to have abandoned his wife and child in 1917 and returned to Russia, where he perished soon afterwards.

15 Efforts to locate Annetta Raphael over the years have not been successful. Some years after World War I, she went to Spain. She is said to have married an Italian and settled in Italy.

16 In Rosenberg's story there are five spots of paint instead of three, which had been put there by the butler's niece rather than a house painter.

CHAPTER SEVEN

17 See Douglas Cooper, *The Courtauld Collection: A Catalogue and Introduction* (London, 1954), p. 15: 'Between 1860 and 1890 British art sank to its lowest depth . . . and the public reserved its appreciation for the pictures in which great attention was paid to detail and which had obviously taken a long time to paint.'

18 Annie and Rachel Rosenberg clearly recalled Mitchell, but not when he came to lodge at their home. Rosenberg and he may have become acquainted as early as 1908 at Birkbeck College.

CHAPTER EIGHT

19 These fragments are found under two separate titles in the *Collected Works:* 'The Pre-Raphaelite Exhibition', pp. 256-258, and 'The Pre-Raphaelites and Imagination in Paint', p. 262. Though Rosenberg's editors separated them, they may have been drafts for the same article. Rosenberg's original manuscripts are no longer extant.

20 The Whitechapel Art Gallery *Catalogue of the Memorial Exhibition,* (compiled by Bomberg and Leftwich), places the year of composition as 1912. However, Bottomley and Harding in the *Collected Works* place the date as 'probably 1915', reinforcing their assumption with a tipped-in note correcting the 1912-13 date printed beneath the actual illustration. Maurice de Sausmarez in the 1959 *Catalogue With Letters* accepts the Bottomley-Harding assumption. I am inclined to agree with Bomberg and Leftwich, as the former was certainly familiar with Rosenberg's compositions in 1912-13. Moreover, the subject matter (innocent love) and the fact that Rosenberg was doing a great deal of figure drawing at that time though not in 1915, tends to give credence to the earlier date. The drawing was bequeathed by Gordon and Emily Bottomley in 1949 to the Carlisle Museum and Art Gallery, which gained possession of it in 1960. The same Gallery also owns Rosenberg's 'Two Figures at a Table' (pen and wash, c. 1910), 'Figures Seated Round a Table' (pen and wash, c. 1910), and 'The Artist's Father' (pencil, 1915).

CHAPTER NINE

21 Binyon returned the autobiographical sketch to Rosenberg and it was lost. If it was written in 1911, as Rosenberg said it was, he apparently did not show it to Leftwich, as there is no mention of it in his diary.

22 Narodiczky left the Ukraine as a young man in 1898 to join the gold rush in South Africa, intending to raise one million pounds with which to buy Palestine from Turkey and re-establish the Jewish homeland. Instead, he disembarked at Tilbury, became fascinated with the East End, and spent the rest of his life in Whitechapel. He gained a world-wide reputation among Hebrew writers, scholars, journalists, and politicians. His friends included Chaim Weizmann, Joseph Brenner, Vladimir Jabotinsky, Chaim Bialik, Sholem Asch, and Rudolf Rocker. D. H. Lawrence came to his printshop in 1915 to ask him to publish six issues of a small fortnightly pacifist paper to be called *The Signature.* Narodiczky was busy printing a Jewish encyclopaedia, but Lawrence prevailed upon him and he published three issues with his imprint and had the fourth in press when the police ordered him to stop printing the paper. He died in 1945 at 69.

23 The Houndsditch murders in December 1910, and the Sydney Street Siege in January 1911 made the London police as sensitive to anarchist conspiracies as it made East End Jews fearful over deportation. In 1911 Scotland Yard uncovered a conspiracy to assassinate the Italian royal family. The pamphlet of instructions, though it bore no imprint, was traced to Narodiczky, who admitted printing it, but had been unaware of its contents because he did not read Italian. When the conspirators were apprehended he was a witness for the Crown. Though he was completely exonerated, he was warned to follow the law and put his imprint on everything he published.

24 This copy is now in my possession. It belonged to Binyon, and his wife Cecily sent it to me before she died. The British Museum has no copy; AW knew of no other, nor have I managed to trace any.

25 Rosenberg's changes were incorporated by Bottomley and Harding into the text of the *Collected Works.*

26 In Laurence Binyon's copy Rosenberg added the poem 'My Songs' (*CW*, p. 178).

27 In this same year Rosenberg composed a dramatic monologue of 109 lines entitled 'Raphael', which draws heavily on Browning's 'Andrea del Sarto'. It is interesting in view of Rosenberg's later efforts at verse-drama.

CHAPTER TEN

28 Only once before had Rosenberg quarrelled seriously with anyone. Several years earlier he had ended his friendship with the actor Michael Sherbrooke, whom he had met through Amshewitz. In his final letter to Mrs. Cohen in December 1912, he told her 'It was only when Mr. Sherbrookes goodness became unendurable that I broke with him' (*CW*, p. 337). Sherbrooke, who admired Rosenberg and wanted to help him, came into possession of Amshewitz's portrait of Rosenberg and kept it for many years before giving it to Jews' College, which, after the Leeds University Exhibition of Rosenberg's works in 1959, returned it to the Amshewitz family. In *The Paintings of J. H. Amshewitz* (London, 1951), p. 17, Sarah Briana Amshewitz, the painter's widow, refers briefly to the portrait of Rosenberg in connection with its inclusion in the London Portrait Society's Exhibition of 1936, adding that 'it was at Amshewitz's instigation that Michael Sherbrooke read [Rosenberg's] poems to a lady who, with two friends, afterwards enabled the young poet and painter to study art at the Slade.' Her account is not necessarily at variance with my belief that Lily Delissa Joseph was responsible for Rosenberg's entry into the Slade.

29 This was in spite of the fact that Sonia was apparently living in Devonshire Street, not far from his studio. Rodker had prevailed upon a Miss Pulley, who had rooms to let in the building where Harold Monro's Poetry Bookshop was located, to rent one to Sonia. Before she was asked to leave, Rosenberg visited her once or twice. He, too, knew Miss Pulley sufficiently well for her to send him 'a box of Turkish' in 1916 when he was in the trenches (*CW*, p. 350).

30 Bomberg's biographer has described it as 'Almost Florentine in execution and the system of proportion' (Lipke, plate 5; p. 34). It is vastly different from either Amshewitz's *fin de siècle* approach or the overly romanticized self-portraits Rosenberg was doing. The drawing became a part of the John Quinn Collection in New York and was sold in 1927 to an unknown buyer for ten dollars when that collection was dispersed.

31 The Camden Town Group was formed by the young painters W. R. Sickert attracted to himself between 1905-10. Since the New English Art Club was, in their view, becoming as stodgy in its limitations on exhibitions as the Royal Academy, the artists decided to form their own society early in 1911. Among the sixteen original members were Augustus John, Wyndham Lewis, Lucien Pissarro and W. R. Sickert. The group held three exhibitions in 1911-12 at the Carfax Gallery and a final one in Brighton in the winter of 1913-14. Dissension soon resulted in the disintegration of the group, and most of its members went on to participate in the development of the London Group.

CHAPTER ELEVEN

32 I have seen only a photograph of this drawing which shows Rosenberg's head in a slanted profile, studious and slightly exotic. Formerly in the possession of AW.

33 See Hassall, p. 280. The book, to be called *Georgian Drawings*, was to consist of the work of twenty unknown artists. Marsh hoped to get four hundred subscriptions at one-half guinea each. Ultimately, the war and the lack of adequate financial support led Marsh to cancel the project.

34 Reprinted in *The Jewish Quarterly*, Vol. 9, No. 2 (Spring, 1972), pp. 24-27. In an introduction to Kramer's 'Form and Shape' Joseph Leftwich wrote that he saw the essay in 1914, the first time he met Kramer, in Gertler's studio which Goldstein was using at the time. Leftwich subsequently translated it into Yiddish, and Kramer published it in June, 1920 in the Yiddish journal *Renaissance*.

35 In the Foreword to *Works by David Bomberg*, Chenil Gallery Catalogue (London, 1914), Bomberg wrote: 'I appeal to a *Sense of Form*. In some of the work I show in the

first room, I completely abandon *Naturalism* and Tradition. I am searching for an *Intenser* expression. In other work in this room, where I use the Naturalistic Form, I have stripped it of *all* irrelevant matter . . . I look upon Nature, while I live in a *steel city*. Where decoration happens, it is accidental. My object is the *construction of Pure Form*. I reject everything in painting that is not Pure Form.'

36 On July 27, 1934, the *Spectator* printed 'An Unpublished Fragment', (No. 5,535, p. 135), beginning 'Where the rock's heart is hidden from the sea', later reprinted as Fragment XIX (*CW*, p. 221). It was composed at Camp's Bay, near Cape Town, on the title-page of *The Italian Futurist Painters*, which Rosenberg was reading in connection with his lecture, and is of interest because it uses the same sea image, in which the tips of the waves are described as 'white tongues', that occurs in 'Sacred, Voluptuous Hollows Deep'. This use of the image tends to confirm that the latter poem was indeed composed in 1914.

37 The self portrait which Rosenberg exhibited is not identified; it could have been one of a number he had completed by 1914. The two literary studies and the portrait of Rosenberg's father (1911) are still in existence. 'Head of a Girl' apparently is lost as its whereabouts was not known at the time of the Leeds Exhibition in 1959. However, it was probably this pencil study, completed in 1914, which Sydney Schiff printed in *Art and Letters*, Vol II, No. 3 (Summer, 1919), p. 109, with five poems and a memorial notice by Annie Rosenberg (Wynick). The subject, in profile, is not identified.

CHAPTER TWELVE

38 Next to the drawing of the female nude, the sketching of trees had been an important part of Rosenberg's training in art. As a student he spent many days in Epping Forest. Naturally, trees are prominently featured in his landscapes. This emphasis, along with his reading, was probably decisive in his later poetic use of tree imagery. Whatever reading he did, he seems never to have known Frazer's *The Golden Bough* published in 1915, and it is unlikely he would have come in contact with Bachoven's *Mutterrecht*, both of which contained extensive analyses of tree roles. Yet his absorption of the tree-goddess myths is sufficient to observe that, just as he was anticipating Eliot, he also predated Robert Graves who with Eliot came to rely heavily on *The Golden Bough*. Graves, incidentally, was one of Rosenberg's strongest admirers in the years just after the Great War, perhaps partly because Rosenberg had captured and expressed the essence of what was to become the dominant motif in Graves's poetry. For observations on tree roles, see Erich Neumann's *The Great Mother* (New York, 1955) pp. 48-50, *passim*.

39 Currie and Gertler were close friends and Rosenberg therefore saw him occasionally before he went to South Africa. In 1912 Currie's picture 'Some later Primitives and Madame Tisceron', depicting Currie, Gertler, Nevinson and John with the proprietress of the Petit Savoyard Café in Soho, attracted widespread favourable comment, and established him as a young artist with an exciting future. In 1914 Currie shot his mistress to death and fatally wounded himself.

40 'Art-Part I', 'Our Dead Heroes', and 'Beauty' appeared in the December 1914 issue of *South African Women in Council*. 'Art-Part II' followed in the January 1915 number.

41 See *Wilfred Owen Collected Letters* (London, 1967), pp. 279-82. For the time being, Owen, like Rosenberg, proposed to sit out the war. In a letter to his mother, he wrote: 'Quite apart from the prospect of this Friendship [with the French poet Laurent Tailhade], I am, for quite an appreciable length of time, imbued with sensations of happiness. The war affects me less than it ought. But I can do no service to anybody by agitating for news or making dole over the slaughter. On the contrary I adopt the perfect English custom of dealing with an offender: a Frenchman duels with him: an Englishman ignores him. I feel my own life all the more precious and more dear in the presence of this deflowering of Europe' (p. 282).

CHAPTER THIRTEEN

42 Gilbert Cannan's novel, *Mendel*, published in 1916 was based on Gertler's early life, using a thin fictional veneer for Gertler's associates. Rosenberg is not included among the novel's characters.

43 'Lark ascending', in an unspecified medium, has apparently not survived. To satisfy myself that 'Hark, Hark the Lark' (now in my possession) is an earlier, separate work, I have had it examined by an expert who is convinced on the basis of comparisons with other pictures Rosenberg drew in 1912 and 1915 that it is strictly a product of his student days at the Slade.

44 Rosenberg wrote, 'I am sending you a thing I copied out years ago from one of our greatest poets and I think one of his best. It is very unlike his usual style, and it is not by F. Thompson. I am showing you this because I think its a discovery of mine' (*CW*, p. 345). He sent Seaton Coleridge's 'Sole Positive of Night', which she read and returned to him. Rosenberg had not written Coleridge's name on the copy, and Bottomley and Harding, finding it among his papers, published it in the *Collected Works* on page 119 as Rosenberg's work. The mistake was discovered too late to cancel the page but an *erratum* slip was tipped in. 'Sole Positive of Night' describes Satan in opposition to God. It may initially have directed Rosenberg toward his God rejection-poet substitution theme; if it was not the impulse it was unquestionably an influence.

45 In the *Collected Works*, Bottomley and Harding assigned the two letters, mentioning the da Vinci copy, and a third one written at the same time to Marsh, to 1914, placing them before Rosenberg's final letters to Marsh prior to his departure for South Africa. Hassall noticed the discrepancy in his biography of Marsh (pp. 287-88), but allowed it to stand, placing out of chronological order his description of Marsh's role in financing *Youth*. Though the letters in question are undated, they could not have been written until the spring of 1915.

46 The poems reprinted from *Night and Day* were: 'Aspiration', 'In the Park', 'Desire Sings of Immortality', 'Noon in the City', 'Dim watery lights', and 'Lady, you are my God'. The remaining titles included 'None Have Seen the Lord of the House', 'A Girl's Thoughts', 'Wedded', 'Midsummer Frost', 'Love and Lust', 'In Piccadilly', 'A Mood', 'April Dawn', 'If you are fire', 'Break in by subtler nearer ways', 'The One Lost', 'My soul is robbed', 'God Made Blind', 'The Dead Heroes', 'The Cloister', and 'Expression'.

47 In July 1915, Rosenberg wrote to Schiff, 'I believe they are getting up a show of Gaudier's work — at least they are talking of it but nothing is settled as far as I know. I do not know his work but I met him once. He gave one a good impression. It is awful bad luck' (*CWL*, p. 8). That Rosenberg did not know Gaudier-Brzeska's work seems odd, particularly as six of his sculptures were exhibited in the Twentieth Century Whitechapel show in May-June 1914. It is conceivable that Rosenberg sailed for South Africa just before the show opened on May 8, but it is unlikely. The logical explanation is that sculpture was of little interest to Rosenberg. He never attempted it nor did he care to comment on it. It was as though sculpture were outside the realm of art.

48 In response to my enquiry regarding their communication in 1915, Pound wrote the following from Saint Elizabeth's Hospital on March 11, 1957: 'Sorry can't recall further details — no records before about 1924.' On the outside of the envelope he added 'Rodker's dead, he might have known something relevant.'

49 The only known surviving copy of *The Jewish Standard* is the one Rosenberg himself preserved, now in my possession.

50 Unpublished letter, undated (August, 1915), in the Regenstein Library, The University of Chicago. As for Yeats, it is not known whether Rosenberg wrote him directly, sending manuscripts, or whether he acquired the information he gave to Pound in some other way.

51 In his biography of Marsh, Hassall has telescoped Rosenberg's contacts with Marsh following his return from South Africa, so that the impression given is that Rosenberg enlisted in the army in the early summer of 1915. He actually joined up in late autumn.

CHAPTER FOURTEEN

52 A convict given a discharge from prison contingent upon immediate enlistment.

53 In *Life for Life's Sake* (New York, 1941) p. 181, Richard Aldington, who also served in the army as a private, described a typical day in camp as follows: '5 a.m.: reveille; wash, shave, dress, re-arrange plank bed, and fold blankets; as orderly man help to fetch tea for 30 men; polish buttons. 5:30-6:30: drill. 6:30: fetch breakfast from cook-house, and afterwards wash up 30 tea bowls and 30 plates, scrub plank bed, and be on parade at 7:30. Until 12:30, physical jerks and drills. 12:30: Fetch dinner and wash up, replace plank bed, polish buttons. 1:30-4:30: drill and bayonet fighting. 4:30: fetch tea, wash up, sweep hut. 7:30-10:30: night operations, including a four-mile march and trench-digging. 10:30: soup for those who wanted it — most of us too tired to drink it. 11 p.m.: in bed. Shortly after we were all asleep, practice fire alarm, at the double.'

54 Woodeson, *op. cit.*, pp. 181-82. Under pressure primarily from D. H. Lawrence and his other pacifist friends, Gertler, determined to stay out of the war and harassed by the fear of conscription, realized that his reliance on Marsh was becoming increasingly hypocritical. In breaking with Marsh, however, Gertler acknowledged his great help and encouragement.

55 Lipke, *op. cit.*, p. 46. Bomberg married Alice Mayes in March 1916, and went to France in June. In 1917 he was transferred to a Canadian Regiment to paint a picture of Canadians in action for the Canadian War Memorial's Fund. Bomberg painted a huge canvas, called 'Sappers at Work Under Hill 60, Near St. Eloi' in Cubist style, which was rejected. He replaced it with a less Cubistic design, now known as the 'Canadian War Memorial, 1919', one of his most impressive works. For examples of Bomberg's war poems, see Lipke, Appendix II, pp. 120-21.

56 Rosenberg's typescript of 'Marching' is preserved in the Regenstein Library, The University of Chicago. John H. Johnston in *English Poetry of the First World War* (Princeton, 1964), p. 215, is in error in attributing to Ezra Pound the transmission of this poem and 'Break of Day in the Trenches'. Rosenberg sent the latter poem directly to Monroe from France.

CHAPTER FIFTEEN

57 The short poems in *Moses* apart from 'Spring, 1916' were 'God'; 'First Fruit' (though this title was not used in the booklet); 'Chagrin'; 'In the Park', reprinted from *Youth;* 'Song of Immortality', reprinted from *Youth* and *Night and Day;* 'Marching'; 'Sleep'; and 'Heart's First Word' (the second version). Again Rosenberg had no inclination to publish 'On First Receiving News of the War', 'Sacred, Voluptuous Hollows Deep', or 'The Female God'.

58 In twenty years of researching Rosenberg memorabilia, I have never seen a bound copy of *Moses.* Insofar as I can determine, only one copy has been put up for sale, and its purchaser is unknown to me.

CHAPTER SIXTEEN

59 Unpublished letter, June 12, 1916, formerly in the possession of AW. Years later when Zangwill realized Rosenberg's literary worth he asked Leftwich why Rosenberg's poems had not been called to his attention while the poet was still alive. Leftwich informed Zangwill, to his chagrin, that at the time he had dismissed Rosenberg's poems as both obscure and trivial. *p. b.* Joseph Leftwich.

60 In both the *PIR* and *CW* Bottomley gives the postmark on Rosenberg's reply as June 12, 1916. The correct date however, was July 12 since Rosenberg's letter was in answer to the one Bottomley wrote to him on July 4, 1916.

61 In a letter Rosenberg had written to Marsh from Bury St. Edmunds, he had voiced his complaints at a time when he knew Marsh was extremely busy. Feeling his letter might annoy Marsh, he closed it saying, 'All this must seem to you like a blur on the window' (*CW*, p. 302). Now their responses to one another were, in a sense, reversed.

62 Rosenberg deleted this line in a different version. The closing lines printed in *Poetry* are also slightly modified. (*CW*, pp. 385-86.)

CHAPTER SEVENTEEN

63 See F. E. Whitton, *History of the 40th Division:* '. . . transport work was a veritable nightmare. All supplies of ammunition, water, rations, clothing, etc., had to be taken up on pack animals, as, owing to the mud, which for the greater part of the distance was seldom less than waist deep, vehicles became obviously impracticable. Nightly a convoy of about eighty animals went up to one battalion. Although the total distance covered from the mule park to handing over the supplies to the battalion was only a very few miles, the return journey lasted from twelve to fifteen hours . . . The men travelled without greatcoats, and did not carry anything which they could conceivably leave in huts. They were mostly dripping with perspiration when they reached their journey's end. Owing to the fact that the ground had been shelled so constantly during the Somme offensive, it was intersected with shell holes long since filled with mud, and when an unfortunate animal or man fell, it was a matter of the very greatest difficulty to extricate him alive. . . . It soon became obvious that the majority of the men were physically unable to continue this nightly strain, and, therefore, in due time reinforcements were procured, so that it was possible to give them one night's rest in three.'

64 The account by Rodker of his experiences as a conscientious objector is movingly related in his anonymously-published *Memoirs of Other Fronts* (Putnam, 1932), which details his forced induction, desertion, escape, apprehension and incarceration. The narrative refers frequently to Muriel, the name he gives in the book to Sonia.

65 Ross (n. 28, p. 264) is in error in claiming that 'Returning, We Hear the Larks' was the last poem Rosenberg wrote, and that he sent it to Marsh on March 28, 1918, as the evidence indicates that the poem was composed in the summer of 1917. 'Through These Pale Cold Days' was the poem sent by Rosenberg in his last letter.

66 (*PIR*, pp. 34-38; *CW*, pp. 371-73). Bottomley and Harding have assigned the date 1916 to the three extracts from Rosenberg's letters to Miss Seaton. Since Rosenberg was not in hospital in the autumn of 1916, they must have been written in 1917.

CHAPTER EIGHTEEN

67 (New York, 1920). The poets included Julian Grenfell, Rupert Brooke, Robert Nichols, Siegfried Sassoon, Robert Graves, R. E. Vernède, C. H. Sorley, Francis Ledwidge, Edward Thomas, F. W. Harvey, Richard Aldington, and Alan Seeger.

68 In the spring of 1960 I strongly urged Annie to make arrangements to give her Rosenberg materials to one of the university libraries in England. Though she discussed the matter with Ian Parsons, Joseph Leftwich and others — there was also a question of choosing a literary executor to succeed her — she did not make her wishes known. I believe that all she possessed has now passed into diverse hands.

Bibliography

Abercrombie, Lascelles. 'John Drinkwater: An Appreciation', *Poetry Review*, I (1912), 169.
——. *The Idea of Great Poetry*, London, 1925.
——. *The Poems of Lascelles Abercrombie*, London, 1930.
Abse, Dannie. 'Homage to Rosenberg', *Jewish Chronicle* (August 7, 1959).
Adler, Michael, ed. *British Jewry Book of Honour*, London, 1922.
Adler, Henry. 'Isaac Rosenberg', *The New English Weekly* (September 30, 1937), 415.
Aldington, Richard. *Life for Life's Sake*, New York, 1941.
[Amshewitz, John H.]. *Catalogue of Paintings and Water Colours by John H. Amschewitz* (sic), Baillie Gallery, London, 1912.
Amshewitz, Sarah Briana. *The Paintings of J. H. Amshewitz*, London, 1951.
[Anglo-Jewish Art]. *Catalogue of the Festival of Britain Anglo-Jewish Exhibition 1851-1951*, Ben Uri Art Gallery, London, 1951.

Beaumont, C. W., and Sadler, M. T. H., eds. *New Paths Verse Prose Pictures, 1917-1918*, London, 1918.
Bergonzi, Bernard. *Heroes' Twilight: A Study of the Literature of the Great War*, London, 1965.
Besant, Walter. *East London*, London, 1903.
Bewley, Marius. 'The Poetry of Isaac Rosenberg'. *Commentary*, 7, No. 1 (January, 1949), 34-44.
Binyon, Laurence, 'The Return to Poetry', *Rhythm*, I, No. 4 (Spring, 1912), 1-2.
——. *Tradition and Reaction in Modern Poetry:* English Association Pamphlet No. 63. 1926.
Birkbeck College Students' Magazine, IV, No. 1 (December, 1908), 3; VI, No. 1 (1910), 3.
Blunden, Edmund. *Undertones of War*, London, 1928.
——. *War-Poets 1914-1918*, British Council Monograph, London, 1958.
Boman, Thorlief. *Hebrew Thought Compared With Greek*, Philadelphia, 1960.
Bomberg, David. 'Foreword', *Works by David Bomberg* [Exhibition Catalogue]. Chenil Gallery, London, 1914.
——. 'The Bomberg Papers', *X A Quarterly Review*, I, No. 3 (1960), 183-90.
Bonnerot, L., and Rivoallan, A. 'Poètes Anglais Contemporains', *Poésie*, XIII (September, 1934), 163.
[Bottomley, Gordon]. 'Gordon Bottomley Poet and Collector', [Exhibition Catalogue], Carlisle City Art Gallery, n.d.
——. *King Lear's Wife and Other Plays*, London, 1920.
——. *Poet and Painter: Being the Correspondence between Gordon Bottomley and Paul Nash, 1910-1946*, edited by Claude Colleer Abbott and Anthony Bertram. London, 1955.

————. Brereton, Frederick, comp. *An Anthology of War Poems.* London, 1930.

Brodzky, Horace. *Henri Gaudier-Brzeska 1891-1915,* London, 1933.

Brooke, Rupert. *Collected Poems.* London, 1918.

Brophy, John, and Partridge, Eric. *The Long Trail,* London, 1965.

Buckley, Vincent. *Poetry and Morality,* London, 1961.

Bullough, Geoffrey, *The Trend of Modern Poetry,* London, 1934.

Burke, Thomas. *The Real East End,* London, 1932.

Bush, Douglas. *English Poetry,* New York, 1952.

Byron, Lord. George Gordon. *The Complete Poetical Works of Byron,* edited by Paul E. More, Boston, 1933.

Cannan, Gilbert. *Mendel,* London, 1916.

Carrington, Charles. *Soldier From The Wars Returning,* New York, 1965.

Chamot, Mary; Farr, Dennis; and Butlin, Martin, eds. *Tate Gallery The Modern British Paintings, Drawings and Sculpture,* 2 vols., London, 1964.

Chapple, J. A. V. *Documentary and Imaginative Literature 1880-1920,* London, 1970.

Charlton, George. 'The Slade School of Fine Art 1871-1946', *The Studio,* October, 1946.

Chipp, Herschel B. *Theories Of Modern Art,* Berkeley, 1973.

Churchill, R. C. 'War and the Poet's Responsibility', *Nineteenth Century and After, CXXXVII* (April, 1945), 155-59.

Clark, Arthur M. *The Realistic Revolt in Modern Poetry,* Oxford, 1922.

Clutton-Brock, A. 'The Post-Impressionists', *Burlington Magazine* XVIII (January 1911), 216-19.

Coffman, Stanley K. *Imagism: A Chapter for the History of Modern Poetry,* Norman, Okla., 1951.

Cohen, Joseph. 'The Wilfred Owen War Poetry Collection', *Library Chronicle of the University of Texas,* V, No. 3 (Spring, 1955), 24-35.

————. 'The Three Roles of Siegfried Sassoon', *Tulane Studies in English,* VII (1957), 169-85.

————. 'Wilfred Owen's "The Show" ', *Explicator,* XVI, No. 2 (November, 1957).

————. 'In Memory of W. B. Yeats — and Wilfred Owen', *Journal of English and Germanic Philology,* LVIII, No. 4 (October, 1959), 637-49.

————. 'The War Poet as Archetypal Spokesman', *Stand,* IV, No. 3 (1960), 23-27.

————. 'Isaac Rosenberg: From Romantic to Classic', *Tulane Studies in English,* X (1960), 129-42.

————. 'Isaac Rosenberg: The Poet's Progress in Print', *English Literature in Transition,* VI, No. 3 (September, 1963), 142-46.

————. 'Wilfred Owen: Fresher Fields Than Flanders', *English Literature in Transition,* VII, No. 1 (March, 1964), 1-7.

————. 'Owen Agonistes', *English Literature in Transition,* VIII, No. 5 (December, 1965), 253-68.

Cohen, J. M. *Poetry Of This Age,* London, 1959.

Coleman, John. 'A Poet From The Trenches', *Sunday Times* (October 2, 1960).

Collins, H. P. *Modern Poetry.* London, 1925.

Cooper, Douglas. *The Courtauld Collection: A Catalogue and Introduction,* London, 1954.

Cork, Richard, ed. *Vorticism and its Allies,* Catalogue of the Arts Council Exhibition, London, 1974.

Cowper, J. M. *The King's Own The Story Of A Royal Regiment 1914-1950,* III, Aldershot, 1957.

Cunliffe, J. W. *English Literature During the Last Half Century,* New York, 1922.

Daiches, David. *Poetry and the Modern World.* Chicago, 1940.

————. 'Isaac Rosenberg: Poet', *Commentary,* 10, No. 1 (July, 1950), 91-93.

Dangerfield, George. *The Strange Death of Liberal England 1910-1914,* New York, Capricorn Books, 1961.

Davies, E. O. G. 'Isaac Rosenberg', unpublished master's thesis, University of Nottingham, 1957.

Davidson, Mildred. *The Poetry is in the Pity*, London, 1972.

Day Lewis, Cecil. *A Hope For Poetry*, London, 1934.

———. 'Isaac Rosenberg', *London Mercury* (August, 1937).

Deghy, Guy, and Waterhouse, Keith. *Café Royal Ninety Years of Bohemia*, London, 1956.

Delattre, Floris. *La Poésie Anglaise d'Aujourd'hui*, Paris, 1921.

de Sausmarez, Maurice and Silkin, Jon, eds, *Isaac Rosenberg 1890-1918 Catalogue with Letters*, Leeds, 1959.

de Sola Pinto, V. *Crisis In English Poetry 1880-1940*, London, 1951.

Deutsch, Babette. *This Modern Poetry*, New York, 1935.

Dickinson, Patric, ed. *Soldiers' Verse*, London, 1945.

———. 'War Poets', *The Spectator,CLXXVII*, No. 6181 (December 13, 1946), 639.

———. 'The Real Voice. A Study of Isaac Rosenberg 1890-1918', British Broadcasting Corporation Radio Script first broadcast over the Third Programme, December 15, 1954.

———. *The Good Minute*, London, 1965.

Douglas, Keith. *Collected Poems*, edited by John Waller, G. S. Fraser, and J. C. Hall, New York, 1966.

Drew, Elizabeth, and John L. Sweeney. *Directions in Modern Poetry*, New York, 1940.

Eberhart, Richard, and Rodman, Selden, eds. *War and the Poet*, New York, 1945.

Ede, H. S. *Savage Messiah, Gaudier-Brzeska*, New York, 1931.

Eglington, Charles. 'Isaac Rosenberg', *Jewish Affairs*, III (May, 1948), 16-19.

Eliot, T. S. *Collected Poems 1909-1935*, New York, 1948.

———. Aldous Huxley, and F. S. Flint. 'Three Critical Essays on Modern Poetry', *Chapbook*, No. 9, 1920.

Emmons, Robert. *The Life and Opinions of Walter Richard Sickert*, London, 1941.

Enright, D. J. 'The Literature Of The First World War', *The Modern Age*. The Pelican Guide to English Literature. Boris Ford, ed. Baltimore: Penguin Books, 1961. 154-69.

Epstein, Jacob. *Let There Be Sculpture*, London, 1940.

Evans, Sir Benjamin Ifor. *English Literature Between the Wars*, London, 1948.

Fellner, Avner C. 'The Life and Poetry of Isaac Rosenberg', unpublished master's thesis, George Washington University, 1960.

Fletcher, John Gould. *Life Is My Song*, New York, 1937.

Fraser, G. S. *The Modern Writer and His World*, London, 1953.

Fry, Herbert, ed. *London In 1890*, London, 1890.

Fry, Roger. *Manet and the Post-Impressionists*, [Exhibition Catalogue], London, 1911.

———. 'The Post-Impressionists', *Nation*, VIII (3 Dec. 1910), 402-3.

———. 'A Postscript on Post-Impressionism,' *Nation*, VIII (24 Dec. 1910), 536-37.

Gardner, Brian, ed. *The Terrible Rain The War Poets 1939-1945*, London, 1966.

———. *Up The Line To Death The War Poets 1914-1918*, 1964.

Gartner, Lloyd P. *The Jewish Immigrant in England. 1870-1914*, London, 1960.

Gibson, Wilfrid. 'The "Georgian Poets", or Twenty Years After', *Bookman*, LXXXII (1932), 82, 280-82.

Ginner, Charles. 'Modern Painting and Teaching' *Art and Letters*, I (July 1917), 19-24.

Gollancz, Ruth. 'Lily Delissa Joseph', *A Loan Exhibition Of Paintings by Solomon J. Solomon and Lily Delissa Joseph* [Catalogue], London, 1946.

Gordan, John D. *Letters to an Editor Georgian Poetry, 1912-1922*, Catalogue of an Exhibition from the Berg Collection, New York, 1967.

Crant, Joy. *Harold Monro and the Poetry Bookshop*, Berkeley, 1967.

Graves, Robert. 'The Future of English Poetry', *Fortnightly Review*, CXIX (1926), 289-302, 443-53.

———. *Good-bye To All That*, London, 1929.

———. *The White Goddess,* New York, 1948.

———. *The Common Asphodel,* London, 1949.

Gregory, Horace. *The Dying Gladiators and other essays,* New York, 1968.

Grierson, H. J. C., and J. C. Smith. *A Critical History of English Poetry,* London, 1947.

Grubb, Frederick. *A Vision of Reality,* London, 1965.

H., G. 'Isaac Rosenberg Exhibition At Leeds University', *New Statesman* (June 6, 1959).

Hamilton, Ian, ed. *The Poetry Of War,* London, 1965.

Harding, D. W: 'Aspects of the Poetry of Isaac Rosenberg', *Scrutiny A Quarterly Review,* III, No. 4 (March, 1935), 358-69.

———. 'Unpublished Poems of Isaac Rosenberg', *Scrutiny A Quarterly Review,* III, No. 4 (Marsh, 1935), 351-57.

———. *Experience Into Words Essays on Poetry,* London, 1963.

Hassall, Christopher. *A Biography of Edward Marsh,* New York, 1959.

———, ed. *Ambrosia and Small Beer,* London, 1964.

———. *Rupert Brooke,* London, 1964.

Hobman, J. B. *David Eder Memoirs Of A Modern Pioneer,* London, 1945.

Hobsbaum, Philip. 'Two Poems by Isaac Rosenberg', *Jewish Quarterly,* 16, No. 4 (Winter, 1968-1969), 24-28.

Hone, Joseph *The Life of Henry Tonks,* London, 1939.

Hughes, Glenn. *Imagism and the Imagists: A Study in Modern Poetry,* Stanford, Calif., 1931.

Hulme, T. E. *Speculations: Essays on Humanism and the Philosophy of Art,* edited by Herbert Read, London, 1936.

———. *Further Speculations,* edited by Samuel Hynes, Minneapolis, 1955.

Hynes, Samuel. *The Edwardian Turn of Mind,* Princeton, 1968.

———. *Edwardian Occasions,* New York, 1972.

Isaacs, J. *An Assessment of Twentieth-Century Literature,* London, 1951.

Jabotinsky, Vladimir, *The Story of the Jewish Legion,* New York, 1945.

'Jews and Cubism', *Jewish World* (c. June 1914).

Johnston, John H. *English Poetry Of The First World War,* Princeton, 1964.

Jones, Alun R. *The Life and Opinions of T. E. Hulme,* London, 1960.

———. 'Notes Toward a History of Imagism' *South Atlantic Quarterly,* LX (1961), 262-85.

Jones, David. *In Parenthesis,* New York, 1961.

Kramer, Jacob. 'Form and Shape', *The Jewish Quarterly,* 9, No. 2 (Spring, 1972), 24-27.

Kenner, Hugh. *The Poetry of Ezra Pound,* London, 1951.

———. *Wyndham Lewis,* London, 1954.

———. *The Pound Era,* Berkeley, 1971.

Kermode, Frank. *Romantic Image,* London, 1961.

———, and Hollander, John. *The Oxford Anthology of English Literature: Modern British Literature,* New York, 1973.

K. L. 'Jewish Art At Whitechapel', *Jewish Chronicle* (May 15, 1914), 10.

Lask, Beth Zion. 'Isaac Rosenberg: Poet', *The Jewish Youth* (June 7, 1928), 6.

Lawrence, D. H. 'The Georgian Renaissance', *Rhythm,* II (March, 1913), Literary Supplement, xvii-xx.

Leavis, F. R. *New Bearings in English Poetry,* London, 1932.

———. 'The Recognition of Isaac Rosenberg', *Scrutiny A Quarterly Review,* VI, No. 2, (September, 1937), 229-30.

Leftwich, Joseph. 'Isaac Rosenberg', Unpublished, longer version of article appearing in the 'Literary Supplement', *The Jewish Chronicle* (February, 1936).

Lewis, Wyndham, ed. *Blast,* I (1914).

———. *The Caliph's Design: Architects! Where is Your Vortex?* London, 1919.

————. *Blasting and Bombardiering,* London, 1937.

————. *The Letters of Wyndham Lewis,* edited by W. K. Rose, London, 1963.

Lidell-Hart, B. H. *The Real War 1914-1918,* Boston, 1930.

Lipke, William. *David Bomberg A Critical Study of His Life and Work,* London, 1967.

————. 'Futurism and the Development of Vorticism', *Studio,* CLXXIII (April 1967), 173-78.

'The London Group', *Athenaeum,* 4507 (14 March 1914), 387.

MacColl, D. S. *Life Work and Setting Of Philip Wilson Steer,* London, 1945.

MacCarthy, Desmond. 'The Post-Impressionist Exhibition of 1910', *Listener,* XXXIII (1 Feb. 1945), 123-24, 129.

'Manet and the Post-Impressionists', *Atheneum,* 4333 (12 Nov. 1910), 598-99.

Marinetti, Filippo. 'New Futurist Manifesto', Arundel del Re, trans., *Poetry and Drama,* I (1913), 319-26.

Marsh, Edward. *Georgian Poetry, 1911-1912, Georgian Poetry 1916-1917,* London, 1912, 1917.

————. *A Number Of People,* New York, 1939.

Megroz, R. L. *Modern English Poetry, 1882-1932,* London, 1933.

Meynell, Everard. *The Life of Francis Thompson,* London, 1916.

Mindel, Joseph. 'Watchman, What Of The Night?', Radio Broadcast in the Eternal Light series, National Broadcasting Company, 1950.

Monroe, Harriet. *A Poet's Life: Seventy Years in a Changing World,* New York, 1938.

Moore, T. Sturge. *Some Soldier Poets,* New York, 1920.

Muir, Edwin. 'Two Poets', *Scots* (July 22, 1937), 15.

Nash, Paul. *Outline,* London, 1949.

Neumann, Erich. *The Great Mother,* New York, 1955.

Nevinson, C. R. W. *Paint and Prejudice,* London, 1937.

Nichols, Robert, ed. *An Anthology of War Poetry,1914-1918,* London, 1943.

Nicolson, Benedict. 'Post-Impressionism and Roger Fry', *Burlington Magazine,* xciii (Jan. 1951), 11-15.

Oliver, W. T. 'First World War Artist and Poet Rediscovered', *Yorkshire Post* (May 29, 1959).

[Ospovat, Henry]. *Catalogue of Drawings by the late Henry Ospovat,* Baillie Gallery, London, 1912.

Owen, Harold. *Journey From Obscurity Wilfred Owen 1893-1918,* Vols. I-III, London, 1963, 1964, 1965.

Owen, Wilfred. *Poems,* edited by Siegfried Sassoon, London, 1920.

————. *The Poems of Wilfred Owen,* edited by Edmund Blunden, London, 1931.

————. *The Collected Poems of Wilfred Owen,* edited by C. Day Lewis, London, 1963.

————. Owen, Wilfred. *Collected Letters,* edited by Harold Owen and John Bell, London, 1967.

Pack, Robert. 'The Georgians, Imagism and Ezra Pound: A Study in Revolution', *Arizona Quarterly,* XII (1956), 250-56.

Palazzeschi, Aldo. 'Futurist Manifesto', Arundel del Re, trans., *New Statesman,* II (1914), 625-26.

Palmer, Herbert, *Post Victorian Poetry,* London, 1938.

Parsons, Geoffrey, 'Isaac Rosenberg', *New Statesman and Nation,* Vol. XIV, No. 336 (July 31, 1937), 194.

Parsons, Ian M. 'The Poems Of Wilfred Owen', *Criterion,* X (July, 1931), 658-69.

Parsons, I. M., ed. *Men Who March Away,* London, 1965.

Partridge, Eric. *Shakespeare's Bawdy.* London, 1961.

Plomer, William. 'Iron, Honey, Gold', *The Spectator,* No. 5,689 (July 9, 1937), 70.

Pound, Ezra. 'A Few Don'ts By an Imagiste', *Poetry* (Chicago), I (March 1913), 200-6.

Pound, Reginald. *The Lost Generation Of 1914*, New York, 1965.

[Pre-Raphaelite Painters]. *Illustrated Catalogue Of Works By English Pre-Raphaelite Painters*, London, 1912.

Press, John. *The Chequer'd Shade, Reflections On Obscurity In Poetry*, London, 1958.

———. *Rule And Energy*. London, 1963.

Pryce-Jones, Alan, ed. *Georgian Poets*. The Pocket Poets, London, 1959.

Read, Herbert. 'Books Of The Quarter', *The Criterion*, XVII, No. LXVI (October, 1937), 136-38.

———. *Annals of Innocence and Experience*, London, 1946.

———. *The Philosophy of Modern Art*, New York, 1953.

———. *Contemporary British Art*, London, 1964.

Reeves, James, ed. *Georgian Poetry*, The Penguin Poets, London, 1962.

Reid, J. C. *Francis Thompson Man and Poet*, London, 1959.

Riding, Laura, and Graves, Robert. *A Survey Of Modernist Poetry*, London, 1927.

Roberts, Michael. *T. E. Hulme*, London, 1938.

Robson, Jeremy, and Abse, Dannie. 'A Survey of Anglo-Jewish Poetry', *The Jewish Quarterly*, 14, No. 2 (Summer 1966), 5-36.

Robson, W. W. *Modern English Literature*, London, 1970.

Rocker, Rudolf. *The London Years*, trans. by Joseph Leftwich, London, 1956.

Roditi, Edouard. 'Judaism And Poetry', *The Jewish Review* (September-December, 1932), 39-50.

Rodker, John. *The Future of Futurism*, London, nd.

———. 'The New Movement in Art', *Dial Monthly*, II (May 1914), 184-88.

[———]. *Memoirs of Other Fronts*, London, 1932.

Rose, Millicent. *The East End Of London*, London, 1951.

Rose, W. K. 'Ezra Pound and Wyndham Lewis, the Crucial Years', *Southern Review*, IV (Jan. 1968), 72-89.

Rosenberg, Annie. 'In Memoriam', *Art And Letters*, II, No. 3 n.s. (Summer 1919), 108, 111.

Rosenberg, Isaac. 'At the Baillie Gallery', *Jewish Chronicle* (May 24, 1912).

———. *Night and Day*, London, 1912.

———. 'Beauty', *South African Women in Council* (December, 1914), 13.

———. 'Our Dead Heroes', *South African Women in Council* (December, 1914), 20.

———. 'Art', *South African Women in Council*, Part I (December, 1914); Part II (January, 1915), 13, 15; 15, 17.

———. *Youth*, London, 1915.

———. 'Heart's First Word', *Colour*, 2, No. 5 (June 1915), 164.

———. 'A Girl's Thoughts', *Colour*, 2, No. 6 (July 1915), 203.

———. 'Wedded', *Colour*, 3, No. 1 (August, 1915), 7.

———. *Moses*, London, 1916.

———. 'Trench Poems', *Poetry A Magazine of Verse*, IX, No. 3 (December, 1916), 128-129. Includes: 'Marching', and 'Break of Day In The Trenches'.

———. *Poems*, edited by Gordon Bottomley, with an introductory memoir by Laurence Binyon, London, 1922.

———. 'An Unpublished Fragment', *Spectator*, No. 5,535 (July 27, 1934), 135.

———. *The Collected Works of Isaac Rosenberg: Poetry, Prose, Letters and Some Drawings*. Gordon Bottomley and Denys Harding, eds., London, 1937.

———. *The Collected Poems of Isaac Rosenberg*, edited by Gordon Bottomley and Denys Harding. Foreword by Siegfried Sassoon, London, 1949.

———. *Collected Poems*, edited by Gordon Bottomley and Denys Harding, London, 1974.

Ross, Robert H. *The Georgian Revolt 1910-1922 Rise and Fall of a Poetic Ideal*, Carbondale, Ill., 1965.

Rothenstein, John. *Modern English Painters*, 2 vols. London, 1952-1956.

Rothenstein, William. *Men and Memories*, 2 vols. London, 1932.

Routh, H. V. *English Literature And Ideas In The Twentieth Century*, New York, 1950.

Rowe, Richard. *Life In the London Streets*, London, 1881.

Russell, C., and Lewis, H. S. *The Jew In London*, London, 1900.
Russell, John. 'Art', *Edwardian England 1901-1914*, edited by Simon Nowell-Smith, London, 1965.
Rutter, Frank. *Some Contemporary Painters*, London, 1922.
――――. *Evolution in Modern Art: A Study of Modern Painting*, 1870-1925, London, 1926.
――――. *Art in My Time*, London, 1933.
Rozran, Bernard. 'A Vorticist Poetry With Visual Implications: The "Forgotten" Experiment of Ezra Pound', *Studio*, CLXXIII (April 1967), 170-2.

Sadlier, M. *Michael Ernest Sadler*, London, 1949.
Sassoon, Siegfried. *The Old Century and Seven More Years*, New York, 1939.
――――. *Siegfried's Journey 1916-1920*, London 1945.
――――. *Collected Poems 1908-1956*, London, 1961.
Siegel, Marc, 'The World Of Isaac Rosenberg', National Broadcasting Company Radio Broadcast, 1965.
Seymour-Smith, Martin. *Guide to Modern World Literature*, London, 1973.
Schlauch, Margaret. *Modern English and American Poetry*, London, 1956.
Sickert, Walter, 'The Post Impressionists', *Fortnightly Review*, LXXXIX (Jan. 1911), 79-89.
Silk, Dennis, 'Isaac Rosenberg (1890-1918)'. *Judaism*, xiv, No. 4 (Autumn, 1965), 562-74.
Silkin, Jon. 'The Forgotten Poet Of Anglo-Jewry', *Jewish Chronicle* (August 26, 1960).
――――. 'The War, Class, and the Jews', *Stand*, IV (1960), 35-38.
――――. *Out of Battle*, London, 1972.
Sisson, C. H. *English Poetry 1900-1950 An Assessment*, London, 1971.
Sitwell, Edith. 'Readers and Writers', *New Age*, XXXI (July 27, 1922), 161.
――――. *Aspects of Modern Poetry*, London, 1934.
Sowden, Dora. 'Isaac Rosenberg, the Anglo-Jewish Poet', *Jewish Affairs*, 7, No. 12 (December, 1952), 21-24.
Spears, Monroe K. *Dionysus and the City*, New York, 1970.
Spencer, Gilbert. *Stanley Spencer*, London, 1961.
Spender, Stephen. *The Destructive Element*, Boston: 1936.
Stein, Gertrude. *Everybody's Autobiography*, New York, 1937.
Swinnerton, Frank. *The Georgian Scene*. New York, 1934.
――――. *The Georgian Literary Scene*, London, 1938.
――――. *Background with Chorus*, New York, 1956.

Tennant, Madge. *Autobiography of an Unarrived Artist*, New York, 1949.
Thompson, Francis. *The Works of Francis Thompson*, 3 vols., London, 1913.
Thorpe, Michael. *Siegfried Sassoon*, Leiden, 1966.
Thwaite, Anthony. *Contemporary English Poetry*, Philadelphia, 1961.
Tindall, William York. *Forces in Modern British Literature*, New York, 1947.
Twentieth Century Art [Exhibition Catalogue], Whitechapel Art Gallery, London, 1914.
Twenty Years Of British Art [Exhibition Catalogue], Whitechapel Art Gallery, London, 1910.

Unsigned Articles and Reviews:
'Ushering in the New Year', *The Times*, No. 39,471 (January 2, 1911), 12.
'A Jewish Futurist/Chat With Mr. David Bomberg', *Jewish Chronicle* (May 8, 1914), 13.
'The Royal Academy/Excellent Work of Jewish Artists', *Jewish Chronicle* (May 8, 1914), 12-13.
'Isaac Rosenberg's Poems', *Times Literary Supplement*, No. 1,065 (June 15, 1922), 393.
'Obscure Poet', *Manchester Guardian* (August 1, 1922).
'Isaac Rosenberg Memorial Exhibition of Paintings and Drawings', *Jewish Chronicle* (June 25, 1937), 41.
'Painter-Poet', *Times Literary Supplement*, No. 1,848 (July 5, 1937), 492.

'Rosenberg's Poetry', *London Times Literary Supplement* (July 28, 1950).
'The Collected Poems of Isaac Rosenberg', *Listener,* XLIV, No. 1129 (September 21, 1950), 389-90.

Vickery, John B. *Robert Graves and the White Goddess,* Lincoln, Neb., 1972.
Vines, Sherrard. *One Hundred Years of English Literature,* London, 1950.

Wees, William C. 'Ezra Pound as a Vorticist', *Wisconsin Studies in Contemporary Literature,* VI (1965), 56-72.
————. *Vorticism and the English Avant-Garde,* Toronto, 1972.
Wellend, D. S. R. *Wilfred Owen A Critical Study,* London, 1960.
Wellesley, Dorothy. *Letters on Poetry from W. B. Yeats to Dorothy Wellesley,* London, 1940.
White, Gertrude M. *Wilfred Owen,* New York,1969.
Whitton, F. E. *History Of The 40th Division,* Aldershot, 1926.
Wilenski, R. H. *The Modern Movement In Art,* London, 1927.
Williams, Oscar, *The War Poets,* New York, 1945.
Woddis, M. J. 'The Café Royal in War Time', *Colour,* II (July 1915), 218-20.
Woodeson, John. *Mark Gertler Biography of a Painter, 1891-1939,* London, 1972.
Woolf, Bella Sidney. 'The Children's Page', *Jewish World* (September 7, 1906), 379.

Yeats, William Butler. *The Oxford Book of Modern Verse.* New York: 1936.
————. *The Variorum Edition* of the Poems of *W. B. Yeats,* edited by Peter Allt and Russell K. Alspach, New York, 1966.
Young, Michael, and Willmott, Peter. *Family and Kinship in East London,* New York, 1957.

Index

to be returned on or before